SHAPING SPACE

the dynamics of three-dimensional design

THIRD EDITION

Paul Zelanski University of Connecticut

Mary Pat Fisher

Shaping Space: The Dynamics of Three-Dimensional Design, Third Edition Paul Zelanski and Mary Pat Fisher

Publisher: Clark Baxter

Acquisitions Editor: John R. Swanson

Assistant Editor: Anne Gittinger and Brianna

Brinkley Wilcox

Editorial Assistant: Allison Roper

Technology Project Manager: David Lionetti

Senior Marketing Manager: Mark Orr

Marketing Assistant: Alexandra Tran

Senior Marketing Communications Manager: Stacey Purviance

Project Manager, Editorial Production: Kimberly Adams

C---+i--- Di---+--- D--- II-

Creative Director: Rob Hugel

Executive Art Director: Maria Epes

Print Buyer: Doreen Suruki

Permissions Editor: Sarah Harkrader

and Bob Kauser

Production Service: Orr Book Services

Text Designer: Gopa & Ted2 Inc. Photo Researcher: Lili Weiner

Copy Editor: Ida May Norton Cover Designer: Gopa & Ted2 Inc.

Cover Image: Anamorphosis and Eva Rothschild, "The Morphic Excess of the

Natural/Landscape in Excess."

Photo: © Jeffrey Debany, 2004. Courtesy The Snow Show, curated by Lance Fung.

Compositor: Lachina Publishing Services

© 2007 Wadsworth, Cengage Learning

ALL RIGHTS RESERVED. No part of this work covered by the copyright herein may be reproduced, transmitted, stored or used in any form or by any means graphic, electronic, or mechanical, including but not limited to photocopying, recording, scanning, digitizing, taping, Web distribution, information networks, or information storage and retrieval systems, except as permitted under Section 107 or 108 of the 1976 United States Copyright Act, without the prior written permission of the publisher.

For product information and technology assistance, contact us at Cengage Learning Customer & Sales Support, 1-800-354-9706

For permission to use material from this text or product, submit all requests online at www.cengage.com/permissions
Further permissions questions can be emailed to permissionrequest@cengage.com

Library of Congress Control Number: 2005938968

ISBN-13: 978-0-534-61393-8

ISBN-10: 0-534-61393-4

Wadsworth

10 Davis Drive Belmont, CA 94002-3098 USA

Cengage Learning is a leading provider of customized learning solutions with office locations around the globe, including Singapore, the United Kingdom, Australia, Mexico, Brazil, and Japan. Locate your local office at: international.cengage.com/region

Cengage Learning products are represented in Canada by Nelson Education, Ltd.

For your course and learning solutions, visit academic.cengage.com

Purchase any of our products at your local college store or at our preferred online store **www.ichapters.com**

PREFACE

haping Space: The Dynamics of Three-Dimensional Design, Third Edition, has been designed to fill a major gap among art textbooks. Unlike most other design books, it serves as an introductory text for three-dimensional design courses. It approaches three-dimensional design with the thoroughness and sensitivity that had previously been granted only to two-dimensional design.

Shaping Space can be used in a variety of three-dimensional courses. It can be used as a core textbook for the foundation-level course in three-dimensional design. As such, it will provide a rich background in three-dimensional aesthetics that broadens students' understanding and creativity beyond the characteristics of the media and methods emphasized in their studio work. It can also be used as a general appreciation textbook for lecture/survey courses in three-dimensional art, both fine and functional. It is also an appropriate supplementary textbook for beginning courses in specific three-dimensional arts, such as ceramics, sculpture, fiber arts, metalsmithing, interior decoration, stage design, applied design, landscape design, or architecture. All of these disciplines are incorporated into the book via discussion and illustration, for they share the same organizing principles and elements of design.

We are excited about three-dimensional design—about the ideas that shape its creation and about how it affects the viewer. We explore these two aspects with care and enthusiasm for both conventional artistic wisdom and new approaches that stretch and transcend the old definitions of what can and should happen in a work of art. Our hope is that students will encounter ideas that have never occurred to them and become more aware of the limitless potential of shaping space.

SPECIAL FEATURES

The third edition of *Shaping Space* offers an engaging, in-depth exploration of the aesthetic and practical considerations of working three-dimensionally. Because the field of three-dimensional design is experiencing a dynamic and exciting period of change, we have included computer-aided sculpture, craft

techniques such as fibers and ceramics used to create nonfunctional art, multicultural and "outsider" art, art as social and political commentary, architecture and industrial design that are conceived sculpturally, public sculpture, sculpture parks, installation pieces, and performance art. The third edition includes new and expanded coverage of kinetic art, ephemeral and conceptual work, and works incorporating video and sound.

This edition of Shaping Space also offers a beautiful new full-color design featuring over three hundred images. New works include video art and installations as well as more examples of global art. The colorful new design enables students to get a fuller sense of these diverse pieces.

In order to give the student a clearer picture of the artistic process, we have incorporated interviews with artists, both historical and contemporary, where the artists explain what they are doing and why, in a way that is direct and insightful. Many relevant color illustrations from all media now appear throughout the book to help the concepts come to life for students.

Studio projects are included in Part Four. There are many more projects than can be covered in most one- or two-semester courses, allowing instructors to choose the projects that they feel are most effective in introducing and broadening three-dimensional awareness and technical skill. For example, the instructor of a basic 3-D course who has a strong ceramics background might emphasize the use of clay, while pre-architecture students might focus on architectural solutions. For courses emphasizing refinement of technical skills, relatively few projects would be assigned, in order to allow the creation of well-finished work. For courses focusing on design potential, many projects could be assigned, using such media as nonhardening clay, wax, plaster, alginate, cardboard, wire, and paper, all of which are inexpensive and allow quick developmental studies.

ORGANIZATION OF THE BOOK

Fundamentals of Three-Dimensional Design. The book begins with three chapters introducing basic considerations in three-dimensional design. Chapter 1 explores the ways in which we experience three-dimensional art, with discussions of the limitations of photographs in representing three-dimensional experiences, the degrees of three-dimensionality, and techniques commonly used to draw people into approaching and exploring a piece. Chapter 2, Working inthe-Round, discusses a variety of practical considerations encountered in three-dimensional work, such as the pull of gravity; the influence of the setting; and issues of size, materials, costs, planning methods, and balancing of form and function. Chapter 3 applies the classical organizing principles of design repetition, variety, rhythm, balance, emphasis, economy, and proportion—to the development of unity in a rich assortment of works.

Elements of Three-Dimensional Design. The second part of Shaping Space devotes a full chapter to each of eight elements present in most three-dimensional works: form, space, line, texture, light, color, and time and movement. Each element is explored in depth, with careful attention paid not only to standard descriptions of ways the element can be used but also to subtleties such as negative forms, implied lines, activation of the space surrounding a piece, use of shadows, and changes through time. The chapters on space and color are particularly strong in treating these elements seriously as major aspects of three-dimensional design.

Construction Methods. The third section of the book offers a chapter on each of four general construction methods—found objects, addition and manipulation, subtraction, and casting. Each is further broken down into subcategories described enough to pique the student's curiosity into exploring new media and methods but not to serve as detailed how-tos.

Adaptations of the Organization. The sequence of the book follows a logical progression from fundamentals, to elements, to experimentation with different construction methods. But the parts and chapters can be assigned in any order, for each is self-contained, with few cross-references. For example, we have introduced the principles of design (Chapter 3) before the elements (Part Two) in order to give students a framework for unifying their solutions to studio problems dealing with the individual elements of design. But some instructors might prefer to introduce the elements before the principles.

In a class stressing design concepts, the third section-Construction Methods—might be given simply as a reading assignment, with students applying the information as needed in solving problems given in the earlier chapters. In a class that stresses construction methods, more emphasis might be placed on exploration of the third section, with the earlier chapters serving as background material to be drawn on in solving problems using found objects, addition and manipulation, subtraction, and casting.

The studio projects given in Part Four allow students to experiment constructively with media and methods with which they may not be familiar. These projects can be created with simple skills and inexpensive materials. Our assumption is that technical expertise with a particular medium can be developed by choice or by requirements of the individual teacher, though the main emphasis in an introductory course will be placed on mastering the fundamentals of design what will work—and on stretching students' concepts of what is possible.

ACKNOWLEDGMENTS

We have enjoyed rewriting and updating Shaping Space, partly because the subject is so fascinating, and partly because so many people have helped so enthusiastically.

We feel very grateful to the working artists whom we interviewed. All have been extremely gracious with their time, perceptive in their comments, and encouraging about this book.

Our reviewers also have been very generous with their time and thoughtful in their suggestions for improving this third edition. We greatly appreciate their help. We particularly wish to thank Gary Webernick, Austin Community College; George Bauer, Savannah College of Art and Design; Charles Brouwer, Radford University; and William J. Zack, Ball State University.

At Wadsworth we have been greatly encouraged by our acquisitions editor, John R. Swanson, and ably assisted by our editors, Brianna Brinkley Wilcox and Anne Gittinger. Gopa and Ted2 Design has developed an excellent new design for this edition. Lili Weiner has worked hard to find all the images needed. Our copy editor, Ida May Norton, has gone to great lengths to keep everything straight. We hope that our joint efforts will make this edition of Shaping Space useful and visually exciting.

Finally, we both want to express our love and appreciation to Annette Zelanski, whose moral support and constructive criticism have helped us to see this third edition to a successful completion.

Many thanks to all of you,

Paul Zelanski Mary Pat Fisher

CONTENTS

PART ONE: HUNDAMENTALS OF THREE	E-DIMENSIONAL DESIGN	
CHAPTER 1	CHAPTER 2	34
Experiencing Three-Dimensionality	Working in-the-Round	7.1
PHOTOGRAPHS OF THREE-DIMENSIONAL WORK	GRAVITY	
Set Point of View 4	THE SETTING	
Flattening Out 5	SIZE	
Scale7	MATERIALS	44
The Photographer's Interpretation	PLANNING THREE-DIMENSIONAL WORK	18
DEGREES OF THREE-DIMENSIONALITY 11	FORM VERSUS FUNCTION	
Frontal Works	COST AND AUDIENCE	
The Full Round	COST AND ADDIENCE	57
Walk-Through Works	CHAPTER 3	62
INVOLVING THE VIEWER	Organizing Principles of Design	02
Engaging Curiosity	REPETITION	61
Representation20	VARIETY	
Abstraction and Stylization	RHYTHM	
Content	BALANCE	
Personal Interaction	EMPHASIS AND ECONOMY	
The Unexpected	PROPORTION	
Verbal Statements and Titles	FROFORTION	, 0
PART TWO: ELEMENTS OF THREE-	IMENSIONAL DESIGN 7	79
CHAPTER 4 80	CHAPTER 5	94
Form	Space	
EXTERIOR VERSUS INTERIOR FORMS 82	DELINEATED FORMS IN SPACE	
PRIMARY AND SECONDARY CONTOURS 84	ACTIVATED SURROUNDING SPACE	
POSITIVE AND NEGATIVE FORMS 86	CONFINED SPACE	
STATIC AND DYNAMIC FORMS	SPATIAL RELATIONSHIPS	
REPRESENTATIONAL, ABSTRACT,	SCALE	
AND NONOBJECTIVE FORMS 91	SPATIAL ILLUSIONS	09

CHAPTER 6112 Line	CHAPTER 9
LINEAR WORKS112	COLOR VOCABULARY154
LINES WITHIN FORMS117	NATURAL COLOR
IMPLIED AND DIRECTIONAL LINES 118	APPLIED COLOR160
QUALITIES OF LINES121	EFFECTS OF COLOR: PHYSIOLOGICAL AND PSYCHOLOGICAL
CHAPTER 7	COLOR COMBINATIONS 169
NATURAL TEXTURE127	CHAPTER 10175
WORKED TEXTURE 129	Time and Movement
VISUAL TEXTURE	
	ILLUSION OF MOVEMENT175
CHAPTER 8	VIEWING TIME177
Light	CONTROLLED TIME180
VALUE	FREE TIME
NATURAL LIGHTING	TIMELESSNESS190
ARTIFICIAL LIGHTING	
REFLECTED LIGHT	
REFLECTED I (3FL)	
LIGHT AS A MEDIUM149	
PART THREE: CONSTRUCTION ME	
PART THREE: CONSTRUCTION ME CHAPTER 11	
PART THREE: CONSTRUCTION ME CHAPTER 11 194 Found Objects	Metal Fabrication
PART THREE: CONSTRUCTION ME CHAPTER 11	Metal Fabrication
PART THREE: CONSTRUCTION ME CHAPTER 11	Metal Fabrication.221Plastic Fabrication.223Stonemasonry.224
PART THREE: CONSTRUCTION ME CHAPTER 11	Metal Fabrication.221Plastic Fabrication.223Stonemasonry.224
PART THREE: CONSTRUCTION ME CHAPTER 11	Metal Fabrication .221 Plastic Fabrication .223 Stonemasonry .224 MIXED MEDIA .224 CHAPTER 13 .228
PART THREE: CONSTRUCTION ME CHAPTER 11	Metal Fabrication .221 Plastic Fabrication .223 Stonemasonry .224 MIXED MEDIA .224 CHAPTER 13 .228 Subtraction
PART THREE: CONSTRUCTION ME CHAPTER 11	Metal Fabrication
PART THREE: CONSTRUCTION ME CHAPTER 11	Metal Fabrication .221 Plastic Fabrication .223 Stonemasonry .224 MIXED MEDIA .224 CHAPTER 13 .228 Subtraction QUALITIES OF THE MATERIALS .228 REVEALING THE FORM .231
PART THREE: CONSTRUCTION ME CHAPTER 11	Metal Fabrication .221 Plastic Fabrication .223 Stonemasonry .224 MIXED MEDIA .224 CHAPTER 13 .228 Subtraction .228 QUALITIES OF THE MATERIALS .228 REVEALING THE FORM .231 TEXTURES AND VALUES .234
PART THREE: CONSTRUCTION ME CHAPTER 11	Metal Fabrication .221 Plastic Fabrication .223 Stonemasonry .224 MIXED MEDIA .224 CHAPTER 13 .228 Subtraction .228 QUALITIES OF THE MATERIALS .228 REVEALING THE FORM .231 TEXTURES AND VALUES .234 CHAPTER 14 .237
PART THREE: CONSTRUCTION ME CHAPTER 11 194 Found Objects INDIVIDUAL FOUND OBJECTS 194 ASSEMBLAGES 196 JUNK SCULPTURE 197 INSTALLATIONS 201 CHAPTER 12 205 Addition and Manipulation MANIPULATING MALLEABLE MATERIALS 205 Clay 206 Wax 211 Plaster and Cement 212	Metal Fabrication 221 Plastic Fabrication 223 Stonemasonry 224 MIXED MEDIA 224 CHAPTER 13 228 Subtraction QUALITIES OF THE MATERIALS 228 REVEALING THE FORM 231 TEXTURES AND VALUES 234 CHAPTER 14 237 Casting
PART THREE: CONSTRUCTION ME CHAPTER 11 194 Found Objects INDIVIDUAL FOUND OBJECTS 194 ASSEMBLAGES 196 JUNK SCULPTURE 197 INSTALLATIONS 201 CHAPTER 12 205 Addition and Manipulation MANIPULATING MALLEABLE MATERIALS 205 Clay 206 Wax 211 Plaster and Cement 212 Malleable Metals 213	Metal Fabrication .221 Plastic Fabrication .223 Stonemasonry .224 MIXED MEDIA .224 CHAPTER 13 .228 Subtraction .228 QUALITIES OF THE MATERIALS .228 REVEALING THE FORM .231 TEXTURES AND VALUES .234 CHAPTER 14 .237 Casting SOLID CASTS .238
PART THREE: CONSTRUCTION ME CHAPTER 11	Metal Fabrication .221 Plastic Fabrication .223 Stonemasonry .224 MIXED MEDIA .224 CHAPTER 13 .228 Subtraction .228 QUALITIES OF THE MATERIALS .228 REVEALING THE FORM .231 TEXTURES AND VALUES .234 CHAPTER 14 .237 Casting SOLID CASTS .238 HOLLOW CASTS .245
PART THREE: CONSTRUCTION ME CHAPTER 11	Metal Fabrication .221 Plastic Fabrication .223 Stonemasonry .224 MIXED MEDIA .224 CHAPTER 13 .228 Subtraction .228 QUALITIES OF THE MATERIALS .228 REVEALING THE FORM .231 TEXTURES AND VALUES .234 CHAPTER 14 .237 Casting .238 HOLLOW CASTS .238 HOLLOW CASTS .245 FOUNDRIES AND EDITIONS .247
PART THREE: CONSTRUCTION ME CHAPTER 11	Metal Fabrication .221 Plastic Fabrication .223 Stonemasonry .224 MIXED MEDIA .224 CHAPTER 13 .228 Subtraction .228 QUALITIES OF THE MATERIALS .228 REVEALING THE FORM .231 TEXTURES AND VALUES .234 CHAPTER 14 .237 Casting SOLID CASTS .238 HOLLOW CASTS .245

CHAPTER 1	Visual Textures
to Three-Dimensionality 252 Modular Low Relief 252 The Wrapped Object 252 Walk-Through Work 253	CHAPTER 8 258 Natural versus Artificial Lighting 258 Shadows 258 Light as a Medium 258
CHAPTER 2 253 Good and Bad Design 253 Form and Function 253 Working with the Setting 253 Defying Gravity 253 Working on a Large Scale 254	CHAPTER 9 258 Natural Colors 258 Applied Color 258 Psychological Effects of Color 259 Removal of Color 259 Color Combinations 259
CHAPTER 3 254 Repetition 254 Variety 254 Visual Rhythm 254 Visual Balance 255 Emphasis 255	CHAPTER 10
CHAPTER 4 255 From Flat Material to Volume 255 Curvilinear Form 255 Exterior and Interior Forms 255	CHAPTER 11. 260 Ready-Made 260 Assemblage 260
Metamorphosis	CHAPTER 12 260 Clay or Wax Sculpture 260 Addition with Malleable Materials 260
CHAPTER 5	Fabrication with Rigid Materials
Scale Change	CHAPTER 13
CHAPTER 6	Plaster Carving
Directional Line	CHAPTER 14
CHAPTER 7 257 Texture Switch 257 Three Textures Together 257	Plaster Casting in Clay
Glossary 263	Photographic Credits 277
Index 269	

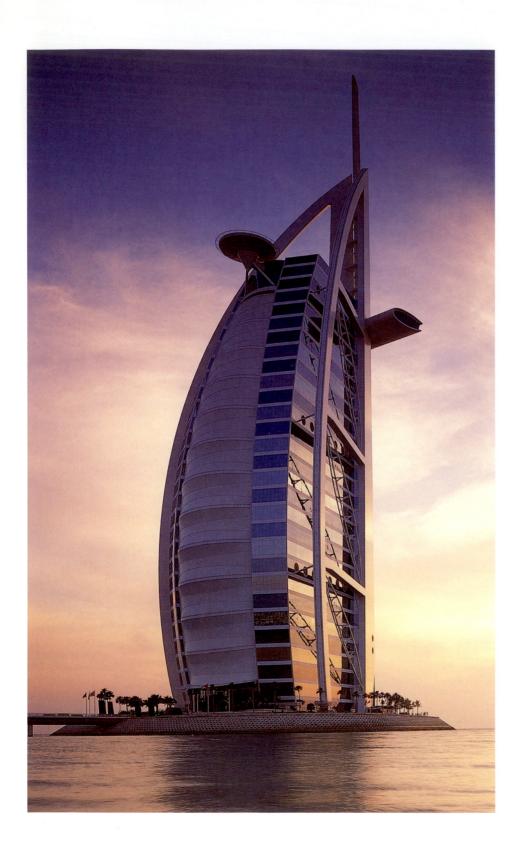

FUNDAMENTALS OF THREE-DIMENSIONAL DESIGN

1

EXPERIENCING THREE-DIMENSIONALITY

HREE-DIMENSIONAL ART HAS height and width, as a painting does, plus a third dimension—depth. This stark definition, though true, gives no hint of the excitement of actually experiencing three-dimensional art. To plunge into this experience, try this experiment: Loosely crumple a piece of paper, any piece of paper. Then look at it. Don't just glance at it briefly; really explore it all over with your eyes. Hold it in your hand and slowly turn it, watching how it changes as the parts you can see and the angle from which you are seeing them change. Play with its relationship to a source of light.

If you are giving yourself fully to this experience, you will find that your piece of crumpled paper becomes endlessly fascinating. Your eyes and mind will be intrigued by the ever-changing patterns created by the paper forms and the empty spaces they define—the myriad ridges, hollows, and tunnels and their relationships to each other, the gradations of light and shadow, the changing surface textures. If your piece of paper happens to have writing on it, follow what happens to the lines of words as they disappear over the edge of a fold. Spend a long time exploring as many ways of looking at your paper "sculpture" as possible. Let your fingers explore it as well.

Three-dimensional experiences—those having height, width, and depth—are the stuff of our everyday life, yet we tend to pay them relatively little notice unless they are isolated for our attention. To be sure that the seven-star luxury hotel Burj Al Arab in Dubai (Fig. 1.1) would have maximum impact, its architects built it in the sea in the form of a billowing sail atop underwater pillars 120 feet (40 meters) tall anchored in the seabed. The hotel's Teflon-coated white facade is bathed by a changing play of colored lights at night, augmented by the natural dramas of sea and sky. A person standing at the lobby level can look upward through the world's tallest atrium, onto which all 60 floors open—a 600-foot-high (180 meters) cavity. If this were not enough, guests can also ride a submarine down to the underwater restaurant, where they can dine

1.1 Burj Al Arab, Dubai, United Arab Emirates. 1999. Architects W. S. Atkins and Partners Overseas. Height 1,060' (321 m). Photo courtesy of Jumeirah.

while watching sea creatures swimming around them—unless they prefer to dine at the top of the world's tallest hotel, viewing the awesome panorama of the Gulf. How are people affected by these stunning three-dimensional sensations? One travel magazine reported about the Al Arab hotel: "First-time reactions to the Burj Al Arab often include awe, shock, horror, disbelief and mute astonishment."

The drama of approaching, entering, and viewing Burj Al Arab in person can only be suggested by viewing it in a photograph. No photograph, no matter how well-planned or dramatic, can possibly replicate the highly personal act of experiencing a three-dimensional piece or place. In this chapter we will examine some of the ways in which photographs distort the three-dimensional experience, demanding a great leap of imagination on your part to appreciate the works shown in this book. As an introduction to the vast range of possibilities for your own three-dimensional work, we also will look at the many different degrees of three-dimensionality and some of the techniques that can be used to draw viewers into the three-dimensional experience.

PHOTOGRAPHS OF THREE-DIMENSIONAL WORK

A photograph eliminates many features of a three-dimensional work. In a black-and-white photograph, color is lost. Even a color photograph cannot convey the surface texture, weight, and balance of a piece—its "feel." Nor can photographs capture such dimensions as smell, sound, or motion. Also lost is the sense of presence a three-dimensional work can create. Indeed, a photograph

¹Nayantara Kilachand, "Dirhams in the Sand," Namaskaar, December 2004, p. 42.

eliminates the use of all senses other than vision, and then it rigidly controls what we can see of a work and how we understand its totality.

Set Point of View

Presenting a single photograph of a three-dimensional piece confines the experience of the work to a single **point of view**—a set distance and angle from which the piece is viewed. Of the almost limitless possibilities, only one viewpoint is chosen to represent the experience of the whole. This approach obviously has its limitations.

The first photograph shown here of Umberto Boccioni's *Unique Forms of Continuity in Space* (Fig. 1.2) illustrates the most commonly used view. The photograph certainly captures the rapidity of the abstracted figure's motion, the sense of garments being blown back as the figure strides forward. This illusion of vigorous movement is what the artist was depicting, as if in a stop-action photograph. But from this side, what can we make of the shoulder area? Of the head? A head-on view (Fig. 1.3) would never make sense by itself, but it gives us a bit more information about the piece. Here we discover that the front of the "face" is like a crucifix, and that where the upper garment opens down the

1.2 Umberto Boccioni. *Unique*Forms of Continuity in Space.
1913. Bronze (cast 1931), 43⁷/₈ × 34⁷/₈ × 15³/₄". Acquired through the Lillie P. Bliss Bequest.
(231.1948) The Museum of Modern Art. New York.

1.3 Umberto Boccioni. *Unique Forms of Continuity in Space.* Photographed from a different angle.

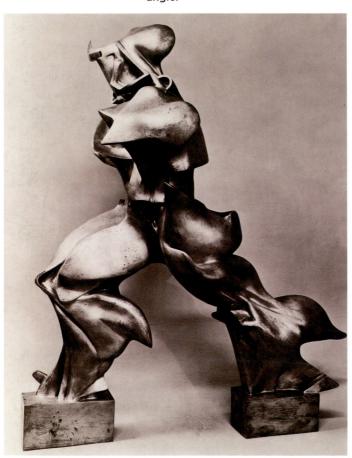

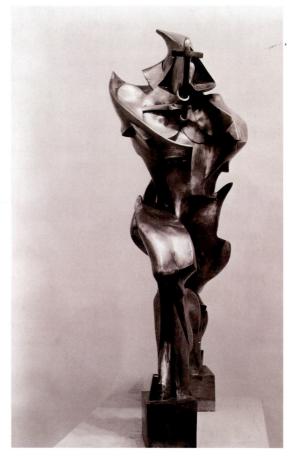

center, it is caught by the wind and billows outward like an exterior rib cage. Here and there, areas of unfilled space are drawn into the embrace of the sculpture by flaring projections from the figure. We can also see the sleek trajectory of the thigh from the hip.

Making a full circle around the piece would reveal even more views and surprises, more dark recesses and strange projections, distorted by the apparent motion of the figure. Boccioni intended for us to explore the sculpture from all sides to see what happens. Good three-dimensional art does that: It compels us to walk all the way around it, examining it from many angles.

Flattening Out

Photographs inevitably distort our perceptions of a three-dimensional piece, for they present it on a flat two-dimensional surface, having only height and width but not depth. Viewing a two-dimensional photograph and mentally translating it into three-dimensionality is an ability most people in our culture have developed. When Australian aborigines are shown a photograph of an area they know, they do not make the mental leap from the flat image to threedimensional reality. But from experience with photographs, you have probably learned to read the clues they provide about depth. These clues include shadows, the overlapping of one area by another, the greater contrast in values (gradations of lights and darks) and in sharpness of edges in areas closer to the viewer than in areas farther away, and linear perspective (the convergence of parallel lines toward a distant vanishing point). By interpreting such clues, we may get some intellectual impression of how deep a piece might be. But the experience remains an intellectual one nevertheless; we cannot fully appreciate the three-dimensional impact of the piece and how the parts relate to one another in space. It is very difficult to judge from the photograph in Figure 1.4a the depth and feel of Frank Lloyd Wright's Guggenheim Museum with Jenny Holzer's installation on the ground floor and around the balconies of the spiraling ramp. Even though the nested curves are clues to depth, we cannot even be sure whether we are looking up at the dome or down at the base of the museum. The photograph in Figure 1.4b, taken from just above the ground floor, offers an entirely different experience of this work.

Many efforts are now being made to provide computer simulation of the experience of viewing a work of art from many angles. Images designed on computers can be manipulated so they can be "seen" from any direction even if they have never been physically constructed.

Video computer disc (VCD) tuchnology also makes it possible for existing artworks to be videotaped in-the-round and then called up on-screen so that viewers can see all sides. Some museum collections are being scanned onto VCDs with interactive technology to simulate for computer viewers the experience of walking through galleries. The screen itself is still a flat space, however, so the technology can only approximate the fullness of existing with and examining a piece in three-dimensional space.

The potential of interacting electronically with a piece of sculpture is also beginning to be manifested in a rudimentary way with the development of

1.4a and 1.4b Jenny Holzer.
Selections from *Truisms,*Inflammatory Essays, The Living
Series, The Survival Series, Under
a Rock, Laments, and new
writing. 1989. Two views of
extended helical tricolor L.E.D.
electronic display signboard,
1'4" × 162' × 6". Solomon R.
Guggenheim Museum, New York.
Partial gift of the artist, 1989.
Photos David Heald © The
Solomon R. Guggenheim
Foundation, New York.

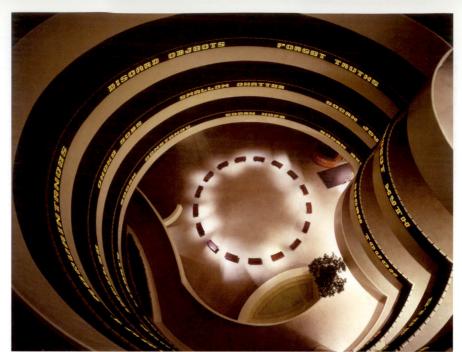

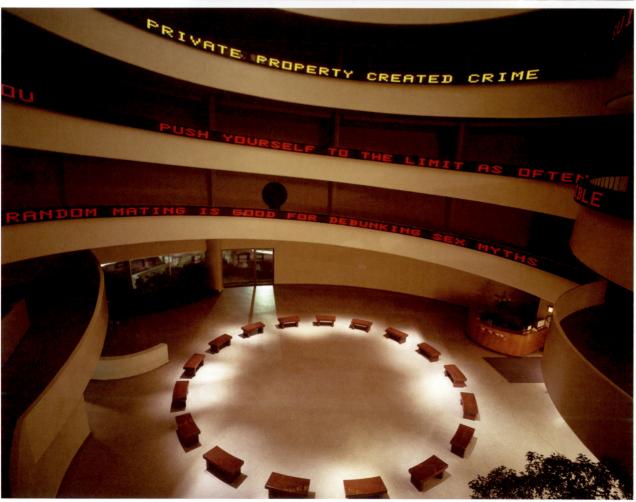

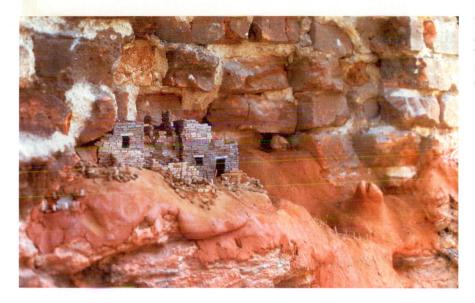

1.5 Charles Simonds. *Dwelling,*East Houston Street, New York.

1972. Unfired clay bricks, each

brick ¹/₂" (1.3 cm) long. Courtesy
the artist.

virtual realities. "Virtual" is a computer term referring to anything that exists only as digital memory in the computer rather than in physical fact. The viewer dons special headgear containing miniature video monitors that block out visual impressions of the actual surroundings. The person also attaches movement-sensing wires to his or her body and can then "walk into," "see," and "manipulate" objects in a simulated three-dimensional environment. Developed for scientific purposes, as were computers themselves, virtual-reality technology is a tool adaptable for use by artists. It is conceivable that a person could walk into an empty room, put on virtual-reality equipment, and then "move through" or "walk around" and examine from every angle a sculptural work that has never existed in physical form. The viewer could even push its moving parts and watch what happens.

Scale

Another distortion introduced by two-dimensional photographs of three-dimensional works is the confusion of **scale**—the relative size of pieces. Many photographs give no clues to whether the object pictured is very small or very large. Charles Simonds's *Dwelling*, shown in **Figure 1.5**, looks larger than the similar structures in the pueblo cliff dwellings shown in **Figure 1.6**, yet Simonds's work is a miniature of tiny clay bricks placed among the bricks of a building, photographed from close range, whereas the cliff dwellings are vast and photographed from a distance.

When photographers want to give some indication of scale, they often include in the photograph something of known size—such as a bench or a human being—to serve as a standard of comparison. The photograph of the true cliff dwellings does include the overhanging rock ledge, but this serves as a clue to scale only for those who are familiar with the vast scale of these hollows in the cliffs of the American Southwest.

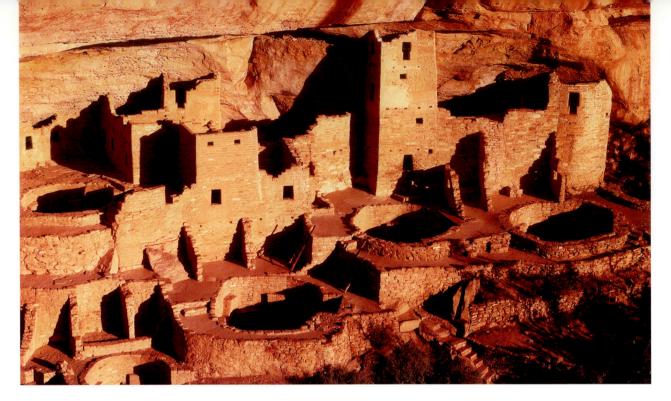

1.7 Gustave Doré. *La Vigne* (The Vintage Vase), 1877–1878. Bronze, 156 × 82". Fine Arts Museums of San Francisco. Gift of M. H. DeYoung, 53696.

1.6 Cliff Palace, Mesa Verde National Park, Colorado. c. AD 1100.© Royalty-Free/Corbis.

An additional intellectual clue to the scale of a three-dimensional work is the size given in the caption. If you merely look at the photograph of the Doré vase (Fig. 1.7), you will likely interpret it as simply a fancy container for flowers one might use on a table. But read the caption: This piece is 11 feet tall; it weighs 6,000 pounds. Those cherubs are as large as real babies. But even with this information, imagining the true scale of this work requires a great imaginative leap on your part.

The Photographer's Interpretation

Yet another limitation introduced in photographs is the difference between the photographer's understanding of a piece and the artist's vision of it. Consider the vast difference between the standard museum photograph of Constantin Brancusi's *Bird in Space* (Fig. 1.8) and Brancusi's own photograph of the work (Fig. 1.9). The first gives us some idea of what the piece looks like; the second has a far more dramatic impact. Brancusi's photograph reveals what he was trying to capture: the mystical wildness of flight. At certain times, birds flying overhead express this quality; all you can see is a flash of light. By contrast, the standard photograph, though graceful, has a static quality, as though it were a statement about a still object.

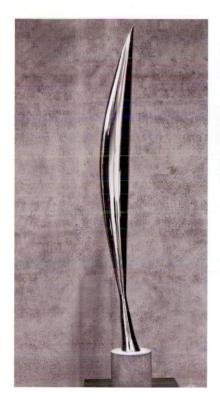

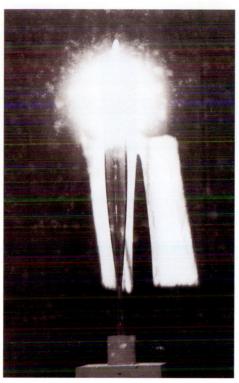

- 1.8 Constantin Brancusi. *Bird in Space.* 1928. Bronze (unique cast), $54 \times 8^{1/2} \times 6^{1/2}$ ". © The Museum of Modern Art, New York. Given anonymously, (153.1934).
- 1.9 Constantin Brancusi. *Bird in Space.* 1928. Photograph by Constantin Brancusi. Musee National d'Art Moderne, Paris. © CNAC/MNAM/Dist. Réunion des Musées Nationaux.

The Photograph as the Work of Art

Despite the limitations of substituting the secondhand experience of viewing a flat photograph for actual involvement with a three-dimensional piece, in some cases a photograph serves as our only way of experiencing a piece. If the work is not nearby, a photograph will have to do. Photographs also preserve an impression of installation pieces erected temporarily in a particular setting. And in certain pieces of **conceptual art**—that is, work or events existing as ideas in the artist's mind but not necessarily presented or maintained in tangible form—the phenomenon created may be so short-lived or difficult to experience that a photograph must serve as the documentation of the work.

Walter De Maria's conceptual piece *The Lightning Field* can best be appreciated during a lightning storm. Yet few of us would stand in the midst of these 400 lightning rods during a lightning storm to see what happens. Fortunately, John Cliett, who took the photograph in Figure 1.10, shared his experience with us.

Andy Goldsworthy's outdoor conceptual art is ephemeral, often consisting of fragile materials such as twigs, leaves, ferns, or ice placed in natural settings with no attempt to protect them from decay and disruption by wind, rain, insects, and animals. In the case of his *Reconstructed Icicles Around a Tree* (Fig. 1.11), this ephemeral art is located where few people might chance upon it to witness its brief life. Goldsworthy constructed and photographed it at a remote riverside under challenging winter conditions; it soon melted and disappeared. But how exquisite its momentary appearance that he captured on film. Goldsworthy explains: "Each work grows, stays, decays—integral parts of a

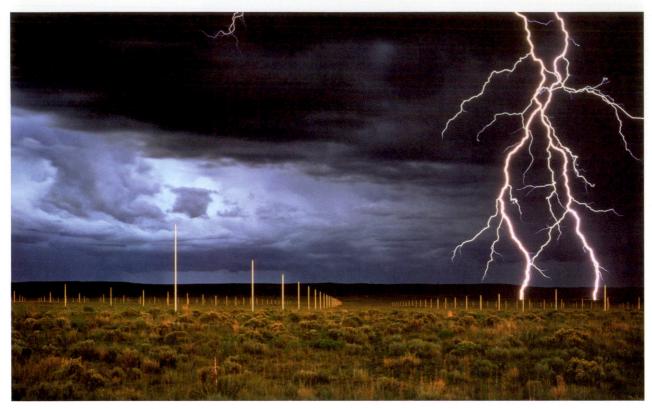

1.10 Walter De Maria. The Lightning Field. 1977, Quemado, New Mexico. Permanent earth sculpture 1 mile × 1 kilometer. 400 stainless-steel poles with solid stainless-steel pointed tips, arranged in a rectangular grid array spaced 220 feet (67.05 m) apart. Pole tips form an even plane. Average pole height is 20' 7" (6.27 m). New Mexico, Dia Center for the Arts. Photo John Cliett © Dia Center for the Arts.

1.11 Andy Goldsworthy.

Reconstructed Icicles Around a

Tree. 1995. Glen Marlin Falls,

Dumfriesshire, United Kingdom.

© Andy Goldsworthy, courtesy

Galerie Lelong, New York.

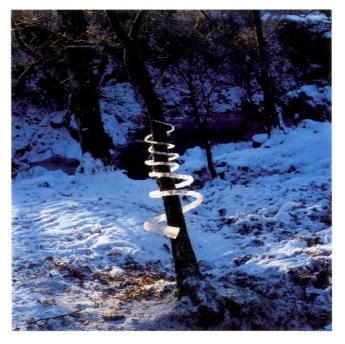

cycle which the photograph shows at its height, making the moment when the work is most alive. There is an intensity about a work at its peak that I hope is expressed in the image. Process and decay are implicit."²

For the most part, however, photographs of three-dimensional works are not intended to be the artistic statement in themselves. In general, you must pierce the layers of abstraction and distortion introduced by the photograph and mentally project yourself into the feeling of personally experiencing the piece.

DEGREES OF THREE-DIMENSIONALITY

In experiencing three-dimensionality, we are controlled to a certain extent—depending on the success of the piece—by the intentions of the artist. Artistic intentions and means of control are discussed throughout this book, but here the focus is on how three-dimensionally the piece was conceived. Possibilities range from nearly flat works to works designed to surround the viewer. The term relief refers to the raising of three-dimensional forms from a flat background. It appears that this artistic convention began very early, for relief works were carved on cave walls by prehistoric peoples. Perhaps the ancient sculptors noted bulges in the cave wall that already looked something like horses or bison; a bit of carving brought out the desired form. Other reliefs have been found in which ancient sculptors created figures by adding damp clay to cave walls and modeling them to resemble animals, such as the two bison from approximately 13,000 BCE shown in Figure 1.12.

The shallowest form of relief is called **low relief**, or **bas-relief**. Although a formal definition of low relief is hard to pin down, the artistic attitude is one of

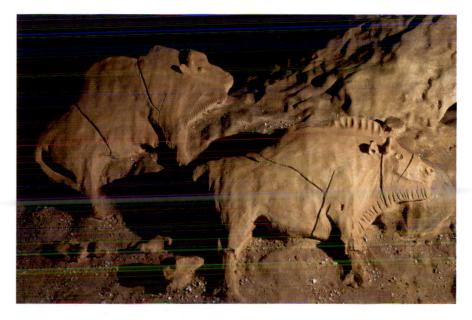

1.12 Bison, Le Tuc d'Audoubert, Ariège, France. 13,000 Bc. Unbaked clay, length 25" (63.5 cm) and 24" (60.9 cm). © Charles & Josette Lenars/Corbis.

²Andrew Goldsworthy, *A Collaboration with Nature* (New York; Harry N. Abrams, 1990), unpaginated introduction.

1.13 Detail from gravestone of Polly Coombes, 1795, Bellingham, Massachusetts. Carving attributed to Joseph Barber Jr. Slate gravestone, size of full stone $29^{1/2} \times 16^{3/4}$ " (74.9 \times 42.5 cm). Photo © Ann Parker, 1985.

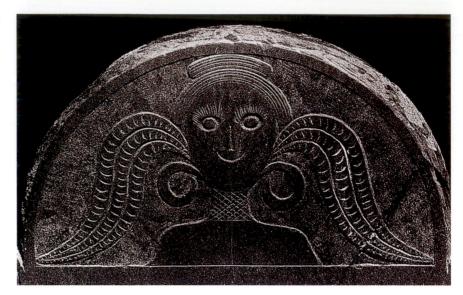

relative flatness. In the gravestone carving in **Figure 1.13**, the angel is barely raised from the incised slate. Note that highlights and shadows are created by the ways the raised areas and strongly chiseled grooves reflect or block the light, helping to accentuate the image.

In **high relief**, forms are brought more fully off the flat surface, for a nearly sculptural effect. Extraordinary examples of such high relief exist in the marble carvings of the Jain Vimal Vasahi Temple in Mount Abu, India. Built over a period of 14 years in the 11th century by 1,500 artisans and 1,200 laborers, the temple consists totally of amazingly intricate marblework. In the *Goddess Vidyadevi* shown in **Figure 1.14**, the far right side shows the thickness of the

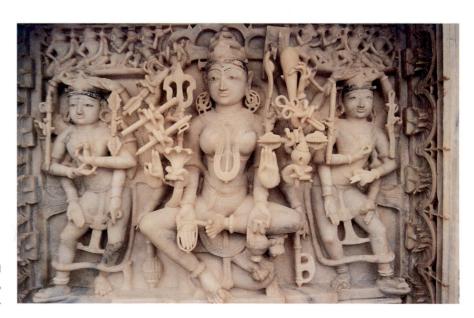

1.14 Goddess Vidyadevi, Vimal Vasahi Temple. 1031. Mount Abu, Rajasthan, India.

original marble block that was carved into to create deeply spatial forms supported by the remaining stone in the background. The most three-dimensional of these is the central goddess figure, whose sixteen graceful hands project far outward. Such deep relief carving creates lights and shadows that enliven the figures.

Reliefs are not limited to figurative works in which the forms and their background are carved or cast from the same material. An example is Kurt Schwitters's *Merz-Relief* (Fig. 1.15), a relief in which found materials have been affixed to a piece of painted wood. This piece controls the viewer's experience in the same way as the earlier examples: By presenting forms against a flat surface, the artist defined a limited space for the viewer's attention and a fixed point of view. Reliefs are designed to be looked at more or less straight on, perhaps with the head lifted somewhat, as in the cases of friezes placed above eye level on buildings.

Frontal Works

The next step in three-dimensionality is work designed to be seen from only one side but not confined to a flat background. Like reliefs, these works are primarily **frontal**—that is, they are organized for being viewed from the front. We can move around these pieces to a certain extent, but the artist does not strongly encourage us to do so.

Most jewelry is of this nature: All the visual interest lies on the front side, with the back only minimally elaborated. Instead of moving around or turning a piece of jewelry to see how its contours change, viewers would tend to scan it from edge to edge like a two-dimensional work, following the interplay of patterns on the surface.

Some one-sided pieces are large enough that viewers can walk along them, examining each section. If you encountered Louise Nevelson's *Sky Cathedral—Moon Garden + One* (Fig. 1.16), you would probably want to examine it in at least two ways: Stand back to see the whole thing from a distance, and also walk from one side to the other, looking into the individual boxes to see what is happening in each one. However, Nevelson does not encourage you to stand to one side and look across the whole piece, for the contents of the boxes do not protrude much beyond the boxes themselves, limiting what you could see from this angle. Neither does she suggest that you explore the back of the piece, for it is backed against a wall, with all parts designed to be seen frontally.

Edward Kienholz and Nancy Reddin Kienholz's *People Holding Bound Ducks* (Fig. 1.17) suggests to viewers an environment that is not to be intruded upon but is to be examined visually from its edges at floor level. The intrigued viewer wants to wander back and forth along the exposed sides of the half-round installation, looking for visual clues and personal mental associations that might help make some sense of it: Why only fragments of bodies? Why the armbands? Why are objects held under the table rather than being placed atop it? Are the metal cases in some way functional? Why ducks? Is some grim statement being made? We cannot be sure of anything in this strange but evocative miniworld, set before us as a stage.

1.15 Kurt Schwitters. Merz-Relief. 1928. Oil, wood, metal. $65 \times 46.4 \times 18$ cm. © Lempertz, Cologne, Germany.

1.16 Louise Nevelson. Sky Cathedral—Moon Garden + One. 1957-1960. Painted wood. $9'1'' \times 10'10'' \times 1'7''$ (276.9 \times 330.2 \times 48.3 cm). Photograph by Ellen Page Wilson. Courtesy of the Pace Gallery.

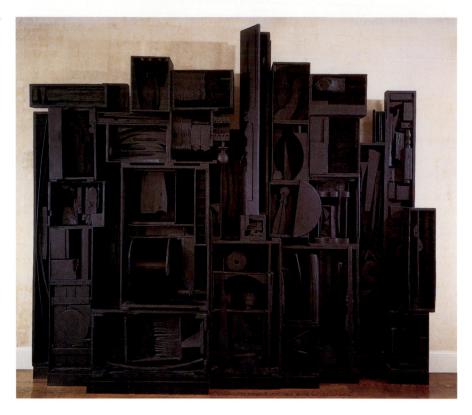

1.17 Edward Kienholz and Nancy Reddin Kienholz. *People Holding Bound Ducks.* 1989. Mixed media, $92^{1}/2 \times 116 \times 44''$. Photo L. A. Louver.

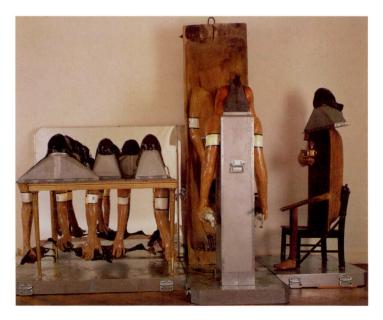

The Full Round

In contrast to reliefs and frontal works, pieces created "in-the-round" are designed to be seen from all sides. Instead of being organized like a two-dimensional work, in which all spatial relationships are fixed across a flat plane, areas in a fully round work have been organized with consideration of their constantly changing relationship to one another. Indeed, if such pieces are successful, they should make us want to walk all around them, discovering how the forms and relationships change when seen from different angles. **Full round** is a description applied to any fully three-dimensional piece, no matter how large or small or how shaped.

Ursula von Rydingsvard's *For Paul* (Fig. 1.18) is like a huge boulder looming above the viewer, larger at the top than the bottom. To see it only in a photograph is particularly frustrating, for its horizontal lines draw us to investigate it in the full round. We want to see what lies around the corner; the cutting and working of the wood also beckon us toward the piece almost as to a place of stable refuge. The artist herself was born of Polish parents, living in forced labor and refugee camps in Germany, and the stability of seemingly time-worn everyday materials often appears as a motif in her works. There is nothing sentimental here, though. Von Rydingsvard once said: "One of the things I would be most ashamed of is to have any pathos in my work. Or to have blatant pain. . . . I want this kind of packed pride, this containment of emotions." "

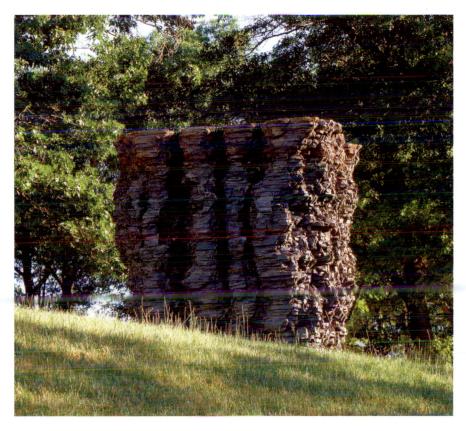

³Ursula von Rydingsvard, quoted in Avis Berman, "Life under Siege," *Art News,* December 1988, p. 97.

1.18 Ursula von Rydingsvard. For Paul. 1990–1992. Cedar and graphite. $14'4'' \times 9' \times 13'8''$. Installed at the Storm King Art Center, Mountainville, New York. Photo Jerry L. Thompson.

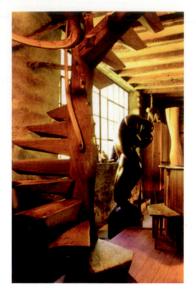

1.19 Wharton Esherick. Treelike stairway hewn from solid logs. 1930. Red oak. Courtesy Wharton Esherick Museum, Paoli, Pennsylvania. Photo William Howland.

Walk-Through Works

The final degree of viewer involvement with three-dimensionality is the experience of actually being surrounded by a work of art—of walking not only up to and around a piece but also into it. This process places you at the center of the work; rather than your circumnavigating its circumference, *it* encircles *you*. This feeling of being surrounded by a 360-degree experience is as impossible to represent in a photograph as the experience of exploring a work from all sides. Again, you must use your imagination to place yourself in the settings pictured.

To experience Wharton Esherick's stairway (Fig. 1.19), you would probably want to walk up to it and around it to see how the logs create two branching, spiraling pathways and to appreciate the weight, form, and texture of the steps and central support. In addition, you might want to climb the stairs to see where they go and how they get there. At each step toward, around, and up the stairs, your spatial relationship with the stairway and the rest of the interior would change, altering and enriching your experience of being surrounded by this organic architectural environment.

Or consider what you would do if you met Nancy Graves's *Camels* (Fig. 1.20). Unless you have no curiosity whatsoever, you would want to move around these realistic creatures in as many ways as the gallery allowed. You would want to study them very closely to see how Graves managed to create such lifelike texture and form. You would want to walk all around and even between them, watching their changing relationships to one another—to look between the legs of one to see the head of another, to see the similarities and differences from head to head, neck to neck, hump to hump. If you have retained or remem-

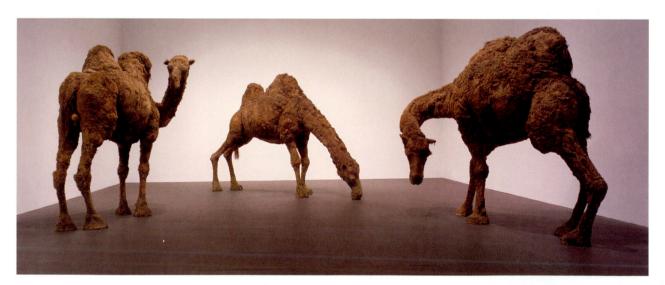

1.20 Nancy Graves. *Camels VII, VI, VIII* (left to right). 1968–1969. Wood, steel, burlap, polyurethane, animal skin, wax, oil paint; $228.6 \times 365.8 \times 121.9$ cm approx. National Gallery of Canada (no. 15842). Art © Nancy Graves Foundation. Licensed by VAGA, New York.

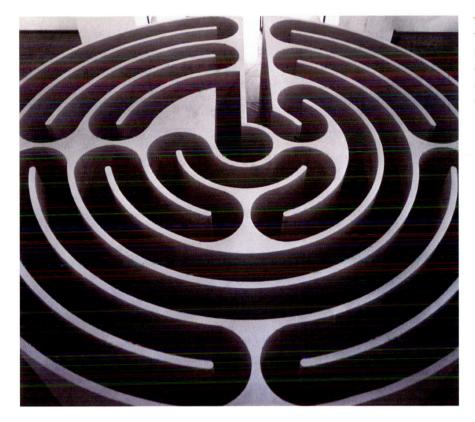

1.21 Robert Morris. Labyrinth.
1974. Plywood, masonite, oil
paint. Height 8' (2.44 m),
diameter 18' (9.14 m),
passageway 1'6" wide (45.72
cm). Institute of Contemporary
Art, Philadelphia.

bered a child's ways of appreciating the world, you might even respond to the playfulness of the piece by walking under the belly of one and gazing upward to see what you can see, discovering in a very personal way how large a camel really is. If the piece called forth these kinds of reactions from you, you would be participating in it fully rather than simply standing aside as a passive observer.

For a walk-through experience, a piece must obviously be large in scale, large enough for people to fit inside. Depending on the artist's intent, the piece may control the ways in which people can walk through it. Architecture often has defined passageways—halls and doors and stairs—that limit the ways we can move through its interior spaces. We may or may not find the means of control pleasant. For many people, walking through Robert Morris's *Labyrinth* (Fig. 1.21) would be a disturbing or even frightening experience. To be caught in the endless curves of this maze would create a sense of not getting anywhere. The 8-foot-high (2.44 m) walls not only would frustrate attempts to find the way into the center—or out—but also would press in uncomfortably along the sides. The emotions evoked in people trying to find their way through the maze create the drama of the piece.

INVOLVING THE VIEWER

If it is effective, art-in-the-round invites some kind of participation by the viewer. Depending on its size and nature, a piece may encourage us to pick it

up and turn it over in our hands, feel its weight, stroke it, smell it, use it, sit on it, visually traverse the piece following its contours, walk around it to see what it becomes on the other side, explore its passageways.

In its very three-dimensionality, art-in-the-round has a direct impact on us. Whereas a two-dimensional piece, such as a painting, is like a window that we must take the time to look through, a three-dimensional piece occupies space and time in our immediate environment. It competes with us for physical space, like a wall that we must either walk around or else bump into.

Yet even three-dimensional art can be ignored by the viewer. To a certain extent, people can walk past three-dimensional pieces without really seeing them, for the viewers' thoughts are elsewhere. One of the tasks facing you as an artist, therefore, is to draw attention to your creations, to invite people to notice and to respond to them.

Techniques for provoking a direct response from viewers appear throughout this book. First, however, it is helpful to examine some general categories of involvement-encouraging factors: tactile/visual appeal, engaging curiosity, representation, abstraction and stylization, scale, content, personal interaction, the unexpected, and verbal statements about the work.

Tactile/Visual Appeal

Involvement in three-dimensional art begins with the artist who creates it. As children, many of us begin exploring three-dimensional art by shaping claylike materials into forms that please our hands and perhaps our eyes. Consider the comments of eight-year-old Ruth Zelanski: "I like to work with clay because it feels mushy—and then when it's glazed and fired it feels nice and glossy." As she talks about her work, her fingers explore it constantly, following its contours, fitting themselves into its concavities, caressing its smoothness, noting the grooves made by fingernail marks. Her description of how she works is studded with highly physical verbs: "pound," "roll," "poke," "pinch," "rub," "mush." Although she explains that when faced with a block of clay she gets a form out of it by "sort of seeing it inside my head," she notes that the forms that evolve are "what my body wants to do."

The joy of touching expressed in children's clay-modeling may often be part of what draws viewers into involvement with a piece. If you could touch Dale Chihuly's fantastic glass installation at the Sheraton Hotel in Seattle (Fig. 1.22), you would probably want to explore it with your fingers, caressing the delicate smoothness of the glass, testing the feel of the slim tendrils, following its fantastic organic curves. Of course, you would not actually be allowed to touch this work, but it is "visually tactile." You are invited to trace its flowerlike forms with your eyes, almost as if you were stroking them with your hand.

Art does not always strike us as beautiful or provoke pleasant sensations, however. Artists may use subject matter, colors, and surface treatments that trigger disturbing emotional responses. Lonnie Holley's *Perspectives 8* (Fig. 1.23) is a series of sculptures he made from a dumpster-full of found materials. The dumpster itself rests in the middle of the installation in the Birmingham (Alabama) Museum of Art's courtyard, covered with a roof made of an old pub-

1.22 Dale Chihuly. Flower Forms #2. Detail from Sheraton Hotel installation, Seattle, Washington. 1986. Blown glass. $6 \times 5 \times 4'$. Photo Dick Busher.

1.23 Lonnie Holley. Perspectives8. 2003-2004. Birmingham(Alabama) Museum of Art.© Photograph by SeanPathasema.

licity banner and draped with found blankets and such, reminiscent of the bits of this and that scraped together by the poor for minimal shelter. On first sight, we may feel discomfort or sadness about the stress of poverty. But then if we examine the junk sculptures more carefully, with a sense of imagination, we begin to find pieces of meaning amid the junk. Two odd "figures" with castaway computer monitors for heads seem to be in conversation with each other, for instance. As such discoveries occur, a different emotional response may begin to emerge—an appreciation of the ingenuity and humor that can be present in the midst of material poverty.

Even if we turn away from a disturbing piece, we are responding to it. It has touched us personally, and we must react.

Engaging Curiosity

Many works involve us by piquing our curiosity, by making us abruptly stop to wonder "What is that?" "What does it mean?" "How should I read this?" or "How did the artist do that?" "What keeps that thing from falling?" "What happens on the other side?" A common device to lure people to explore a piece in the full round is the use of forms that disappear around the edge of what can be seen from a single point of view. We human beings are simply too curious to glance at a figure like Erika Mayer's *Waterdancer* (Fig. 1.24) from a fixed position and go no further. Seen at the angle from which this photograph was taken, the piece provokes our native curiosity. Lured by the translucent beauty of the cast-crystal goddess, we want to see her and the changing reflections of her body in the water from all sides.

1.24 Erika Mayer. Waterdancer. 2003. Cast crystal, $32 \times 14 \times 18$ cm. Photo courtesy Gaffer Studio Glass, Hong Kong.

1.25 John Rogers. "Wounded to the Rear," One More Shot. 1864; this cast, 1865. 23¹/₄ × 10 × 10" (59.1 × 25.4 × 25.4 cm). Rogers Fund, 1917 (17.174). The Metropolitan Museum of Art.

Our knowledge of the human body creates a vague dissatisfaction that is not quieted until we have "found" all the expected parts of a human figure. If we see one hand or foot, we look for a second one; we want to follow the arm line out from the shoulder to complete the suggestion that an elbow lies just out of view. Sculptures frequently twist torsos into extreme positions, not only for the sake of the visual excitement thus created but also to hide parts of the anatomy from view, piquing viewers' curiosity. An effective piece of three-dimensional art may change continually as we move around it, beckoning the curious onward.

Pieces may also engage our curiosity by presenting us with visual puzzles we don't immediately understand. In *Waterdancer*, we wonder how the woman's figure can be so impossibly floating in the air. Her ethereal long hair gives no visual clue to being part of an anchoring device. Nonetheless, natural curiosity would prompt us to walk around and look into the water where the hair is streaming to find some base offsetting the weight of the figure.

Representation

Certain works engage our attention by accurately replicating forms with which we are familiar. This approach is called **representational art**—visual accuracy in artistic representation of objects from our three-dimensional world. Such works are recognizable, bringing a satisfying sort of involvement if the piece reminds us of something we know.

There are many degrees of representation. Artists may not try to copy all details of an object precisely, concentrating rather on certain features that convey the intended content of the piece. John Rogers's "Wounded to the Rear," One More Shot (Fig. 1.25), emphasizes the wounds—arm in sling, leg being bandaged—of the Union soldiers but not the sweat, dirt, blood, and terror actually experienced in war. The artist's intent seems to be to evoke pride in heroism rather than horror.

1.26 Marilyn Levine. *Spot's Suitcase*. 1981. Ceramic and mixed media. $8^{1}/_{2} \times 29$ wide \times 17 $^{3}/_{4}$ " deep. Photo: Richard Sargent © Robert W. Hayes.

In extremely representational work, the artist may attempt to describe the visual characteristics of an object precisely, without any editing or sentimentalizing. In such cases, viewers' interest in recognizing the real may take the form of amazement that such artful duplication is possible. Marilyn Levine's *Spot's Suitcase* (Fig. 1.26) so perfectly replicates a worn leather suitcase—down to the limpness of the strap, the patina of the old hardware, the slightly scuffed texture of the leather surface, and the lighter area where half of one clasp used to be—that it is difficult to grasp the fact that the piece is made of ceramic. If you saw it in a gallery, you would want to touch it to verify its nature. We are intrigued by that which successfully fools us.

Abstraction and Stylization

A third way of involving viewers is to eliminate all but a few characteristics of a figure, forcing people to use their imagination to link this highly simplified form with the more detailed object they know. This technique is called **abstraction**—reduction of details in order to focus on a thing's essence. In the ancient *Woman of Willendorf* (Fig. 1.27), the female form is reduced to its procreative features—the great breasts and rounded belly of pregnancy, the essence of fertility. Everything extraneous—arms, feet, even the face—is deleted to center our focus on the fecundity of Woman.

Figures 1.28a through **1.28d** allow us to watch this process of abstraction, as it evolved over a period of years in a single artist's approach to the same subject. Henri Matisse created a series of low-relief bronzes of a woman's back. From a fairly naturalistic approach in *The Back I*, he straightened, simplified, and rounded forms, until in *The Back IV* the figure is like a pillar of strength, an almost architectural representation of the solidity of Woman.

In addition to eliminating nonessential features, artists may **stylize** a form, subordinating accurate representation to a desired way of design. In **Figure 1.29**, the horse has been transformed into a few arched cylinders, yet it is still recognizable as a horse. In general, the more an artist abstracts or stylizes a representational figure, the more viewers must bring to the work, drawing on memories, imagination, and intellect to make sense of what they see.

1.27 Woman of Willendorf. c. 30,000-25,000 Bc. Stone (cast of original), height 4³/8" (10.16 cm). Naturhistorisches Museum, Vienna. © Archivo Iconografico, S.A./Corbis.

1.28a Henri Matisse. *The Back, I.* Paris and Issy-les-Moulineaux, 1908–1909. Bronze, $6'2^3/8'' \times 44^1/2'' \times 6^1/2''$ (188.9 \times 113 \times 16.5 cm).

1.28b Henri Matisse. *The Back, II.* Issy-les-Moulineaux, 1913. Bronze, $6'2^{1}/4'' \times 47^{5}/8'' \times 6''$ (188.5 × 121 × 15.2 cm).

1.28c Henri Matisse. *The Back, III.* Issy-les-Moulineaux, 1916.
Bronze, 6'2¹/₂" × 44" × 6"
(189.2 × 111.8 × 15.2 cm).

1.28d Henri Matisse. *The Back, IV.* Nice, c. 1931. Bronze, $6'2'' \times 44^{1/4}'' \times 6''$ (188 \times 112.4 \times 15.2 cm). (All) © CNAC/MNAM/Dist. Réunion des Musées Nationaux.

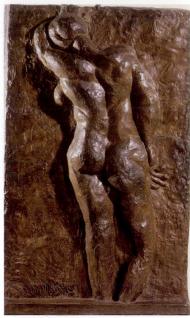

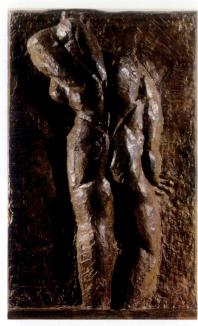

Scale

Viewers may be enticed into responding to a work because of its scale—its size in relationship to its surroundings. The very small draws us in, for we must get close in order to see it. The people shown in **Figure 1.30** have stopped on the street, lured by the tiny scale of the miniature cliff dwellings Charles Simonds constructed among the bricks (detail shown in Fig. 1.5). Like most of us, these passersby are fascinated by miniaturization, especially when craftsmanship produces a precise image of something that is much larger in real life.

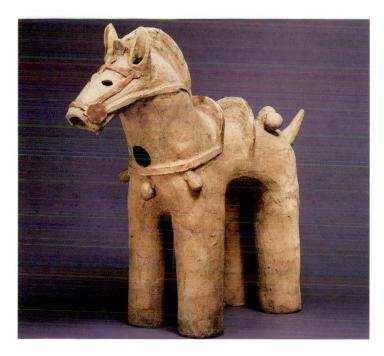

1.29 Horse. Haniwa figure, Japanese, Kofun Period (3rd century-538). Earthenware with traces of pigment. 59.7 cm × 66 cm. © The Cleveland Museum of Art, 2003. The Norweb Collection 1957.27.

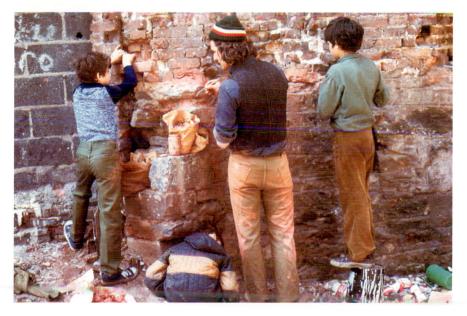

1.30 Charles Simonds. Passersby with *Dwelling, East Houston*Street, New York. 1972. Unfired clay bricks, each brick 1/2" (1.3 cm) long. Courtesy the artist.

The very large provokes an emotional response as well. Claes Oldenburg elicits strong reactions from viewers by vastly enlarging objects as mundane as a clothespin (Fig. 1.31). A massive cathedral, such as Chartres (Fig. 1.32), dwarfs viewers, filling them with awe at the soaring vastness and grandeur of the universe. And some works are so huge that viewers cannot understand the whole from their limited point of view. The mysterious Nazca lines in Peru cannot be comprehended from the ground at all; only an aerial photo reveals the ancient

INVOLVING THE VIEWER | 23

1.31 Claes Oldenburg. Clothespin. 1976. Cor-Ten stainless steels. $45' \times 12'3'' \times 4'6''$ (13.7 \times 3.7 \times 1.4 m). Centre Square Plaza, Fifteenth and Market Streets, Philadelphia.

1.32 Chartres Cathedral.
 c. 1194-1221. View through nave, looking toward the apse. Chartres, France.
 © Scala/Art Resource, New York.

1.33 Monkey drawn in Nazca lines, Peru. c. 100 BC-AD 700. © Keren Su/Corbis.

patterns created by removing rocks to expose the lighter soil. In Figure 1.33, a Nazca line forms a gigantic monkey whose left hand alone is 40 feet (12.2 m) across.

Scale can thus be manipulated to involve viewers by making them feel *they* are changing in size. When presented with a Lilliputian village, we become towering Gullivers; when we see works that seem to have been created by giants, we become tiny Lilliputians.

Content

We are also drawn into experiencing what a work is "about." In contrast to its form, the **content** of a piece is its subject matter (e.g., "a woman") plus all its emotional, intellectual, symbolic, spiritual, and/or narrative implications.

Much of today's art has political content, often referring to the experiences of ethnic, racial, or gender oppression. Unless a work is openly illustrative, its content may exist in subtle connotations, in layers of meaning that require viewers to devote considerable time, attention, and perhaps historical and political knowledge of their interpretations.

Yang Zhenzhong's installation *Then, Edison's Direct Current Was Failed to the Alternating Current* (Fig. 1.34) displays massage chairs stripped of padding, with electrical wires and such added to suggest electric chairs used in death sentences. The title refers to the first electric-chair execution, in which amid a dispute whether to use direct or alternating current, the electric charge was insufficient to kill the prisoner. Thus the full horror of electrical execution is brought to our attention in a dramatic and disturbing way, including the implication that many people are being killed by electric chairs. Here the content involves ethical issues that are under public debate, starting with the ethics of imposing the death penalty. Three-dimensional art has great potential for pulling the viewer in and stirring up inner feelings and thoughts.

INVOLVING THE VIEWER | 25

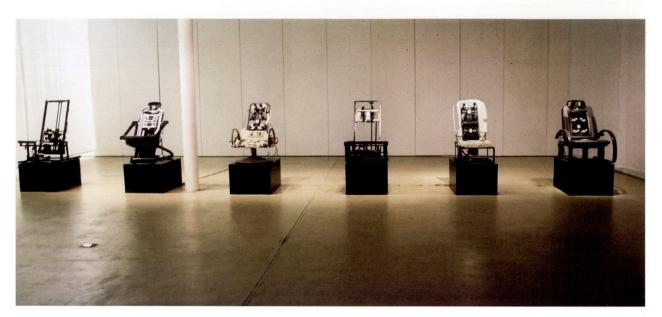

1.34 Yang Zhenzhong. *Then, Edison's Direct Current Was Failed to the Alternating Current.* 2003. Courtesy Shanghart Gallery, Shanghai.

Unless the artist chooses to provide explicit statements about the intended content of a piece, its nature can be described only subjectively. Two people may interpret the content of a given work quite differently. Consider responses to spiritual connotations, for instance. Certain works suggest themes that are universally understood. Chartres Cathedral (Fig. 1.32) was designed to uplift the consciousness of worshipers, helping them to transcend their narrow personal viewpoint to experience a more cosmic awareness. The spaciousness and height of the interior and the upward thrust of its columns and arches will tend to convey the same connotations to people of all cultures.

Although the grand scale of Chartres would have an impact on anyone's consciousness, many religious pieces have spiritual connotations only for those who are personally imbued with a particular spiritual tradition. For those familiar with the mystical Christian tradition, *The Ecstasy of Saint Theresa* (Fig. 1.35) narrates a known story and evokes personal memories of the feeling of spiritual ecstasy. The statue of *Coatlicue* (Fig. 1.36), goddess of earth and death, must have inspired awe or even terror in her Aztec worshipers.

The visual symbolism that people of the Aztec culture understood is not so obvious to people of other cultures today. What is the symbolic meaning of the four hands in the center, for instance? But symbols from one's own contemporary culture may be immediately understood. If a person from the United States looks at Steven Dolbin's *Relic of Memory* (Fig. 1.37), it at once suggests the tragic loss of lives in the World Trade Center on September 11, 2001. The business shirt and tie and broken stonelike blocks are poignant symbols of the missing human presence and the ruins of the structure, as if the piece consisted of fragments found at an archeological site.

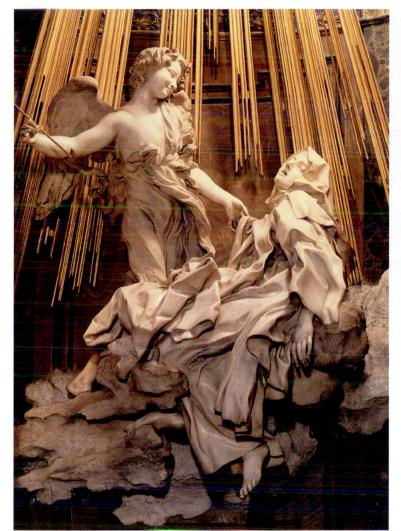

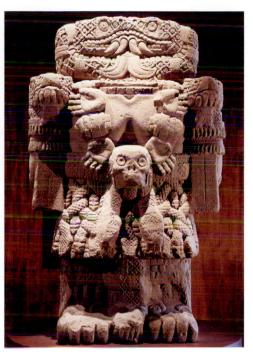

1.36 Coatlicue, Goddess of Earth and Death (the Earth Mother). Aztec. 15th century. Andesite, height approx. 8 1/2" Head formed from facing heads of two rattlesnakes; necklace of hearts, hands, and skull. One of a pair of colossal statues that stood in the courtyard of the Great Temple at Tenochtitlán. Museo Nacional de Antropologia, Mexico City. © Gianni Dagli Orti/Corbis.

It is possible to become involved with symbolic content on levels other than what was originally intended. There is the intellectual challenge of interpreting ideograms and symbolic messages on pieces such as *Coatlicue*. We can also admire the artfulness with which religious works were created—for example, Bernini's skill in sculpting hard marble to suggest soft fabric in *The Ecstasy of Saint Theresa*. If we not only appreciate the artfulness of a work but also respond to it as an evocation of a tradition that has deep personal meaning for us, the content we perceive in the work will include emotional and spiritual implications.

The spiritual content of a work is not limited to specifically religious connotations. Pieces growing out of the artist's personal exploration of life may speak volumes to the viewer who is similarly searching.

1.37 Steven Dolbin. Relic of Memory. 2002. Mixed materials, 42" × 45" × 42". A 9/11 memorial sculpture from "Parallel Reflections on the World Trade Center," New Century Artist Gallery, New York.

Personal Interaction

There are numerous ways of drawing people into a living encounter with a work of art. Some art is designed to be worn. For her *Acetabularia* bracelet (Fig. 1.38), Ruth Zelanski was inspired by microscopic plant forms. These delicate shapes of handworked silver, wrapped tenderly around the wrist and also projecting outward, make a unique and attention-luring statement about the invisible made visible. As the artist explained, "My aim is to enhance the wearer's

1.38 Ruth Zelanski. *Acetabularia*. 2004. Silver bracelet.

1.39 Louis Kahn. Detail of the Suhrawardi Hospital at Shere-Bangla Nagar, the capital's official complex, in Dhaka, Bangladesh. 1963-1983. Photo Shamin Javed.

beauty with the very things we ignore in our daily lives, the things we try to avoid: bacteria, molds, viruses, spores, algae, etc. By appropriating and recontextualizing that which is negative, it can become positive."⁴ Wearing a work of art takes what is usually a private experience between the viewer and the piece into the public domain. In turn, the wearer responds not only to his or her feelings about the piece but also to other people's reactions.

Architecture involves "viewers" by forcing them to walk through fixed passageways and to experience environments varying between open and confined. The great arched openings of Louis Kahn's Suhrawardi Hospital in Dhaka (Fig. 1.39) create a feeling of welcome airiness in this hot climate and at the same time delineate inner and outer passageways to regulate the flow of foot traffic.

Large installation pieces—designed environments installed in museums, sometimes temporarily—may have a similar way of involving viewers. Hiroshi Teshigahara's bamboo installation (Fig. 1.40) tells us precisely where to walk: inside the bamboo tunnel, noticing the play of light and shadow as filtered by the bamboo strips. The intrigue of walking into a piece of art has often been used as a come-on in roadside folk art, enticing customers into shops by disguising the stores as oversized lobster traps, tipis, chickens, wheels of cheese, hot dogs, derby hats, or even open-jawed fish.

Performance pieces involve viewers in a live experience conducted or set up by the artist. Often these are staged as theater, with captive audiences. Marina Abramovic staged a stark twelve-day performance piece, *The House with the Ocean View* (**Fig. 1.41**), in which she herself stayed exposed to public scrutiny as she fasted and maintained total silence on a platform with three open-sided "rooms." Nothing was hidden from public view, except that the

⁴ Ruth Zelanski, author's statement, December 3, 2004.

1.40 Hiroshi Teshigahara. Bamboo installation at 65 Thompson Street Gallery, New York, 1990. Photo © Dorothy Zeidman, 1990, New York.

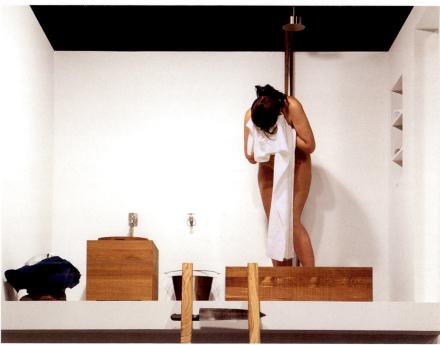

1.41 Marina Abramovic. Detail from *The House with the Ocean View.* 2002. Living performance. Courtesy Sean Kelly Gallery, New York.

gallery was closed at night. Even her bathroom activities became part of the unscripted performance. A telescope was provided on the floor for watching what happened more closely, and a metronome's clicking marked the slow passage of time. Sometimes she walked around, moved the furniture, looked out fixedly at members of the audience, sat, sang, smiled gently, covered her face with her hands, or cried. Aside from the presence of the audience, the performance resembled a Buddhist *vipassana* retreat, in which a person tries to maintain complete mindfulness of everything happening in the moment. The audience seemed to enter a similar mind state, as the silence and paucity of activity helped to focus attention exquisitely on the present reality. People were free to enter and leave the gallery quietly during the performance, but many stayed on for some time, strangely fascinated.

Contemporary art often refers to contemporary culture itself, and this content tends to draw people into personal interaction with the works. **Video art** uses the apex of popular culture—the familiar but still compelling presence of television—to draw people into an artistic event. The pioneering Korean video artist Nam June Paik used television monitors themselves—plus other technologies such as laser projections, prisms, motors, music CDs, and mirrors—to create dynamic installations. He is often quoted as saying, "I make technology look ridiculous." This is surely the case in his *Technology* (Fig. 1 42) which resembles a cross between an old radio cabinet and an electronic cathedral

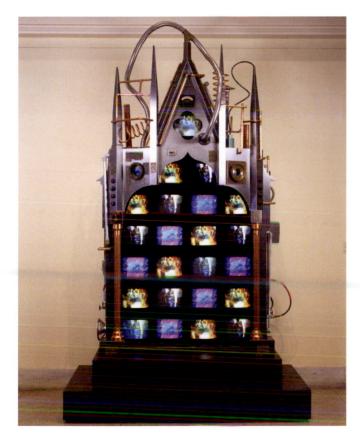

1.42 Nam June Paik. *Technology*. 1991. 25 video monitors, 3 laser disc players with 3 discs in cabinet. Side view. Smithsonian American Art Museum, Washington, D.C.

1.44 Meret Oppenheim. Object
[Le dejeuner en fourrure]. 1936.
Fur-covered cup, saucer, and
spoon. Cup, 4 3/8" diameter;
saucer, 9 3/8" diameter; spoon 8"
long; overall height 2 7/8"
(130.1946a-c). The Museum of
Modern Art, New York.

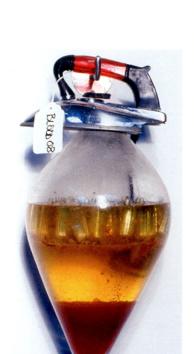

1.43 Donald Lipski. *Blood #8.* 1991. Glass, iron, liquid, hardware, $21 \times 10^{1}/2 \times 10^{"}$. Courtesy Galerie LeLong, New York.

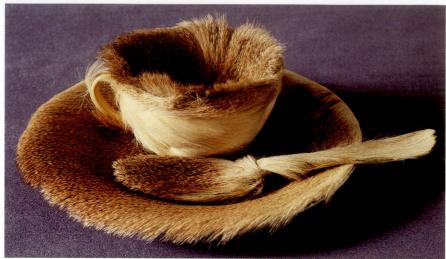

designed by a mad inventor, with twenty-five video monitors going simultaneously. In Paik's hands, rapidly evolving video technologies are used both vigorously and ironically to create three-dimensional works that simultaneously capitalize on and subvert the mesmerizing, frantic effects of the medium.

The Unexpected

Some artists evoke viewer involvement by surprise. Certain pieces are deliberately designed to be shocking—to draw sudden attention to something that people normally do not see or do not want to see. Or, something may suddenly be perceived in an unexpected place, such as the Nazca lines in the Peruvian desert (Fig. 1.33). Coming upon such an anomaly provokes people to wonder "Why?"

Some art startles us with seemingly incongruous elements that defy our stereotyped notions of how things "should be." In Donald Lipski's *Blood #8*, viewers are visually stimulated or perhaps confused by the contrast of an iron that produces not steam but a glass vial of blood (Fig. 1.43). Similarly, faced with Meret Oppenheim's fur cup (Fig. 1.44), viewers find themselves incapable of reconciling the associations they mentally make with "fur" with those they make with "cup." Such works become visual puzzles, luring viewers into the mental exercise of trying to determine what the artist intended.

Verbal Statements and Titles

Though not strictly part of a work of art itself, written statements about a piece or about a particular artist's work may also help draw people into the experience the artist intended. Sometimes these statements are written by art critics or museum curators; sometimes they are written by the artists themselves. Artists working in **applied design** disciplines—the creation of functional projects, such as interior design, landscape design, and industrial or product design—are often required to give verbal explanations of their ideas to prospective clients.

Many artists find it difficult to articulate what they are trying to do, for they have chosen a nonverbal medium to express their nonverbal ideas. The impulses that lead them to work in a certain way are often as mysterious to them as to others. Nevertheless, if they attempt to record their feelings and inspirations related to a work, such statements may be keys to deeper appreciation for the viewer.

Titles may also play a significant role in the artist's development of the piece as well as in viewers' discovery of its meaning. If Maria Lewis's minimalist conceptual piece shown in **Figure 1.45** were listed simply as *Untitled*, we could identify its design elements—the way light turns the stitching holes into a line of bright spots, the gentle curvature of the paper band, the color changes where light strikes the piece. But its title—*Gateless Gate*—brings more meaningful attention to what the artist is trying to do. Even though the title is obscure, it starts to awaken some dim kind of awareness within us. The artist helps us further with a brief explanation of her process in developing 49 paper works on the theme "Gateless Gate":

These forty-nine works are all inspired by Zen koans. These koans were written in the 13th century by the Zen master Ekai. A typical Zen master would say to his students about these koan stories: "If you like sweets and easy living, skip this; it is about being tremendously intent on Satori, ENLIGHTENMENT. It can happen to you. In a flashing moment something opens, you are new all through. You see the same unsame world with fresh eyes." None of the stories make any pretense at logic. They are dealing with states of mind rather than words.

I contemplated for a while how to photograph these ephemeral works. My main focus was to express the joy of enlightenment through them. For me that meant they had to change, they needed to be one way and then present themselves in another. It was quite by accident that one day I held one up in the window, and then I instantly felt they had a connection; they had become a window between heaven and earth. They could express on their own that tiny portal of spiritual space that is needed to move toward enlightenment.⁵

Thus, we will be referring to titles and artists' words throughout this book. These informative sources will help to enrich the experience of three-dimensional art.

1.45 Maria Lewis. Gateless Gate 46. 2004. Part of a series of 49 works from The Gateless Gate Series. Paper, sewing thread, height 11", width 5", depth 3".

© Maria Lewis.

⁵Maria Lewis, personal communication with coauthor, August 27, 2004.

WORKING IN-THE-ROUND

LL ART BEGINS AS AN IDEA in the mind of the artist and is developed through a dialogue with the medium. To bring this evolving idea into reality, to create the form imagined, requires dealing successfully with a number of technical details. Each idea demands certain practical considerations and specific skills. Still, there are overarching general issues that arise in every attempt to create art-in-the-round. The care and ingenuity with which artists approach these factors will make the difference between pieces that fall apart or fail to achieve what the artist intended and those that give high-quality expression to the artist's vision.

GRAVITY

We are so accustomed to accommodating the force of gravity in our everyday existence that we give it little thought. Yet this downward pull must be dealt with very consciously and carefully by the three-dimensional artist. Over a period of time, the sheer heaviness of things takes its toll. Even apparently lightweight objects are surprisingly gravity-bound. Have you ever tacked a poster to a wall, nice and flat, only to discover later that it has bowed out as it slid downward, enlarging and perhaps eventually tearing the upper tack-holes? Or try holding your arm out parallel to the floor; as time passes, its heaviness becomes increasingly apparent and difficult to resist. The pull of gravity may present the artist with difficult challenges, but in some cases the successful defiance of gravity's downward pull may be a major ingredient of the excitement of a work.

Some artists learn to accommodate the force of gravity by trial and error; others conceive ideas that require extensive knowledge of physics or architectural systems, as in Figure 2.1. At the simplest level, any three-dimensional

2.1 Architectural systems.

2.2 Antonio Pollaiuolo. Hercules
Crushing Antaeus. c. 1475.
Bronze, height with base 18"
(45.72 cm). Museo Nazionale del
Bargello, Florence. Photo
Scala/Art Resource, New York.

artist learns that whatever projects from the vertical axis is subject to downward pressure and must be firmly anchored to prevent its breaking off as well as counterbalanced to prevent its pulling the whole piece over. Antonio Pollaiuolo's *Hercules Crushing Antaeus* (Fig. 2.2) is only 18 inches high, including its base, and yet the weight of Antaeus's outstretched leg would be enough to topple Hercules off the pedestal. In addition to building up a strong vertical mass from other parts of the two figures to help anchor the leg on the left and thrusting Hercules' back far to the right as a counterbalance, the artist's ultimate solution to offset the leg's pull was to add a secondary form behind Hercules. The sculpture would probably be more exciting and aesthetically pleasing without the prop, for then Hercules would seem to be the strong force holding Antaeus in the air, but given the state of the art of bronze-casting at the time, Hercules himself required support.

In some works, there is no indication of the tug of gravity, for the artist has skillfully hidden the means of defying it. Objects may be suspended by nearly invisible threads, making the pieces appear to float in space. In *The Splash*

2.3 Thom Puckey. The Splash. 1998. Bronze and marble. Bronze part: $7 \times 2 \times 2.7$ m. Marble part: $1.9 \times 1.2 \times 1.1$ m. Installation at Law Courts Garden, Groningen, The Netherlands. Photo Thom Puckey.

(Fig. 2.3), Thom Puckey created a different kind of visual riddle: What appears to be a waterfall seems to be flowing off a rock ledge that has neither support nor water source. This puzzling effect is a hook that draws viewers in, to come to the counterintuitive conclusion that the "water" itself is actually supporting the "ledge."

Certain works require great engineering skill if they are to counter the force of gravity successfully. To hang a 142,000-square-foot (12,780 sq m) orange nylon curtain across Rifle Gap in Colorado (Fig. 2.4), Christo and Jeanne-Claude had to hire consulting engineers and contractors to help devise ways to support the weight of the curtain from above. The initial solution involved cables running from 7-ton concrete anchors on either side of the gap, but geological tests showed that these would have been pulled right out of the mountain. Instead, construction crews had to build 200-ton concrete top-anchors to offset the anticipated pressures of gravity and wind on the curtain.

Adding the weight of a person to a piece raises additional considerations. Verner Panton's side chair (Fig. 2.5) is daringly balanced, elegantly curvaceous. It is also designed for the functional ability to stack one chair atop another. Yet there is another functional consideration: Will it retain its cantilevered, unsupported form when a person sits on it?

GRAVITY 1 37

2.4 Christo and Jeanne-Claude.

Valley Curtain. 1970-1972. Span
1,250' (381 m). Height curving
from 365' to 182' (111.25 m to
56.39 m). 142,000 sq ft (12,780
sq m) of nylon polyamide fabric,
110,000 pounds of steel cables.
Grand Hogback, Rifle, Colorado.
Project Director Jan van der
Marck. Photo Wolfgang Volz.
© 1972 Christo, New York.

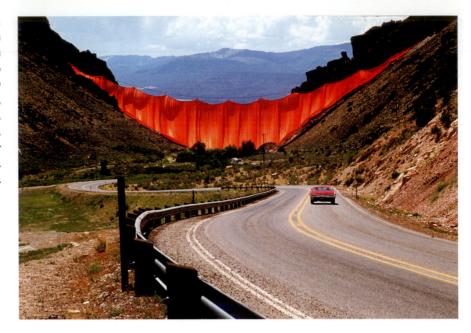

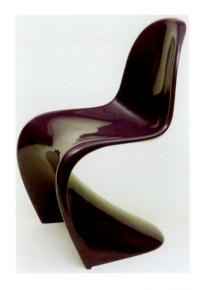

2.5 Verner Panton. Stacking Side Chair. 1959–1960. Rigid polyurethane foam with lacquer finish. 32 5/8 × 19 1/4 × 23 1/2". Gift of Herman Miller AG Basel. (339.1969). The Museum of Modern Art, New York.

Gravity is not necessarily a disagreeable force with which to work, however. For the artist who understands it, calling viewers' attention to this everyday phenomenon can be central to the idea of a piece. Claes Oldenburg presented a humorous glimpse of what would happen to a familiar object—the toilet—if it were too soft to resist the pull of gravity (Fig. 2.6). And in Kenneth Snelson's *Dragon* (Fig. 2.7), the metal tubes seem to defy gravity like an acrobat flipping high through the air. Even though the cables holding the tubes aloft are slightly visible, the mastery with which they have been rigged from only three points touching the earth creates the drama of the sculpture.

THE SETTING

In many cases, a second major consideration is where a piece will be presented. In recent years, there has been a noticeable shift from regarding art as a private or museum experience to presenting large pieces in public settings. Town planners, architects, politicians, and corporations are recognizing that art presented in public spaces may enhance the appeal of those spaces. Despite negative public responses to some pieces, state and municipal governments and private businesses are increasingly setting aside a percentage of the cost of new buildings to be used for the purchase of works of art. The setting of such pieces—foyers of large buildings, public plazas, and the like—dictates use of a very different approach from one based on the assumption that a piece will be displayed on a mantel or desktop or behind glass in a museum.

Awareness of whether a work is to be shown indoors or outdoors is a major factor in the design process. In general, considerations of safety and vandal-

proofing dictate simpler designs for outdoor sculptures, because people tend to try to climb on them. Indoor works can be more delicate. For large outdoor works, engineering consultants may be needed to help calculate specifications for factors such as wind loads, snow loads, seismic stability, and the necessary size and depth of footings.

Anything to be displayed outdoors will be exposed to weathering processes. If the material used will age, the change should be one that the artist considers desirable. For example, some artists value the shiny brown or green patina that develops on bronze as the surface corrodes. The Great Mosque at Djenné, Mali, West Africa (Fig. 2.8), has been built of mud brick in a climate where rain is infrequent. When rain does come, however, it is heavy, but the mosque has stood for nearly 100 years with only sporadic replastering.

If a piece is to be displayed in a specific place, the lighting of the area should also be determined and perhaps controlled by the artist. Daniel French, sculptor of the *Abraham Lincoln* for the Lincoln Memorial in Washington, D.C., complained that the lighting in the building did not bring out the strength and drama of the face as he had conceived it. To prove his point, he had two photographs made of a full-size model of the head, one with natural light cast

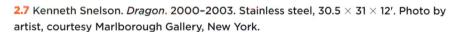

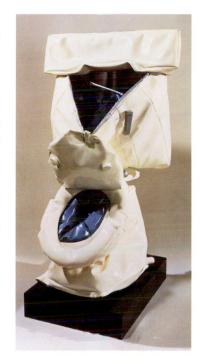

2.6 Claes Oldenburg. Soft Toilet. 1966. Wood, vinyl, Plexiglas, kapok, wire on metal stand and painted wood base. Overall: $57^{1}/_{16} \times 27^{5}/_{8} \times 18^{1}/_{16}"$ (144.9 \times 70.2 \times 71.3 cm). Collection of Whitney Museum of American Art, New York.

39

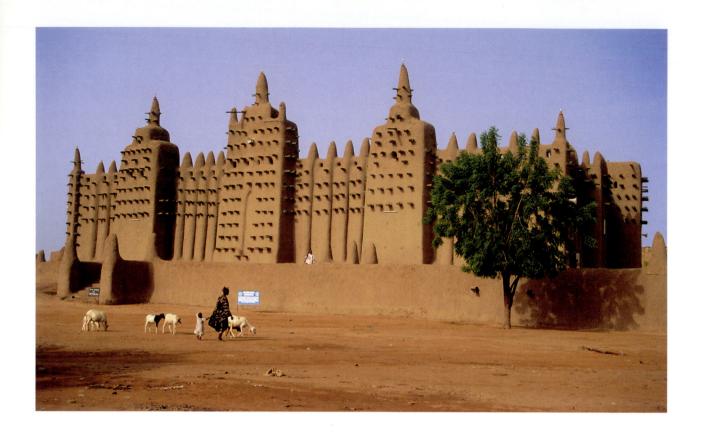

2.8 Great Mosque, Djenné, Mali, West Africa. 1907. Mud brick.
© Robert Harding World Imagery/Getty Images.

upward, as if coming through the east door entrance of the building (Fig. 2.9a), and the other with artificial lighting shining down on the sculpture from a 45-degree angle (Fig. 2.9b). The characteristics thus revealed were so strikingly different that French's requests for artificial lighting were finally granted.

The wildly imaginative contours of Frank Gehry's *Guggenheim Museum* in Bilbao, Spain (Fig. 2.10), are mirrored in the Nervion River that runs alongside. The reflections double the extraordinarily dynamic visual effects of this Deconstructionist architecture. When the sky is cloudy—as it often is in Bilbao—the clouds, water, and explosive symmetrical masses all begin to reflect the same hues in a dreamlike cacophony of forms and colors.

Pieces designed for a particular setting must take its size and characteristics into account. The challenge to the commissioned artist is to exercise creativity in conceiving pieces that work well not only in themselves but also in relationship to the scale and nature of their surroundings.

To relate a work to its environment, however, does not necessarily mean copying the style of the surroundings. Boston's Post Office Square once was dominated by an ugly parking garage that blocked the sunlight. The area was so depressing that instead of using the square, people avoided it. But a group of citizens who saw its potential as a great public space hired the Halvorson

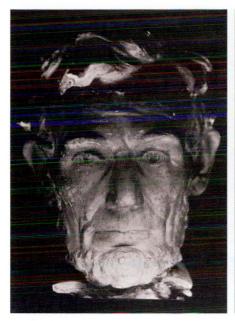

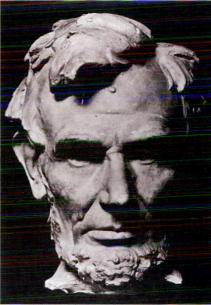

2.10 Frank Gehry. *Guggenheim Museum.* 1997. Bilbao, Spain. Photo Guggenheim Foundation, Bilbao, Spain. © FMGB Guggenheim Bilbao Museoa, 2006. Photograph by Erika Barahona Ede.

2.9a Daniel Chester French. Head of Abraham Lincoln. 1911-1922. Plaster model, executed in 1917, 50 \(^1/2''\) high (including shirt collar), same size as head of white marble statue, total figure 19' high. Lincoln Memorial, Washington, D.C., architect Henry Bacon. Photographed by order of the sculptor in 1922 under replication of original lighting conditions.

2.9b Daniel Chester French.
Head of Abraham Lincoln.
1911–1922. Photographed by
order of the sculptor in 1922
under desired lighting conditions. (Both photos) Chesterwood Museum Archives,
Chesterwood, a property of
the National Trust for Historic
Preservation, Stockbridge,
Massachusetts. Photo De Witt
Ward.

41

Company to redesign the area completely; the solution was to place the seventier parking garage underground (Fig. 2.11) and create an enticing park at street level (Fig. 2.12). Now the square features a series of garden rooms, trellised colonnades, sculptural fountains, specimen plantings, and inviting openings from the surrounding sidewalks. Throngs of office workers and tourists enjoy this urban oasis in good weather, and the buildings on the square have been redesigned to focus upon the park.

Artists have highly individual ways of relating their work to its environment—yet no artist ignores it. One version of a successful relationship between art and its surroundings is Henry Moore's placement of his large sculptures in the pastures around his home in England. Moore found architecture too distracting as a background for his work, preferring the sky as a backdrop: "There

2.11 Park and entrance to underground garage at Boston's Post Office Square; Ellenzweig Associates (Cambridge), architect, garage and park structures; The Halvorson Company, Inc. (Boston), landscape architect, park. Drawing by Ellenzweig Associates.

2.12 Park and entrance to underground garage at Boston's Post Office Square. Photo
© Peter Vanderwarker.

is no background to sculpture better than the sky, because you are contrasting solid form with its opposite space. The sculpture then has no competition, no distraction from other solid objects. If I wanted the most foolproof background for a sculpture, I would always choose the sky."¹

In Moore's *Sheep Piece* (Fig. 2.13), the coexistence of art and nature is enhanced by the presence of the sheep that share a pasture with the piece. The distinctively rounded, huddled bulks of the live sheep visually reinforce the essence of Moore's sculptural forms.

SIZE

Size is of importance not only in scaling a work to its surroundings but also in managing the practical details of creating, transporting, and displaying it. Look back at Kenneth Snelson's *Dragon* (Fig. 2.7). Its scale is aesthetically successful in its open outdoor setting, leaping into the sky. But imagine the process of assembling the piece. Obviously, it could not be built in a studio or workshop and then transported intact, for it is far too large to fit through a door or onto a truck. Since he chose to work on this large scale, the artist had to make the parts separately and figure out how to assemble them on-site. If artists envision

2.13 Henry Moore. Sheep Piece. 1971-1972. Bronze, edition of 3, height 18 1/2′ (570 cm). Hoglands, Hertfordshire, England. Photo Errol Jackson, © The Henry Moore Foundation, London.

¹ Henry Moore, in Stephen Spender, *Sculptures on Landscape*, © J. M. Stenersongs Forlag (Oslo: Clarkson Potter).

2.14 Ergon 2® chair/seating by Herman Miller, Inc., Zeeland, Michigan. 1976. Photo courtesy Herman Miller, Inc.

circumstances in which they will not be on-site to supervise the assembly and setup of their works, they must prepare detailed instructions for others to follow.

The size chosen will also determine whether a piece can be constructed by the artist working alone or whether help will be needed. Even relatively small pieces of very dense materials like marble or glass may be too heavy for one person to maneuver; works made of lighter materials such as aluminum can become much larger before assistance is needed. Some three-dimensional pieces, such as marble sculptures, need not be carried around while they are being worked, and the artist can mount them on a revolving stand for easy access to all sides. But the problem remains: How then to transport such works of art out of the studio to be displayed?

For functional designs, the size of the piece relative to the size of the intended user is a major practical consideration. For instance, if the handle of a mug is too small, large-handed users drinking hot liquids may burn their knuckles. Older people find low sports cars or high vans difficult to enter and exit. The relatively new science of ergonomics—the study of how people relate physically to their environment—has led to the designing of office furniture that minimizes fatigue and improves work efficiency by properly fitting and supporting the human body. The Ergon chair (Fig. 2.14), designed by William Stumpf for Herman Miller, has a shortened seat to prevent restriction of the blood vessels in the thighs, an anatomically contoured back and seat to support the user's upper and lower back, open sides that encourage people to move somewhat instead of getting cramped and numb from sitting still, and armrests that double as backrests when the person is sitting sidewise in the chair. The model shown is designed specifically for people who work long hours seated at computer terminals or other office machines, offering the support of a high seatback with adjustable height, plus height and angle adjustments for the chair as a whole to help fit it to the individual user. Despite the many functional aspects of the chair, it also works well aesthetically, with a nice marriage of the flowing upper forms to the convincingly untippable and mobile five-footed base.

MATERIALS

In choosing and working with materials, artists range between two extremes: crafting the material to resemble something else or presenting the material in such a way that its own nature is emphasized. Either way, the unique qualities of each material must be taken into account.

In Chapter 1, we noted that the viewer-involving device in Marilyn Levine's *Spot's Suitcase* (Fig. 1.16) is the use of clay to look exactly like worn leather. At this extreme, the denial of the characteristics of the medium is sometimes called **trompe l'oeil**, or "fool the eye." Similarly, some artists have developed great skillfulness in sculpting the hardness of marble to convey the softness of skin, hair, and draped clothing, as in Bernini's *Ecstasy of Saint Theresa* (Fig. 1.35).

Steel is usually fabricated in rectilinear or cylindrical forms, but in Richard Serra's sculptures, such as his *Torqued Ellipses* (Fig. 2.15) installed in the

2.15 Richard Serra. Torqued Ellipses. 1996-1999. Steel plates. Guggenheim Museum, Bilbao.
© FMGB Guggenheim Bilbao Museoa, 2006. Photo Erika Barahona Ede.

Guggenheim Bilbao Museum, massive plates of steel are bent this way and that to form continuously changing curves. Serra's intention is to use steel like a living skin to enclose and give shape to space. These sculptures each weigh approximately two tons and some are over 13 feet high, yet Serra has seemingly bent them as easily as one would bend a piece of paper. Such an approach to the medium required a computer design process using software originally designed for aerospace uses, plus complex fabrication that very few steel mills could manage.

At the other extreme, artists may choose to work a material as little as possible, presenting it in a form closely resembling its natural state. Elyn Zimmerman's *Marabar* (Fig. 2.16) presents the natural textures and forms of carnelian granite boulders as an interesting contrast to the straight lines of the National Geographic Society building and as a reference to the interests of the organization. Zimmerman further accentuated the weather-worn and grainy outer surface of the boulders by splitting them and polishing their cleft faces to an utterly smooth and reflective sheen that is the opposite of their exteriors.

Another approach to a material is to work it in such a way as to bring out its inner beauty. To the unknowing eye, a burl growing on a tree trunk would appear to be just an ugly, irregular knob. But woodworkers have discovered burls to be filled with swirling grain patterns that, when planed and polished, have a unique beauty. In shaping *Star Chamber* (Fig. 2.17) from a walnut burl, Bruce Mitchell chose to retain a portion of the gnarled outside to emphasize by contrast the natural beauty of the interior lines and colors. The piece beckons

MATERIALS | 45

2.16 Elyn Zimmerman. *Marabar*.

1984. Plaza and garden sculpture, National Geographic Society, Washington, D.C.

Shown: 5 natural cleft and polished carnelian granite boulders ranging in height from $3^{1}/2'$ to $10^{1}/2'$ (91.44 cm to 3.05 m), surrounding a pool, $60 \times 6 \times 18'$, constructed of polished carnelian granite. Courtesy Elyn Zimmerman, New York.

us to caress this bowl with our fingers, to explore its smooth curves and test the feeling of its strange knobs.

Each material has its own unique qualities that artists must understand and respect, whether they choose to emphasize or override these qualities. Claes Oldenburg's statement about materials illustrates a healthy respect for the challenges they pose:

I like to work in material that is organic-seeming and full of surprises, inventive all by itself. For example, wire, which has a decided life of

2.17 Bruce Mitchell. Star Chamber.
 Walnut burl, 1987. 12¹/₄ × 26³/₄ × 24". © Smithsonian American Art Museum, Washington, D.C./Art Resource, New York.

its own, paper, which one must obey and will not be ruled too much, or cardboard, which is downright hostile, or wood with its sullen stubbornness. I am a little afraid of metal or glass because they have the capacity like a lion to gash and kill, and if I gave them the freedom I give my other materials they probably would.²

Combining different materials requires particular skills and knowledge of their unique properties. John Matt's *Wind Chant* (Fig. 2.18) mixes the reflective surfaces of polished aluminum with the warm feel and colors of woods—Philippine mahogany, walnut, and rosewood. Wood can always be expected to move—to shrink, expand, and perhaps crack—no matter how thick, old, or dense it is. Metals have very different properties that allow them to bend and to span distances without being very thick. In this piece, all wood parts are allowed to move independently of each other and of the metal. It is also possible to join wood to metal without cracking the wood, but careful craftsmanship is essential.

2.18 John Matt. *Wind Chant*. 1979. Aluminum and hardwood, 6'2¹/₂" (1.88 m) tall, 6'9" (2.06 m) long, 2'7" (78.74 cm) wide. Collection of the artist.

 $^{^2}$ Claes Oldenburg, from Barbara Rose, *Claes Oldenburg* (New York: The Museum of Modern Art, 1970), p. 189.

The wealth of new materials available to the artist today and the flexibility of today's aesthetics allow artists to use anything they choose—from plastics to camel fur—so long as it works, carrying out the role for which it was chosen. Respect for the material cannot be overemphasized, for carelessness or mistakes in this area can undermine even the most elegant of designs. Witness the initial fate of Christo and Jeanne-Claude's *Valley Curtain* (Fig. 2.4). After months of elaborate preparations and hundreds of thousands of dollars of expenses, the huge curtain unfurled itself prematurely during its test run, snagging and tearing on the rocks. Why? Workmen tying the knots that were to hold the curtain bundled around the cable until everything was ready ran out of the tape they were supposed to be using. Rather than climb down to get a new roll of tape, they simply used old tape they found stuck to the curtain. Under stress, first the tape gave way, and then the knots, and then the curtain itself. No detail—including the suitability of each material for its intended purpose—is too small to be overlooked.

PLANNING THREE-DIMENSIONAL WORK

Sometimes artists work directly with their chosen material, manipulating it until it approximates their vision. But when a piece will be large, entail costly materials, or require time-consuming techniques of construction, the artist will usually begin by experimenting with its form, using some medium that is cheaper and more easily manipulated.

Often drawings are used in the planning stage. If so, the artist must learn to translate a three-dimensional idea into two-dimensional sketches and, in turn, envision them three-dimensionally. Usually several sketches are required, with the artist studying the form from many different points of view. Before beginning construction of *Wind Chant* (Fig. 2.18), John Matt filled pages of his sketchbook with drawings like those shown in Figure 2.19, "thinking nonverbally" about forms, their relationships to each other, and ways of putting them together.

In fields such as architecture and landscape or interior design, plans may include **layouts** (two-dimensional plans viewed from overhead), requiring an additional leap of the imagination to envision the three-dimensional reality of the projected work. Pieces that must be **fabricated**—constructed using industrial techniques—by someone other than the artist may require mechanical drawings to scale for precise duplication. Views from the top, end, side, and sometimes cross-section specify exact sizes and fittings for the craftsperson to use. Often cross-sections are included with dotted lines to indicate the inner construction of joints that will not be apparent on the surface, as in **Figure 2.20**. This is an excerpt from the mechanical drawings for Linda Howard's *Rectangles*, a 25-foot-long (7.62 m) hanging redwood sculpture assembled with nuts, bolts, washers, and steel rods.

For **site-specific** works—those to be installed in a particular location—drawings of the piece in place as the viewer will see it are usually necessary. They

2.19 John Matt. Excerpt from preliminary sketches for *Wind Chant*. 1979. Black fine-point ballpoint pen on white drawing paper. Photo by Frank Noelker.

2.20 Linda Howard. Section of blueprint detail drawings for *Rectangles*. 1982. Finished piece of redwood, $25 \times 14 \times 7'$ ($7.62 \times 4.27 \times 2.13$ m). Collection Pacific Lumber Company, San Francisco.

2.21 Claes Oldenburg. *Proposed*Colossal Monument to Replace
the Washington Obelisk, Washington, D.C.: Scissors in Motion.
1967. Crayon and watercolor,
30 × 19¹/₄" (76.2 × 50.2 cm).
© Claes Oldenburg and Coosje
Van Bruggeno.

are helpful in judging how well the piece fits into its surroundings, not only in form but also in scale. In Claes Oldenburg's drawing for a *Proposed Colossal Monument to Replace the Washington Obelisk, Washington, D.C.: Scissors in Motion* (Fig. 2.21), we get the sense of what it would be to see these scissor blades thrusting far above the trees into the sky. Such drawings, when created by famous artists like Oldenburg and Christo, become collector's items in themselves.

Computer technology now offers the potential for creating programs that will generate two-dimensional drawings of projected three-dimensional projects in perfect perspective. Computer-aided designs can be rotated, shrunk, or enlarged for viewing from any angle or distance. In effect, the varying graphics displays that can be called up allow the artist to walk around a work before it is even constructed. The programs also allow the designs to be changed in specific dimensions, as variations on a basic theme. The rapidity of changes once the initial program is created makes it possible for artists with a knowledge of computer programming to experiment with a greater variety of solutions to any visual problem they can conceive, changing specifications until they find the design that works best.

In preparing digital renderings of his design for a new transportation hub at the World Trade Center (Fig. 2.22), architect Santiago Calatrava was able to

2.22 Santiago Calatrava. Digital rendering of the World Trade Center PATH Terminal. Projected completion date 2009.

demonstrate not only how the complex would fit into its newly built surroundings but also the effect of hydraulically opening the huge glass and steel "wings" over the main concourse every year on September 11. He could also show the commissioning Port Authority how natural light would filter through glass blocks in the floors in order to reach train platforms up to 60 feet underground.

After or instead of drawings, planning can also be carried out in a variety of three-dimensional modes, allowing direct exploration of the intended forms. Sculptors often mold a small **maquette** (small-scale model) of soft clay as they do their initial nonverbal thinking about a piece. The work itself may be a further evolution of the idea rather than a literal translation of the maquette into a larger scale and more durable material. Sometimes, however, construction of the final work may be done by assistants copying the model. In this case, the model may be small-scale, with enlargements carried out by exacting caliper measurements, or it may be full-scale. Frederick Hart's two-ton full-scale plasticine model for *Ex nihilo* (**Fig. 2.23**) was then being carved in stone above the

2.23 Frederick Hart working on a detail of a plasticine model for *Ex nihilo*, tympanum that was carved over entrance to the National Cathedral, Washington, D.C. Dedicated 1982. Photo Darrell Acree, Washington, D.C.

2.24 John Matt. 1985. Maquette for a proposed sculpture. Paper and thread, height 2' (60.96 cm). Photo courtesy the artist.

entrance to the National Cathedral in Washington by master stonecutters. The model itself was preceded by a traditional planning process: Hart first sketched the design and made a small plasticine model of it. The model was then cast in plaster and enlarged to a rough full-scale plasticine copy. After Hart finished the detail work on the model, as shown, it was cast in plaster by sections. The stonecutters worked from this cast, taking its measurements to carve the final piece.

Maquettes may be made of anything the artist finds suitable. John Matt's maquette shown in Figure 2.24 is made of paper and thread, hanging from a 2-foot-high (0.61 m) stand. Matt explained that if he were seeking a commission for the piece, his next step would be to construct a larger model—perhaps 10 feet (3.05 m) high—of aluminum and stainless steel for a more realistic preview of the finished piece. In his vision, the piece would be 50 to 100 feet (15.25 to 30.5 m) high, perhaps soaring and floating through the foyer of a large building. Even in the 2-foot-high (0.61 m) maquette, Matt included the small paper figure of a human dwarfed by the sculpture, to create a sense of the vast scale he envisioned.

Some artists prefer to do their experimenting directly, learning from a piece itself what is possible as it evolves. Arthur Hoener, whose sculpture shown in **Figure 2.25** was one of a series based on repetition of same-size wooden modules, explained this way of working:

So many decisions are made as I go along that each piece becomes a sketch for the next piece. I'm already turning the next piece over in my mind as I see what develops on an individual piece. I find that trying to do any drawings ends up restricting what form I can make. So rather than restrict the form to drawings, I allow my mind and the work in progress to develop new ideas.

Hoener's way of working does not imply a lack of planning, however. In his mind, he determined the general plan: "This time I'll use alternating pieces of dark and light wood that are an inch and a quarter thick, and this time I'll use a 45-degree angle and then cut them and sand them for a tight sensuous surface that exposes the interior form." With this coherent pattern in mind, Hoener could then work freely with the individual modules, "weaving" them together in the ways that seemed to work best as the sculpture took shape.

FORM VERSUS FUNCTION

Traditionally, a distinction has been made between the fine arts and the applied arts. **Fine art**, such as sculpture, is meant to be looked at; the **applied** or **functional arts**, such as architecture, interior design, landscape design, and product design, are meant to be used. Although these definitions seem distinct in theory, in actuality the line between the two is imprecise.

Crafts—functional pieces made by hand—help to blur the distinction between form and function, for although they serve some useful purpose, they

³ Arthur Hoener, interview with coauthors, November 1985.

are typically also designed with an appreciation of aesthetic considerations. That is, they are created with attention to the **elements of design**—form, space, line, texture, light, and color—and the **principles of design**—repetition, variety, rhythm, balance, emphasis, economy, and proportion—that are explored in the next chapters of this book. For example, Oskar Sørensen's *Silver Liqueur Decanter*, shown in **Figure 2.26**, was handcrafted with loving awareness of the effects of form, line, surface texture, and light.

Techniques developed for use in creating functional works are now often adopted in construction of nonfunctional works designed solely as artistic experiences. Ceramics have been used for creating vessels since ancient times, but those same technologies are now being appropriated for an unlimited variety of nonfunctional works of art. New works conceived in clay are unlike anything ever seen before in other media.

To create monumental aesthetic experiences such as the *Valley Curtain* (Fig. 2.4), Christo and Jeanne-Claude draw on methods and materials not traditionally linked with art—from excavation, drilling, concrete pouring, curtain fabrication, and cable-hanging to the great complexities of "non-art" activities: obtaining permits from landowners, highway departments, environmental protection agencies and local officials, and raising the funds necessary to support their visions.

Another variation on the form/function relationship appears in **industrial design**—styling of the functional, often mass-produced, products that fill our environment, from appliances to office interiors, with consideration of their aesthetic appeal. By creating open-topped drawers that can revolve around a central axis (**Fig. 2.27**), Shiro Kuramata offered consumers a functional sculptural piece whose form can be changed according to the desires and needs of the user. For easy physical and visual access to the contents of the drawers—whether office supplies or vegetables—it is unlikely that a person would position them in a straight vertical line, since each drawer would then hide the contents of the one below. In everyday use, therefore, the form of the cabinet is likely to keep changing, and every arrangement will be visually intriguing as well as functional. First designed in 1970, the piece has become a classic, serving both as a sculptural work and as a storage system.

Kuramata was especially known for his combination of a paradoxical, imaginative, metaphysical worldview—in which drawers are treated as mysterious concealers of secrets—and a rational sense of functionality. The San Francisco Museum of Modern Arts, which added several of Kuramata's pieces of furniture to its permanent collection, including a chair shown in Figure 4.8, explained their appeal: "Drawn to the unusual, the sensual, and the ephemeral, Kuramata reassessed the relationship between form and function, imposing his own vision of the surreal and of minimalist ideals on everyday objects such as tables, chairs, and lamps."

2.25 Arthur Hoener. *Standing Figure No. 2.* 1969. Honduras mahogany and poplar, $7'5'' \times 2'6'' \times 1'9''$ (2.26 m \times 76.2 cm \times 53.34 cm).

2.26 Oskar Sørensen for Tostrup. Silver Liqueur Decanter, birdshaped. 1937. 10.6" (27 cm) high. Marks: "830 S. J. Tostrup, Oslo." Collection Oslo Museum of Applied Art. Acquired through the Grosch Fund, 1938.

 $^{^4}$ http://www.sfmoma.org/exhibitions/exhib_detail/97/exhib.shiro.kuramata.html. Accessed September 2005,

Even computers are developed and judged partly on the basis of exterior design characteristics. Manufacturers consider design an important marketing tool, a way of increasing sales. Industrial designers have been commissioned to enhance the visual appeal of everything from automobiles and refrigerators to soda bottles and cell phones.

In some cases, and in some historical periods, form has been the primary consideration in creating functional pieces. The saltcellar that Benvenuto Cellini created for Francis I (Fig. 2.28) elaborates form far beyond what is strictly necessary in a vessel to hold salt. By contrast, rather than elaborate form for its own sake, some artists have felt that in a functional piece, form should evolve alongside functional considerations. At the Bauhaus, a famous German design school that opened in 1919 under the credo "There is no essential difference between the artist and the craftsman," form and function were treated not as isolated considerations but as a single unity, an organic whole. In this approach to integrity in design, industrial designers may enhance the way a product functions. The streamlined locomotive that Raymond Loewy designed for the Pennsylvania Railroad reduced wind drag by 33 percent. And the *Bauhaus/Blocks* designed by Alma Sledhoff-Buscher (Fig. 2.29) are classically appealing in form, texture, and color and at the same time well suited to the function of entertaining and educating children. Scaled for manipulation

2.27 Shiro Kuramata.
The Revolving Cabinet.
1970. Fabricated by Cappellini
SPA. 20 drawers of polished
red metacrylate revolving
around a vertical metal bar, $14.2 \times 9.9 \times 72.8''.$

2.28 Benvenuto Cellini. *Saltcellar of Francis I.* 1539–1543. Gold, $10^{1}/4 \times 13''$ (26 \times 33 cm). Kunsthistorisches Museum, Vienna. © Francis G. Mayer/Corbis.

2.29 Alma Sledhoff-Buscher. Bauhaus/Blocks. Designed 1923. 21 wood pieces, $10 \times 2^{1/2} \times 1^{3/4}$ " (25.4 \times 6.35 \times 4.57 cm). Photo Naef AG.

by small hands, the pieces fit perfectly into their rectangular package and can be combined to create a great variety of representational and nonrepresentational forms.

On a grander scale, the marriage of computer-aided mathematics, modern technology, and artistic sensitivity allows creation of technically and artistically elegant structures like the Brotonne Bridge (Fig. 2.30). Designed by Jean Muller, the cable-supported plan is free of the clutter of overhead trusses. Instead, the precise calculation of stresses allowed the bridge to be hung from only two central towers, a design that is at once structurally sound, inexpensive, and lyrically graceful.

Certain pieces we now appreciate as fine art were initially created not as art but as useful objects. The Shaker furnishings (Fig. 2.31) many people now admire for their beauty of form were created under strictly functional considerations. Lines were sparse and storage was recessed to avoid cluttering or pampering the senses, so that all thoughts could be directed toward God. Pegs on the walls allowed chairs to be hung out of the way when the floor was being cleaned. Paint was usually not applied to the native wood, for to do so was considered an elaboration. From our vantage point in time, we judge these Shaker rooms as aesthetically pleasing, but at the time, the preferences of the larger society were for the ornate.

Despite all these exceptions and variations, the fact remains that an artist designing a functional piece does so with a slightly different attitude from that of an artist designing a piece not intended for use. A functional piece must work. If it does not, it is not successful on a practical basis, no matter how successful it is aesthetically. In some cases, aesthetics must be sacrificed some-

FORM VERSUS FUNCTION | 55

2.30 Jean Muller. Brotonne Bridge over the Seine near Rouen, France, completed 1977. Campernon Bernhard Engineering Firm, Paris.

2.31 Shaker dwelling room. Early 19th-century community, Enfield, New Hampshire. Henry Francis du Pont Winterthur Museum, Winterthur, Delaware.

what in the interests of functionality. A case in point: The *Max II Cups and Saucers* (Fig. 2.32) were designed by Vignelli Associates to be both highly functional—the pieces stack neatly in a small space, can be used indoors or out, and can be mass-produced of high-quality plastic—and aesthetically elegant. However, one of the strong aesthetic points of the cup proved to be nonfunctional and had to be abandoned: The open-channeled handle presented a negative (or unfilled) space that flowed intriguingly up the handle and disappeared down into the interior of the cup. Unfortunately, when users filled the cup to the brim (as American coffee-drinkers are likely to do and as the designers had not predicted), the hot liquid would follow this convenient channel to flow out onto their hands. Consequently, the design had to be changed to place a dam at the top of the handle, arresting the flow not only of coffee but also of the eye. The version shown is the original, still the designers' favorite.

COST AND AUDIENCE

Finally, many artists are forced to consider who might buy their pieces and how much they can afford to pay. Some artists create works of art chiefly to satisfy their own curiosity or inner compulsion; they may or may not connect with buyers who like their work. Others must take into account the demands of the marketplace or of specific clients or employers.

The costs of producing a piece depend on three factors: time, materials, and tools involved. If a potter designs a cup whose handle requires an hour to create, the piece cannot be sold for \$5. A fine piece of marble is a beautiful medium with which to work, but it is not inexpensive. An industrial designer might have wonderful ideas for products that must be set aside because the company has already invested heavily in different technology and cannot afford to retool for the processes required. As a student, you will be working chiefly with inexpensive materials and readily available tools; if you become successful as an artist, the prices you can get for your work may allow you to move into more expensive materials and processes.

Who is the audience? Must a piece be mass-producible for instant appeal to a mass market? At the other extreme, is the audience a profitable corporation willing to spend a large sum to bring art to its employees and customers? What are the artistic tastes of this audience? Aesthetic preferences change, sometimes rapidly. Today there is an appreciation of simple, clean lines, perhaps as an antidote to the busy clutter of our lives. There is also an attraction to honesty in design. For example, public fountains were once expected to be graceful, highly ornamental works like the *Triton Fountain* in Rome (Fig. 2.33). The water pouring from a figure was secondary to the figure itself. By contrast, in Isamu Noguchi's *Horace E. Dodge and Son Memorial Fountain* (Fig. 2.34), the water and the fountain cannot be separated. The water pipe is one with the water; together they create a dramatic statement that reflects the technologically advanced character of the Civic Center, itself designed to present Detroit as a forward-looking city. The new aesthetic that

2.32 Massimo and Lella Vignelli, Vignelli Associates for Heller Design. Max II Cups and Saucers. 1970. Melamine. Cup: height 2¹¹/₁₆" (68 mm), diameter 3³/₁₆" (80 mm), width at handle 4¹/₂" (110 mm). Saucer: diameter 5³/₄" (145 mm). Permanent Collection of Design, The Museum of Modern Art, New York. Courtesy Vignelli Associates.

57

2.33 Gianlorenzo Bernini. Triton Fountain, Piazza Barberini, Rome. 1642–1643. Travertine.
© Scala/Art Resource.

allows appreciation of Noguchi's fountain accepts a work for what it is: A fountain *moves water*, and in this case, it even responds to changes in the weather by moderating the flow.

Or consider the desire for a quiet, inspiring spiritual retreat that led to the unique house designed by Emilio Ambasz outside Seville, the *Casa de Retiro Espiritual* (Fig. 2.35). The living quarters are underground, protected by the earth from the intense Spanish summer heat. The visible portion is a starkly simple wind-moderating facade created by two tall walls carrying a staircase

2.34 Isamu Noguchi. *Horace E. Dodge and Son Memorial Fountain,* Civic Center Plaza, Detroit. 24' (7.32 m) high, stainless-steel loop, granite well, 35 sprays and light sources. © Dave G. Houser/Corbis.

high into the sky and opening onto a handcrafted traditional wooden balcony that overlooks a lake. As visitors ascend the staircase, the sound of water descending through a groove in the handrail and then falling into a pool at the base becomes fainter and fainter, until they step out onto the balcony and simultaneously experience the absence of sound and the presence of a stunning view. Ambasz, renowned as an innovator, made this comment: "Sound has long been an under-appreciated aspect of architecture." 5

In contrast to the client who desires a quiet retreat, imagine the audience for architecture in Tokyo, where there is no central city, no order, no unifying continuity over time or from one building to another. New buildings are soon torn down to be replaced by even more modern and extravagant edifices. Old and new, large and small, are thrown together with no intentional aesthetic rela-

⁵ Emilio Ambasz, in Albert Hill, "Off the Wall," Wallpaper, October 2004, p. 107.

2.35 Emilio Ambasz. Casa de Retiro Espiritual. 1975. Spain. Photo by Michele Alassio.

tionships. As noted by architect Arata Isozaki, "Tokyo is a distressingly ugly and chaotic city, but it also possesses such mysterious vitality that building in it is a great challenge to an architect." 6

Makoto Sei Watanabe's solution in his design for Aoyama College—itself a design school—was to exceed all other Tokyo buildings in shock value. Like a mad grasshopper from a science-fiction movie, it rears its "legs" above the surrounding jumble of buildings (Fig. 2.36). To enter it and discover floors that are horizontal, with recognizable classroom chairs in which a human being can comfortably sit, is indeed the greatest surprise. Yet if the structure did not function well as a space for classes, it would not have been commissioned.

Despite changes in tastes and values, certain pieces transcend the mood of their times to invoke a more timeless appeal. They become classics because

⁶ Arata Isozaki, quoted in Michael Webb, "An Architect at Home in Both the East and West," *Smithsonian*, July 1992, pp. 66–67.

2.36 Makoto Sei Watanabe, architect. Aoyama College, Tokyo. 1990.

their excellence in design—both aesthetic and functional—is unquestionable. The *Bauhaus/Blocks*, for instance (Fig. 2.29), were designed in 1923 but are still being sold today, for they work on every level.

This chapter has covered some practical considerations that determine whether a piece is functional; the next chapter addresses some general aesthetic considerations that determine the success of a work of art.

ORGANIZING PRINCIPLES OF DESIGN

a work is the central idea or problem with which the artist is working. This idea forms the intangible focus of the work, that which underlies its form. One artist's intent may be to create an extremely lifelike representation of some object; another may be trying to reveal the beauty of a material or of pure form. Yet another might intend to evoke a particular emotional atmosphere or intellectual realization.

Currently, the intent behind many works is political: confronting complacency and bigotry, defying mainstream standards of taste, or asserting the validity of oppressed cultures. Pepon Osorio's *La Cama* (Fig. 3.2) exaggerates the decorative quality associated with Puerto Rican popular culture, using multiples of mass-produced trinkets and religious icons. This work is not a parody but a proclamation that what has been dismissed as bad taste by a secular, intellectual art establishment has cultural and social value. The bed is rich in memories of Osorio's wife and collaborator, Merian Soto, and of his "second mother" who cared for him when he was a child. The bedcover is ornamented with a great number of *capias*, commemorative ribbons used in Puerto Rico to

3.1 Toshiko Takaezu. Bronze Bell. 1980s. 21×36 ". Collection of Bristol Myers Squibb Pharmaceutical Group. Photo Charles Cowles Gallery, New York.

¹ Toshiko Takaezu, quoted in Douglas Dreishpoon, "Toshiko Takaezu: Recent Work," catalog for Pennsylvania Academy of Fine Arts show, Morris Gallery, March 6–April 26, 1992.

3.2 Pepon Osorio. *La Cama* (The Bed). 1987. Mixed media/medio mixto, $75 \times 57^{1/2}$ " $\times 81^{1/2}$ ". Museum purchase, \$93.68. Collection El Museo del Barrio, New York. Photo by Tony Velez.

celebrate special occasions. The *capias* have been donated by dozens of the couple's friends in the Puerto Rican community in the United States, where they serve as a testimony to the value of the family and of the Puerto Rican culture.

The intent behind a work might be to solve a visual problem the artist has created, such as the studio projects suggested in this book, or to address a particular concern. It is what the piece is "about." Without some initial sense of intention, the artist has nothing around which to unify a piece.

Working from a central intention, artists have traditionally striven for unity—the coordination of all parts of a work to express their intent. To unify a work is to make its many parts come together as one coherent whole. Despite vast differences in Intent and style, artworks whose aesthetic value holds up over the centuries tend to have certain unifying characteristics in common. Traditionally, they have been labeled the principles of design. These aesthetic considerations—repetition, variety, rhythm, balance, emphasis, economy, and proportion—are general ways of organizing a work. They satisfy the mind's desire to create order out of chaos. Although "unity" is sometimes treated as a

separate principle of design, the term is used here to connote the combined result of all organizing principles of design.

The principles discussed in this chapter are not absolute rules. A successful piece need not conform to all of them, and many artists use them more intuitively than intellectually. The principles can also be interpreted in many different ways. Art is a living field; it changes with its times. And three-dimensional design today does not represent a single, unified approach to art. Rather, contemporary three-dimensional expression ranges from the strictly representational to totally nonrepresentational, from efforts to create beauty to attempts at social commentary, from sculpture to functional pieces. Although the same principles are relevant to all these works and to all historical periods, to define and use the principles in a narrow sense is to ignore their limitless potential.

Before we examine the individual principles of design, first note that they are artists' ways of unifying their manipulation of the **elements of design**—form, space, line, texture, light, color, and time. These elements are explored in detail in subsequent chapters.

REPETITION

Repetition is the use of similar design features again and again. This device gives the viewer's mind an obvious way to understand what the eye is perceiving: "They're all alike," or "Oh, look, this one is like that one, and here's another one." If we look down the stairwell at the Guggenheim Museum (**Fig. 3.3**), we are immediately struck by the repetition of similar lines, creating what appears to be a series of nested triangles. We don't perceive one line in isolation; instead, we "read" from one to the next to the next, grouping them logically into a pattern.

In three-dimensional work, forms that are identical may not appear so, for each has a different relationship to the light source and thus a different pattern of values (light and dark areas). By repeating the same quiet, minimal rectangle at precise intervals in his untitled piece shown in **Figure 3.4**, Donald Judd provides us an opportunity to become aware of the changes in value that occur from one to the next and the shadow patterns between them. The blocks are quite different visually if we pay attention to what we are seeing rather than immediately assigning them a mental category—"Oh, ten blocks"—and not looking closely to see what is really happening. However, if repetition is not handled adeptly by the artist, with attention to surfaces and proportions and intervals, the effect can be irritating, as if someone is repeatedly poking you in the arm.

Repetition that is handled subtly satisfies our desire for order without calling attention to itself. Moshe Safdie's *Habitat* (**Fig. 3.5**) is built from a series of identical 70-ton rectangular modules. But because the modules can be assembled in different ways—with different ends facing the viewer and with varying degrees of overhang—the fact of their repetition may be intellectually discovered but does not announce itself at first glance.

3.3 Frank Lloyd Wright. Stairwell, Guggenheim Museum, New York. © The Solomon R. Guggenheim Foundation, New York.

As is true of other organizing principles of design, repetition is a framework within which the artist may feel a paradoxical sense of freedom. Arthur Hoener, whose work was shown in Figure 2.25, explained the phenomenon this way:

I've found that I have the greatest freedom if I use certain restrictions—if, for instance, I make up my mind to use repetition of light and dark modules of the same size to develop a form. Most such decisions are based on one's knowledge of the principles of design: I know that if I use repetition, for example, the piece will hold together. Then I have tremendous freedom in developing the form—in pushing it as far as I can.²

3.4 Donald Judd. *Untitled.* 1990. Orange anodized aluminum with clear Plexiglas. Ten units, each $6 \times 27 \times 24$ ". Overall $10' \times 27'' \times 24$ ". Photograph by Ellen Page Wilson, courtesy Pace Wildenstein, New York. © Judd Foundation. Licensed by VAGA, New York.

² Interview with Arthur Hoener, November 1985.

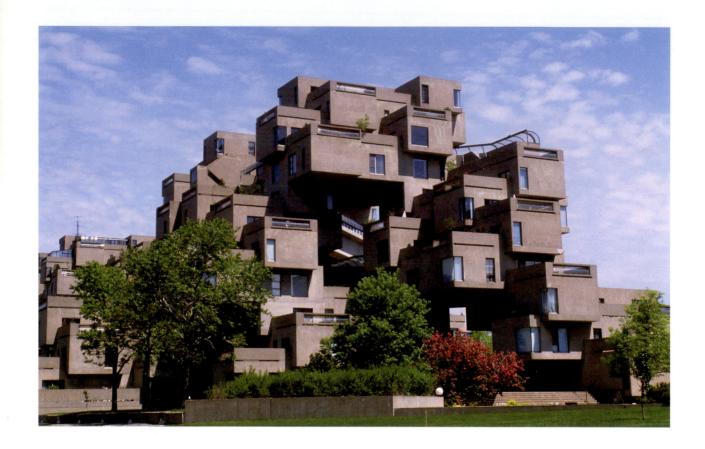

3.5 Moshe Safdie. Habitat, Montreal. Built for the 1967 Expo. The 354 modular construction units form 158 houses. Each modular box is $17'6'' \times 38'6'' \times 10'$ (5.33 \times 11.12 \times 3.05 m), precast in concrete with metal reinforcements. © Carl and Ann Purcell/Corbis.

VARIETY

While our minds can comprehend repetition with some facility, they can also create order from the chaos of incoming sensations when they can discern some unifying theme among disparate inputs. The organizational principle of variety does not refer to chaos, for few people can tolerate total meaning-lessness—unless perhaps randomness is itself the organizing theme of a work. Rather, **variety** is a form of order in which the organizing principle must be discovered by the viewer. In works organized on the principle of variety, parts that are seemingly different from each other nonetheless have something in common.

Variety is often expressed as variations on a theme. At first glance, the separate parts of *Eva Hesse's Studio* (Fig. 3.6) seem to have something to do with one another, but their variety is initially much more apparent than their similarity. Nevertheless, just below consciousness you may feel that the parts are related somehow. In other words, you feel their similarity more quickly than you consciously perceive it. Gradually you may become aware of the common themes on which these parts are variations: All are hanging; all have drooping, ropish qualities; all make reference to circles or elongated circular forms. Then you may begin to pick out pairs of similar things, such as the single round ball

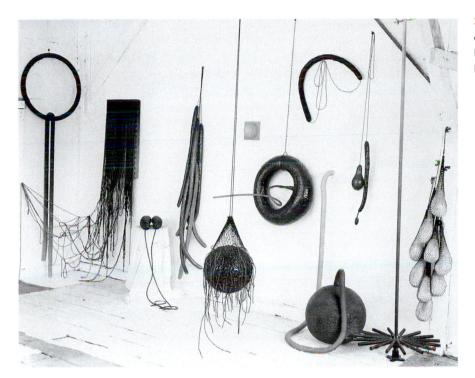

3.6 Eva Hesse. Eva Hesse's Studio. 1966. © The Estate of Eva Hesse. Hauser and Wirth Zurich, London.

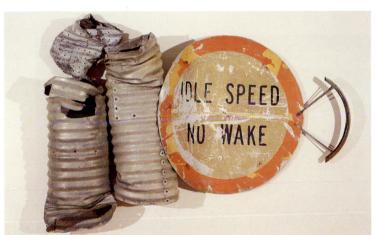

3.7 Robert Rauschenberg. *No Wake Glut.* 1986. Construction of found metal objects (aluminum and steel), $61^1/2 \times 89^1/4 \times 18^1/4''$. Photo © Dorothy Zeidman 1987. Art © Robert Rauschenberg/Licensed by VAGA, New York.

in a string bag versus a cluster of sagging ovoid forms in separate string bags, or two small spheres on a table with rope drooping to the floor versus one large sphere on the floor with its tube attached above. The piece becomes like a child's puzzle to solve: Which things go together? Which thing is different? Is it somehow similar, too?

The unifying theme in some works is almost beyond the viewer's grasp. Confronted with Robert Rauschenberg's *No Wake Glut* (Fig. 3.7), we may have an intuitive sense that these juxtaposed objects fit together somehow, but our minds cannot easily seize the unifying principle of the piece. The only obvious

conclusion is that they are all "found objects." We are likely to try to read the faint letters and assign them a meaning having something to do with boating. But then what are those ribbed cylinders on the left? The arc on the right? Muffler parts? Steering-wheel parts? Do they also have something to do with boats? Perhaps it doesn't really matter what they are. All refer to circular motion, which is picked up again in the ribs of the cylinders. With this bare unifying thread, the work holds our attention as we look from one object to the next, trying to decipher what they are and how each one relates to the whole. Perhaps it has more than one solution; perhaps it has no solution. The sense of the whole is elusive, hovering right on the edge of our consciousness barely beyond our reach. Our inability to grasp what is going on does not mean that the piece has failed, however. In presenting exactly enough information to suggest some hidden unity, the piece encourages us as viewers to try to pull the parts together into a coherent whole.

Variations may also occur in the elements of design. Artists may present us with **contrasts**—juxtaposition of dissimilar areas. These contrasts engage our participation in comparing, for instance, light and dark areas, wide lines and thin lines, heavy forms and lightweight forms, filled spaces and unfilled spaces. In isolating two river stones by weaving sticks around them like ripples in water (Fig. 3.8), Andy Goldsworthy created a contrast of many thin lines against two

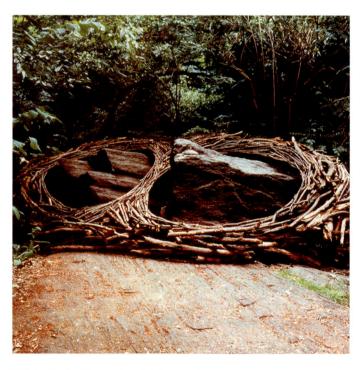

3.8 Andy Goldsworthy. *Sticks Stacked Around Two Rocks.* 1993. Central Park, New York. Courtesy Galerie Lelong, New York.

large forms, set off as a unified whole in incongruous contrast to the surrounding dry land and forest.

Variety may be handled boldly, as in the juxtaposition of dramatically contrasting areas. Or it may be handled less obviously, with a dark area gently blending into a light area, wide dwindling to narrow. This gradual introduction of variety is known as **transition**. Transitions help to tie a work together, for they easily lead the mind from one quality to another, revealing the logic of their relationship.

RHYTHM

Repetition and variety in art tend to create a certain visual **rhythm**—a more or less regular pattern created by the elements of design as they seem to move and change through time and space. It is actually the eye that moves across the changing surfaces of the piece. Movements in and out, up and down, flowing and pausing, and sudden changes in size, value, or complexity create visual effects that can be compared to music. As the eye explores a three-dimensional piece, we may get a sense of accented and unaccented beats or of crescendos and decrescendos. Rhythm exists as a substratum that usually does not call attention to itself but nonetheless helps to unify our perception of a piece.

Beats may be quite distinct. The forms of the Easter Island statues (Fig. 3.9) can be seen as accented beats, separated by the unfilled spaces between them. The statues suggest a series of dramatic single pulses, like heavy individual beats played on a deep-throated drum or gong. In Frederic Remington's narrative sculpture *Coming through the Rye* (Fig. 3.10), individual visual beats are less distinct, but a rapid staccato rhythm is set up nevertheless as the outlines of the forms abruptly shift direction up and down, in and out, through space. The many hooves striking the ground in succession, punctuated by the upraised arms, make this a very "noisy" piece of sculpture.

3.9 Statues of Ahu-Akivi, Easter Island. 17th century or earlier. Height 30' (9.14 m). © The Image Bank/Getty Images.

3.10 Frederic Remington. Coming through the Rye. 1902.
 Bronze (cast no. 12). 30³/₄ × 29³/₄ × 28¹/₄". Amon Carter Museum, Fort Worth, Texas (1961.23).

3.11 Max Bill. Monoangulated Surface in Space. 1959. Gilded brass, $15 \times 18 \times 26''$ (38.1 \times 45.72 \times 66.04 cm). © The Detroit Institute of Arts. Gift of W. Hawkins Ferry.

In some pieces, there may be a sense of movement that has no beginning and no end. The curving lines of Max Bill's *Monoangulated Surface in Space* (Fig. 3.11) set up a continuing song, endlessly flowing back into itself. As it rises, the "sound" swells in a gentle crescendo; as the two sides meet and flow downward again, the rhythm resolves temporarily into a decrescendo and then rises again with barely a pause. The piece almost becomes a visual mantra, like a continually chanted "Om."

Some works contrast with the rhythm of their surroundings. Pieces that suggest a single beat can be very effective in contrast with the cacophony of an urban environment. On the other hand, some works echo the rhythms around

them. Michael Singer's *First Gate Ritual Series* (Fig. 3.12) fits in with the soft rhythm set up by its natural environment—the whispering ripples and highlights of slow-moving water. The work gently adds its own lightly sustained, overlapping notes to the passing flow of shimmering reflections.

BALANCE

The sense that a three-dimensional work is visually balanced is another way in which a work may satisfy the mind's search for order. If pieces were not in fact balanced or anchored, they would fall over. But beyond the physical fact of their remaining as placed, works convey a sense of **visual balance**. Each area suggests a certain **visual weight**, a certain degree of lightness or heaviness. Factors such as value, texture, form, size, and color affect our perception of visual weight. For example, light colors appear lighter in weight than dark colors; transparent areas seem to weigh less than opaque areas. Yellow areas seem to expand in size, whereas blue areas tend to contract. To balance a work is to distribute the visual weight of its parts in such a way that the viewer is satisfied the piece is not about to pull itself over.

One form of visual balance is **symmetrical balance**—the formal placement of identical parts on each side of an imaginary **vertical axis**, a central line that

3.12 Michael Singer. First Gate Ritual Series. 1976. Oak and rock. Installed at the Nassau County Museum of Fine Art, Roslyn, New York. Photo Michael Singer.

3.14 Water Organ. c. 1550. Villa d'Este, Tivoli, near Rome. © Robert Harding World Imagery/Getty Images.

3.13 Beverly Pepper. Cleopatra's Wedge. 1991. Steel, 18'6" high × 6'6" wide (5.60 × 1.90 m).
© Beverly Pepper, courtesy Marlborough Gallery, New York.

could be drawn vertically through the piece. In *Cleopatra's Wedge* (Fig. 3.13), Beverly Pepper created a vertical axis with sides of the slender wedge flaring only slightly outward from this imaginary line. The cube on which it rests, and the inverted cone upon which *that* rests, follow the same principle of absolute symmetry. The impression given is that this perfect symmetry is absolutely necessary as the only force that allows the tall wedge to remain balanced on the base. In *Water Organ* (Fig. 3.14), the organ-pipe-like jets of water are exactly the same on both sides, mirror images of each other. Such a configuration tends to create a secure, safe feeling, a sense of solidity that transcends the fluidity of the medium.

Asymmetrical balance is a trickier balancing act. In this case, areas on either side of a central vertical axis are not identical but appear to have the same visual weight nonetheless. To balance forms asymmetrically, a thrust away from the vertical axis in one area may be balanced by a counterthrust in the opposite direction on the other side of the vertical axis. In Jacques Lipchitz's *Prometheus Strangling the Vulture* (Fig. 3.15), the projection of the vulture and Prometheus's head to the right is offset by the thrust of the form billowing out to the left, making it appear logical that Prometheus could indeed be balancing his considerable weight atop the small ball at the base. Here, the central axis is suggested by presentation of a visible balancing point—a fulcrum at the base upon which the entire upper portion of the composition seems to be balanced.

In asymmetrically balanced pieces, the balancing point may not fall in the exact center of the work. Mark di Suvero's *Mozart's Birthday* (Fig. 3.16) has two apparent balancing points: the tops of the triangular bases from which every-

3.15 Jacques Lipchitz.

Prometheus Strangling the Vulture. 1944-1953. Bronze, 91³/₄ × 90 × 57". Collection Walker Art Center, Minneapolis. Gift of the T.B. Walker Foundation, 1956.

3.16 Mark di Suvero. *Mozart's Birthday.* 1989. Steel, $25'6'' \times 35'6'' \times 47'$. Installation view Paris, France. © George Bellamy. Courtesy of Mark di Suvero and Spacetime C.C.

thing else seems to be hung, suspended, or supported. By contrast, the symmetrically balanced "Atollo" lamp shown in Figure 3.17 has a single balancing point in dead center.

Designs must be balanced vertically as well as horizontally; that is, if an imaginary line is drawn horizontally through the center of a piece, representing its horizontal axis, the area above the line must be balanced by the area below the line. In judging this vertical balance, we may feel that absolute symmetry—the same weight above as below—is unbalanced. Based on our experiences in the three-dimensional world, we expect that greater weight is needed on the bottom to support the area rising above the horizontal axis. In John Storrs's sky-

3.17 Vico Magistretti. "Atollo" table lamp (no. 233). 1977. Aluminum with polyurethane plastic. H. 26" (66 cm); diam. 19 \(^1/4\)" (48.9 cm); base diam. 8" (20.3 cm). Gift of O-Luce Italia. (481.1978). The Museum of Modern Art, New York.

73

3.18 John Storrs. Forms in Space. Metals in combination. Without base: height 201/4" (51.30 cm), greatest width 4" (10.16 cm). With base: height 25" (63.5 cm), base height 41/4" (11.68 cm), width 51/2" (13.71 cm), depth 31/8" (8.12 cm). The Metropolitan Museum of Art, New York. Francis Lathrop Fund, 1967. 67.238.

scraper-like *Forms in Space* (**Fig. 3.18**), we sense that the great height of the figure relative to its width is possible only because the shorter outer columns provide "support" for the tallest central columns.

The complexities of visual balancing are compounded by the fact that the components of the balance change as we walk around a three-dimensional piece. Although our view of Lipchitz's *Prometheus* (Fig. 3.15) is frozen by the photograph, the projection of forms on either side of the balancing point is quite different from other points of view but equally well balanced. Because balance is often too complex to be determined intellectually, artists are more likely to work with it intuitively, manipulating the elements of design until areas feel balanced in relationship to one another.

Can a piece of three-dimensional work be visually unbalanced? It depends on the intent of the artist. In some cases, a suggestion of imbalance is central to the excitement of a piece. In *Prometheus*, the lack of a broad base for Prometheus's great bulk makes his struggle with the vulture all the more exciting, for he seems to have precise balance as well as considerable strength. In Arthur Hoener's *Standing Figure No. 2* (Fig. 2.25), the fact that the sculpture seems slightly off balance adds to its sinuous quality, as though it were in motion.

EMPHASIS AND ECONOMY

Many works are successful because they adhere to the principle of **emphasis**—stressing of a particular area or characteristic rather than presenting a maze of details of equal importance. One method of achieving emphasis is to make one area or quality **dominant**, or most important visually, with other areas contributing but subordinate. That area of a piece to which the eye is drawn most compellingly may be the largest, brightest, darkest, or most complex part of the whole, or it may be given special attention because it stands out for some other reason. In Naum Gabo's *Linear Construction* (Fig. 3.19), we can see the oval void in the center as the **focal point**—the place where our gaze tends to center. Though consisting of unfilled space, it stands out because it runs through the physical center of the work and because its simplicity contrasts with the fine lines of the filled areas that surround it.

Although focal points are commonly used as unifying characteristics in two-dimensional art, a three-dimensional work may not have a single focal point, since there may be no one point that can be seen from all sides. Gabo's piece is transparent, thus allowing the central void to be seen from all angles. But in works that must be walked around, the eye may be led from one area to another, so the notion of focal point is not easily applied. One-sided works may be organized around a single dominant area, however. And in works that physically surround the viewer, such as gardens, a contrasting element such as a fountain or piece of sculpture may be used to draw people into or through the work.

Another form of emphasis is the directing of all elements of design toward the intended goal. In Antoni Gaudi's *Church of the Sagrada Familia* (Fig. 3.20), the aesthetic intent is to uplift the awareness of the viewer. To this end, the major forms rise in slender spires, making the cathedral's height much greater than its width. The visual accent is on the vertical, creating a pronounced

upward thrust. The latticelike cutouts make the materials appear much lighter than they actually are, creating an airy effect, as though the building were stretching upward in a spiritual reaching that defies the pull of the earth's gravity.

Yet another way of creating emphasis is to limit the viewer's focus to only a few elements of design. This device is called **visual economy**—stripping away all nonessentials to reveal the essence of a visual idea. In pieces such as the pot shown in **Figure 3.21**, the late British potter Hans Coper limited his use of colors and textures to leave the viewer room to experience the bare essence of abstract form. This austere aesthetic eliminates clutter, allowing the mind to focus on the beauty of the seemingly simple.

To implement the principle of visual economy is not simple, however. To reduce an aesthetic statement or a form to its simplest components requires an elegant mental feat on the artist's part. It also asks much of the viewer. For **minimal art**—art based on the concept that less is more—to work, precisely enough information must be given, in the right scale and proportion, and viewers must be willing to fill out the picture from their experiences in the three-

3.19 Naum Gabo. *Linear Construction No. 1.* 1943. Lucite with nylon thread, $24^{1}/_{8} \times 24^{1}/_{4} \times 9^{7}/_{8}$ " (61.2 × 61.5 × 25.0 cm). © The Phillips Collection, Washington, D.C.

3.20 Antoni Gaudi. *Church of the Sagrada Familia*, 1903-1926. Barcelona. © Archivo Iconografico, SA/Corbis.

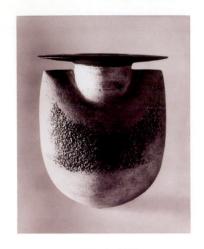

dimensional world. The Robert Morris piece in Figure 3.22 asks a great deal of the viewer. Why and how are we to react? The artist has not given any title to the work, so there are no clues. An unnamed piece compels us to bring more of our experience to bear if we are to grasp the artist's intent. The Morris work is very large and dominating. Why? It looks quite heavy until we recognize that it is made of felt. Then we can play mental games with the observation that although the component parts form a 90-degree angle between wall and floor, they sag at the top. What is this about? A minimalist piece is about such questioning rather than about conclusions. It is much more difficult to emphasize by understating than by overstating, for in understatement the directing of the viewer's understanding is reduced to an absolute minimum. Many viewers may not understand—or care to try.

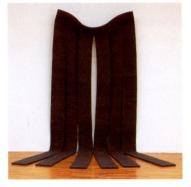

3.21 Hans Coper. Ceramic pot. Height 8" (20.32 cm). From Tony Birks, *Hans Coper* (Sherborne, Dorset: Marston House, 1984). Photo Jane Gate.

3.22 Robert Morris. *Untitled*. 1969. Gray-green felt, $15'^3/4'' \times 6'^1/2'' \times 1'^1/8''$ (459.2 \times 184.1 \times 2.8 cm). The Gilman Foundation Fund. The Museum of Modern Art, New York.

PROPORTION

A final, subtle organizing principle of design is **proportion**—the size relationships among parts of a work. When proportions are correct—when they "feel right"—the work as a whole will tend to fall into place with a satisfying sense of order in the mind of the viewer.

The issue of proportion can be approached mathematically. The ancient Greeks felt that the most aesthetically perfect size relationship between two unequal parts of a whole was a ratio of 1 to 1.618. In a rectangle whose short side was one foot (0.3 m) long, for instance, the length of the long side would be 1.618 feet (0.49 m). Enshrined as the **Golden Section**, these proportions were thought to be the epitome of beauty and were used in the designing of buildings such as the Parthenon (**Fig. 3.23**). The same size ratio can be found in many natural growth patterns, such as the size relationship of successive florets in the center of a daisy, or stages of growth in a nautilus shell.

Parts of the human body also exist in specific size relationships to each other. The representational artist must bring the ratios between parts of the body into conscious awareness to satisfy viewers' sense of proper proportion. Students usually learn, for example, that the body as a whole is seven and a half heads high. Finger joints, hands, and arms exist in predictable mathematical relationships to each other.

Aside from known associations with the proportions of the human body or other familiar figures from our three-dimensional world, we have a subtle intuitive sense of what looks correct. The proportion of base to shade in the Atollo lamp (Fig. 3.17) seems exactly right. This sense of perfect correctness was captured by the Zen monks who designed the Ryoan-Ji rock garden in Kyoto (Fig. 3.24). The outer dimensions of the garden, the height and distance between rocks, the distances between the rocks and the viewer, the mountainlike height of the rocks from this distance, the width of the furrows in the raked sand, and the proportion of the sand raked in concentric circles around the islands of stone—all aspects of the composition exist in such perfect relationship to one another that the viewer feels a great sense of peace, of everything being as it must be. One feels that if a single proportion were changed, the unity of the piece would be destroyed.

3.23 Parthenon facade designed according to Golden Section.

3.24 Rock garden of Ryoan-Ji Temple, Kyoto, Japan. © Archivo Iconografico, S.A./Corbis.

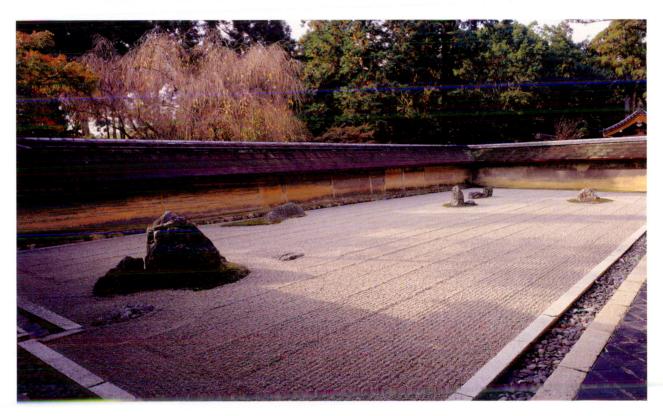

Although the principles of design have been examined here separately, they work together to create an impression of unity. Satisfying proportions are not the only unifying feature of the Ryoan-Ji garden. Consider the other principles discussed in this chapter—repetition, variety, rhythm, balance, emphasis, economy. How is each reflected in the organization of this classic work, making it a coherent, aesthetically pleasing whole rather than several unrelated rocks stuck in some sand?

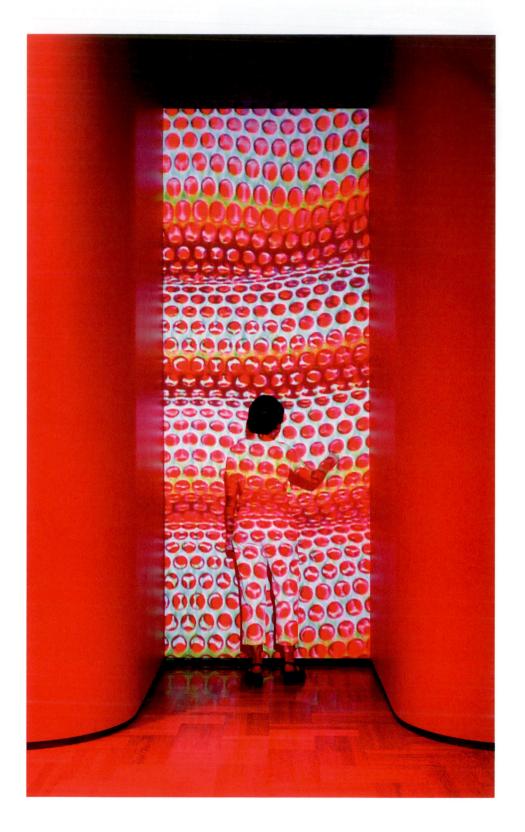

ELEMENTS OF THREE-DIMENSIONAL DESIGN

4 FORM

ORM IS PERHAPS THE MOST OBVIOUS ELEMENT of three-dimensional design, because *form* defines what three-dimensional art is: It is that which occupies three-dimensional space (in contrast to a *shape*, which is flat, two-dimensional). Yet defining form itself is not so simple. A limited definition of **form** is the physical contour of a work, the volume or **mass** that it carves out of space. In Tony Smith's *Die* (Fig. 4.1), the form is clearly a six-foot (1.83 m) cube. But in certain works the question of what constitutes the form of the piece is less obvious.

In Clayton James's hand-built pots (Fig. 4.2), the forms are shells enclosing empty space. Yet the volume they enclose seems to be a positive force in itself, as if it were pushing the walls of the pots outward.

In Sylvia Stone's *Another Place* (Fig. 4.3), the form of the piece could be described as a sprawling assembly of flat Plexiglas panels. By such a definition, its form is almost nonexistent, since the thin Plexiglas occupies very little space and is also transparent. Stone's work almost transcends form in the literal sense. But to limit understanding of form to its physical existence is to overlook the fullness of the experience of such a piece. To broaden our understanding, we could say that the form of Stone's work includes the interior spaces it encloses and the varying but barely visible Plexiglas configurations that can be grasped at the very edge of perception as the viewer shifts position.

The elements of design can be understood as dynamic aspects of three-dimensionality that the artist manipulates in order to create desired effects. The words we use for these elements—form, space, line, texture, light, color, and time—are simple and familiar terms in everyday language. Yet their use to describe what happens in a work of art vastly expands the potential of their meaning to encompass a world of nonverbal experience that can only be poorly hinted at through the use of words.

In these chapters on the elements of design, we hope to indicate something of the great range of effects that can be created through use of each element.

4.1 Tony Smith. *Die.* 1962. Steel, 6' (1.83 m) cube. Courtesy Paula Cooper Gallery, New York.

4.2 Clayton James. Hand-built forms. Photo © Mary Randlett.

4.3 Sylvia Stone. Another Place. 1972. Plexiglas, $6'8'' \times 17' \times 28'2''$ (203 \times 518 \times 859 cm). Photo Linda Schwartz.

Although artists work with many elements of design at once, directing them toward a unified goal, the purpose here is to study them by isolating each element and exploring what it can do. For the element of form, the focus is on interior as well as exterior forms; secondary as well as primary contours; negative as well as positive forms; static forms and dynamic forms; and representational, stylized, abstract, and nonobjective forms.

EXTERIOR VERSUS INTERIOR FORMS

We normally think of form as referring to the outside of a piece—its **exterior form**—but works may also reveal an **interior form**. Comparing the relationships between the two can be a major part of the aesthetic experience.

At the most literal level, the inner form is simply the reverse of the outer form of a hollow piece. A bowl has both a convex exterior form and a concave interior form. Elena Karina draws us into the intriguing interior forms of her ceramic sculpture (Fig. 4.4), whose open fringes appear as a colony of plants or animals kept in motion by the sea. She inspires in us a desire to explore whether these openings are hollow in their depths, and if so, what the passages look like inside.

Sometimes artists create the illusion of revealing a hidden inner form. In *Sphere with Perforations* (Fig. 4.5), Arnaldo Pomodoro has "opened" a gleaming bronze sphere to show its secret core, mysterious interior forms of which the exterior form gives no hint. On another level, sculptors often feel that in removing excess stone from a block, they are revealing a form that was hidden inside all along. This process of bringing the interior form to light is illustrated in Michelangelo's unfinished *Slave Called Atlas* (Fig. 4.6). It is not known whether

4.4 Elena Karina. *Sky Trumpet.* 1980. Porcelain, clay, glazes, lusters, 10'' h \times 18'' diameter. Photo Bill Scott.

4.5 Arnaldo Pomodoro. Sfera con Perforazione (Sphere with Perforations). 1966. Bronze, one-half cast, diameter 23 1/2"
(60 cm). © Arnaldo Pomodoro, courtesy Marlborough Gallery, New York.

4.6 Michelangelo. Slave Called Atlas. 1530-1534. Marble. Galleria dell' Accademia, Florence. © Scala/Art Resource, N.Y.

Michelangelo intended to finish bringing the inner form out of the marble, or whether the piece is intended as a statement of the outer forces almost totally constraining the inner life and freedom of a human being.

Another expression of the contrast between interior and exterior forms appears in pieces in which one form is physically separate from but contained within another. When all or part of the interior form can be seen through the exterior form, the relationship between the two and the discovery of the inner form can be quite exciting. A classic example is the traditional Japanese "package" (Fig. 4.7), which a farmer or woodcutter would bring to the workplace from home. Through the horizontals and verticals of the exterior reed form, we can see the elegance of what many designers consider the perfect natural form: the egg.

In architecture, glass walls may allow us to see the interior forms, such as stairwells and furniture, encased within the exterior framework of the building.

4.7 Tamago no tsuto (The Egg Package). Rice straw, 16" (40 cm). Collection Hideyuki Oka.

4.8 Shiro Kuramata.
How High the Moon. 1986. Steel mesh. Galleria Carla Sozzani.

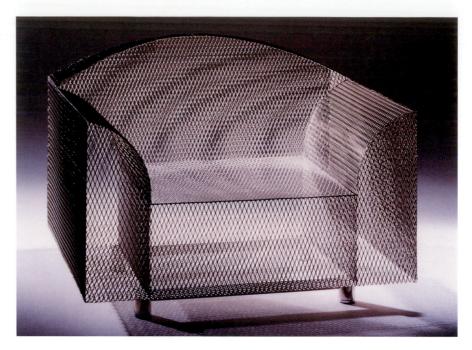

Similar effects are sometimes created in sculptures with exterior forms that either contain visual openings or are transparent. Shiro Kuramata imitated the form of a traditional upholstered armchair (Fig. 4.8) but used steel mesh, whose transparency reveals the underlying framework of the chair as well as the exterior surface. The transparency creates interesting spatial ambiguities as we try to sort out the relationships among the parts of this work.

In contrast to works in which we are invited to compare inner and outer forms, some pieces present an outer form that is hollow, implying an inner form that cannot be seen. There may be a sense of a force bulging outward, pushing the walls of the piece into outer shapes by pressure from within. Or in the case of jewelry, masks, or medieval body armor, a piece may be made to fit over the form of a body. When shown without a body inside, the outer form is both interesting in itself and reminiscent of the inner form it once enclosed. The suits of armor made for Henry VIII from 1515 to 1540 (Fig. 4.9) reveal his physical evolution from the slenderness of youth to middle-aged paunch.

PRIMARY AND SECONDARY CONTOURS

In any form with surface elaboration, a distinction can be made between the **primary contour** of the piece—the shape of its outermost extremity—and its **secondary contours**—the forms developed on its surface. The cylindrical outline of

4.9a, b, c, d Tournament and field armors for Henry VIII. c. 1520, 1515, 1540, 1535-1540. Steel with various decoration. The Board of Trustees of the Royal Armories; Royal Collection © 1992 Her Majesty Queen Elizabeth II (a-c); The Royal Picture Library, Windsor Castle (d).

4.10 Column of Trajan, Rome. AD 113. Marble, 125' (38 m) high. © Vittoriano Rastelli/Corbis.

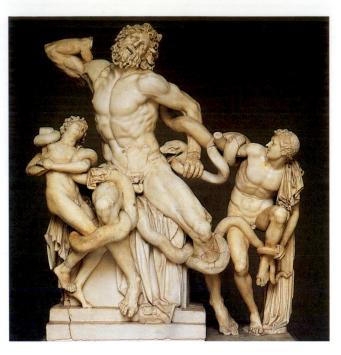

4.11 Hagesandros, Athanodoros, Polydoros. *Laocoön.* 2d or 1st century BC. Marble, 6' (1.84 m) high. Vatican Museums, Museo Pio Clementino.

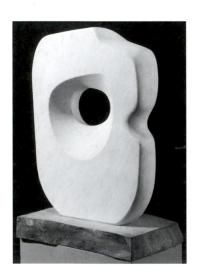

4.12 Dame Barbara Hepworth.
Pierced Form. 1963-1964. Pentelic marble. 126.4 × 97.2 × 22.9 cm,
630 kg. The Tate Gallery, London/Art Resource, New York. © Alan Bowness, Hepworth Estate.

Trajan's Column (Fig. 4.10) is its primary contour; the low relief carvings spiraling around it to tell the story of Trajan's campaigns constitute its secondary contours.

In many cases there is no clear distinction between primary and secondary contours but rather an ever-changing interplay between them. In the famous Greek statue *Laocoön* (Fig. 4.11), the primary contour is the complex outline of the piece; the secondary contours are the details of the snake and the bodies of Laocoön and his sons. Not apparent from a photograph, however, is that the primary contour of the sculpture will change as the viewer moves around it, seeing different areas created by the "secondary contours" as outermost.

The words "primary" and "secondary" do not have any hierarchical significance, either. Neither is automatically more important. In *Laocoön* the real excitement lies in the relationships between secondary forms—parts of the snake to parts of the humans, arm to arm, leg to leg.

POSITIVE AND NEGATIVE FORMS

Another set of polarities that arises in three-dimensional work with form is the distinction between **positive forms**—solid areas that occupy space—and **negative** (or **implied**) **forms** or **voids**—the shapes of spaces that are enclosed or delineated by positive forms. The difference between the two is apparent in Barbara Hepworth's *Pierced Form* (Fig. 4.12). Here the positive form is sculpted

white marble; the negative form is the space opened within it. The viewer is invited to experience both. Although the negative form cannot be seen, its shape is almost totally defined by the marble, and the two complete each other as a single unit. For Hepworth, this sense of unity between mass and void grew out of her personal experience of the wholeness of life:

All my early memories are of forms and shapes and textures. Moving through and over the West Riding [England] landscape with my father in his car, the hills were sculptures; the roads defined the form. Above all, there was the sensation of moving physically over the contours of fullnesses and concavities, through hollows and over peaks—feeling, touching, seeing, through mind and hand and eye. This sensation has never left me. I, the sculptor, *am* the landscape. I am the form and I am the hollow, the thrust and the contour.

Although negative forms consist of empty space, they can be as active and important in a piece as the positive forms. In Le Corbusier's *Notre Dame du Haut* (Fig. 4.13), the negative window forms in the thick walls are highly active, for they are both channels for light and intriguingly varied volumes in themselves.

4.13 Le Corbusier. *Notre Dame du Haut* (interior south wall). 1950-1955. Ronchamp, France.

© Wim Wiskerke/Alamy.

¹ Barbara Hepworth, *Barbara Hepworth: A Pictorial Autobiography* (Wiltshire, U.K.: Moonraker Press, 1978), p. 9.

4.14 Erwin Hauer. Inversion of Volumes. 1965. Bronze, $24 \times 8 \times 8'' \ (61 \times 20 \times 20 \ cm)$. Collection Fondazione Maguerite Arp, Locarno, Switzerland.

4.15 Sol LeWitt. *Progression from Two Corners*. 1996. Wood painted white on gray flat base, $50 \times 30 \times 30$ " Hollis Taggart Galleries.

A void in a piece of sculpture allows the exposure of inner surfaces, creates spatial relationships among forms that would not otherwise occur, and invokes playful or curious attempts by viewers to look through the piece. In Erwin Hauer's *Inversion of Volumes* (Fig. 4.14), the opening of a void in the lower area creates lovely interplays of rounded positive and negative forms. Note that the artist created a visual game in which the viewer may discover that the upper portion is a re-creation of what has been carved away below—the positive of the negative, so to speak.

The absence of something expected may create visual tension in a work that successfully engages our attention. Conceptual artist Sol LeWitt attempted to challenge viewers mentally rather than engage them emotionally in his *Progression from Two Corners* (Fig. 4.15). Not only is a void created between the two converging masses; in addition, each of the cubes that create the larger forms also contains more negative than positive areas. The two intersecting forms are therefore themselves only partially complete, luring us to make the mental leap of perceiving them as airy volumes. A quotation from LeWitt's seminal piece, "Paragraphs on Conceptual Art," illustrates his thinking:

Space can be thought of as the cubic area occupied by a three-dimensional volume. Any volume would occupy space. It is air and cannot be seen. It is the interval between things that can be measured. The intervals and measurements can be important to a work of art. If certain distances are important they will be made obvious in the piece. If space is relatively unimportant it can be regularized and made

4.16 The Great Pyramids at Giza, Egypt. After 2700 BC. © Simon Harrus/Robert Harding Picture Library.

equal (things placed equal distances apart) to mitigate any interest in interval. Regular space might also become a metric time element, a kind of regular beat or pulse. When the interval is kept regular whatever is irregular gains more importance.²

STATIC AND DYNAMIC FORMS

Certain works have a stability of form that can be called **static**, in the sense of appearing stationary, nonmoving. One of the most static forms is the pyramid (**Fig. 4.16**). Because the base is so much broader than the top, no inner force could conceivably cause the form to move or fall over. But although these silent, permanent forms seem grounded in eternity, to stand at the base and gaze up to the summit and the vastness of the sky beyond also inspires awareness of another aspect of reality: infinity.

Like pyramids, architecture with straight walls and ground-hugging proportions gives a sense of visual stability. Although many static forms are straight-sided geometric solids, some have curving edges and may even represent living belings. The energy of life is obvious in *Guaea worsniping* (Fig. 4.17), and yet the figure does not appear to be in motion. Rather than presenting a stop-action image of a moving person, the sculptor of this ancient piece gave us a still image of a still figure. Feet, hands, and shoulders are at the same position on both sides. Nothing suggests physical movement.

4.17 Gudea Worshiping. Telloh. c. 2100 Bc. Dolerite, height approximately 42" (107 cm). Louvre, Paris. Scala/Art Resource, New York.

² Sol LeWitt, "Paragraphs on Conceptual Art," *Artforum* 5, no. 10 (1967). Available at www.ic. sunysb.edu/Stu/kswenson/lewitt.htm; accessed September 2005.

4.18 Victor Horta. Door handle in the Hotel Solvay, Brussels. 1895-1900. The Museum of Modern Art, New York.

By contrast, **dynamic** forms are those characterized by motion and change, or energy that will lead to motion and change. Victor Horta's door handle (**Fig. 4.18**) is a highly dynamic form, for it appears to be in a state of constant motion. Although made of metal, it has the flowing quality of a plant form, as do many similar Art Nouveau pieces from the late nineteenth to early twentieth century.

Even buildings can be shaped into dynamic forms, as was architect John Lautner's *Arango House* (Fig. 4.19) overlooking Acapulco Bay. The walls, moat, and massive concrete roof of this house curve with such apparent ease that the structure seems to have the energy to continue the established flowing visual motion.

Or compare Michelangelo's *David* (Fig. 4.20) with *Gudea Worshiping* (Fig. 4.17). Whereas the latter seems to be fixed in an attitude of worshipful concentration, David's posture as he watches Goliath approach bespeaks a reserve of energy as if a coiled snake is ready to strike. Although he is moving only slowly, if at all, nothing in his body is passive or at rest. The two sides of his body are asymmetrical, suggesting a readiness to spring into action, foreshadowed by the swelling tension in the sinews of his anchored foot, clenching lower hand, and neck. The dynamism of this form is understated, but a perceptive observer can read tremendous power waiting within it.

4.19 John Lautner. *Arango House*, Acapulco. 1973. Photographer: Alan Weintraub/Arcaid.

4.20 Michelangelo. *David.*1501-1504. Marble, height approximately 18' (5.49 m) including base. Galleria dell'Accademia, Florence. © Michael S. Yamashita/Corbis.

4.21 John DeAndrea. *Joan.* 1992. Life-size, polyvinyl resin polychromed in oil. Courtesy ACA Galleries, New York.

REPRESENTATIONAL, ABSTRACT, AND NONOBJECTIVE FORMS

A final range of effects that can be created using form involves degrees of likeness to known objects. Distinctions among these kinds of forms are not easily made, but the terms and ideas are useful, for they indicate different attitudes toward form on the part of the artist.

Representational or **figurative** forms are those that refer directly to an object from the three-dimensional world of our experience. The highest degree of representationalism is sometimes called **superrealism**. An example of this attitude toward form is John DeAndrea's nude *Joan* (**Fig. 4.21**), a body casting that faithfully reproduces the contours of a specific human body in all its naked imperfection. The artist is uncompromising in the details.

Although we may not be aware of it, we are more accustomed to forms that are slightly **idealized**. That is, contours and proportions are directed toward an ideal of what the object would look like in its imagined or inner perfection

rather than its less-than-perfect superficial appearance. In sculpture, the ideal may exist in the mind of the artist, who may extract qualities from a variety of human models to serve his or her vision rather than try to represent a single model realistically. Michelangelo's *David*, for instance, is clearly a representation of a young man. The master has chosen not to reproduce every flawed detail of a living human body, however. David—known biblically as the chosen of God—is presented as an idealized conception of the perfect body, strong, lithe, and without blemish. He is seen as a giant among men—the statue alone is a colossal 13.5 feet (4 m) high and stands on a five-foot (1.5 m) pedestal. The sculpture is still regarded as a classic representation of male beauty almost five hundred years after its creation.

In some cases, the ideal in the artist's mind is an emotion rather than a specific form. Here, realism in outer form is subordinated to representation of what that emotion would look like if projected to its fullest through a being with whom the viewer can identify. In Bernini's *The Ecstasy of Saint Theresa* (Fig. 1.35), the saint's limp posture, closed eyes, thrown-back head, and open mouth constitute an outward exaggeration of form to suggest an extreme inner spiritual experience.

Another variation from reality occurs in representational works that are highly **stylized**. In these pieces, the form has been simplified and altered to conform to a particular historical style or to stress a particular design characteristic. In *Gudea Worshiping* (Fig. 4.17), the figure is recognizable as a man, but his contours have been reduced to the simplified outline of a standing, draped figure, and his robe falls straight to his feet with only a few stylized folds. In a more realistic piece, the draping would be detailed, following the more complex forms of the human body. In addition to simplifying contours to create a strong design, the Mesopotamian sculptor used the stylistic conventions of the times: a direct frontal pose, large eyes, and thick eyebrows. Despite all these stylizations, this ancient piece conveys the impression of a unique and genuine personality as well as elegance in design.

At the next remove from superficial reality are **abstract** works—those in which the artist has reduced a real form to its bare essence. In the horse effigy baton shown in **Figure 4.22**, a Lakota artist used only a head and one leg to suggest an entire horse. Constantin Brancusi's *White Seal ("Miracle")* (**Fig. 4.23**) has no eyes, mouth, or flippers, but Brancusi's genius in abstracting the essential qualities of "sealness" leaves no doubt as to what the creature is. These qualities seem to include its streamlined contours and a form that is ideal for gliding underwater but appears bulky on land. Despite its awkward manner of ground travel, the seal still has surprising facility at balancing on small surfaces, so this marvelous seal form poised on a tiny stone appears both wonderful and believable. As we noted in Chapter 2, the more the artist leaves out, the more the viewer must bring to the work in order to understand and appreciate it.

Works that do not refer at all to any object from our three-dimensional world are called **nonobjective** or **nonrepresentational**. This approach to three-dimensional art can be traced to the Constructivist movement that developed in Russia between 1914 and 1922. In this new approach to art, Constructivists set aside the old attempts to imitate nature through descriptions of human fig-

4.22 Dennis Fox, Jr. *Horse Dance Stick.* 1996. Wood, feathers, horsehair, leather, beads, brass, wire, angora, and felt marker. © Canadian Museum of Civilization, no. V-H-23, photo Harry Foster, S98-004.

Nonobjective forms are sometimes unfamiliar shapes growing out of the artist's inner imaginings; sometimes they are elaborations of geometric shapes, suggesting the orderly mathematical structures that form the building blocks of life. Whereas viewers judge representational works partly on the basis of how well they re-create the sense of a known object, nonobjective forms may invite viewers to move beyond mental associations and experience directly the impact of form, line, texture, value, color, space, or time.

4.23 Constantin Brancusi. White Seal ("Miracle"). 1924–1936. Marble, height 43". Base of two stone sections, height 21⁵/8". Solomon R. Guggenheim Museum, New York. © The Solomon R. Guggenheim Foundation, New York. (56.1450).

4.24 Antoine Pevsner. Spatial Construction in the 3rd and 4th. 1961. Bronze. 103 × 52 × 77 cm. Musee National d'Art Moderne, Centre Georges Pompidou, Paris, France.

5 SPACE

PACE IS A VERY REAL AND IMPORTANT ELEMENT of three-dimensional design, but it is difficult to conceptualize. Space is the three-dimensional field with which the artist works. It may include unfilled as well as filled areas, or what are referred to respectively as negative and positive areas. The positive space is the part of the work that physically occupies space; the negative space is all unfilled space that is activated by the piece. Although a good artist works with both kinds of space at the same time, viewers' experiences of negative space are so subtle and subjective that it is hard to define and measure. The use of two-dimensional photographs further limits understanding of spatial concepts, for these subtle experiences change as the viewer moves.

Within these limitations, we focus in this chapter on some of the ways in which artists work with space. These include delineated shapes in space, activated surrounding space, confined space, spatial relationships, scale, and illusionary space.

DELINEATED FORMS IN SPACE

In addition to occupying space physically, positive forms may carve negative forms out of the unfilled spaces within and around them. In David Smith's *Cubi XII* (Fig. 5.1), the angle from which the photograph was taken reveals triangular forms framed within the sculpture. We can also discern a series of partial forms where the surrounding space meets the sharp edges of the piece. For instance, at the edges of the two small balanced cubes in the upper right, unfilled space seems to thrust inward at 90-degree angles as a sort of counterforce to the triangular spaces pushing outward from within. Below the broader but thinner block jutting out farthest to the right is a notched form in space. If you follow the edges around the piece, you will find dynamic forms meeting these edges in space. In a sense, these strong forms created in unfilled space help to maintain the tense visual balance of the blocks, giving cohesiveness to the precariously balanced structure.

Delineated spaces, those forms carved out of space by positive forms, may serve a variety of aesthetic functions in a work. In Naum Gabo's *Linear Construction* (Fig. 3.19), for example, the elegant delineated space in the center is the focal point of the work. In his view of such sculpture, "space is not a part of the universal space surrounding the object; it is a material by itself, a structural part of the object—so much so that it has the faculty of conveying a volume as does any other rigid material."

Often, delineated spaces are visually interesting or appealing in themselves, whether the viewer is conscious of "seeing" them or not. To make these unfilled forms more visible, three-dimensional works are often photographed against a plain background. In the photograph of the work shown in **Figure 5.1**, the delineated spaces are filled with details of the nearby trees, a situation that can realistically be expected to occur in an outdoor setting. Louise Bourgeois's *Needle* (**Fig. 5.2**), by contrast, is presented against a plain wall, so that both the

5.1 David Smith. *Cubi XII*. 1963. Stainless steel, 9'1⁵/8" × 4'1¹/4" × 2'8¹/4" (278.5 × 125.1 × 81.9 cm). Hirshhorn Museum and Sculpture Garden, Smithsonian Institution. Gift of the Joseph H. Hirshhorn Foundation, 1972. Art © Estate of David Smith/Licensed by VAGA, New York.

5.2 Louise Bourgeois. *Needle* (*Fuseau*). 1992. Steel, flax, mirror, and wood, 109 × 101 × 56". Courtesy Cheim & Read, New York. Photo Jocken Littkemann. Art © Louise Bourgeois/Licensed by VAGA, New York.

 $^{^{\}rm I}$ Naum Gabo, *Of Divers Arts.* Bollingen Series 35, The Mellon Lectures in Fine Art (New York: Pantheon Books, 1962), p. 100.

half-oval space defined by the large curved needle and thread and the shadows falling on the wall behind are clearly presented for our attention. Here the positive outline is almost secondary to the unfilled shape it defines, and the shape is repeated in the oval shadows of the wooden balls.

ACTIVATED SURROUNDING SPACE

Somewhat different from the carving of identifiable forms out of space is the tendency of some works to activate an area larger than their physical confines. This happens when the visual statement made by the piece draws the viewer's attention to a broader area or charges the surrounding atmosphere with a subtle yet active energy. The **spatial presence** of a work is something that can only be sensed; it usually cannot be seen unless it is limited to the contours of the piece. Judgments about the size of a work's presence are quite subjective; they depend not only on the work but also on the awareness and personality of the viewer.

One way of activating surrounding space is to draw the viewer's attention to **eye lines** through space. In Henry Moore's *Madonna and Child* (Fig. 5.3), the mother's gaze fills an area extending far off to her right, while the child's mild gaze projects outward to his left. It is as if they are seeing different areas in time as well as space. Without this treatment of the eyes, the space activated by the sculpture would be considerably smaller.

In Wind Chant (Fig. 2.18), John Matt activated surrounding space by filling it with "music." The open lines of the sculpture invite space to flow through the harplike section in lyrical curves suggested by the curving line in the piece. The presence of Wind Chant may therefore be perceived as a mystical presence—a suggestion of unseen winds playing subtle music beyond human perception. Matt described this aspect of his piece:

The music that I feel when I see [Wind Chant] is like sound in three dimensions. The sound covers a large or small space, depending on where the piece is shown. The image itself is like a scale, a note; it almost reminds me of a harp, a stringed instrument with a sounding board. There is an aura encompassing it, an airiness about it, a very lyrical nature—it suggests the vocabulary we usually associate with music.²

George Rickey's *N Lines Vertical* (Fig. 5.4) activates a large area in yet other ways. First is its use of pointing lines, for their sharp outward thrust directs the viewer's vision infinitely outward; the lines given in the sculpture seem to be only the beginning of implied lines that continue far out into space. A second

² John Matt, interview with coauthors, September 1986.

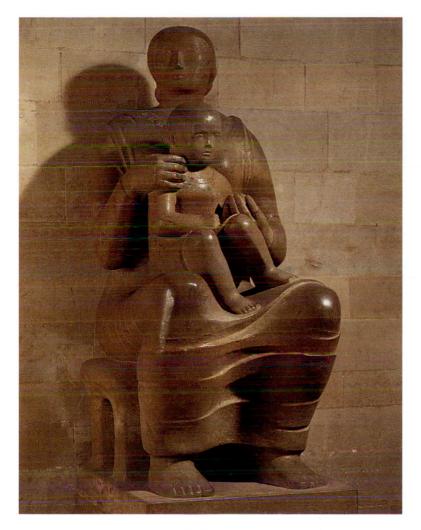

5.3 Henry Moore. Madonna and Child. 1943-1944. Hornton stone, 59" (150 cm) high. Church of Saint Matthew, Northampton, England.© The Henry Moore Foundation. LH226.

reason for the great presence of Rickey's sculpture is the sharp points of the piece. They tend to keep viewers at some distance in healthy respect for the possibility of being pricked.

A third presence-enlarging factor cannot be appreciated in a still photograph: The piece moves with the wind. The rotation of the sharp-pointed lines through space activates an even larger space that seems to belong to the sculpture. Psychologists have found that people tend to do the same thing: They subconsciously establish a certain distance around their bodies as their "personal space." If you have ever intruded on the personal space of someone who is feeling angry or sharp-edged, you will understand the concept of activated space.

The spatial presence of a work is not necessarily a hostile environment, of course. But to the sensitive individual, it may engender a certain respect.

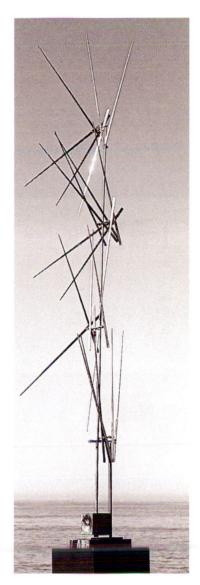

5.4 George Rickey. *N Lines Vertical.* 1967. Kinetic sculpture—stainless steel and lead with marble base. $95 \times 10 \times 29''$ (241.3 \times 25.4 \times 73.7 cm). Art © Estate of George Rickey/Licensed by VAGA, New York.

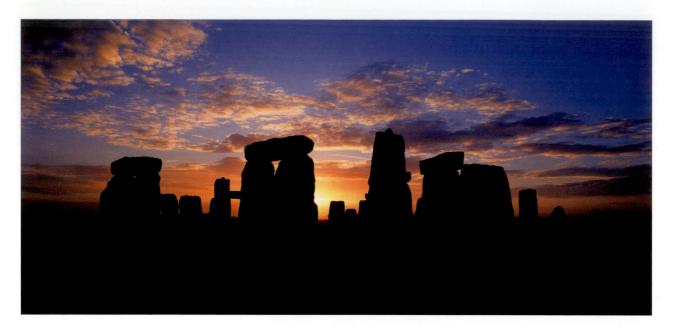

5.5 Stonehenge. c. 2000–1500 BC. Height of stones 13'6" (4.11 m). Salisbury Plain, England. © Wild Country/Corbis.

Stonehenge (Fig. 5.5) has such colossal spatial presence that even from a distance, people are touched and awed by it. Its great size and mysterious appearance against the vastness of bare plain and sky endow it with presence that radiates almost infinitely.

By contrast, some large works are designed to welcome people, enticing them inward rather than creating an outward-expanding spatial presence. **Participatory sculpture** is meant to be touched, climbed on, or swung from by viewers. Public sculpture may weigh many tons, but if its contours are low and rounded, people may treat it as familiar furniture, leaning against it and perching all over it. Some people are drawn to sit on public sculpture even if they have to go to some trouble to do so. The pair eating lunch on Clement Meadmore's *Upstart* (**Fig. 5.6**) had to hoist themselves far above normal chair height to attain their perch, apparently unintimidated by the looming bulk of this large piece.

In the world of virtual reality, the activated space may seem quite large, but it exists only in the monitors recording the viewer's movements and feeding back visual information. The University of North Carolina's Department of Computer Science building was designed with the help of a virtual-reality system (Fig. 5.7). As the building was being designed, people could "walk through" it on a treadmill, view it from all interior angles, and turn down corridors by turning the handlebars of the treadmill. They discovered that the walls were too close together in one area, and the design was easily changed before construction began.

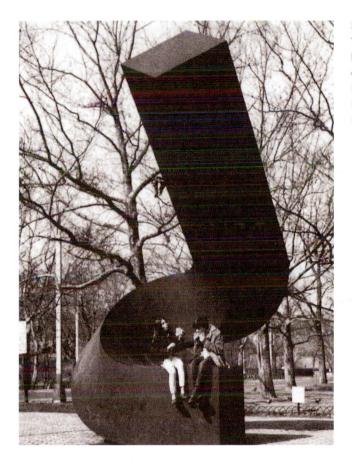

5.6 Clement Meadmore. *Upstart*. 1967. Welded Cor-Ten steel, height 20'6" (6.25 m). Fabricated at Lippincott, Inc., New Haven, Connecticut. Collection Bradley Family Foundation, Milwaukee, Wisconsin.

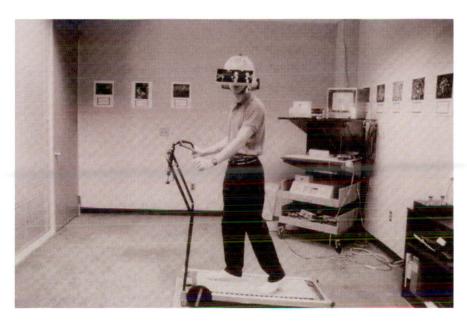

5.7 University of North Carolina, Department of Computer Science. Walk-through treadmill. From Steve Aukslakalnis and David Blatner, *Silicon Mirage*. 1992.

Introduced as an aid to high-tech applications, virtual reality has recently been appropriated by artists as an art form. The three-dimensional illusions created exist in an entirely different environment from any solid works—there is no acid rain to corrode the works, no snow load, no fading of colors, no breakage potential, no problem with gravity.

CONFINED SPACE

Some three-dimensional pieces are developed within clearly defined boundaries. Within these boundaries, the artist controls not only filled areas but also the remaining unfilled areas.

In an installation piece, the artist attempts to incorporate an entire room of a gallery or museum into the aesthetic experience. The characteristics of the existing space must be dealt with in order to create a controlled environment with no elements that distract people from the intended experience. For instance, heating pipes and floor joists overhead may be busy visual distractions from the lines of a work, or they may be used creatively as places from which to hang items. Low ceilings may not allow enough visual room for the upward thrust of some pieces. High ceilings may create a space bigger than the work can control; a false ceiling or other visual barrier may be needed to stop the eye and shrink the space. Noise from adjacent areas may intrude on the mood the artist intends; some artists use sounds as part of an installation to cover background noise and/or to create the desired atmosphere.

In a relief work, the panel from which figures are raised defines the spatial world of the images. In Joseph Cornell's boxes, such as *Suite de la Longitude* (Fig. 5.8), the space with which the artist worked is confined within the dimensions of the glass-fronted box, a space little more than four inches (11 cm) deep.

5.8 Joseph Cornell. Suite de la Longitude. 1955–1957. Painted wood, printed papers, glass, marbles, cork, metal rings, ink wash, and pencil in glass-faced wood box. 13 ¹/₄ × 19 ³/₄ × 4 ³/₈" (33.8 × 50.2 × 11.2 cm). Hirshhorn Museum. Gift of Joseph H. Hirshhorn, 1966 (66.979). Art © The Joseph and Robert Cornell Memorial Foundation/Licensed by VAGA, New York.

Note that Cornell makes reference to further confinements within the box: marbles confined within glasses, like planets confined within their orbits, and orbitlike rings whose freedom of movement is limited by the rod from which they hang. Here the confinement of aesthetic space is a paradox, for we associate the images of globe and planetlike spheres with the vastness of outer space, yet everything is small-scale and contained. Cornell draws us in close by piquing our curiosity with what resembles old scientific writing; it is in French, so viewers with some knowledge of French may be held near to the work even longer as they try to understand the writing.

Instead of standing on the outside looking in as we do with Cornell's work, viewers may find themselves within the confined space of a work. Sometimes the artist's intent is to emphasize the feeling of confinement, either physically or psychologically. Tony Smith's *Smoke* (Fig. 5.9) so monopolizes the space

5.9 Tony Smith. *Smoke.* 1967. Plywood, $24 \times 34 \times 48'$ (7.32 \times 10.37 \times 14.64 m). Photographed at the Corcoran Gallery of Art, Washington, D.C. Courtesy Paula Cooper Gallery, New York.

within the Corcoran Gallery of Art that it practically forces viewers to walk beneath its bulk. Not only does it crowd onlookers; it also seems to be overpowering the delicacy of the gallery itself, pushing outward at its Grecian columns and upward into the space of the second-floor balcony.

How will those who walk through such a work respond? Our experience of being confined within a controlled space is highly subjective. If we find ourselves sharing a space with an object we dislike, the space will feel too small, crowded, since we cannot put enough distance between ourselves and the object. On the other hand, confinement within certain spaces may seem like welcome refuge. A place we love to come home to surrounds us with an intimate environment of our own choosing. Urban plazas are often designed to lure people into the shops opening onto them by suggesting a sense of enclosure, a friendly oasis set off from the disorder of city streets. Toronto's Nathan Phillips Square (Fig. 5.10) is "protected" by the twin towers of its City Hall, rising like cupped hands, and by the viewing platform surrounding the plaza on three sides, providing a band of shelter for those just stepping off the street or exiting from mass transit. The life-filled plaza is so popular that it is booked every day of the year for events ranging from drum-majorette demonstrations to rock concerts. Similarly, the atrium within the Ford Foundation Building (Fig. 5.11) is a restful change from the busy street scene outside. The contrast

5.10 Nathan Phillips Square, Toronto. © Getty Images.

5.11 Kevin Roche, John Dinkeloo & Associates. Interior, Ford Foundation Building, New York. 1967. Photo Ezra Stoller © Esto, Mamaroneck, New York.

in environments as people step down into this parklike space is dramatic—it is highly unlikely anyone would perceive its confinement as unpleasant.

Whereas our focus is directed inward in some spatially confined works, such as Cornell's box (Fig. 5.8), some works of this type invite us to compare the confined space with what surrounds it, to find either contrasts (as in the Ford Foundation atrium) or similarities, as in Eero Saarinen's *TWA Flight Center* (Fig. 5.12). Designed to suggest the excitement of air travel, the building surrounds participants with soaring interior spaces shaped by concrete structures whose winglike appearance is even more evident in the outer form of the building (Fig. 5.13). The interior "confined" space refers us not only to the exterior of the Flight Center but also to airplanes on runways beyond, in an extended comparison of inner and outer space.

5.12 Eero Saarinen. Interior, TWA Flight Center, Kennedy International Airport, New York. 1962. Ezra Stoller © Esto. All rights reserved.

SPATIAL RELATIONSHIPS

Another aspect of space with which the artist works is the spatial relationships between forms, between forms and the setting, and between forms and the viewer.

5.13 Eero Saarinen. Exterior, TWA Flight Center, Kennedy International Airport, New York. 1962. Ezra Stoller © Esto. All rights reserved.

Landscape designers and architects may work together to bring outdoor structures, walkways, and plantings into harmonious relationship with buildings and users of buildings and to bring both landscape design and architecture into spatial harmony with the greater environment. Architects and interior designers control passageways and viewing points by use of corridors, furniture placement, and openings in walls. Japanese gardens such as the one shown in Figure 5.14 lure people to walk along winding paths, pausing at specified intervals to look at tableaux created from natural and manufactured forms. The gardens beckon by calculated placement of stepping stones, visual barriers and openings, and use of visual accents. When such designs are successful, we are not aware of being manipulated. Other gardens, such as the formal garden at Blenheim Palace (Fig. 5.15), allow continual appreciation of the entire panorama. Although the pathways control the way we can walk through the garden, the absence of visual obstructions allows us to gauge at any time where we are in space in relationship to the whole garden as well as to the vista beyond.

A "Snow Show" held in Finland paired architects and artists in developing site-specific works in which the natural materials at hand during winter—ice and snow—were crafted into ephemeral works in two Arctic cities. Anamorphosis's creation, *The Morphic Excess of the Natural/Landscape in*

5.14 Japanese garden. Courtesy House and Garden Guide.9 1968 Conde Nast Publications, Inc.

5.15 Blenheim Palace Park, Oxford, England. 18th century. Garden renovated in 1920s with landscapist Achille Duchene. By kind permission of the Duke of Marlborough.

SPATIAL RELATIONSHIPS | 105

Excess (Figure 5.16), resembled an archaic amphitheater because of its classic tiered form and large scale. Eva Rothschild added a cascade of giant ice crystals to the frozen architecture. Placement of the building-sized construction blocks created an urban environment which emphasized the architectural nature of the piece. Despite its appearance of great longevity it was destined nonetheless to melt by springtime.

In the world of permanent architecture, spatial planning is often influenced by economic and political constraints. The increase in real estate costs in cities has led to construction of taller and taller buildings on small plots of land, sometimes at considerable sacrifice to the quality of life perceived by the person on the street. Zoning requirements about setbacks have sought to ensure "sun rights," but overall planning of spatial relationships among buildings is often lacking. Architectural critic Paul Goldberger has described the kind of thinking necessary to create pleasing spatial relationships within urban settings:

5.16 Anamorphosis and Eva Rothschild. *The Morphic Excess* of the Natural/Landscape in Excess. 2003. From "The Snow Show," Kemi, Finland. Photo Jeffrey Debany, courtesy The Snow Show.

A city, physically, represents a kind of social contract. There must be a common agreement as to the way in which buildings work together, the kinds of uses to which they will be put and the physical form that

they will take. . . . Light, a sense of space, quiet, visual variety, modest scale—we may not be able to quantify the effects of these things, but we can know that we can have no civilized city without them. They are disappearing fast. 3

On a smaller scale, effective installation of three-dimensional works of art requires consideration of their spatial relationships to each other and to their setting. Their placement—whether nearer or farther, to one side or the other, higher or lower—has a direct impact on how well pieces work aesthetically. Museum curators find it more difficult to mount a show of three-dimensional works than of two-dimensional works like paintings, for if one three-dimensional piece is moved, it affects not only the items on either side but also everything within the space. Because three-dimensional works interact with one another and with what is around them, many artists prefer to take on the time-consuming job of arranging their pieces themselves.

When Erwin Hauer displayed his condor sculptures at the Choate School in Connecticut (Fig. 5.17), he was careful to place them in the highest space available rather than under the mezzanine shown in the foreground, for these

5.17 Erwin Hauer. *Project California Condor.* 1978–1983. Plastic laminate, 9 to 10' (2.75 to 3.05 m) wing tip to wing tip. Collection the artist.

⁵ Paul Goldberger, "What Has Architecture to Do with the Quality of Life?" [©] New York Times Co.; reprinted by permission.

high-flying creatures of open spaces would have seemed crowded beneath the low ceiling. The condors are placed in varying relationships to one another and to the ground, each assuming a different pose, creating an impression of the movements of takeoff and landing as a viewer looks from one bird to the next. The space-embracing wings and pointing wing tips of the condors activate the areas around them; a viewer can almost feel the air pressure created by motions of the heavy wings.

As the viewer moves through the space activated by the condors, the visual relationships of form to form and filled to unfilled spaces change constantly. So does the viewer's spatial relationship to the forms. Seeing a sculpture of a condor at a distance is quite different from a close encounter with one of these imposing birds, much less being surrounded by six of them. Life-size, the sculptures have wingspans of up to 10 feet (3.05 m). Some of Hauer's condors (though not those in this exhibit) are set on platforms that revolve very slowly, constantly changing the spatial relationships among the condors and between the viewer and the long wings.

The viewer's spatial relationship to objects within the three-dimensional field may be carefully controlled by the artist. In Hauer's placement of the condors, the inward-turned focus of the birds and their placement to either side of a central corridor tend to compel the viewer to use this corridor as a path through the work.

SCALE

The effective use of space also involves consideration of **scale**—the size of an object in relationship to other objects and to its surroundings. We human beings tend to judge sizes relative to our own size and to the sizes we have learned to associate with the objects in our three-dimensional world. Some works may challenge our notion of our own size and importance within the three-dimensional field, however.

Some representational works are presented in life-size scale. Hauer's condors awe us with their realistically great size, perhaps making us feel smaller than usual because we are not accustomed to such large birds. When works offer realistic representation of humans in life-size scale, we may feel strangely excluded from their spatial field, because they are lifeless and thus ignore us.

A work may be presented in miniature scale, either relative to human scale or to the scale of the object being represented. Miniatures often make us feel like giants. They are so much smaller than what we expect that we swell in relative size. Dollhouses make children feel very large and grown-up, for they can play at controlling the movements of figures within extremely scaled-down domestic settings. They fascinate people of all ages, for great care may have gone into replicating every detail from cradles and kitchen utensils to bird-cages. Charles Matton's *Perec Library #3* (Fig. 5.18) works much the same way, with its intricately detailed miniature books and papers, plus the added intrigue of an appearance of great depth, a spatial illusion created within a shallow box.

5.18 Charles Matton. Perec Library #3. 2004. Mixed media box construction, $36^{1}/4 \times 33^{1}/2 \times 44''$. Photo Forum Gallery, New York.

5.19 Claes Oldenburg and Coosje van Bruggen. Spoonbridge and Cherry. 1988. Stainless steel, and aluminum, painted with polyurethane enamel. $354 \times 618 \times 162''$ (9 \times 15.7 \times 4.1 m). Minneapolis Sculpture Garden, Walker Art Center, Minneapolis.

The largest end of the scale spectrum is **monumental works**. They may be nonobjective works so large in relation to human scale that they dwarf us, such as Stonehenge (**Fig. 5.5**), or larger-than-life representations of familiar objects. In the past, monumental sculptures conveyed the idea of the heroic grandeur of the human spirit. In Michelangelo's *David* (**Fig. 4.20**), a man preparing to slay a giant was himself represented as a 13-foot-tall giant. More recently, other artists have elevated mundane objects from our everyday lives to monumental scale. Claes Oldenburg and Coosje van Bruggen's *Spoonbridge and Cherry* (**Fig. 5.19**), installed at Walker Art Center in Minneapolis, is so large that the stem of the cherry alone is 12 feet high. People who are tempted to climb on the "bridge" (despite a sign requesting them not to) take on the size of ants walking on a real spoon. It is possible to read into this unexpected use of scale a political statement about the materialism of our times. But in this case, its intent is more playful than political, and water sprays from the cherry stem as a fountaln.

SPATIAL ILLUSIONS

We are so accustomed to dealing with space in our three-dimensional world that we have learned to make certain assumptions about the spatial implications of what we see. For instance, if several identical objects are presented at varying distances from us, we see them as being different sizes but automatically override that visual impression with the mental assumption that they are

SPATIAL ILLUSIONS | 109

probably all the same size. Artists can use these assumptions to advantage in situations that call for fooling the viewer about the size or relative distance of objects.

In Japanese gardens such as the one shown in **Figure 5.14**, certain artistic conventions create the illusion of nature's peaceful spaciousness within what is actually a small space. This technique of spatial illusion was developed in response to Japan's dense population occupying a limited amount of land, most of which is mountainous and unsuitable for building. Within the walls of the small garden, visitors can experience a world of a different scale, in which rocks become mountains and areas of sand or water become the ocean. This reduction of scale is not merely symbolic. Many illusionary devices are used to make the space appear larger than it is. For example, trees with relatively few leaves, such as white birches, are planted close to a house; viewing the garden through their open branches helps to push it back in space. Trees, screens, or boulders can obscure parts of the garden from immediate view, also creating an illusion of depth, and stepping stones of varied sizes wind around these barriers to lead to new vistas, making paths appear longer and wider.

Color may be used to create contrasts that increase the appearance of three-dimensionality. Della Robbia's polychromed relief *Madonna and Child* (Fig. 5.20) is painted in bright contrasting hues that help the viewer's eye to separate the various images spatially, even though they exist in a relatively shallow three-dimensional area. The relief modeling of the white lilies and arch come forward visually by value (light/dark) contrast with the blue sky, which thus seems to recede into deep space. Within the area framed by the arch, the child is brought forward toward the viewer by the light value of his skin, in contrast with the darker surrounding colors of garments and starry sky.

The art of stage design makes considerable use of spatial illusion, for the designer must often use the small space of the stage to create the impression of a much larger area. One illusionary device commonly used in stage design is **forced perspective**—the exaggeration of **linear perspective**, the apparent converging of parallel lines toward the horizon. In David Hockney's stage set for Act II of Mozart's *The Magic Flute* (**Fig. 5.21**), the columns and staircase sides appear to recede into a far deeper space than the shallow space of the stage would permit. At this point in the opera, the hero cannot speak to the heroine because he is undergoing initiation rites. She doesn't know this and instead thinks he is indifferent. "I feel as if it is a wound to my soul," she cries. Hockney's setting emphasizes her grief, as if the freedom of the open sky is far away and she is in the depths of despair. Space is not just a matter of visual tricks in set design; it can be used to present metaphors for the content of the play.

Hockney did not use another painterly device to exaggerate the illusion of spatial depth: **atmospheric perspective**, where areas represented as being closer to the viewers are painted with sharper details, value contrasts, and color intensity than areas intended to appear farther away through atmospheric haze. Instead of capitalizing on this natural optical phenomenon, he painted the columns and sky in uniform colors, making them appear slightly surrealistic, as if the drama were the stuff of dreams.

5.20 Luca della Robbia. Madonna and Child. c. 1445–1460. Glazed terracotta, diameter 180 m. Orsanmichele, Florence. © Scala/ Art Resource, New York.

In many works, the artist's use of space is thus a subtle vehicle for the content of the piece. Ideas or emotions may be expressed not only by creating metaphorical spatial illusions but also by developing delineated shapes in space, drawing attention to the interaction between forms and the surrounding area or to spatial relationships among forms, confining a form—or the viewer—within a defined space, or altering the scale of the familiar.

5.21 David Hockney. *A Great Hall.* 1977. Model from Glyndebourne Festival production of Mozart's *The Magic Flute,* Act II. Photographs on cardboard, tissue, and wire; 16 × 21 × 12". © David Hockney. Photo © Guy Gravett Picture Index.

6 LINE

E TEND TO IDENTIFY LINE as a stroke on a twodimensional page, yet line exists also in our three-dimensional world. Branches, grasses, late-afternoon shadows, icicles, telephone poles, cables, fences, waterways, and jet trails all appear as lines. In general, a **line** is an area whose length is considerably greater than its width.

In three-dimensional art, whole works may consist of lines. Lines also may appear within forms or even implied in space. Depending on their character, lines can steer our attention in a particular direction or perhaps help to convey the emotional effect the artist intended. To a certain extent, these experiences are subjective. The degree to which an area is seen as a line depends on the viewer's distance and awareness, and the emotional qualities ascribed to different kinds of lines may not affect everybody in exactly the same way. Nevertheless, line can be a powerful and direct tool in the hands of the artist.

6.1 Gardener's secateurs. Japan. Photo Yasuhiro Ishimoto.

LINEAR WORKS

Many everyday objects have a strong **linear** quality. In the Japanese gardener's scissors shown in **Figure 6.1**, the gracefully symmetrical handles appear to be a single line turning back into itself, carrying the eye through its flowing curves. The design is actually quite functional, for the shears can be used equally well by right- or left-handed people, and it concentrates the force of the hand-squeeze precisely where it is needed for nipping off tough plant stems.

Bare trees appear as series of lines in a landscape. Isolated wooden boards or branches often have a linear effect, as do many objects made from lumber and branches. In the Thonet rocker (Fig. 6.2), wood has been bent into the vinelike curves of Art Nouveau lines. Arms, legs, and frame grow outward as if

6.2 Gebrüder Thonet, company design. Rocking chair. c. 1860. Beechwood, cane, 37 3/8" high, 22 3/4" wide, 42 1/2" deep; seat height 17 1/4". Manufacturer: Gebrüder Thonet, Vienna, Austria. Photo courtesy of Falcon Industries.

they were wild plants continually seeking spots to cling to. The lines even terminate in vinelike tendrils curling back on themselves.

In *Salicylic* (Fig. 6.3), Ron Lambert created lines by making molds of willow branches and using them to create casts from a mixture of crushed aspirin, glue, and steel wire. He wanted the willowlike lines to be sufficiently supple to sway slightly without cracking. He explains his choice of materials:

For centuries people knew that willow bark decreased pain, and in Victorian times the willow was a symbol for melancholia due to its drooping limbs and fragility during storms. I wanted the viewer to be at first attracted to the form and display, and after the information provided in the materials set in, I wanted the viewer to be somewhat repulsed by the futility of the gesture of putting aspirin back into the willow. I am interested in a push-pull between aesthetics and subversive content. The castings seem frail and move slightly when one walks by, giving a sense of their impermanence, which reminded me of the sense of our own impermanence despite the best efforts of science and medicine.

The white willowlike lines are almost invisible when installed against a white wall. More noticeable are the lines formed by the shadows against the wall. As the "branches" sway, the shadows and thus the relationships between and among the lines change; the same occurs when the viewer moves. When the

¹ Ron Lambert, personal communication, December 8, 2004.

6.3 Ron Lambert. Salicylic.
2003. Willow tree branches cast in aspirin with glue and steel wire. Variable sizes.

6.4 Jesús-Rafael Soto. *Cubo Virtual.* 1988. Nylon with acrylic, $12 \times 4 \times 4$ " (255 \times 208 \times 208 cm).

piece is installed against a dark wall, the white lines become dominant and the shadows less visible.

Fiber art has a naturally linear quality, since it is composed of threadlike materials assembled by a process such as weaving. For *Cubo Virtual* (Fig. 6.4), Jesús-Rafael Soto suspended nylon threads lengthwise, like the warp of a weaving without the crosswise woof. He also painted them to create the illusion of a three-dimensional cube floating in the air. Notice that where slight gaps occur between the vertical threads, the unfilled spaces become negative lines of varying width. As you move around the piece, or as it is stirred by a slight breeze, these spaces change to give a continually varying reading of the work.

Three-dimensional pieces made from linear materials like wire often retain a strongly linear quality. Alexander Calder's *The Brass Family* (Fig. 6.5) uses line almost as a two-dimensional drawing does—as outlines wherein we obligingly fill in full-bodied three-dimensional figures with our imagination.

The linear nature of the human figure seen from a distance is often called into play by choreographers, who turn dancers into moving linear sculptures. In *Ciona* by Pilobolus Dance Theater (**Fig. 6.6**), the organic lines suggested by the dancers' variously joined bodies are accentuated by high-contrast lighting. Pilobolus, named for a kind of fungus, has pioneered in innovative ways of combining muscular human forms into a limitless repertoire of linear group compositions.

6.5 Alexander Calder. The Brass Family. 1927. Brass wire and painted wood, height 66 3/8" (168.6 cm), width 40" (101.6 cm), depth 8" (20.3 cm). Collection Whitney Museum of American Art, New York. Gift of the artist.

6.6 Pilobolus Dance Theater. *Ciona.* Courtesy of Pilobolus Dance Theater.

6.7 Alberto Giacometti. *Tall Figure*. 1947. Bronze. 79 \(^1/4 \times 8 \angle 8 \angle 8 \times 16 \angle 5 \angle a'' \) (201.2 \times 21.1 \times 42.2 cm). Hirshhorn Museum and Sculpture Garden, Smithsonian Institution. Gift of Joseph H. Hirshhorn, 1966.

Sculptor Alberto Giacometti elongated the human body into a single thin line in *Tall Figure* (**Fig. 6.7**). From any distance and in any light, this figure's proportions—80 inches (203.2 cm) in height contrasted to only 5 inches (12.7 cm) at its greatest width—will appear to be a line isolated in space. Indeed, the sculpture affects us with a poignant sense of loneliness—of unhappy withdrawal from the other denizens of this planet; the lonely figure even seems to be drawing away vertically from the horizontal surface of the planet itself.

Our distance from certain works plays a big part in whether we perceive them as linear. Seen from the ground, a street appears as a wide slab; from the air, we can see its length in relationship to its width and thus recognize its linear quality. From a distance, Eero Saarinen's *Jefferson National Expansion Memorial* (Fig. 6.8) in Saint Louis thrusts a line high into the sky. But seen from its base, it is a massive form, an arch 630 feet (192.15 m) high with legs broad enough to permit carrying forty people at a time in an elevator up to the observation room at the top. Robert Smithson's *Spiral Jetty* (Fig. 6.9) does not reveal its spiraling line until the viewer is at sufficient distance to get the sort of perspective shown in the photograph. Many such earthworks—large-scale, three-dimensional projects involving physical alterations of the earth's surface for aesthetic purposes—are designed to create a monumental line across the landscape.

6.8 Eero Saarinen. Jefferson National Expansion Memorial (Gateway Arch), Saint Louis, Missouri. 1966. © David Muench/Corbis.

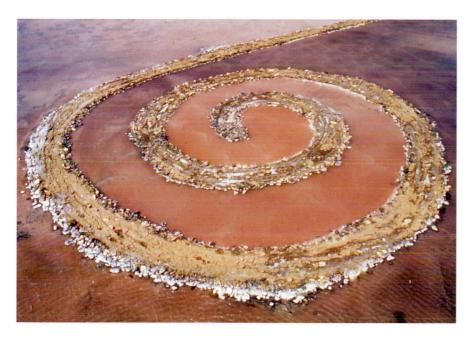

6.9 Robert Smithson. *Spiral Jetty.* 1970. Black rock, salt crystals, earth, red water (algae); coil 1,500′ (477 m) long, approximately 15′ (4.6 m) wide. Great Salt Lake, Utah. Photo Gianfranco Gorgoni. Courtesy James Cohan Gallery, New York. Collection: DIA Center for the Arts, New York. © Estate of Robert Smithson/Licensed by VAGA, New York.

LINES WITHIN FORMS

In addition to being used in primarily linear works, lines also commonly appear within forms. Sometimes lines are simply applied to the surface. Ceramics may have linear details built up with clay slip or incised into the surface. Jean Dubuffet applied black lines across an artificial white-painted landscape to create his 600-square-meter installation *Enamel Garden* (Fig. 6.10). The lines delineate the contours and also elaborate the flat-faced forms, creating a surreal interactive environment. Both children and adults find it an inviting place to play.

In some cases, the lines naturally appearing in the material are revealed and used aesthetically. The grain of wood often adds linear patterns to a work; stone can have similar markings. In sculpting *Adolescence* (Fig. 6.11), Etienne Hajdu used the fissures within the marble to suggest growth and change. The dark lines almost suggest an X-ray view of the human circulatory system carrying the hormones that activate the changes of puberty. The organic quality of these lines presents a lively contrast to the more formally controlled outer contours of the figure.

Lines are often created by **edges**—by the lines along which two planes or pieces of material meet—as well as by the distinction between the outer contours, or **outlines**, of a piece and its surroundings. When people say a piece has "nice lines," they are usually talking about its edges. We can see edges as lines

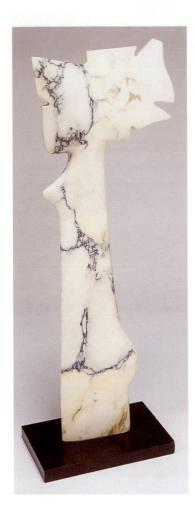

6.11 Etienne Hajdu. Adolescence. 1957. Marble, $35^{1}/2 \times 11^{7}/8 \times 2^{1}/4^{\prime\prime}$ (90 \times 30 \times 6 cm). Hirshhorn Museum and Sculpture Garden, Smithsonian Institution. Gift of Joseph H. Hirshhorn, 1966 (66.2314).

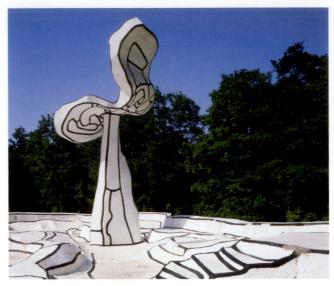

6.10 Jean Dubuffet. *Enamel Garden*. 1974. © Nicolas Sepieha/Art Resource, New York.

because of differences in values—in relative lightness and darkness. In carved sculptures, deep undercuts create shadows that define the edges bordering them. Tara Donovan created strong lines in her installation piece *Transplanted* (Fig. 6.12) by means of the value contrasts occurring as light and shadow strike the black pieces of torn tar paper. The surfaces appear much lighter; their edges create dark linear shadows that transform the mundane industrial material into a vast organic landscape reminiscent of geological layers of thin rock slabs.

IMPLIED AND DIRECTIONAL LINES

Certain lines are not physically present in a work but can nevertheless be subtly perceived. These **implied lines** may appear as eye lines between figures or between a figure and something at which it is gazing. In the ancient bronze *Thorn Puller* (Fig. 6.13), we can perceive a strong eye line between the boy's eyes and the bottom of his foot where the offending thorn must be.

We may also perceive implied lines as continuations or completions of lines given in a work. The sculptural group *Ugolino and His Sons* (Fig. 6.14) contains a very dramatic eye line from the largest son to his father. But the entire composition is built upon a series of lines formed by arms and legs that tend to flow together into larger implied lines. For instance, the forward arm of the largest son leads the viewer's eye up to the father's knee and back across the father's other thigh and down through the son's neck. Alternate visual paths might be traced from the largest son's arm up through the father's knee to the elbow resting on it, up the forearm to the head, or up the upper arm, around the shoulders, and down the opposite arm to the outer leg of the son on the right and thence down into the arm of the smallest child at the bottom, which leads the eye

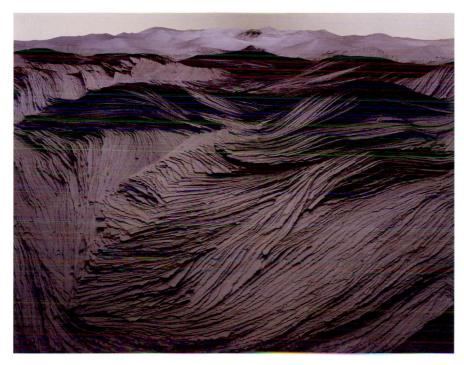

6.12 Tara Donovan. *Transplanted*. 2001. Ripped and stacked tar paper, installation 2'8" (H) \times 33'8 $^{1}/_{4}$ " (W) \times 24'6 $^{1}/_{2}$ " (D). Installation Ace Gallery, New York. Courtesy of Ace Gallery.

6.13 Thorn Puller (Spinario). Bronze, height 28 3/4" (73 cm). Capitoline Museum, Rome. Photo Timothy McCarthy/Art Resource, New York.

6.14 Jean-Baptiste Carpeaux.

Ugolino and His Sons. After a
model completed in Rome
1860–1861. Marble, 6'5" (1.95 m)
high. The Metropolitan Museum of
Art, New York. Purchase, The
Josephine Bay Paul and C. Michael
Paul Foundation Inc. and the
Charles Ulrick and Josephine Bay
Foundation Inc. gifts, 1967.

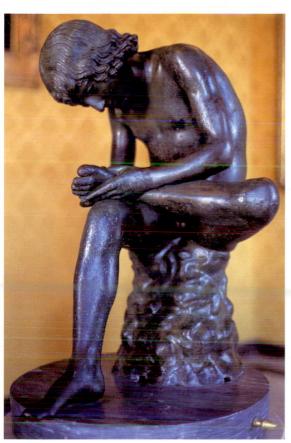

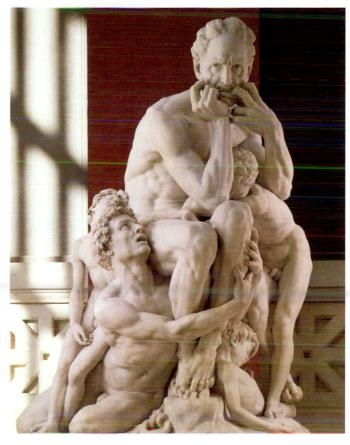

IMPLIED AND DIRECTIONAL LINES | 119

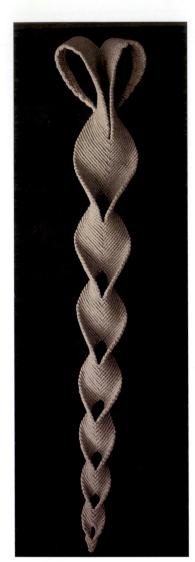

6.15 Joan Michaels Paque. Moebius Extension. 1977. Knotted and woven synthetic fiber, approximately 8' (2.44 m) long. Collection Dr. and Mrs. Robert Monk, Waukesha, Wisconsin.

6.16 Jonathan Borofsky. Man Walking to the Sky. 1992. Fiberglass, aluminum, painted steel, 73' 9" high. Installed in front of the Fridericianum Museum, Kassel, Germany. Collection City of Kassel. Photo Laurent Lecat, courtesy Paula Cooper Gallery, New York. back up into the center. Seen this way, the group becomes a swirl of implied lines leading from one anguished figure to another and tying them all together visually.

Lines may have a strong **directional** quality—the characteristic of pointing the viewer's eye in a certain direction, sometimes creating implied lines thereby. Joan Michaels Paque's *Moebius Extension* (**Fig. 6.15**) draws together the edges of the woven forms as pointers, each leading the eye to the next point above. If you follow these directions from bottom to top, a perceptual line is created up the center of the piece that strengthens and completes the faint line that repeatedly appears where the weaving patterns join along the midline and then disappears into the shadows.

In Chapter 5, we noted that space may be activated by implied lines that direct the eye into unfilled space surrounding a three-dimensional piece. The lines in *N Lines Vertical* (Fig. 5.4), for instance, point the eye into the distance beyond. This effect is even more obvious in Jonathan Borofsky's *Man Walking to the Sky* (Fig. 6.16). Not only is the diagonal pole itself a pointing line, but the man walking on it also directs our eye along the line and toward its projected

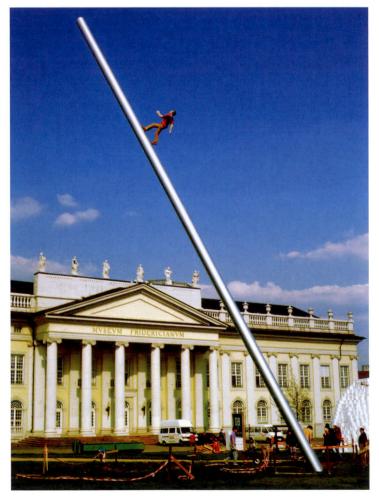

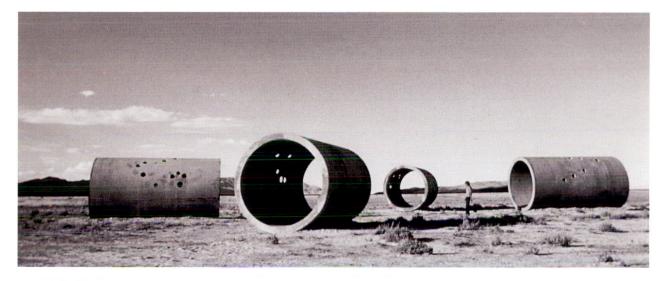

6.17 Nancy Holt. Sun Tunnels. 1973–1976. The Great Basin Desert, Utah. Concrete pipes, 22 tons each; tunnel lengths 18′ (5.49 m), height 9′2¹/2″ (2.8 m), total length 86′ (26.23 m). The tunnels are aligned with the sun on the horizon (sunrises and sunsets) on the solstices. Photo John Weber Gallery, New York. Art © Nancy Holt/Licensed by VAGA, New York.

but invisible destination in the sky. He strides so swiftly and earnestly that we read quickly to the end of the pole and wonder, What will happen when he gets to the end of it? Why and how is he walking on a steeply diagonal pole? What conclusion might we draw here about the direction, meaning, and endpoint of our own fast lives? Or, if we think about the mechanics of the piece, we can see that even a line may have great weight. We must inevitably wonder how the piece is anchored and counterbalanced to support the weight of the pole over time.

Awareness of directional and implied lines makes it possible to see Nancy Holt's *Sun Tunnels* (Fig. 6.17) as being "about" lines. For one thing, the sun's rays pierce the holes in the concrete pipes, forming lines of sunlight into the pipes themselves. If you were to look through one of the pipes, you would see a defined line into the surrounding landscape—directed "tunnel vision." Furthermore, the pipes are placed to honor the sunrises and sunsets during the solstices in this Lincoln, Utah, setting. At dawn and dusk on the days marking the height of winter and summer, the sun itself beams directly into one of the tunnels, creating a line of pure light.

QUALITIES OF LINES

Individual artists' use of line is highly varied, as is the background each viewer brings to perception of a work of art. Nevertheless, art does touch us emotionally in somewhat predictable ways. Linear elements in works tend to evoke certain responses, depending on the characteristics of the lines.

Our eye tends to move very quickly over simple, smooth lines like those of *Man Walking to the Sky,* whereas we scan, or **read**, complex lines or rough edges more slowly. These natural tendencies lead us to think of lines as being "quick" or "slow," no matter with what speed they were actually made. Michael Heizer's earthwork *Isolated Mass/Circumflex* (**Fig. 6.18**) appears from a distance to be such a smooth and simple line that it seems created by a quick gesture. This impression belies the work involved in its creation, for it is actually a trench dug across 120 feet (36.6 m) of Nevada desert.

Rough or jagged lines or lines that go in many different directions convey a feeling of emotional upheaval. The ragged lines of the marble fissures and head area in Hajdu's *Adolescence* (Fig. 6.11) suggest an emotional turbulence that contrasts with the smooth outlines of the torso.

Curving lines remind us of flowing motion. Single lines that curve, perhaps flaring and thinning as they round corners, may evoke a poignant sense of beauty, even in so mundane an object as the Japanese gardener's shears (Fig. 6.1), for they tend to mold our awareness itself into a flowing line. No matter how brief the experience, it may be a welcome change from the scattered, frenetic pace of modern life.

6.18 Michael Heizer. *Isolated Mass/Circumflex.* 1968 (deteriorated). #9 of Nine Nevada Depressions. Massacre Dry Creek Lake, Vya, Nevada. Six-ton displacement in playa surface, $120 \times 12 \times 1'$. Commissioned by Robert Scull.

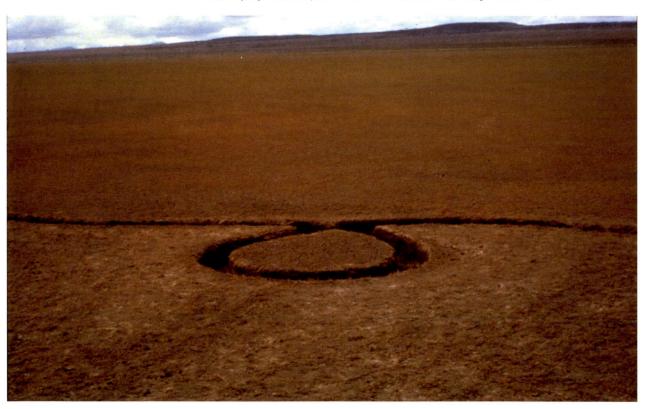

The use of many curving lines, as in Antoni Gaudi's Casa Milá apartment building (Fig. 6.19), may evoke a sense of romance or playfulness. We usually associate living quarters with straight horizontal and vertical lines, so this structure's many curves—in and out, up and down—are a whimsical surprise to the imagination.

Horizontal lines often carry a restful, secure feeling, perhaps through association with the earth's horizon line and our horizontal position when sleeping. The straight horizontal lines that predominate in David Rockefeller's office in the Chase Manhattan Bank (Fig. 6.20) convey an elegant sense of calmness. Even the chairs are squared off and low to the ground, adding to the feeling of stability. The message is one of assurance that this bank is solid, trustworthy, and comfortable with wealth.

Lines that are predominantly vertical do not convey this feeling of stability unless they are anchored in strong horizontal lines. Rather, they suggest defiance of or escape from the earth's gravitational pull. Strong verticals such as the supporting pillars inside a high-ceilinged cathedral are designed to give worshipers a sense of being spiritually uplifted above dense worldly concerns.

6.19 Antoni Gaudi. Casa Milá apartment house, Barcelona. 1905-1907. © Stephanie Colasanti/Corbis.

QUALITIES OF LINES | 123

6.20 CMP Interiors. Office of David Rockefeller. 17th floor, One Chase Manhattan Plaza, New York. 1961. Photo Alexandre Georges/Chase Manhattan Archives, New York.

Diagonal lines invoke feelings of drama or energy, as in Judy Chicago's *Rainbow Pickett* (Fig. 6.21). The pieces are all touching the wall, so there is a connection between floor and wall, yet there is a subliminal question posed: Are they holding up the wall or just leaning on it? This unresolved visual question adds to the tension of the installation. The angular shadows—which change as the viewer moves along the installation—and its use of different colors to increase the apparent length of the longest diagonal also add to its dynamism.

Combining different kinds of lines is akin to composing music for a whole orchestra. If the sounds of different instruments are not blended harmoniously, the result is cacophony. The same can occur in art; indeed, the artist may intentionally produce comparable visual chaos. But in Toshio Odate's *Pride of New England* (Fig. 6.22), differing line qualities are blended into a unified whole that both draws the viewer's attention and issues an invitation to quiet contemplation. Trained as a Japanese *shoji* screen maker, Odate used lines to create three kinds of space-defining screens in this piece: the long section featuring a handsome 18-foot (5.49 m) slab of red oak, a section of vertical slats (barely visible beyond and to the right of the slab in this photograph), and an opaque panel featuring a translucent rice-paper circle with wooden lattice. The slab of oak becomes a directional line leading to the circle panel and the low box set among rounded stones before it; the composition suggests the box is a place for seated meditation. Along the oak slab, the vertical dowels and the negative lines

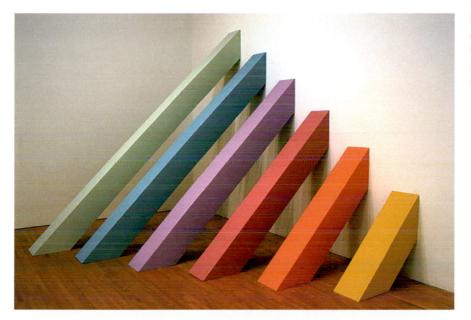

6.21 Judy Chicago. *Rainbow Pickett*. 2004. Large scale sculpture, plywood, canvas and latex paint. $10'6'' \times 9'2''$. Photo Donald Woodman.

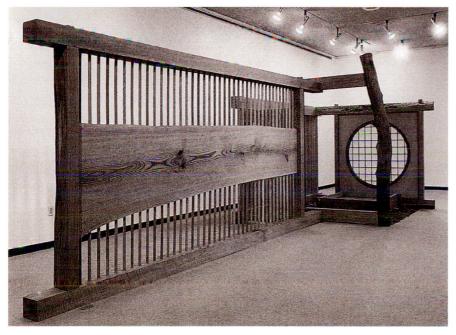

6.22 Toshio Odate. Pride of New England. 1982. Red oak plank, 18' (5.49 m) long, 3'6" (1.07 m) wide.

formed by the spaces between them are small enough to emphasize the horizontal by contrast, rather than fighting with it for dominance. The horizontals and verticals are repeated in the panels and framework at the far end. And the subtle curve of the oak slab is repeated in the circular line around the rice paper, the roundness of the stones, and again in the curve of the natural tree trunk. Lines in nature are rarely perfectly straight, but through balanced use of repetition and contrast, Odate unified the straight lines of manufactured lumber with the curving lines of organic forms.

QUALITIES OF LINES | 125

TEXTURE

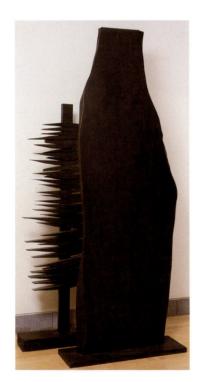

7.1 Louise Nevelson. First Personage. 1956. Wood sculpture, height 94" (2.38 m). Brooklyn Museum. Gift of Mr. and Mrs. Nathan Berliawsky, 57.23A-B.

HE TEXTURE OF A WORK is the surface characteristics we could feel if we touched it—its hardness, softness, bumpiness, smoothness, sharpness, furriness, or whatever. Our interest in these tactile qualities is part of what draws us into exploring a piece. When we cannot or do not touch an object, impressions of what it would feel like are conveyed to us visually. As we will discover, our eye can be fooled about texture. Artists may therefore work with visual texture—the apparent rather than actual texture of a surface.

The textural characteristics of a work may not be the first feature we notice. We tend to scan a three-dimensional object quickly with our eyes, streamlining its contours, and then perhaps moving in closer to see what it is made of and how. We see distant hills as having smoothly rolling outlines; we do not notice the differences in height and form of individual trees that reveal a jagged textural effect when examined more closely. In certain works of art, however, we are not given a chance to ignore the texture. Louise Nevelson's *First Personage* (Fig. 7.1) demands our immediate attention to the contrasting surfaces of the two pieces of wood. Our eye registers at once what the surfaces would feel like if we touched them—the torsolike right side would be relatively soft to the touch, but the "back" side warns us not to put a hand near its sharp points. This strong contrast between the invitation of the soft contours and the KEEP AWAY signals of the back points seems to be the subject of the piece, a visual puzzle for us to explore and ponder.

Almost all works of three-dimensional art have a surface texture that can be felt. Those examined in this chapter tend to make the viewer extremely aware of their textural effects. Although texture cannot be isolated from other elements of design, such as color, form, or line, much attention may be drawn to the natural texture of materials as well as to worked or visual textures that differ from the actual textures of the piece.

NATURAL TEXTURE

Many artists use objects exactly as they come from nature, or make only minimal changes to the surface of their chosen material. In Magdalena Jetelova's *Der Setzungandere Seite* (Fig. 7.2), roughly translated as "the other side," her massive wooden beams are not planed on all sides, with rough areas left as a reminder of the trees from which they came. A tension is created by these huge beams crowding the small room, as if the wood were still growing. This tension holds our attention as our eyes search for answers in the textural wooden forms.

Sometimes natural textures are used not to call attention to their identity but rather to evoke other similar textures. The Hawaiian artisan who created the ritual figure shown in Figure 7.3 conveyed the texture and color of human skin by using feathers, and that of human teeth by using dogs' teeth. The wet, shimmering surface of the human eye is captured with pearl shells. Usually we must be familiar with the texture of both the natural material being used and the texture it is representing to appreciate such pieces fully. But how familiar are we with what the surface of the eye feels like? We dare not touch this sensitive surface; we know its texture more by what it looks like than by how it is perceived through the touch sensors in the fingers.

7.2 Magdalena Jetelova. *Der Setzungandere Seite*. 1987. Wood, c. $385 \times 700 \times 300$ cm. Aachen, Ludwig Forum fur Internationale Kunst. Photo © the artist.

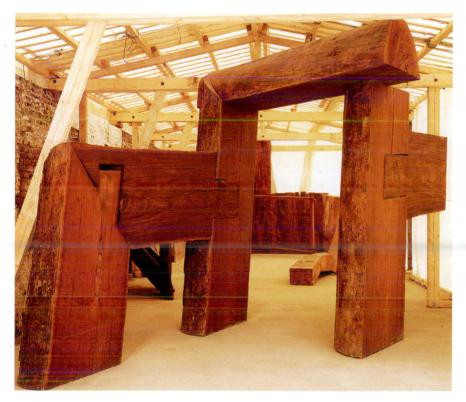

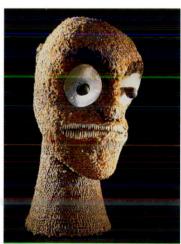

7.3 Image. Feathers, wicker, dog teeth, pearl shell, wood, height 24½" (62 cm). Museum fur Volkerkunde, Vienna. Collected on Captain Cook's third Hawaiian voyage, 1778–1779.

7.4 Sheila Hicks. Ephemera Bundle.
1975. Silk, 20.2 × 20.2 × 7.6 cm.
The Cleveland Museum of Art.
Gift of Mildred Constantine,
92.250.

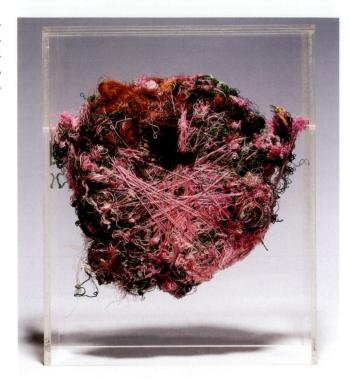

7.5 Robert Smithson. Mirror Displacement (Cayuga Salt Mine Project). 1969. Rock salt and mirrors. 11 × 30 × 360". © Estate of Robert Smithson/Licensed by VAGA, New York. Image courtesy of James Cohan Gallery, New York.

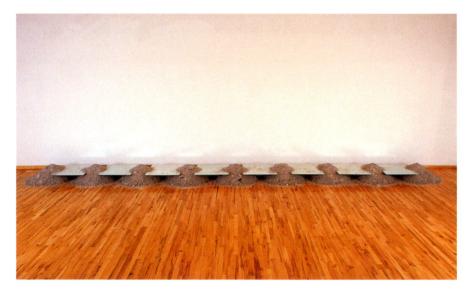

Certain pieces seem to offer a single natural texture for our exploration, yet a subtle form of contrast or variation is often present to engage our awareness. Sheila Hicks's *Ephemera Bundle* (Fig. 7.4) appears at first glance to be a tangle of soft, curly silk yarns. Yet closer inspection reveals continual variations among tautly spun linear strands, loosely spun curly strands, thinly straying single fibers, and even bits of coarsely woven cloth. We even have the impres-

sion of interior texture here—the suggestion that there are layers upon hidden layers of these textures wrapped around each other from the core outward.

Just as Hicks's silk yarns are human-made but used in their "natural" state, artists' textural palette includes an infinite variety of manufactured products, from tar paper to vermicelli noodles. Robert Smithson contrasted the human-made smooth texture and reflective surface of mirrors with the natural texture of unprocessed rock salt in *Mirror Displacement (Cayuga Salt Mine Project)* (Fig. 7.05). This installation piece is the "non-site" museum gallery part of a larger project, in which the same manufactured, geometric objects—the mirrors—were also installed on-site in the amorphous interior of the salt mine, surrounded by its natural textures.

WORKED TEXTURE

The surface of a material may be manipulated, or worked, by the artist to create a great variety of textural effects. Materials may be carved, blasted, polished, ground, hammered, built up, or woven together for a number of different reasons. Perhaps the most obvious reasons are to shape the material to the desired form and to simulate the texture of an actual three-dimensional object. To create a portrait of Georgia O'Keeffe (Fig. 7.6), Marisol used the natural texture of weathered wood and rock to convey the qualities of solidity and strength that we associate with these materials; the head of a stuffed, real antelope

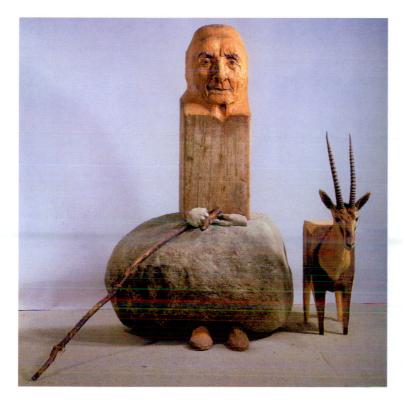

7.6 Marisol. Portrait of Georgia O'Keeffe with Antelope. 1980. Wood, stone, plaster, charcoal, $55 \times 55 \times 42^{1/2}$ ". Courtesy Marlborough Gallery, New York. Art © Marisol/Licensed by VAGA, New York.

emphasizes the message that this grande dame of American painting was very much at home among the creatures and landscape of America's Southwestern desert. Yet to make the portrait more recognizable as Georgia O'Keeffe, Marisol carved a likeness of her wise, discerning face into the wood. The textural lines created by the chipping away of the wood become character lines that further describe her venerable subject.

Chakaia Booker has discovered the textural potential of old tires. She shreds, slices, and interweaves them into sculptures in which the tires speak not only of themselves but also of other themes, such as *It's So Hard to be Green* (Fig. 7.7), in which the tires take on an improbably organic appearance. Booker gave this explanation in a 2003 interview:

When you're working with found materials, each one comes with its own purpose, history, and use. Like a painter having a palette, my palette is the textures of the treads, the fibers from discarded materials, and tires that I use to create varied effects. I've heard that tires can last up to 2,000 years. I'm excited to be using a material that has been a foundation for this country and the world. I've used tires to translate ideas of universal importance into visual works. I am delighted that I was able to bring tires into the art world. I

Rather than emphasizing form, texture sometimes may be used to deny it. From a distance, Ursula von Rydingsvard's *Land Rollers* appears as a series of 14-foot-long cedar logs on the edge of a hill (Fig. 7.8). But as we come closer,

7.7 Chakaia Booker. It's So Hard to Be Green. 2000. Rubber tires and wood, 150 × 252 × 24".
Photo Nelson Tejada. © Chakaia Booker, courtesy Marlborough Gallery.

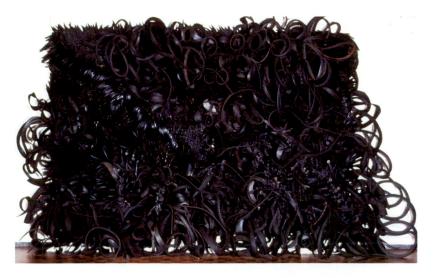

¹ Chakaia Booker, Sculpture, January/February 2003, pp. 31–33.

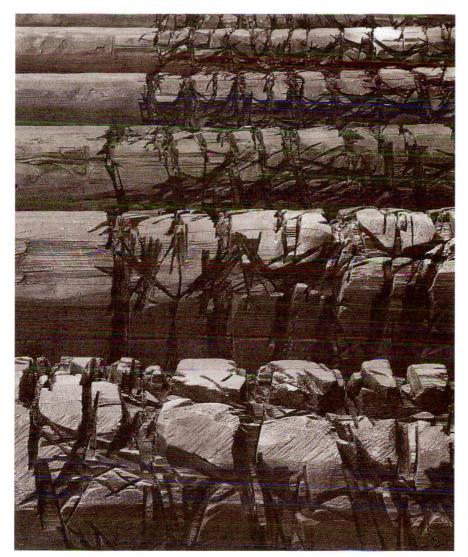

7.8 Ursula von Rydingsvard. Detail of *Land Rollers*. 1992. Cedar, 3'8" × 14'4" × 55'8". Installed at Storm King Art Center, Mountainville, New York. Photo Jerry L. Thompson. Courtesy of the artist and Galerie Lelong.

deep gashes slashed and chiseled into the wood draw our attention away from the whole forms and into their scarified surfaces. They seem worn by time and circumstance—scarred by painful wounds, which they nonetheless withstand, just as von Rydingsvard and her family survived eight years in forced-labor and refugee camps in Germany during and after World War II.

Textures may also be manipulated to provide contrasts, either within a work or between the work and its surroundings. In *Jaguar Woman* (Fig. 7.9), Isabel Case Borgatta works with the contrast between the smoothness of stone when it is sculpted and polished to look like soft facial skin, and the roughness we more commonly associate with stone, here used for the fabric and jaguar. Deep pits give the optical impression of spots; this texture also bestows an abstract

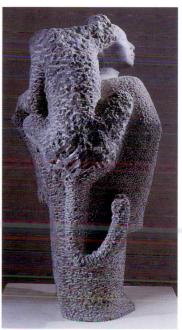

7.9 Isabel Case Borgatta. *Jaguar Woman.* 1992. Granite, 31" high.

sense of strength and wildness upon the beast, which is thought to carry great spiritual power.

Some works invite us to compare the textures of a work and its setting. What could be a greater contrast to the hard, rectangular, masonry surfaces of a city than the waving stalks and heads of a wheat field? Think of walking in the field shown in **Figure 7.10**, feeling it brush against your skin, hearing the swish of the green leaves or the rasp of the ripe heads. The incongruity of such experiences in the midst of congested Manhattan allowed Agnes Denes to make a social and environmental point: "to call people's attention to having to rethink their priorities."

Surfaces may be worked to create texture that is aesthetically pleasing. Marble and wood sculptures that are extremely smooth invite us to caress them with hand and eye, enjoying the sensual flow of the contours. When metal is smooth and highly polished, this manipulation of the material also gives it an

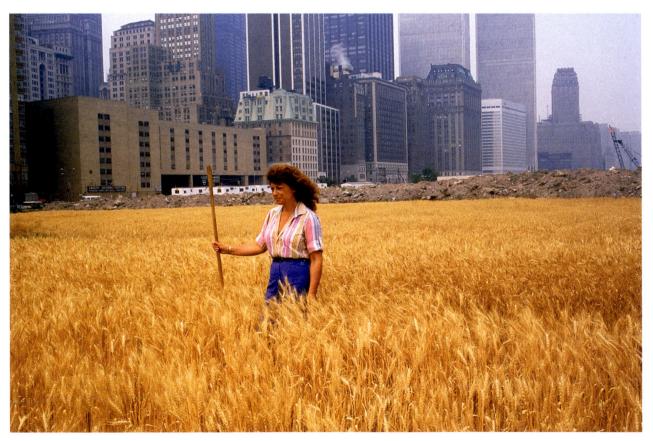

 $^{^2}$ Agnes Denes, as quoted by Robin Cembalest, "The Ecological Art Explosion," *ARTnews*, Summer 1991, p. 101.

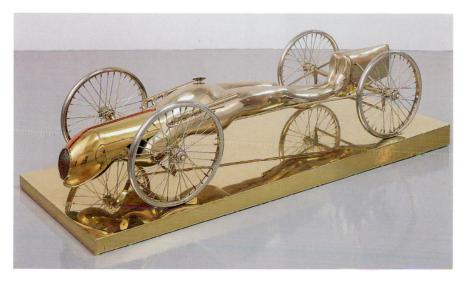

7.11 Ernest Trova. *Study: Falling Man (Carman).* 1965. Polished silicone bronze and enamel, $20^{1}/4 \times 78 \times 30^{3}/4$ ". Hirshhorn Museum and Sculpture Garden, Smithsonian Institution. Gift of Joseph H. Hirshhorn, 1972 (72.300).

extremely reflective quality. The highly polished silicone bronze surface of Ernest Trova's *Study: Falling Man (Carman)* (Fig. 7.11) offers a gleaming accent to the contours of the human form and picks up reflections of whatever is near the piece, adding to its visual interest. The shiny, sleek surface also contributes to the illusion of speed—a visual image of man not only as a car but a very fast car. Our eye would move more slowly across a rough surface, and we would tend to ascribe this slowness to the object itself: We would not expect a rusty car to move very fast.

The manipulation of the surface of an object to enhance its appearance is intimately bound to cultural and historical definitions of beauty. Our culture tends to value soft but smooth skin, with surface ornamentation confined to clothes, jewelry, cosmetics, and textural manipulation of the hair. But some cultures have preferred raised textural effects in the skin itself, as in the body scarification shown in Figure 7.12. The complex details of such body sculpture may be emphasized by the use of oils and cosmetics. Those who have learned to cherish the smooth skin of youth may react negatively to this form of body art. We can easily imagine what it would feel like to run a hand across these raised textures—or to endure the initial pain of the scarification process—and our immediate reaction may not be a pleasant one. It may be difficult for us to appreciate the viewpoint of those who consider this worked texture beautiful on a human body or who take pride in being thus adorned. In addition to the fact that beauty is in the eye of the beholder, not all art intends to be beautiful. Though the love of beauty is often a motivating factor, many artists are motivated by the quest for a public or a private truth.

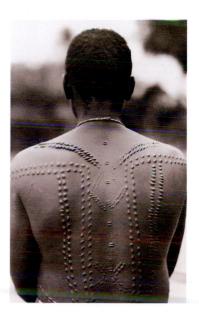

7.12 Mbwaka woman with scarification on her back. North-central Zaire. Photo Casimi d'Ostoja Zagourski, 1926. Zagourski Collection, Eliot Elisofon Photographic Archives, National Museum of African Art, Smithsonian Institution.

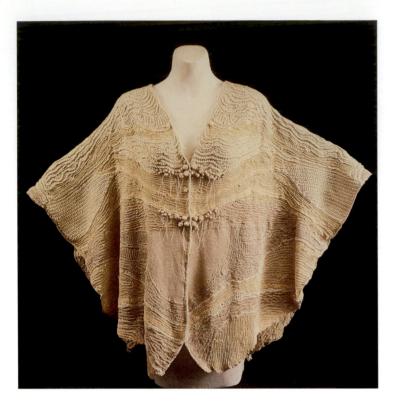

7.13 Norma Minkowitz. Inner Rhythms. 1980. Fiber (cotton), $32 \times 29''$ (81 \times 74 cm). Collection Christine Carter. Photo Bob Hanson.

7.14 Frank Stella. Zimming. 1992. Stainless steel, bronze, and aluminum, $16 \times 13 \times 12$ ". Photo Steve Sloman/Knoedler & Company.

Finally, textures may be worked to create a paradoxically natural effect. The many intricate textures of Norma Minkowitz's *Inner Rhythms* (Fig. 7.13) flow across the cape like organic forms. Yet they are the result of extremely detailed crochet work by which the artist has completely altered the straightness of the single fibers used. Minkowitz explains that in her wearable art she works with fiber to create lines reminiscent of fine pen and ink drawings: "I like to work with fiber as if I were sketching in pen and ink. The pieces become like imaginary landscapes." 3

In the abstract work *Zimming* (Fig. 7.14), Frank Stella used industrial metals to suggest textures that are decidedly organic, as if colonies of creatures were growing on something that had fallen into the sea. No real creatures are portrayed, yet the suggestion of organic life is so strong that we could imagine returning to see the piece later and finding that it has moved and changed, perhaps even bringing new forms into view.

VISUAL TEXTURE

Many works present an optically perceived visual texture that does not correspond with the actual texture of the material. A familiar example is the carving

³ Norma Minkowitz, personal communication with coauthor, October 1984.

of stone to represent softer textures. In *Bust of a Nubian* (Figure 7.15), Charles Henry Joseph Cordier beautifully captured the textures of skin in cast bronze and of draping fabric in sculpted jasper. The skin looks realistically supple and the fabric as if it would move when touched. Of course if you *were* to touch the bust, your hand would register a different tactile sensation from what your eyes perceived. You would feel the cool hardness of jasper and bronze. The perceptual effect depends not only on the sculptor's skill but also on a historical tradition of portraying transient moments and materials in the enduring media of stone and metal. They have been used for human portraits for so long that we have learned to associate these materials with soft visual textures.

Visual textures may be used not only to capture the likeness of soft objects in more permanent form but also for other reasons. Sometimes the optical illusions are designed to amaze the viewer with their clever simulation of actual textures. The success of Marilyn Levine's *Two-Toned Golf Bag* (Fig. 7.16) depends on its perfect replication in stoneware of the textures of worn leather and metal fittings. At this extreme, visual textures become **trompe l'oeil** (pronounced "tromp loy"), or "fool the eye" imagery.

Another way in which visual textures are used is to make objects more visually pleasing or acceptable. Early in the Industrial Revolution, many people preferred the ornate hand-wrought styles with which they were familiar to the simpler lines more natural to machine-made products. Attempts to satisfy the

7.15 Charles Henry Joseph Cordier. Bust of a Nubian. 19thcentury France. Silvered bronze and jasper on porphyry, height 38¹/₄" (97 cm). The Minneapolis Institute of Arts.

7.16 Marilyn Levine. *Two-Toned Golf Bag.* 1980. Stoneware with nylon reinforcement, $35 \times 10^{1/2} \times 7''$ (89 × 27 × 18 cm).

© Robert W. Hayes.

VISUAL TEXTURE | 135

7.17 Rose Engine Lathe. German, c. 1750. Science Museum, London. British Crown Copyright.

7.18 David Smith. XI Books III
Apples. 1959. Stainless steel,
94 × 35 × 16 1/4". Storm King Art
Center, Mountainville, New York.
Gift of the Ralph E. Ogden
Foundation 1967.3. Photo Jerry
L. Thompson. Art © Estate of
David Smith/Licensed by VAGA,
New York.

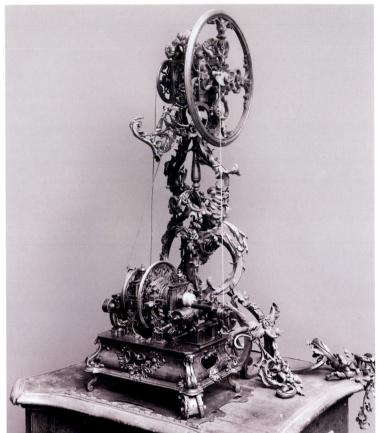

older aesthetic led to creations such as the German Rose Engine Lathe shown in **Figure 7.17**. Its elaborate, vinelike visual texture is designed to camouflage the presumed ugliness of its function as a machine. Indeed, it appears almost too fragile to stand up under the stress of continual motion.

Visual textures are not necessarily an attempt to fool the eye, however. In some cases, they grow out of the complexities of reality. David Smith scoured the steel surfaces of *XI Books III Apples* (Fig. 7.18) to create interesting light-reflecting patterns that have the optical softness of velvet, a nice contrast to the hardness and the sharp edges of the steel forms. Interestingly, Smith himself used textural metaphors to describe the creative impetus of the artist: "I know now that sculpture is made from rough externals by rough characters or men who have passed through all polish and are back to the rough again." 4

In a sense, art grows out of the textural qualities of the artist's life—the polishing and grinding and reworking, the soft places and the hard, the affinity for nature or for the accretions of civilization, the love of the beautiful surface and the scratching beneath the surface to reveal what lies within.

⁴ David Smith, from John Russell, "David Smith's Art Is Best Revealed in Natural Settings," *Smithsonian*, no. 12 (March 1977): 7, p. 73.

I IGHT

IGHT IS A SUBTLE ELEMENT of design but nonetheless a dramatic tool when used consciously. In three-dimensional design, light develops a range of values as it falls across a piece, creating highlights, shaded areas, and shadows stretching beyond the work.

These effects will vary considerably depending on the angle and intensity of the light source and whether the lighting is natural or artificial. The effects of light on a piece will also depend on its surface texture and the degree to which its surfaces curve away from the light.

In addition to using the light cast upon a piece as a design element, artists may incorporate reflections into their work. Light itself may even be the medium with which the artist is working.

VALUE

The light reflected from a surface determines its color. Color is such a rich element of design that we will devote the entire next chapter to it. **Value**, or degrees of lightness and darkness, is a characteristic of color. If you look at your surroundings, you can see that surfaces seem to change in color as they curve away from a light source. A wood desk might appear yellow on top where it catches the light and dark brown on sides away from the light. These differences are actually changes in value. Brown is a dark value of the hue we call yellow. It is useful to separate value from the other characteristics of color explored in the next chapter, for value has a number of specific functions in three-dimensional art.

To study values, we observe the darkness or lightness of areas in relation to each other. It is easy to see value differences in black-and-white photographs, for they reduce color differences to a range of values from black through grays to white. In real life, we tend to assign objects a global color label, thus ignoring the actual differences that can be perceived in various areas of their

8.1 Gaston Lachaise. *Standing Woman.* 1932. Bronze, 7'4" \times 41¹/8" \times 19¹/8" (223.6 \times 104.3 \times 48.4 cm). The Museum of Modern Art, New York. Mrs. Simon Guggenheim Fund.

8.2 7-step gray scale.

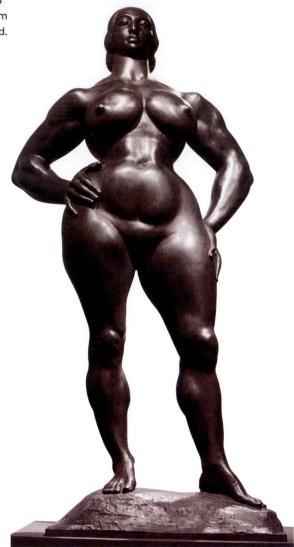

surfaces. If you saw Gaston Lachaise's *Standing Woman* (Fig. 8.1) in the Museum of Modern Art, you might mentally label its color as bronze and thereby overlook the fact that its polished surface reflects light as near-white highlights and then develops darker values ranging to near-black in areas where light is blocked. The underside of the chin, for instance, is in deep shadow because the protrusion of the face prevents the overhead lighting from reaching this area. The **highlights**—brilliantly lit areas that appear as luminous spots—occur in areas that receive the most direct illumination.

Gradations in value from black to white can be talked about in terms of a **gray scale**, such as the one shown in **Figure 8.2**. Here, the range from black to white is represented as 7 equal steps. In reality, the range of values is almost infinite; many slight changes in value could occur between each of the 7 steps shown. Values nearer the white end of the gray scale are assigned higher numbers.

On a 10-step gray scale, white is 10 and black is 1. Since we perceive values in relationship to what lies around them, the gray scale is often shown with middle gray circles to illustrate how our perception of this mid-gray changes depending on its surroundings. It appears far darker on the high end of the scale in juxtaposition to white, and far lighter in juxtaposition to black, but it is, despite these appearances, in reality the same value throughout.

Although we may be only subconsciously aware of values, artists use them consciously for a variety of purposes. One function of value is to provide clues to three-dimensional form. From our experiences in the three-dimensional world, we have learned to associate gradual value shifts with rounded surfaces. Value changes are far more abrupt across sharply angled surfaces, for they juxtapose areas that catch the light and areas in which illumination is blocked. In the *Standing Woman*, the slowly changing range of gray values across the thighs helps us to perceive their full roundness; the sharper curve of the breasts away from the overhead light is indicated by the much more rapid transition from high values to low values. These areas of high-value contrast created by exaggerating the curves of a muscular female figure add dramatic emphasis to the contours of the piece.

In addition to emphasizing forms, value contrasts may be used to create patterns of light and shadow that are interesting in themselves. The visual appeal of Barbara Hepworth's *Two Segments and Sphere* (Fig. 8.3) is enhanced by the series of semicircular shadows its forms cast. These shadows subtly repeat and vary the theme of sphere and slices of a sphere introduced by the three forms themselves.

In designing *The Artichoke Lamp* (Fig. 8.4), Poul Henningsen was clearly aware that arranging thin curving planes of steel around an illuminated core

8.3 Barbara Hepworth. Two Segments and Sphere. 1935-1936.
White marble, height 12" (30 cm). Collection Mrs. L. Florsheim, Chicago. Barbara Hepworth Museum (Tate Gallery), London. © Alan Bowness. Photo Innervisions.
All rights reserved.

8.4 Poul Henningsen. The Artichoke Lamp. 1958. Tin steel.
Manufacturer: Louis Poulsen
& Co. A/S. Courtesy Danish
Design Council.

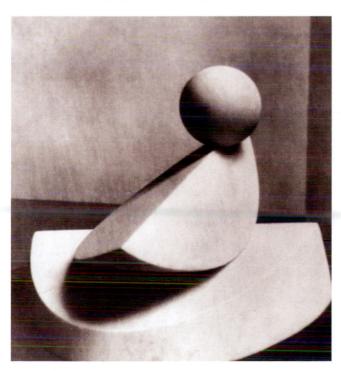

VALUE | **139**

would create such a range of values. These variations in value, from near-black at the base where the light is blocked to near-white on the brightly lit areas, are some of the most compelling visual features of the lamp.

Patterns of value contrasts may not only tie a work together but also unite it visually with its surroundings. In Frank Lloyd Wright's design for a client's house, known as "Fallingwater" (Fig. 8.5), the extremely cantilevered forms of the house create dramatic contrasts between brightly lit surfaces and areas of dark shadows that echo the value patterns and forms of the deeply undercut natural rock shelves below. Such devices helped Wright to create houses that seemed intimately related to their natural environments.

Values may be used to help us make spatial sense of a piece or to heighten its spatial effects. In Larry Bell's *The Iceberg and Its Shadow* (Fig. 8.6), the slight optical darkening that occurs when the tinted but transparent glass panels overlap allows us to judge how the panels relate to one another in space. Barbara Hepworth relates this function of value to "stereognosis," the ability to perceive three-dimensional form through the sense of sight. In a sense, values allow us to grasp the three-dimensionality of a form with our eyes rather than our hands. According to Hepworth:

The importance of light in relation to form will always interest me. In sculpture it seems to be an extension of the stereognostic sensibility, and through it I feel it ought to be possible to induce those evocative responses that seem to be part of primeval life, and which are a vital necessity to a full apprehension of space and volume. There is an

8.6 Larry Bell. *The Iceberg and Its Shadow.* 1975. ³/8" clear and gray glass coated with Iconel and quartz, 56 panels, 60" wide, heights from 57" to 100". Modern Art Museum of Fort Worth, Fort Worth, Texas. Albert and Vera List family.

8.7 Alberto Giacometti. *Monumental Head.* 1960. Bronze, $37 \times 11^3/_4 \times 14^3/_8$ " (94.0 \times 29.7 \times 36.3 cm). Hirshhorn Museum and Sculpture Garden, Smithsonian Institution. Gift of Joseph H. Hirshhorn, 1966.

inside and an outside to every form. When they are in special accord, as for instance a nut in its shell or a child in the womb, or in the structure of shells or crystals, or when one senses the architecture of bones in the human figure, then I am most drawn to the effect of light. Every shadow cast by the sun from an ever-varying angle reveals the harmony of the inside and outside. Light gives full play to our tactile perceptions through the experience of our eyes, and the vitality of forms is revealed by the interplay between space and volume. ¹

In addition to describing forms, value contrasts allow us to see surface textures. The angle and intensity of light striking Alberto Giacometti's *Monumental Head* (Fig. 8.7) create a series of highlights and shadows that emphasize the irregular surface textures, enhancing the aged and weathered appearance of the image.

¹ Barbara Hepworth, *Barbara Hepworth: A Pictorial Autobiography* (Wiltshire, U.K.: Moonraker Press, 1978), p. 27.

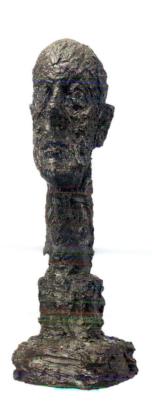

NATURAL LIGHTING

Any piece that is placed outdoors will be subject to the vagaries of changing light conditions. Although these are not under the artist's control, in some cases the artist can plan for them. In any case, changes in angle and intensity of natural lighting may enhance the liveliness of the aesthetic experience, for the changes in lighting make the pieces themselves ever-changing in mood and visual impact. Andy Goldsworthy's *East Coast Sea Cairn* (Fig. 8.8) changes dramatically every day, not only because of the ebb and flow of the tide but also because of the movement of the sun's position. In the particular timings photographed, the sun's light is shifting around the piece, illuminating it partially and then fully as seen from the shore, and finally disappearing at sunset, leaving the cairn very dark. When the sea is calm, the reflections from the cairn on the water also become part of the piece.

To appreciate an outdoor work fully, you should return again and again to see it under many different lighting conditions. In bright overhead sunlight in the Museum of Modern Art Sculpture Garden, Lachaise's *Standing Woman* (Fig. 8.1) glistens as though the figure had just emerged from the water. On a gray day she appears far softer, with her muscle structure less prominent. To appreciate her more fully, a viewer should also see her in the warm sidelight of dawn or dusk, in a dense mist, or bearing new-fallen snow.

The greater the intensity of natural lighting, the stronger the value contrasts created. Under very bright sunlight, Frank Lloyd Wright's "Fallingwater" is a dramatic series of very light exposed and very dark undercut areas, as shown in **Figure 8.5**. Under overcast lighting conditions, both the house and the waterfall appear as a more medium range of tones.

Changes occur not only in intensity but also in the angle of natural lighting. The sun moves from east to west each day at an angle that is most directly overhead in the summer and closest to the horizon in winter. During the shift from morning to afternoon sunlight, shadows will shift from one side of a piece to the other. When the position of shadows is of aesthetic importance, the artist must observe where they will fall during the day to determine the most desirable placement of the piece.

Shadows cast by objects other than the work of art may also influence its placement. Buildings themselves may cast shade on a sculpture. Often artists try to avoid the uniform values created by total shade. On the other hand, shadows created by the surroundings may in some cases enhance the work.

Shadows play such an important part in large-scale works that **shadow studies** are often undertaken in planning outdoor pieces, including buildings. Urban planners use shadow studies because "sun rights" are now demanded by many city dwellers in cool climates. New high-rise buildings are therefore required to be recessed from the sidewalk. Post Office Square in Boston (**Fig. 2.12**) was specifically designed to bring as much light as possible into an area that had previously been darkened by the shadow of a parking garage. Except for trees, overhead sun blocks are avoided in the park. Even the "roof" over a colonnade is an open latticework that lets light pass through to ground level.

8.8 Andy Goldsworthy. *East Coast Sea Cairn*. 2001. New Rochelle, New York. © Andy Goldsworthy. Courtesy Galerie Lelong, New York.

ARTIFICIAL LIGHTING

The controlled use of artificial lighting is not subject to the daily changes in natural lighting. Used well, it can considerably improve the aesthetic success of a work of art. In Chapter 2 we saw how the mood of Daniel French's *Abraham Lincoln* (Figs. 2.9a and b) was dramatically changed by the addition of artificial lighting. In the natural light coming from below, the face appeared soft and

perhaps a bit haggard, with light inappropriately concentrated around the chin. When illuminated by artificial spotlights from above, dramatic shadows developed beneath the eyebrows and mouth, considerably altering the appearance of the statue.

Whereas daylight tends to flood an object with light from a particular direction—the sun's position—artificial lighting can range from a small, intense spotlight to banks of floodlights, arranged wherever the artist feels they are most effective. Illuminated by overhead sunlight at midday, New York City's Lincoln Center for the Performing Arts (Fig. 8.9) features dark, cavernous arches between brightly lit columns. Attention is also drawn to the lines leading to the fountain in the central plaza. The darkness of the arches almost holds the viewer away, as though the fronts of the buildings were solid. By contrast, artificial floodlighting of the buildings' interiors by night (Fig. 8.10) transforms them into pools of light, warmly beckoning the viewer into the delicate intricacies within. The effect is so changed that the second picture almost appears to be a photo negative of the first, with black areas transformed into light areas and vice versa.

8.9 Lincoln Center for the Performing Arts, New York. 1962–1969. Left to right: New York State Theater, Metropolitan Opera House, Vivian Beaumont Theater and Library and Museum of the Performing Arts, Philharmonic Hall (now Avery Fisher Hall), seen by daylight. Buildings and the Guggenheim Bandshell in Damrosch Park arranged around three interconnecting plazas. Photo Bob Serating/© Lincoln Center for the Performing Arts, New York.

8.10 Lincoln Center for the Performing Arts, New York. 1962–1969. Night view, illuminated by artificial floodlights. Photo Morris Warman/Lincoln Center for the Performing Arts, New York.

The use of artificial light to create value contrasts can emphasize spatial and textural qualities of a piece. On the other hand, when artificial lighting is used without thought, just to cast light upon an object, it does not enhance the image. Under the uniform lighting used for Leonard Baskin's *Oppressed Man* in Figure 8.11, the sculpture appears to be rather flat, with little surface texture, whereas in fact its surface is highly textural and the form is fully three-dimensional. The only sense of real depth occurs under the legs of the owl where a shadow inevitably falls. Other very subtle hints of three-dimensionality appear in the slight shadow on the right side of the owl, the shadow caused by the nose, and a shadow at the base of the sculpture. There is very little value contrast between the sculpture and the background, further flattening the effect of the presentation. Use of a contrasting background and careful manipulation of artificial lighting can enhance the photographic impact of a piece.

A truly great work of art cannot be diminished by any kind of lighting. But even a great work can be enhanced by skillful artificial lighting. Millions have been touched by the beauty and pathos of Michelangelo's *Pietà* (Fig. 8.12). Yet photographer Robert Hupka manipulated artificial lighting as well as camera angle to take a series of photographs of the work such as the one shown in Figure 8.13 that make its emotional statement even more compelling. The high-value contrast in areas such as the folds of Mary's robe heightens the

8.11 Leonard Baskin. Oppressed Man. 1960. Painted wood, $31 \times 12^3/8 \times 14''$ (78.7 \times 31.4 \times 35.6 cm). Collection of Whitney Museum of American Art, New York.

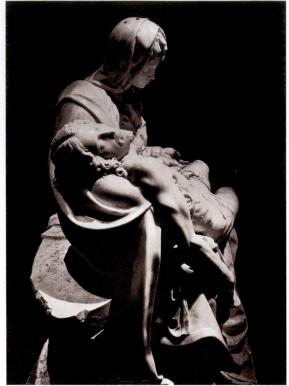

8.12 and 8.13 Michelangelo. Pietà. 1498-1499. Saint Peter's Basilica, Rome. Photo © 1975 by Robert Hupka, from his book Michelangelo: Pietà (New York: Crown, 1975).

drama of the sculpture. And to lose Mary's face in the shadows draws attention away from the surface characteristics of her figure and allows us to focus more on the quality of her presence—the tremendous love and sense of loss but yet an eternal serenity that transcends the pathos of suffering.

REFLECTED LIGHT

Another way in which artists may use light consciously is to create areas in which reflections may occur. Dull or rough surfaces absorb all light striking them, but shiny, smooth surfaces may reflect light back to the viewer, making the objects seem to glow with inner life. Highly polished flat surfaces will also mirror their surroundings; curving polished surfaces will present a distorted reflection of whatever passes before them. The undulating contours of Ron Arad's *Big Easy* (Fig. 8.14) are enlivened by an ever-changing play of abstracted images as life moves around them. Many objects in our three-dimensional world have this reflective quality, yet we rarely stop to enjoy the patterns that develop on their surfaces.

Mirrors, polished glass, or water may also be used by artists as reflective surfaces. Henry Moore's *Lincoln Center Reclining Figure* (Fig. 8.15) has been placed over a reflecting pool with obvious awareness that calm water will provide a

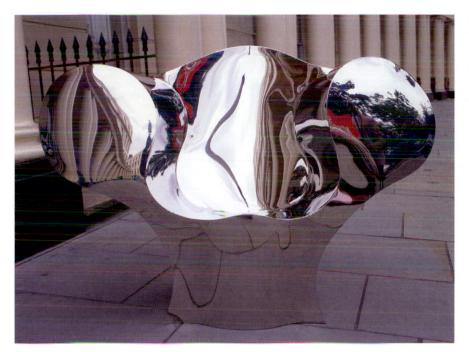

8.14 Ron Arad. *Big Easy Volume 2*. 1988. Hollow welded volume in stainless steel with polished welds. 36 ⁵/8" (93 cm) high. Photo Tom Vack. Ron Arad Associates.

8.15 Henry Moore. *Lincoln Center Reclining Figure* in reflecting pool. 1965. Bronze. Lincoln Center Plaza North, New York. Photo Bob Serating/© Lincoln Center for the Performing Arts, New York.

REFLECTED LIGHT | 147

8.16 Francisco Infante. Serial Work. 1978–1989. Photo courtesy International Images.

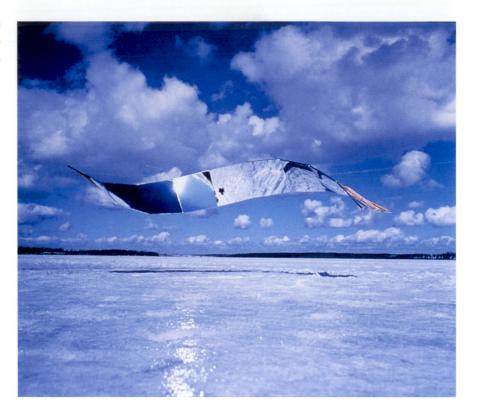

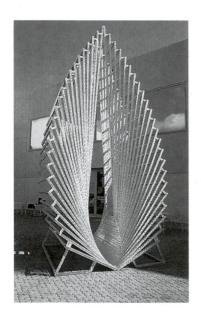

8.17 Linda Howard. Star Burst. 1993. Brushed aluminum, 20' high \times 9' wide \times 8' deep. Schoenbaum Collection, Charleston, West Virginia.

mirror for the piece. The reflections in the water below become an active part of the sculpture. Reflections of the sky in the water give the sculpture and its reflections the appearance of floating in a displaced sky.

Light glancing off the surface of a highly polished work may dazzle the eye of the beholder. In Brancusi's *Bird in Space* (Fig. 1.8), this dazzling light helps to create an ephemeral sense of the quick flash of a bird through the sky. The panels of Francisco Infante's installation over a frozen expanse of water (Fig. 8.16) reflect sunlight brilliantly when the panels are in a certain relationship to the sun. At other angles, the kite panels reflect the light on the snow's surface, placing it oddly in the air among the clouds.

In sculpting *Star Burst* (Fig. 8.17), Linda Howard ground wavy lines to a high sheen along the aluminum surfaces for a slightly different purpose. Her intent is to use light to visually dematerialize matter into a semblance of the energy patterns that actually underlie the apparent solidity of things. The shimmering surfaces almost disappear from view in bright sunlight. At the same time, the shadows cast by the strips balance the disappearing tendency by reinforcing the physicality of the structure. The sculptural form is created by elements rotating through space, but even more compelling than the form is the illusion of energy patterns. These are created by the wavelike **moiré** patterns of the interweaving of brightly lit elements, shaded segments, and unfilled spaces,

repeated with ever-changing variations throughout the work and even beyond the sculpture to the shadow patterns cast on the ground.

Howard explained how her use of light is an attempt to give visual form to the ideas of contemporary physics and Eastern philosophies:

I am deeply concerned with the paradox that exists between our experience of physical reality and our scientific knowledge of conceptual reality, with finding connections between these apparent opposites. Light is an important element in my work, for it brings out both sides of the paradox. Ambient light functions may either dematerialize structure into an almost totally ethereal experience of light and energy, reinforce structure, or sometimes even add illusionary structural elements. I want to dematerialize structure because I have always been struck by the ambiguity of matter. It seems physically hard but contemporary physics says that all matter is composed of energy, which simultaneously manifests itself as discrete particles and as waves. I'm working with that balance between our knowledge of matter as anything but solid and our actual experiences with its seeming solidity.²

LIGHT AS A MEDIUM

In addition to its many ways of dramatizing works of art, light itself may be the medium with which the artist works. In a sense, natural light is being harnessed as a medium in Le Corbusier's *Notre Dame du Haut* (Fig. 4.13), for as light streams through the windows it creates highly active forms.

Contemporary technologies have made it possible to build sculptural forms and lines using nothing but directed light. Lasers, for instance, create thin beams of colored light that can be thrown against the sky.

In other light sculptures, light is shaped by some outer shell, such as fluorescent or neon light tubes. For light sculptor Craig Kraft, the challenge in using neon light as a visual accent to an architectural setting was the fragility of the medium: "Three-dimensional neon-lit sculpture on this scale is hard to find because of the difficulty in constructing a three-dimensional structure capable of securely holding fragile glass neon tubes." The solution was to construct a supporting structure of rolled aluminum as an integral part of the architecture of Silver Plaza in Silver Spring, Maryland. The resulting *Lightweb* (Figure 8.18) is now a hallmark of the plaza, giving it the visual impression of vigor and social significance.

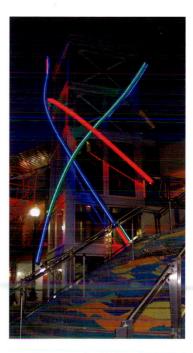

8.18 Craig Kraft. *Lightweb*. 2004. Rolled aluminum and neon, $35' \times 10' \times 10'$. Located at the Silver Plaza in downtown Silver Spring, Maryland.

² Personal communication with author, August 1993.

³ Craig Kraft, "Commissions: Lightweb," Sculpture, October 2004, p. 25.

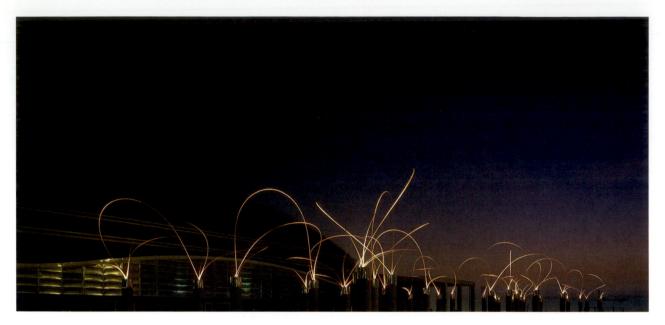

8.19 Aiko Miyawaki. *Utsurohi.* 1990. Flexible steel wires. Installed in front of the Olympic Sports Hall, Barcelona. Photo Shigeo Anzai.

Normally light travels in a straight line, but neon tubing and fiber-optic strands can conduct light in curving paths. For *Utsurohi* (Fig. 8.19), Aiko Miyawaki shaped flexible steel wire into great loops and then illuminated them from their bases. These reflective surfaces shine as lovely free arcs of light against the night sky in Barcelona.

Stephen Hendee has created diffused lighting effects by illuminating fluorescent lights and lights covered with colored gels behind sheets of plastic that are pieced together with black tape. In *Ascension* (Fig. 8.20), the effects of light and color are gradually modulated as the viewer approaches and then climbs the staircase, becoming enveloped by a changing and ethereal atmosphere.

James Turrell, a pioneer in aesthetic uses of light, has created pieces in which the natural sky is the medium. His "skyspaces" are constructed chambers in which viewers sit around the walls on benches to look at a framed piece of the sky through the roof. His *Knight Rise* (Fig. 8.21) offers a view of the sky through an elliptical hole in the roof. The sky appears as a solid form, an abstract aesthetic experience of color and light that changes with the time of day and weather. At sunrise and sunset, the sky even appears to be descending upon the viewer.

Light is also used as a medium in theater, where stage lighting is as important as set design, costuming, makeup, sound, and acting in creating the desired effects. According to stage lighting designer Don Murray:

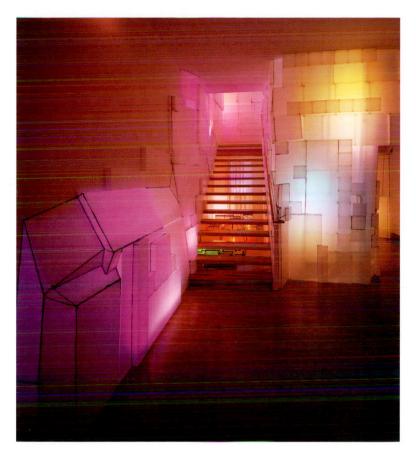

8.20 Stephen Hendee. *Ascension*. 2003. Polypropylene, black glue, fluorescent lights, and gels. Birmingham (Alabama) Museum of Art. Photo Mark Gooch.

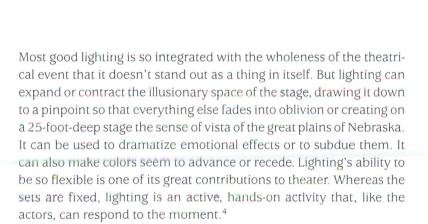

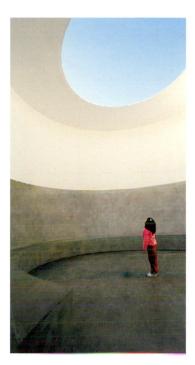

8.21 James Turrell. Knight Rise. 2001. Plaster, concrete, and steel, 18' wide. The Scottsdale (Arizona) Museum of Contemporary Art (SMoCA), commissioned 1997 by the Scottsdale Public Art Program.

⁴ Personal communication with coauthor, May 1986.

The impact of lighting on theatrical illusion is quite apparent in Franz Merz's lighting design for Sophocles' *Oedipus Rex* (Fig. 8.22). Here the space of the stage has been divided by lighting into one area of highly concentrated light, beyond which the boundaries of the stage are lost in total darkness. The makeup, costuming, and masks all repeat the high-contrast values, emphasizing the stark black-and-white tragedy of the play. Although all elements work together harmoniously, imagine what a difference it would make if the dramatic lighting were replaced by normal institutional lighting, such as that of a supermarket or a classroom. Instead of seeing masklike human faces, masks, and a pool of light against a vast darkness, the audience could be looking at the curtains, the wings, the underpinnings of the sets, and perhaps even at each other. Light, used consciously, is thus a very powerful tool in the artist's control of the aesthetic experience.

8.22 Franz Merz. Design for Oedipus Rex (Sophocles). Photo German Information Center.

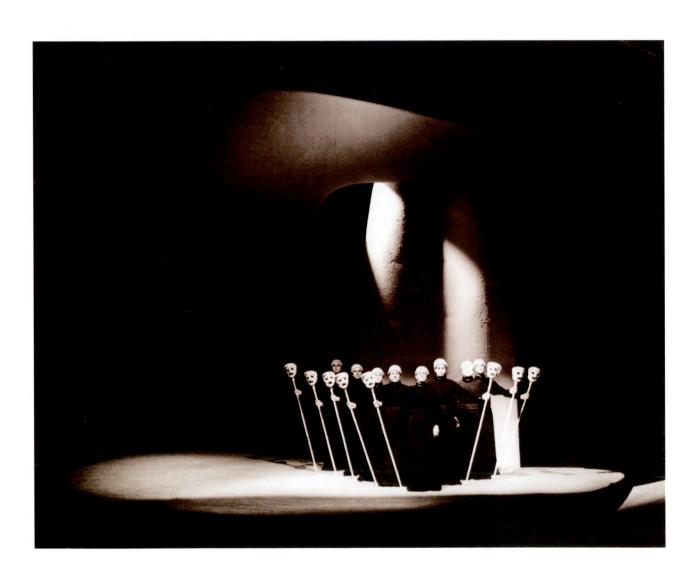

COLOR O

OLOR IS SUCH A POWERFUL ELEMENT of design that we have purposely minimized it in discussing earlier works to avoid detracting from the other elements. So compelling is the desire to add color to things that anonymous artists of all times have taken pleasure in painting natural rock formations. A rock outcropping near Marlborough, Connecticut, has reminded generations of folk artists of a lizard, complete with claws, and thus the dull gray rock has been painted and repainted in brilliant hues, as in Figure 9.1.

Color is an extremely rich tool the artist can use in many ways, whether working with the natural colors of materials or adding color to them. Before we can talk about colors, however, we must introduce the basics of color theory so that we will have a vocabulary to draw on.

9.1 Painted lizard rock image. Marlborough, Connecticut. Photo Annette Zelanski, 2004.

COLOR VOCABULARY

Despite the impression that objects "are" certain colors, colors exist not on the surfaces we see but in our brains. Colors exist as invisible energy waves in white light. We pick up these waves of electromagnetic radiation when they are either refracted or reflected. When passed through a prism, light is broken down or **refracted** into the rainbow of the **visible spectrum** (**Fig. 9.2**). **Reflection** occurs when light strikes an opaque surface. Waves of certain lengths are absorbed; others are reflected. When these reflected waves are conveyed to the rods and cones in the retinas of our eyes, the sensation is translated as a particular color.

To change the color of a material, artists use **pigments** that reflect the wavelengths associated with the desired color. Mixing pigments together produces a slightly darker color, for each subtracts its energy from the light reflected. Pigment mixing is therefore called a **subtractive** method of mixing colors. The exception is adding white pigment to another pigment to create a lighter value, or **tint**, of that color. Adding black produces a **shade**, or darker value, of a color.

Although most color mixing is done by the subtractive method, artists who work directly with light—as in photography, television, video, lighting, computer graphics, and laser art—are using an **additive** method of color mixing. That is, each color adds its energy to that of the others used, raising the value of the mixture slightly. **Optical color mixtures** occur when colors are mixed in the viewer's perception rather than on the surface of an object. Optical mixtures may occur when colors lie so close to each other that their energies interact or when colored forms are transparent, allowing one color to be seen through another and thereby mixing with it visually.

Colors can be classified by three main characteristics: hue, saturation, and value. **Hue** is the characteristic we identify by color names: red, blue, green, yellow, yellow-green, and so on. Variations between hues are almost infinite, but a simple model of their interrelationships can be expressed by a **color wheel**, such as the one shown in **Figure 9.3**. In pigment mixing, all hues can be obtained by mixtures of only three hues. In traditional color theory, these basic hues from which all others can be mixed are red, blue, and yellow, called **primary colors**. Mixing two primaries together produces **secondary colors**—

9.2 The visible spectrum.

green (blue plus yellow), orange (red plus yellow), and purple (red plus blue). Mixtures of a primary and a secondary produced from it create a third set of colors: the **tertiaries**—red-purple, red-orange, orange-yellow, yellow-green, blue-green, and purple-blue. Many more hues are created by mixtures falling between these named positions on the color wheel. In light mixtures, the primaries from which all other hues can be mixed are red, green, and blue-violet. Although other color theories posit slightly different basic hues, these will do as an initial vocabulary for our discussion of color.

The second characteristic of the colors we perceive is **saturation** (also called **chroma** or **intensity**). This term is a measure of the relative purity or brightness of a color. When colors lying opposite each other on the color wheel—known as **complementary colors** (such as red and green)—are mixed together, they tend to neutralize each other, producing a grayer version of one hue or the other. Mixed in the correct proportions, they will produce a gray that resembles neither. Gray is shown in the center of the color wheel, for this position places it between each set of complementaries. Another way to gray a color is simply to add gray or black to it.

Colors are said to be highly saturated when they are very bright. Colors of very low saturation—those that are closer to gray than to the named hues of the outer ring of the color wheel—are sometimes called **neutrals**. They are of interest to decorators and clothing designers, for since they are almost lacking in hue, they can be used next to a variety of more saturated colors without undesirable hue contrasts.

Value we discussed in the last chapter: It is the relative lightness or darkness of a color. To represent color relationships in these three dimensions—hue, saturation, and value—colorist Albert Munsell patented a three-dimensional

COLOR VOCABULARY | 155

model in which steps of value change along the vertical axis, saturation changes are shown through the horizontal axis, and hue differences are shown around the periphery, as diagrammed in **Figure 9.4**. Munsell's system has been adopted as an instrument for measuring and naming colors by many official institutions, including the National Bureau of Standards in the United States. Note that Munsell's classification is based on five primary hues (which he terms *principal hues*) rather than the traditional three. Each primary and *intermediate* (secondary) hue is designated by its initials. Colors are then given numbers in which the first refers to the step of value and the second refers to the degree of saturation, with higher numbers indicating a higher degree of saturation.

Hues differ in the number of equal steps required to reach their maximum saturation, as shown in **Figure 9.4**. Hues also differ in the step of value at which they reach their greatest saturation: Yellow (which is relatively light in its purest form) reaches maximum saturation at step 8 of value, whereas purple-blue (which is dark in its purest form) reaches maximum saturation at step 3 of value.

The colors we perceive, besides being affected by the pigmentation of a surface, are also a function of the glossiness of the surface, the surrounding colors, and the ambient lighting. A highly polished surface will pick up highlights, which will make colors appear lighter. In a principle known as **simultaneous contrast**, juxtaposition of two colors exaggerates their differences and reduces their similarities. Complementaries intensify each other's saturation if used together—red appears redder next to a green, and vice versa. Butchers often put fake green parsley next to meat to make it appear redder and therefore fresher. Hues optically "subtract" their own wavelengths from hues to which

9.4 Diagram of relationships in hue, saturation, and value.

they are juxtaposed, so meat would look a sickly gray on a bright red plate. As for lighting, bright light creates strong value contrasts; an overcast day or dim indoor lighting shifts color perceptions to the middle range of values. Because the redness of late afternoon sunlight, the yellowness of incandescent lighting, and the blueness of fluorescent lighting produce such different color sensations, colors should always be examined under the lighting in which they will be used.

NATURAL COLOR

Although pigments can be carefully mixed to approximate the subtle colors of nature—or natural plant dyes used to the same end—artists often work instead with the natural color characteristics of their chosen medium. It is this use of the **local color** of the material that we are calling "natural color."

Craftspeople often search for materials that are naturally beautiful and then present them in such a way that this beauty is enhanced. Peter Michael Adams's *Dotoh* (Fig. 9.5) features not only elegant, flowing form but also the sensual visual appeal of laminated walnut. By smoothly sanding and oiling the surface of the wood, Adams has brought out its warm colors and its close-grained striations. The rich colors and smoothness of the surface are like beacons drawing us in to touch and enjoy this coffee table. The beauty of the colors cannot be separated from the other aesthetic and functional aspects of the piece, however. Adams explains the integration of his work: "A successful piece will not only mirror my sensitivity to sight and touch, but give credence to my conviction that functional forms can speak eloquently of sculpture, movement, and sensuousness, and still maintain their practicality."

9.5 Peter Michael Adams. *Dotoh.* Coffee table, 1983. Laminated and carved walnut, oil finish, $1'6'' \times 4'2'' \times 2'4''$ (0.46 \times 1.27 \times 0.71 m). Photo Dan Bailey.

Peter Michael Adams, "Portfolio," American Craft, August/September 1984, p. 26.

9.6 Louis Comfort Tiffany. Neck-lace. c. 1900. Mexican fire opals, green enameling, and pearls against a gold ground, 8 3/4" × 41/4" × 7/16" (22.2 × 10.8 × 1.11 cm). Virginia Museum of Fine Arts, Richmond. Gift of Sydney and Frances Lewis. Photo Katherine Wetzel.

Could any human being improve upon the natural colors of polished opals such as those used by Louis Comfort Tiffany in the turn-of-the-century necklace shown in **Figure 9.6**? Multiple hues play across the surface of each stone, inviting us to a closer examination. The natural pearls and gold are likewise presented unadorned. Such beautiful stones and metals are rarely found in large quantities in nature. Opals occur not as boulders but rather as small, precious gifts.

Whereas the striations of Adams's walnut slabs and the gradations in the opals occur randomly, in Charles Henry Joseph Cordier's *Bust of a Nubian* (Figure 7.15), the creamy body and darker gold bands of color in a block of jasper are used quite consciously to provide decorative detail. The natural lines in the stone become bands of extraordinary richness representing woven patterns in some sumptuous material. In places such as the sleeve on the left in the photograph, the sculptor has even altered the carving to make the occasional irregularities appear to be plausible curves of the fabric. Selection of just the right piece of stone was obviously vital to this artist. The natural colors of the porphyry used for the base add to the impression of opulence. And silvered bronze provided precisely the desired skin color, enriched by a range of lighter values as the polished facial features curve to reflect the light.

In contrast to the richly decorative use of natural color in Cordier's bust, natural color may sometimes be chosen for its simplicity. Aesthetically, this simplicity of color may allow attention to be drawn to other elements of design, such as form. During China's Ming Dynasty, porcelain pots and figures were often high-fired to the subtle white of the clay body itself. With no other colors added to distract the eye, the viewer could fully appreciate the forms of the pieces. At the same time, isolating nature's warm eggshell white brought attention to this white itself as a color.

Natural color may also be used conceptually. In George Segal's *The Parking Garage* (Fig. 9.7), the stark natural white of the plaster is used to make a conceptual statement: The attendant appears to lead a bleached-out existence amid the garish colors of contemporary urban life. Here, the material world becomes the vibrant reality; by contrast, the white plaster human figure is the one element in the scene that appears lifeless. To see a normally dark-skinned African-American man depicted as totally white, including his clothing, suggests that he has become invisible to society. Perhaps he is more forgotten than lifeless.

In other works, use of natural color may have the opposite effect—that of linking the work to its surroundings. Architect Frank Lloyd Wright's Wisconsin house, *Taliesin* (Fig. 9.8), expresses his philosophy of the "natural house"—a dwelling that appears to be at one with its environment. To tie it in with its site, he has made extensive use of local stone that echoes the pale earth tones of a nearby hill. The wood shingles weather naturally to the dark gray-brown of the shadows across the stone; the wood framing is treated with a preservative that allows it to weather to a pale warm gray. Sand from the river has been mixed with the plaster of the walls to link their color and texture to the earth tones. Even the red-brown accents in the window framing fall within the palette of hues reminiscent of the earth, and the green shrubbery further blurs the boundary between the house and its surroundings. Both seem to flow together as an organic whole.

9.7 George Segal. The Parking Garage. 1968. Plaster, wood, metal, electrical parts, and light-bulbs. $10' \times 12'8'' \times 4'$ (3.05 \times 3.84 \times 1.22 m). Collection of The Newark Museum, Newark, New Jersey. Purchased 1968 with funds from the National Endowment for the Arts and Trustee Contributions. © The George and Helen Segal Foundation/Licensed by VAGA, New York.

In landscape design, the natural colors of plants are used because they are what is available to the designer. Planning a garden is actually a manipulation of colors as well as forms and textures in three-dimensional space. When used consciously, the natural colors of plantings can be extremely effective. The designer of the topiary (sculpted shrubbery) garden at Levens Hall in England (Fig. 9.9) used a very limited palette to bring out the richness of variations among a few hues. We look

9.8 Frank Lloyd Wright. *Taliesin*.1925. Spring Green, Wisconsin.© Layne Kennedy/Corbis.

9.9 Topiary garden, Levens Hall, near Kendal, Cumbria, England. Courtesy of the British Tourist Authority.

from the tender green of the grass to the bronzed greens of the sculpted evergreen shrubs to the varying greens of the leaves of the surrounding deciduous trees. The greens are set off beautifully by the yellows and reds of the flowers and the gray of the stone building in the background. The colors of gardens change dramatically with daily changes in the weather and seasonal changes in foliage. In winter, only the evergreens and the building would retain their summer colors, but imagine their appearance against the ever-changing color of the sky.

APPLIED COLOR

Despite the wide range of effects possible through use of natural colors, artists have often chosen to apply pigments to the surface of their materials or otherwise change the natural color characteristics of the media. Historically, works were colored to bring them closer to physical or mystical perceptions of reality. More recently, artists have chosen colors for other reasons to enhance the impact of their pieces and sometimes even to display colors as ends unto themselves.

Although we tend to think of classical marble statues as unembellished, revealing the elegant simplicity of the natural stone, the marble sculptures of ancient Greece and Rome were in fact originally painted. Researchers have determined that they were not painted on all surfaces, however. As suggested by the photograph of *Peplos Kore* (Fig. 9.10), only certain areas were painted with pigments in hot wax (the long-lasting **encaustic** method). These colored areas served partly

as decorative, eye-catching accents to the white of the marble, which was itself accentuated by waxing and polishing. Slight traces of paint remain on the meandering patterns of the tunic, as does the startling red of the hair, eyes, and lips. Was this figure really painted with these reds, or was this an undercoating for another color that has since worn away? We cannot be sure, but the addition of color does seem to bring the statue to vibrant life—particularly the painting of the eyes: Instead of being blank, they make direct eye contact with us.

For an example of a fully painted statue in which most of the detail remains, the fifteenth-century *Virgin and Child* shown in **Figure 9.11** is fairly well preserved. In this **polychromed** (multicolored) wooden piece, the applied colors enhance the realism of the stylized carving, help us to distinguish skin from fabric, and create details such as the border of the robe that are not indicated at all in the carved form. Note that unlike a two-dimensional painting, in which values must be painted explicitly to create modeling effects, classical polychromed sculptures were typically painted in solid colors, with the contours of the form itself creating a range of values as surfaces catch or are hidden from

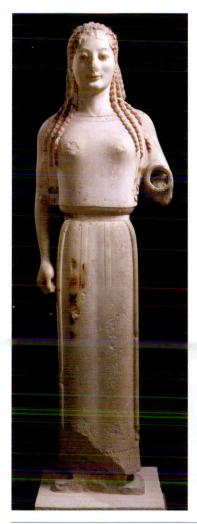

9.10 Peplos Kore, Acropolis, Athens. c. 530 Bc. Marble. H: 48" (122 cm). Acropolis Museum, Athens. Photo Nimatallah/Art Resource, New York.

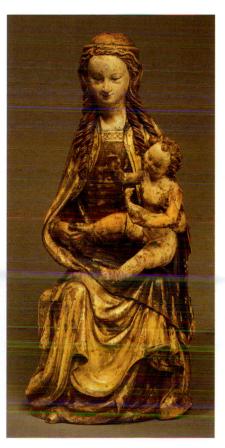

9.11 Virgin and Child. Unknown artist. Walnut, painted and gilded, height 13'1/8" (37.3 cm). The Metropolitan Museum of Art. Gift of Mr. and Mrs. Frederick B. Pratt, 1935 (44.85.3).

the light. The varying hues seen in the draped fabric across Mary's legs can be attributed to the aging of this fifteenth-century piece, as the upper layer of paint flakes away to reveal undercoats and the raw wood itself.

Color may also be added for its decorative appeal to the senses. Lush or pleasing colors may be food for the eyes and perhaps the spirit. Consider the veritable symphony of colors used in the Baroque interior of the Benedictine abbey church in Ottobeuren, Germany (Fig. 9.12). The effect of the golden ceiling areas and pastel marble columns, set off by the pure white of the woodwork, quite overwhelms the worshiper with the splendor of the heavens. Behind the altar, the deeper tones enhance the sense of shrouded mysteries. The viewer's consciousness is drawn both upward by the golds and inward by the muted tones of the altarpiece, creating an architectural environment that encourages exploration of these two dimensions of the human search for the divine.

9.12 Johann Michael Fischer.Interior, Abbey Church, Ottobeuren, Germany. 1736-1766.© Vanni/Art Resource, New York.

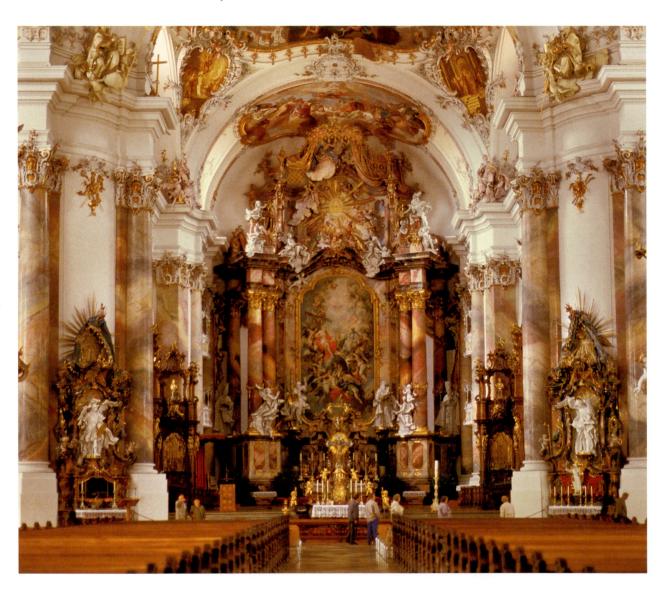

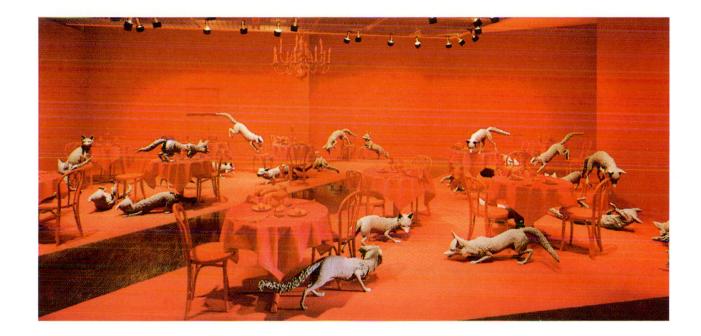

Another motivation for adding color to a work is to attract attention. Color is the hook that draws the viewer's eye to *Fox Games*, an installation by Sandy Skoglund (Fig. 9.13). Without this color combination, the piece would not have the impact that it does. With the color added, the piece evokes questions, a playfulness that makes us become intellectually and emotionally involved. The completely red interior, from plates to chandelier, makes us reconsider objects that might be otherwise ignored because of their familiarity. The gray foxes become a counterpoint to the red of the room, adding to the mystery.

Instead of using only paints to create a lush sensual environment, Larry Totah also used white and colored lights to bathe the walls and selective spots on columns and furniture of the Odeum, a Tokyo karaoke club (Fig. 9.14). Washes of primary colors play one wall off another and lead us down the hallway into a warm and intimate space.

Sometimes color is used to give visual strength to a form. The late Niki de Saint Phalle's final site-specific work, *Queen Califia's Magical Circle* (Fig. 9.15), is a monumental sculpture garden of serpentine walls enclosing a great variety of totem poles, with a huge central mythological figure atop which the powerful legendary queen stands ready to set a bird free to soar, as if presaging the artist's own death. The huge central sculpture is quite remarkable in its form, with the head of a condor and half-familiar contours evoking a sense of lost cultures and extinct species. However, the addition of colors by means of ceramic mosaics and bits of reflective colored glass applied to the surface gives the sculpture extraordinary and startling visual appeal.

The potential for creating color effects with computerized video installations has allowed artists to dispense with physical form and present color effects as virtual three-dimensional experiences. Bill Viola's light-and-sound installation

9.13 Sandy Skoglund. Fox Games. 1989. Multimedia installation of purchased furnishings, painted bread, and polyester resin handmade sculptures. Dimensions variable, approx. $30' \times 20' \times 12'$ high. Denver Art Museum Collection.

9.14 Larry Totah. Odeum Karaoke Club, Tokyo. Columns of copper metal spray over molded fiberglass; tables of cast glass tops over bases of copper plate over cast bronze; velvet upholstery. Totah Design Studio, Santa Monica, Calif. Photo Nacasa and Partners, Inc.

9.15 Niki de Saint Phalle. Queen Califia's Magical Circle. 2003. Detail of Queen Califia and the Eagle Throne. Site-specific work in Escondido, Calif. Photo Shubroto Chattopadhyay.

9.16 Bill Viola. Five Angels for the Millennium. 2001. Video and sound installation. Photo Kira Perov.

Five Angels for the Millennium (Figure 9.16) surrounds the viewer with five dynamic images projected together into a dark room, creating a phantasmagoria of dynamic virtual presences.

New media artist Jennifer Steinkamp projected colored lights with undulating, spinning mesh cylinders in *X-Room* (Figure 9.17) to create a virtual color sculpture in which the viewer's own body becomes enmeshed in the work. So powerful are the projected color sensations that the three-dimensionality of the viewer's figure is almost lost visually in the play of colors.

EFFECTS OF COLOR: PHYSIOLOGICAL AND PSYCHOLOGICAL

To varying degrees, artists also use colors to control the emotional responses of viewers—to elicit a certain emotion rather than give a literal depiction of the local color of an object. In our culture, colors have acquired certain common emotional connotations: Yellow is linked with cheerfulness (though also with cowardice), red with passion (including aggressiveness), blue and green with peaceful meditative states (but also with depression), purple with mysticism, black with death, and white with purity. To a certain extent, these associations are culturally learned—in China, the color white is associated with death. But considerable research has been done on the effects of colors on our physiological processes, and thus on our emotional state. In general, hues in the red range do tend to be stimulating, whereas blues and greens tend to

9.17 Jennifer Steinkamp. X-Room. 2000. Images $4.5' \times 12'$ room $35' \times 31'$. Equipment: 2 Phillips lumen projectors, 2 laserdisc players, quad sound. Photo Peter Maus/Esto, courtesy ACME, Los Angeles and Greengrassi, London.

have a calming effect, though these effects may be reversed over time. Violent prisoners are initially calmed by being placed in pink rooms, but after about fifteen minutes, their fury returns. Blue initially lowers blood pressure and pulse rate, but the opposite effect may later replace this initial response.

In traditional usage, reds, oranges, and yellows are referred to as **warm colors**; blues and greens are called **cool colors**. These temperature associations are probably based partly on learned visual association of reds with fire and blues and greens with the coolness of water and shade trees, and partly on innate physiological responses to differences between colors. Experiments show that red seems to accelerate tissue healing, whereas blue decreases hormonal activity and retards wound healing. This stepping up and slowing down of metabolism may slightly raise or lower the body temperature, thus validating the "warm" and "cool" labels. People actually feel colder in a room painted a cool color than in one painted a warm color.

Spatially, the warm colors seem to advance, giving the impression of reducing the apparent size and weight of objects. When walls are painted in cool colors, they expand the apparent size of a room, since they seem to recede. High-visibility orange helps hunters to distinguish one another from the deer not only because this orange is a highly saturated color but also because this hue can be sharply focused by the eye; blue is far more difficult to bring into focus.

The wealth of research on such effects of color is valuable and fascinating, but it is not yet sufficiently refined to account for the great range of colors within each

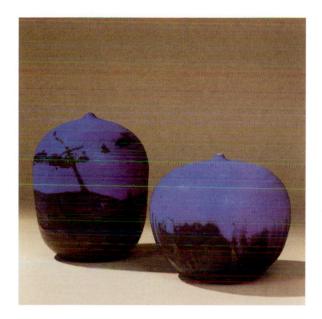

9.18 Toshiko Takaezu. *Blue Small Forms*. 1988. Porcelain-thrown. Left: $6^1/2^n \times 6^1/2^n \times 6^n$. Right: $6^n \times 6^n \times 7^1/2^n$. Courtesy of The Montclair Art Museum, Montclair, New Jersey.

named hue. Also, factors other than hue may offset the already subtle effects of the colors themselves. In art, these factors include the size of the colored area, the value and saturation of the hue, its "contamination" by other hues, the forms on which it is presented, manipulation by the artist of other elements of design, and the viewer's current emotional state and learned associations with color.

Consider blue. This hue has often been associated with cooling and peace. By extension, it may even connote depression: "I feel blue." But look at Toshiko Takaezu's blue glazes on the two pots shown in **Figure 9.18**. These intense colors, one somewhat more purple than the other, are rare in ceramics. Toshiko, who made these glazes, explained her reaction to the color:

I just happened to develop it by chance. It is one of my favorite colors. I like the intense blue, and I use it in rugs and in clothes as well. It gives me a wonderful feeling, a very happy feeling, I think because there is something very cool and soothing. It could be that I associate it with water. When I go back to Hawaii, the ocean is that way, and sometimes the water is purple. I must have taken it from the land-scape, from natural things, but I don't know where I got it.²

Now consider the emotional effects evoked by the use of blue in MarJorle Strider's *Blue Sky* (Figure 9.19). Here we see blue sky oozing playfully down a spiral staircase, in gay disregard for its proper place high over our heads. Toward the top of the staircase, the blue becomes paler, emphasizing the distance by the principle of atmospheric perspective (things seen at a distance have less value contrast and less distinct edges than things seen nearby). At its deepest value,

9.19 Marjorie Strider. *Blue Sky.* 1976. Urethane foam and pigment, height 20' (6.1 m), width 8' (2.44 m), depth 5' (1.53 m). Temporary installation at the Clocktower (work destroyed).

² Toshiko Takaezu, personal communication, July 13, 1993.

the blue is that of children's clay or fingerpaints, a plastic, not-quite-real, just-for-fun quality. Or is this just one person's interpretation? Art critic Donald Kuspit described a different range of emotional responses to the work:

Irrepressible, irresistible, this flow seems a comic hallucination, but it also evokes primordial terrors. It is at once a science-fiction fantasy of doom and our own consciousness as it swarms over and swamps things. Strider's ooze is at once the reflex response of mind to a reality gotten out of hand—gone berserk—and a monstrous suppuration

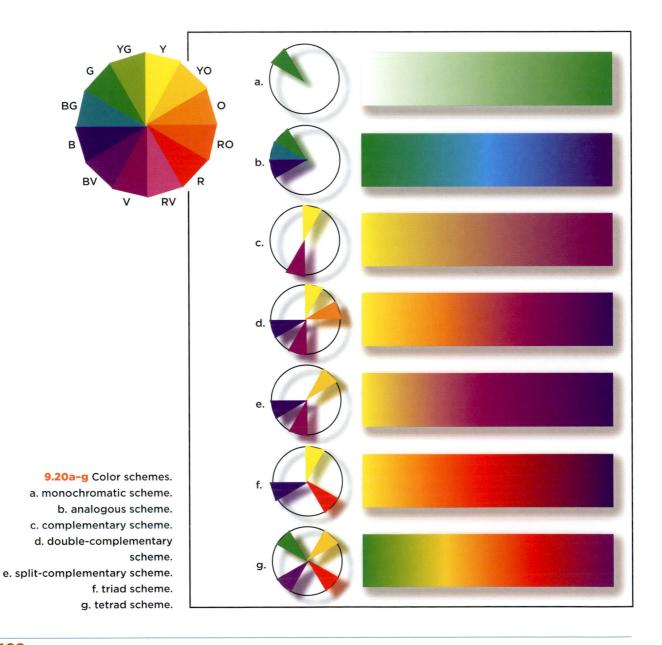

from an invisible wound. If Strider's ooze is seen as static "form," it is a dumb heap; if it is seen as a flow, it acquires powerful being, an insidious ability to insinuate itself everywhere.³

Is life so simple that we can identify only one gross reaction in ourselves to each of its events? Are we either happy or sad? Or do many emotional states flow through our awareness as a complex and ever-changing mirror of inner and outer patterns? Can blue be said inevitably to represent any one of these states?

COLOR COMBINATIONS

Not only do single colors vary in their emotional effects, but colors are also varied by their juxtaposition to other colors. In general, color combinations have been traditionally classified according to whether the colors are closely related or contrasting. When hues are closely related, visual interest is usually created by adding certain slightly contrasting notes to the existing harmony. In a contrasting color scheme, contrast is the rule rather than the exception.

These relationships are judged according to the relative position of hues on the two-dimensional color wheel. But as we have seen in Figure 9.4, a more sophisticated model of the complexities of color variations is three-dimensional. Since there are no easy ways to account for relationships among colors that differ in value and saturation as well as hue, artists often combine colors more intuitively than intellectually until they achieve the effect they desire. Public tastes in color combinations change over time. At the beginning of the twentieth century, the combination of blue with green was considered awful, whereas today color tastes show great diversity. Nevertheless, we will briefly review the standard models of color combinations to explore their characteristics.

The most closely related colors are those that all stem from a single hue but vary in value and/or saturation. This combination is called a **monochromatic** color scheme, shown diagrammatically in **Figure 9.20a**. As an example, the room shown in **Figure 9.21** is a series of yellow-greens that are almost identical in hue. In this example of a monochromatic color scheme, even the values of the rug, built-in furniture, walls, and ceiling are quite similar. The effect is one of quiet coolness, allowing the subtle hues of the window panels by William Gray Purcell and George Elmslie to be appreciated. Monochromatic color schemes often include small areas of other colors as accents, such as the stained glass in the windows, the peach of the pillows, and the black of the lamp in this room.

Although it is fairly safe to assume that monochromatic colors will not clash with each other, we cannot assume that the effect will necessarily be restful or pleasing. Imagine this room in values of red, with an abundance of highly saturated reds and pinks. What would be difficult to live with as a home

³ Donald Kuspit, "Strider's Projecting Presences," Art in America, May/June 1976, p. 89.

9.21 Saskia Weinstein. Interior, with rug and built-in furniture by Saskia Weinstein, window panels by William Gray Purcell and George Elmslie. Photo by John Hall.

environment, however, might make an exciting color scheme for a single piece of three-dimensional art. To use a monochromatic color scheme in a setting where more hues would be expected may make a powerful psychological statement. George Segal tinted the faces and adjacent areas of his men standing in a Depression bread line (Figure 9.22) a sickly green, with just a hint of red in the otherwise neutral black of the coats and bricks. They seem bathed only in green light in a sort of netherworld of despair. Instead of being individuals, they become representative of the suffering masses as a whole through this monochromatic color treatment.

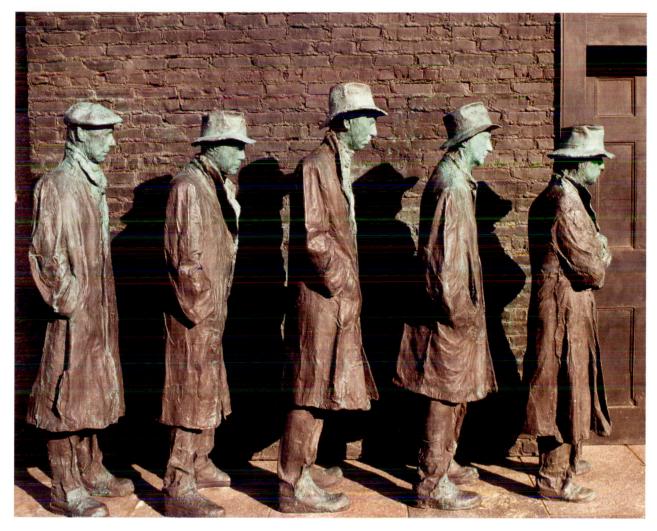

9.22 George Segal. *Depression Bread Line*. 1991. Sculpture for FDR Memorial, Washington, D.C. © The George and Helen Segal Foundation/Licensed by VAGA, New York. © James P. Blair/Corbis.

Analogous color schemes combine colors that lie next to each other on the color wheel. John Lewis's *Urn* (Figure 9.23) uses blues, blue-greens, greens, and a small amount of yellow-green. As Figure 9.20b illustrates, this is a progression of adjacent hues. The effect of the combination is a pleasing, quiet harmony.

Analogous color schemes do not always have calming effects. The yelloworange and orange-pink used together on Lawrence Ajanaku's Nigerian costume *Odogu* (Ancient Mother) (Figure 9.24) are so highly saturated that they seem almost to vibrate. The black-and-white bands provide a bit of space between them—much as when you take a sip of water between tastes to cleanse your palate—but the bands also keep the orange and pink as bright as

9.24 Lawrence Ajanaku. Odogu (Ancient Mother) headpiece and costume. Headpiece wood frame, appliqué, and yarn, $19^{1/2}$ " \times 20" (49.5 \times 51 cm). Costume $41^{1/2}$ " (105.5 cm). Nigeria, Ogiriga village, Okpella people. Collection Fowler Museum of Cultural History, University of California, Los Angeles.

possible by not allowing them to affect each other. Placed side by side, each would seem to fade somewhat by simultaneous contrast as they optically subtracted their own wavelengths from each other. Emphasizing the brightness of the colors heightens the sense of pageantry. And imagine the added effect of movement as the wearer of the costume dances down the street in the masquerade procession.

Hues at greater intervals on the color wheel are in general somewhat more contrasting than closely analogous hues. However, we tend to perceive less contrast between hues when their value is high or their saturation is low. The orange, yellow, and green of John Ferren's *Construction in Wood: Daylight Experiment* (Fig. 9.25) blend harmoniously. Although the colors are quite clear (highly saturated), they are all relatively high in value. What we are seeing in juxtaposition are pale color shadows reflected off the painted backs of the wood columns, rather than pigmented surfaces. All the surfaces we can see from the front are actually painted white to act as pure reflectors for the sunlight that comes from behind and then is bounced off the orange, green, or yel-

low backs of the columns. If we were to look at the piece in reverse, seeing the darker values of the painted backs of the columns rather than their paler shadows, we might see greater contrast between the colors.

Hues are said to show the greatest degree of contrast when they lie opposite each other on the color wheel as complementary colors (Fig. 9.20c). Closely juxtaposed, complementaries intensify each other's brightness. The intensity of the contrast may create a feeling of excitement. The Spanish interior shown in Figure 9.26 conveys a feeling of exuberance by Juxtaposition of the complementaries blue-green and orange, both in the fabric used and in the painting of walls and door frames. Another series of contrasts occurs between very dark values, such as the deep brown of the window and chair legs and the black of the planter, and lighter values, such as the lampshade and the walls of the closer room. In being unafraid to combine colors normally considered clashing, the designer has created an atmosphere that surrounds people with a sense of vigorous health.

Some other contrasting color schemes can be identified as *double-comple-mentary* (two adjacent hues and their complements), *split-complementary* (one hue plus the hues on either side of its complement), *triad* (three hues equidis-

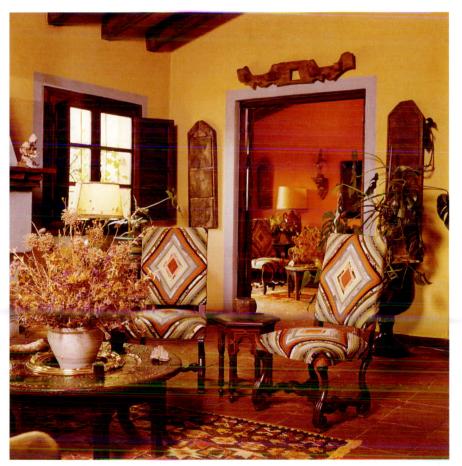

9.25 John Ferren. Construction in Wood: Daylight Experiment (facade). 1968. Painted wood, 6"/2" × 4' × 1'2" (1.84 × 1.21 × 0.35 m). Hirshhorn Museum and Sculpture Garden, Smithsonian Institution, gift of the artist through the Joseph H. Hirshhorn Foundation, 1972. Photograph by Lee Stalsworth.

9.26 Interior in southern Spain. Michael Dunne/Elizabeth Whiting & Associates, London.

173

9.27 Bessie Harvey. Tribal Spirits.1988. Mixed media. 45" high, 26" wide, 20" deep. Dallas Museum of Art, Metropolitan Life Foundation. Purchase grant.

tant from each other on the color wheel), and *tetrad* (any four hues that are equidistant on the color wheel), as shown in **Figure 9.20d** through **g**. Such combinations are said to be both stimulating and balanced, since they include both cool and warm hues. When colors far distant from each other on the color wheel are used together, their physical distance within a piece and their relative amounts will affect their degree of harmony or contrast.

There is a limit to how far we can analyze intellectually why a particular way of using colors works well. We cannot ignore the power of an artist's instinctive sense of color. Bessie Harvey is a self-taught African-American folk artist, working from the heart rather than academic formulas, and yet her *Tribal Spirits* (Figure 9.27) is very successful in whimsically combining every color in the spectrum to create a monumental wholeness. Harvey's colors would seem rather gaudy if isolated, but the amounts she has used, with touches of red coming up the piece through areas of blue and green and yellows passing up and down, somehow all seem to work together. Or perhaps it is the flashes of white appearing here and there throughout the work that unify the juxtaposition of so many different colors. She was working so intuitively that it is difficult to say just why the piece feels so right.

In today's wide-open world of art, artists are free to use the rich tool of color any way they want, so long as they can make it do what they intend. The "rules" of color combining are useful as general guides to the understanding of color, but the subtleties and possibilities reach far beyond.

TIME AND 100 MOVEMENT

HUS FAR WE HAVE TALKED only about elements of design as occupying space. But there is another dimension to experience: time. Aesthetic experiences occupy time as well as space, from subtle or uncontrolled or even illusionary movement through time on the part of the viewer or the work of art, to clearly defined sequences of change through time. Accustomed as we are to being entertained—or bored—by temporal arts such as television and movies, we nonetheless maintain a child-like fascination with things that move and change as we watch. The time element is therefore a dynamic tool at the artist's disposal for involving people with a work of art. Many contemporary artists are in fact using time and change or movement through time as central aspects of their work.

ILLUSION OF MOVEMENT

Before we examine movement through time on the part of the viewer or the work, we should note that certain works, though stationary, are designed to appear to move and change through time. Rather than appearing to be a single moment frozen in time, works such as Rodin's *Saint John the Baptist Preaching* (Fig. 10.1) enable us to read successive stages of motion as a time sequence. Rodin created this effect quite consciously, explaining that "movement is the transition from one attitude to another." In a sense, we "see" Saint John walking, for Rodin shows us one movement flowing logically into another. Our eyes are drawn by the saint's left hand pointing down to his left foot, where his weight seems momentarily planted. Reading upward toward his gesturing right hand, we see a gradual shift in weight toward his right foot, with his left shoulder raised to take the weight off the left foot so it can be swung forward again. This is not a single frame from a motion picture; it is more like a composite of several frames, each represented by a certain part of the body and read in sequence. Rodin contrasted the effect with that of a stop-action photograph:

10.1 Auguste Rodin. Saint John the Baptist Preaching.
1878–1880. Bronze, 6'6³/₄"
(200.1 cm) high, at base 37 ×
22¹/₂" (94 × 57.2 cm) (irregular).
Victoria and Albert Museum.
© Victoria and Albert Museum/
Art Resource, New York.

While my Saint John is represented with both feet on the ground, it is probable that an instantaneous photograph from a model making the same movement would show the back foot already raised and carried toward the other. Or else, on the contrary, the front foot would not yet be on the ground if the back leg occupied in the photograph the same position as in my statue. . . . It is the artist who is truthful and it is photography which lies, for in reality time does not stop. ¹

¹ Auguste Rodin, *Art*, trans. from the French of Paul Csell by Mrs. Romilly Fedden (Boston: Small, Maynard and Co., 1912), pp. 74–76.

Another way of representing the illusion of time-spanning motion in a single stationary work was explored by Futurist painter and sculptor Umberto Boccioni. As a Futurist, he was interested in representing the fast pace of life in a modern industrial society. In painting, a succession of similar images overlapping was often used to give this impression. But few artists tried to translate the Futurist manifesto into sculpture. Boccioni's *Unique Forms of Continuity in Space* (Figures 1.2 and 1.3), however, manages to convey the impression of a person striding rapidly through space and time. We see not only a forward-pressing leading edge to the left, but also slightly separate forms suggesting blurred afterimages of previous movement. The forms streaming backward are not literal descriptions of motion, as in *Saint John*. Rather, they are visual metaphors for speed and for describing the optical continuity of perceiving several quickly successive images at once, like the extra legs seen on a galloping horse.

VIEWING TIME

A more common way that the temporal dimension enters a work of three-dimensional art is the time it takes to explore the piece. This aspect of time is highly variable, of course. Some people will walk right by a work and pay little attention to it. But to appreciate a piece of three-dimensional art fully, we must take the time to view it from a distance, come in close, and move all around it.

Mark di Suvero's *Gorky's Pillow* (Fig. 10.2) is more than 23 feet (7.01 m) long and 9 feet (2.74 m) wide. To see it from all angles, we must walk over 64 feet (19.52 m) around its perimeter. We could also walk beneath it and around the hanging forms to examine them individually. Their playful quality invites lengthier participation—climbing on and seeing what happens, and perhaps even trying out the bell. If the sculpture has drawn the attention of children, we might stay even longer to watch their ways of enjoying it.

10.2 Mark di Suvero. Gorky's Pillow. 1980. Steel, brass bell. 15' \times 23'1" \times 9'7". © Pierre Plattier. Courtesy of Mark di Suvero and Spacetime C.C.

VIEWING TIME | 177

To a certain extent, the length of time people devote to exploring a piece is an indication of the artist's success. By this criterion, Dieter Roth's *Garden Sculpture* (Figure 10.3) is highly successful for viewers who take the time to try to understand what is going on. The Swiss artist has assembled an improbable mixture of a great variety of things, but yet there seems to be some elusive logic behind the installation. At first we may be struck by the repetition of ladders, but when we follow them, we find that they lead nowhere. Then perhaps we may notice windows placed as if functionally, but upon investigation, they also give views of nothing in particular. As we discover repetition of certain objects—such as TV monitors or paint cans—they invite attempts at understanding, but again and again, our minds hit a dead end. In such a process, we may spend considerable time trying to make sense of this complex contraption.

The length of time spent with a three-dimensional work is partly a function of the physical size of the piece. Harvey Fite's *Opus 40* (Fig. 10.4) is an environmental sculpture covering six and one-half acres. Not only is it large in scale, but it also controls the viewer's movements through time and space by stone steps, walls, and terraces. As these formations disappear intriguingly out of view, they lead the viewer up and down into deep-walled enclosures and around and through the structure as if it were a building. The only point of moving through it, however, is to explore it. The experience stretches across a considerable amount of time simply because the work is so large. Similarly, a piece small enough to be held may also engage our attention for a long time span, for we can turn it over in our hands repeatedly until our curiosity is satisfied and our appreciation of the experience complete.

Even greater control of viewing time is commanded by narrative pieces such as *Trajan's Column* (Fig. 10.5). It presents the story of the emperor Trajan's

10.3 Dieter Roth. Gartenskulptur (Garden Sculpture). 1970-1998. Wood, wire, rope, metal, construction materials, and various objects including video equipment, TV monitors, paint cans, and toys. AP Photo/MOMA, Dominik Labhardt/ Courtesy the Flick Collection. Estate of Dieter Roth. © Estate of Dieter Roth. © Dieter Roth Foundation, Hamburg.

10.4 Harvey Fite. Portion of *Opus 40*. 1939-1976. Environmental sculpture, bluestone rubble. Covers 6.5 acres on the site of an abandoned bluestone quarry, 7480 Fite Road, Saugerties, New York. Friends of Opus 40, photo Tad Richards.

10.5 Trajan's Campaign against the Dacians, detail of Trajan's Column. AD 106-113. Marble, height of frieze band 4'2" (127 cm). © Angelo Hornak/Corbis.

adventures in a series of carvings that wind around the immense marble column. To "read" the story, the viewer must walk repeatedly around the column, reading upward from the bottom.

CONTROLLED TIME

In contrast to pieces in which it is the viewer who moves through time, certain works are themselves designed to move and change through time. They are referred to as **kinetic art**. A now-classic example is José de Rivera's *Brussels Construction* (Fig. 10.6). Its single line flows continuously not only through space but also through time, for the plinth on which it sits is motorized to revolve slowly. As viewers watch from a single perspective, the line curves in and out, up and down, gracefully changing its relationships with other parts of the same line.

George Rickey, whose *N Lines Vertical* (**Fig. 5.4**) moves with the wind, once pointed out that the three-dimensional world in which we live is often a world of motion rather than of frozen tableaux: "The artist finds waiting for him, as subject, not the landscape, but the *waving* of the branches and the *trembling of* stems, the piling up or scudding of clouds, the rising and setting and waxing and waning of heavenly bodies, the creeping of spilled water on the floor, the repertory of the sea—from ripple and wavelet to tide and torrent."²

Even the movement of the sun across the sky affects art in time, as it creates lighting and shadow effects. Architect Arata Isozaki captured this slow movement as art in his huge sundial that casts its shadow on the cylindrical court-

² George Rickey, "The Morphology of Movement: A Study of Kinesthetic Art," in Gyorgy Kepes, ed., *The Nature and Art of Motion, Vision and Value Series (New York: George Brazillier, 1955)* p. 110.

yard enclosure of the Team Disney Building (Fig. 10.7). The wall of colored stucco is marked in such a way that the shadow actually does accomplish its function of measuring time.

Those works of art that are designed to move through a predetermined sequence of events exist in what can be called **controlled time**. An example of a time-controlled piece of kinetic art whose very simplicity is part of its intent is Jesse Good's *Yellow* (Figure 10.8). The yellow pillows are at first limply deflated. The viewer watches them slowly inflate and climb up the central pole. Then they slowly deflate, returning to their original state. The artist offered this perspective:

I just like the notion of movement, but also transformation involved in these [pillows]. Anticipation is a big part of these: waiting for it to do what you know it's going to do. It is predictable, and yet at any point in time that you lay your eyes on it, it may be in a different phase of its cycle. They are completely abstract, but I like the connotation of breathing, and the organic shapes and movements, and using the air as the medium. Sculpting the air, using fabric, timers, and electricity. I also like the contrasting between when they are inflating and deflating—so very yin yang."⁵

10.7 Arata Isozaki. Team Disney Building, detail of sundial in courtyard. Photograph © Peter Aaron/Esto.

³ Jesse Good, personal communication, January 27, 2005.

10.8 Jesse Good. Yellow. 2004.
2.5' long × 2.5' wide, height starts at 2.5' and inflates to 5'. Ripstop nylon, wood with timer and motor.

Works such as **mobiles** (changing sculptures activated by the wind) and folk art **whirligigs** such as the bicycling man shown in **Figure 10.9** can move only in preestablished directions, though the speed of movement will depend on the wind that propels them. In this whirligig, the propeller paddles catch the wind, and as they rotate, they activate wires that move Uncle Sam's legs as though he were pedaling the cycle. The faster the wind blows, the faster he will seem to be pedaling. Even at rest, the piece creates the illusion of movement through the rippled carving of the flag and the flaring of Uncle Sam's coattails, as if blown by the wind. Indeed, the top part of the whirligig is movable and will always head into the wind.

The artist may directly provide the impetus for controlled movement of a piece through time. Alexander Calder designed an entire miniature circus of wire figures with moving parts, such as *Rigoulot*, *the Strong Man* (Fig. 10.10). For 30 years, Calder delighted groups of his friends with staged performances in which he not only moved the figures through their daring routines but also supplied the flamboyant voice of the ringmaster. He and his wife even served peanuts at intermission. The figures are marvelous, but to see Calder himself moving them was the height of entertainment for all ages. The wonderful humor of these shows has been preserved in a priceless short film.

Another form of controlled time exists in works designed to last only a specified amount of time. Like the mobiles and whirligigs, Jean Tinguely's *Homage to New York: A Self-Constructing and Self-Destroying Work of Art* (a moment

10.9 Whirligig: Uncle Sam Riding a Bicycle. 1880–1920. Artist unknown, Northeastern United States. Carved and polychromed wood, metal. From the permanent collection of the American Folk Art Museum (promised bequest of Dorothy and Leo Rabkin). P2.1981.6. Photo John Parnell, New York, New York.

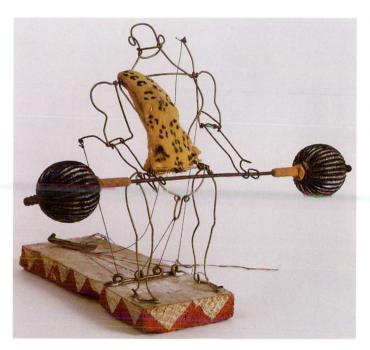

10.10 Alexander Calder. Rigoulot, the Strong Man, weight lifter, from Calder's Circus. 1926–1931. Wire, cloth, metal, thread, and tape on painted wood base. Dimensions variable: $7^7/8 \times 10^1/2 \times 7^3/4''$. Collection of Whitney Museum of American Art, New York.

CONTROLLED TIME | 183

from whose life is shown in **Fig. 10.11**) is designed to follow a set sequence of events through time. But unlike the other pieces, Tinguely's machine could carry through the routine only once. It existed for only one performance, in which this zany machine created and then destroyed itself. This category of controlled kinetic art is called **kinetic sculpture performance**. Self-destruction is not mandatory.

Some conceptual art pieces operate within a similarly limited time framework: a brief static or kinetic display, sometimes observed only by the artist, with nothing saved for posterity except perhaps some photographs of the event. Christo and Jeanne-Claude's *Valley Curtain* (Fig. 2.4) was supposed to hang for only a few weeks and then be dismantled, a process the wind started somewhat prematurely. It can be argued that such works faithfully imitate life, for our experiences are fleeting rather than carved in eternal stone. We cannot hold on to a single moment; if we do not appreciate it as it flows by, it is gone forever.

Even though **performance art** also occupies a limited place in time, it nevertheless allows the artist to engage an audience for a brief time and perhaps leave a more lasting impression. Performance art has been used to make artistic statements about critical social issues, such as racism, militarism, and gender

10.11 Jean Tinguely. Homage to New York: A Self-Constructing and Self-Destroying Work of Art. Self-destroyed March 17, 1960. Assemblage of piano, machine parts, bicycle parts, weather balloon, fireworks, etc., in the garden of The Museum of Modern Art, New York. Photo © David Gahr.

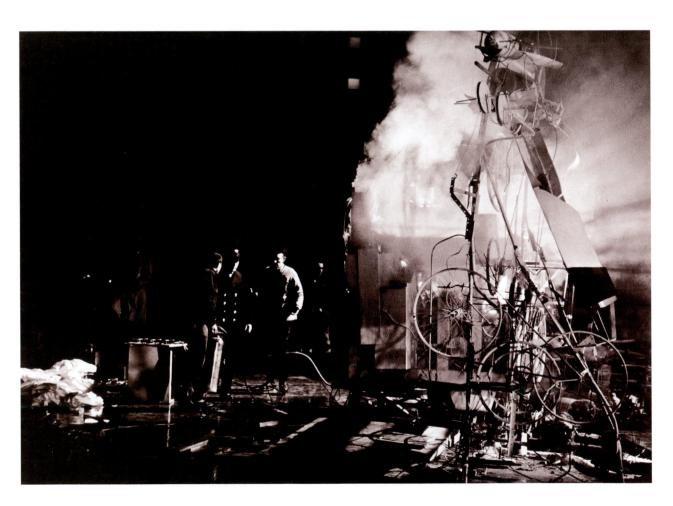

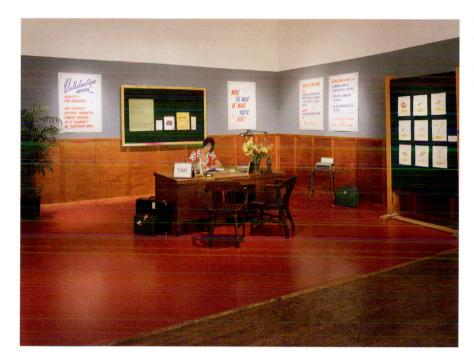

10.12 Christine Hill. "The Volksboutique Home Office" (workspace prototype). 2003. Ronald Feldman in New York City.

prejudice, sometimes through direct confrontation of the audience. Christine Hill's "The Volksboutique Home Office" (Figure 10.12) brought the world of commercial activity into an artistic environment—an art gallery—thus deliberately blurring the line between business and art. The artist herself was the actress performing all the roles on different days—receptionist, accountant, public relations specialist, manager, and producer of the services. Her "office" was in the corner of the gallery, with trunks holding props suitable for the various functions. For the "Reception" piece, the props included a flowery dress, nail polish, a dish of candy, and the nameplate "Ms. Hill." The business services that Hill promoted through her performance piece included transforming "neglected reception areas around the city through artistic intervention" and turning workplaces into "Home Museums." Thus people who came merely to observe the performance piece may have become immersed in a longer-term relationship with this artistic enterprise.

FREE TIME

Whereas controlled-time pieces can move only within a certain pattern preestablished by the artist, works that exist in **free time** are shaped partially by factors beyond the artist's control. These pieces will therefore vary somewhat randomly and unpredictably through time. "Free" is a relative label, though, because all art, no matter how minimal, implies a degree of control on the part of the artist in order to bring some object or experience to the viewer's attention.

Some artists work with natural forces that change unpredictably through time, such as water or wind. All outdoor pieces are subject to their eroding

FREE TIME | 185

effects, with changes measured in months, years, or centuries, depending on the durability of the material. The relentless pounding of water on a 20-ton suspended rock in Arata Isozaki's design for the art center in Mito, Japan (Fig. 10.13), is a dramatic reminder of these forces. Many earthworks are relatively short-lived, soon reclaimed by the earth through natural processes of attrition. Some metals used for outdoor pieces rust to a point and then the rust itself forms a sort of protective coat for the material. Some plastics theoretically have a very long lifespan, being highly resistant to corrosion, but they could melt in a fire. Marble, used historically for its great durability as well as its beauty, may be eaten into by acid rain resulting from airborne pollutants.

On a more immediately observable time scale, we can see the movement of water as it flows through channels and around obstructions. James Fitzgerald seems intentionally to have limited his control over the movement of water through his waterfall-like *Fountain Sculpture* (Fig. 10.14). To create a natural, free-flowing effect, Fitzgerald crafted a series of metal planes, each so flat that

10.13 Arata Isozaki. Suspended rock fountain, Art Tower Mito, Japan. 1990. Rock suspended by wire. Photo Jun Tazawa, courtesy Art Tower Mito.

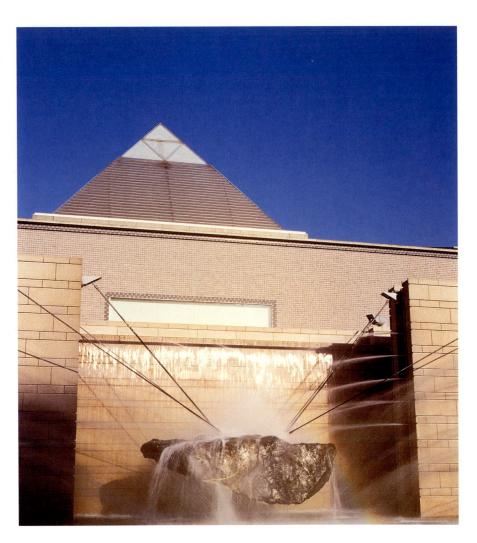

there is no obvious downward channel for the water to follow in its response to the pull of gravity. The water therefore spills off a little here, a little there, in quantities that change randomly through time. The shapes of the edges of the planes consistently determine the forms taken by water as it spills over the edges, but variations in the amounts trickling over any one point will alter the pattern of the water curtain.

We are fascinated by the continual movement and evanescent beauty of such a phenomenon. And watching the freely changing patterns of water tends to free our minds to flow in simple appreciation of the moment. Watching a fire has a similarly spellbinding effect, so some artists have crafted pieces that are consumed by fire as an audience watches.

Whereas *Fountain Sculpture* invokes free time through the unpredictability of natural forces, some works involve the unpredictability of human behavior. One quality that sometimes affects public art is vulnerability to destruction. The miniature dwellings that Charles Simonds built on New York's Lower East Side (Figs. 1.5 and 1.30) so fascinated the children of these poor neighborhoods that they tried to protect them from vandalism. But sooner or later, all were destroyed. The longest-lived, in an inaccessible location, lasted five years. Simonds accepted the temporary nature of his works, for he chose to construct

10.14 James Fitzgerald. Fountain Sculpture. 1961. IBM Building, Seattle. 5,000 pounds of black bronze, 24' (7.32 m) high, fountain with 40 tuned nozzles, activated by a 350-gallon pump. Photo John Schoettler, Seattle, Washington.

FREE TIME | 187

them in such a way that they could not be moved and then he left them for the whole community to enjoy. That they were destroyed became part of the saga of the "little people," the imaginary ones for whom he built. Despite the violence to which the miniatures were subjected, the mythical little people survived by moving through the city, always rebuilding. Their determination to survive despite the presence of danger became a symbol of hope for the people of the ghettos who followed their trail.

10.15 Adrian Piper. Installation view from the exhibition "Dislocations." October 16, 1991, through January 7, 1992. Environmental installation with lights, mirrors, four videodisks, and music soundtrack. The Museum of Modern Art, New York.

Another aspect of human behavior that may enter into artwork is willingness or unwillingness to participate. How long did viewers watch Adrian Piper's installation videotape of an African-American man repeating over and over, "I am not a thief; I am not scary; I am not sneaky; I am not shiftless"? The seats for this "show," depicted in **Figure 10.15**, were uncomfortably hard; the video was small and isolated from the bleachers. Yet this repetition of denials of racial stereotypes in a seemingly sterile environment clearly registered itself on the audience's memory. Long after viewers departed, their minds continued replaying the scene and the statements again and again, pondering them, considering their individual response to the statements. The experience lasted far longer in time than the number of minutes a viewer sat watching it.

Although people readily set mobiles into motion or push buttons designed to activate kinetic sculptures, they may be reluctant to become actively involved as part of a work of art. Street theater is an example of an art form that depends partly on viewer participation, which can be provoked but never counted upon. When we are faced with a novel situation, who knows how we will act? When invited to participate actively, we may avoid getting personally involved in unusual experiences for fear of appearing foolish to others or of learning something new about ourselves. We humans tend to have a herd mentality; many of us are reluctant to plunge into novel situations until others do so first. Art that operates in free time in which the unpredictable variable is human behavior therefore depends on free people in order to work.

In general, the freest people are children. Chicago's Millennium Park has proved so captivating to children that their happy interactive participation becomes an integral part of the works created there by well-known artists. Children gleefully play in Jaume Plensa's *Crown Fountain*, in which a huge, continually changing display of faces of Chicago citizens spews forth a stream of water. But people of all ages cannot resist walking around the bean-shaped *Cloud Gate* by Anish Kapoor (Figure 10.16) to see themselves and the Chicago skyline—including the illuminated buildings at night—reflected in distorted ways by the contours of the piece. Many people roar with laughter as they watch their weird reflections. The piece becomes a living, breathing thing, changing with the weather, the time of day, the number of people around it, and how they respond.

10.16 Millennium Park, Chicago. July 2004. Showing (left) Anish Kapoor's Cloud Gate, and (right) the Jay Pritzker Pavilion band shell and trellis, designed by Frank Gehry. Photo City of Chicago/Peter J. Schutz.

FREE TIME | 189

TIMELESSNESS

All art is finite—it exists only a certain amount of time before it decays or otherwise comes to an end. Some works are created in materials designed to withstand the ravages of time, such as marble, but nothing made by human beings is truly permanent. There are ways, however, other than the permanence of an individual piece by which art can transcend chronological time.

One of these is classical appeal. Certain designs last through time because they transcend contemporary aesthetic trends to express more universal standards of beauty or truth. Throughout this book, we have shown numerous very old works that still stand today as examples of good design. In Chapter 4, for instance, we admired not only Michelangelo's *David* (Fig. 4.20), sculpted 1501–1504, but also the figure called *Gudea Worshiping* (Fig. 4.17), created around 2100 Bc. We don't think of Michelangelo as only a Renaissance artist; we think of him as a consummate artist whose work will always be loved. Some more recent works have also outlasted our society's tendency toward short-lived fads. Mies van der Rohe's lounge chair (Fig. 10.17)—called the *Barcelona Chair* because it was first shown at the Barcelona Fair in 1929—is still being manufactured. It is already referred to as a classic since its beautiful lines, textural contrasts, pleasing proportions, and elegant workmanship have kept it in demand.

In contrast to the long-lived method of transcending time, certain interactive pieces are outside of time in the sense that they do not exist until someone becomes involved with them. Nan Hoover played video projections of light phenomena across the walls of her installation piece *Movement from Either Direction*. But the piece did not really come to life until a viewer walked into it, adding his or her own shadows (Fig. 10.18). The more the viewer moved around, the more active the piece became. The viewer's intervention thus became an important part of the work. The work did not exist in its "completed" form until someone stood before it, and each time a different person was there to complete the work, it was different.

Finally, much art presents us with the opportunity to transcend time by becoming so fully involved with a work that we forget ourselves, lose track of the passage of time, and experience the vastness of the moment, beyond time. This is an inner experience that cannot be represented in a photograph. But to get some idea of what can happen, consider Beth Galston's *Lightwall* (Fig. 10.19). The installation consisted of two panels of mirrored Plexiglas strips, one on the uneven floor and one suspended from above. Four light projectors trained on the strips created reflected linear patterns on the walls that changed subtly through time as a computerized dissolve unit changed the lights. When people entered the installation, the reflections played across their bodies. The combined effects had the potential for lifting participants out of their normal consciousness and into a world in which space and time took on entirely different dimensions. Lois Tarlow described some typical responses:

10.17 Mies van der Rohe. Barcelona Chair. 1929. The Knoll Group, New York, New York.

Visitors entering the dark room invariably uttered sounds generally reserved for fireflies and falling stars. They approached the strips tentatively, uncertain as to whether they were connected by invisible barriers. Finding easy access, the viewers roamed among the free-hanging mirrors, thereby jostling them and causing the streaks on the walls to lurch about wildly. People spoke in hushed tones. One young man said, "I'd like to live here forever."

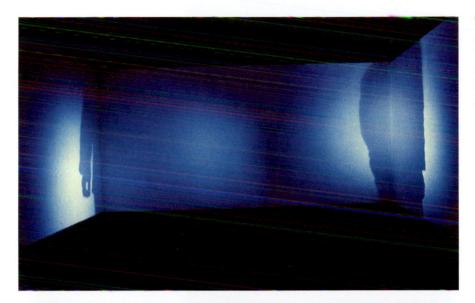

10.18 Nan Hoover. Movement from Either Direction. 1995. Video installation. Bonn, Kunstund Ausstellungshalle der Bundesrepublic Deutscheland. Photo © 1998 Nan Hoover.

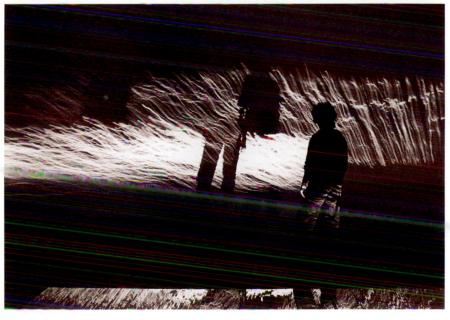

10.19 Beth Galston. Lightwall. 1983. Mirrored Plexiglas strips, projectors, computerized dissolve unit. Size of gallery space: $35 \times 35 \times 12'$ (10.68 \times 10.68 \times 3.66 m). Installation at Kingston Gallery (collection of the artist).

⁴ Lois Tarlow, from Beth Galston, "Alternative Space," *Art New England*, June 1984, p. 6.

CONSTRUCTION METHODS

FOUND OBJECTS

FOUND OBJECT IS ANY OBJECT not originally created as a work of art but appreciated for its aesthetic qualities or personal meaning. Can there be anyone who has not regarded some kind of found object as a treasure? We pick up rounded stones or shells at the beach, enjoying the way they look and feel, and perhaps we keep some for luck or display. A colorful feather found on a path seems worth saving, though we may not know quite what to "do" with it. Some of us dig through old dumps for antique medicine bottles, admiring the aesthetic qualities of the handblown glass. Weathered old tools may be appreciated for their interesting forms and textures. Semiprecious stones such as amethysts, rock quartz crystals, and onyx are often displayed in their uncut natural state because of the beauty of their colors or transparent clarity.

The appreciation of found treasures seems universal. Throughout human history, people have carried this love for the beauty and personal meaning of non-art objects into statements now considered to be art forms. This use of found objects is the first of four major "construction" methods considered in these final chapters.

In some cases, no construction is involved at all; a found object is simply considered worthy of interest in its own right. Sometimes a base is fabricated using art methods and media, and then found objects are somehow woven, braided, tied, glued, or otherwise fastened to it. Or found objects themselves may be transformed or assembled to create a piece in which the original identity of the objects is a meaningful or humorous counterpart to the overall form. In any case, the primary talents the artist brings to these works are an eye for design in unexpected places and imagination in envisioning how found things could be worked or put together.

INDIVIDUAL FOUND OBJECTS

Nonindustrial societies living close to the earth learn to watch for natural objects that can serve useful functions. Although the objects themselves are found rather

than made for the intended purpose, they may be decorated to add an artistic dimension to everyday experiences. The bush people of Southwest Africa find an ostrich eggshell a perfect container for precious drinking water and may carefully engrave and paint ornamental lines on its surface (Fig. 11.1).

Some natural objects are prized simply for their beauty or design interest. When such found objects are not portable, viewers may travel to see them. In the fishing village of Yehliu in Taiwan, erosion of the local sandstone by wind and water has produced fantastic natural sculptures such as the *Queen's Head* shown in Figure 11.2. The "head" consists of harder rock than the more eroded

11.1 Ostrich eggshell drinking vessels decorated by bushmen of the Kalahari. © Peter Johnson/Corbis.

11.2 Queen's Head. Yehliu, Taiwan. Naturally eroded rock formation. © Free Agents Limited/Corbis.

11.3 Marcel Duchamp. Photograph of Bottle Rack (no longer extant) from Boite-en-valise (Box in a Valise). 1941. The Museum of Modern Art, New York, James Thrall Soby Fund.

"neck." The resulting formation bears a great resemblance to the sculptures of Alberto Giacometti (Figures 6.7 and 8.7). Travelers and scholars who have found or seen these natural sculptures refer to them as "national treasures."

Marcel Duchamp is credited with the discovery that manufactured objects such as industrial bottle racks (Fig. 11.3), bicycle wheels, snow shovels, or even urinals can be appropriated and displayed as "ready-made" art. Even without embracing Duchamp's complex and ironic Dadaist aesthetic, we can appreciate the design principles involved in found objects, such as the rhythmic repetition, use of both inward- and outward-directed lines, and changing proportions of the tiers of the manufactured bottle rack. Many of us therefore follow Duchamp's lead in bringing manufactured objects into our homes for uses other than their original functions.

ASSEMBLAGES

When everyday non-art materials are combined to create a work of art, the result is often called an **assemblage**. Some such works are used for special spiritual functions, for the personal or group meaning attached to each thing adds to the spirit of the whole. A handmade quilt may enhance a family's sense of historical kinship, for each bit of fabric may recall incidents in family history: "This one was from the dress Carrie wore the first day of school; this was John's christening dress; here's a scrap of your mother's wedding dress. . . ." Likewise, to put together found objects representing earth, air, water, and fire brings the artist into symbolic contact with the universe.

In African tribal cultures, assemblages of found materials are amassed for ritual display and power-enhancing purposes. Objects attached to masks, headdresses, or power figures like the piece shown in Figure 11.4 may carry symbolic social significance—indicators of wealth and status, for example—as well as invoke the aid of supernatural forces. Cowrie shells connote wealth, for the shells are used as money in many of these groups. The shells also have intriguing tactile and visual qualities, with a combination of surface smoothness and dark hidden inner recesses that many cultures have linked symbolically with femaleness.

The design of a ritual display or power piece may be sufficiently informal that it can be added to as time passes and additional materials are found. These range from skulls of small animals, teeth, seed pods, shells, fur, feathers, and claws to mirrors, nails, beads, and shotgun shells, with an emphasis on repetition of many small units. In the accretion of materials, the prevailing feeling seems to be "the more, the better," and many people may bring found objects to the piece over time, giving it a variety of textures and forms and a lively organic appearance of growth. Each addition brings a different kind of spiritual power—as well as form and texture—to the piece. The addition of new mate-

11.4 Fetish figure. Wood sculpture, Zaire, Congo. Height $23^{1}/8''$ (58.8 cm). The Metropolitan Museum of Art, The Michael C. Rockefeller Memorial Collection, bequest of Nelson A. Rockefeller, 1979.

rials is often accompanied by special chants and spreading of dried blood or the like on the piece to honor and increase the magical powers being drawn into the sculpture. Even if we are not privy to the symbolism involved, we may find such a piece visually and psychologically exciting. It raises questions for which the mind has no answers: Why? How? Where did they get those?

Assemblages may also express devotion. In Naples, devotion to various saints as intermediaries between the individual and heaven is often expressed in homemade roadside shrines. Whatever is available to enhance the love offering is incorporated into the design, from bits of ironwork, plastic, and sculpture to flowers, candles, and even neon lights. Continual additions to such pieces allow the person to maintain a sense of personal contact with the divine. The shrine in Figure 11.5 includes a skull, perhaps as a reminder that things of the earth are fleeting and that earthlings should keep their vision set on the eternal.

The local emotional response to such pieces, be they tribal sculptures or Catholic shrines, stems from a shared spiritual tradition that everyone in the area understands. An outsider untutored in these beliefs may nevertheless experience a certain aura of mystery or sacredness surrounding these assemblages, as though they awaken deep-buried memories from what psychologist Carl Jung called the "collective unconscious." Be that as it may, certain artists can evoke the sense of sacrosanct mysteries without referring to any tradition with which we are familiar. Lucas Samaras's *Untitled Box Number 3* (Fig. 11.6) creates such an effect by suggesting a hidden, secret place. Found materials are used as though collected by a bird to create a nest of sorts, woven of bits of wood and bristling with thousands of pins. The frayed twine dangling below is strangely out of scale for a nest, but its outsized appearance makes it all the more noticeable as something found and brought to this creation. The stuffed bird nestles within, protecting a dark and secret space into which we feel we should not intrude.

JUNK SCULPTURE

Our affluent society's tendency to throw away used objects rather than reuse or recycle them has opened fertile new ground for artists. Sometimes in protest against wastefulness, sometimes in delight at finding creative uses for castoffs, a number of artists turn what is considered junk into assemblages that work as art.

In some **junk sculpture** assemblages, the discovery that a castoff resembles something entirely different is both the artist's motivation and the viewer's surprise. In Picasso's *Baboon and Young* (Fig. 11.7), our interest is suddenly captured when we notice that the baboon mother's head is actually a toy car. The relationship between these two forms is totally unexpected, an altogether original perception. That it works so well—with the back tires enlarged as ears—is a tribute to Picasso's imagination, his gift for seeing possibilities in even the most mundane materials.

Sometimes a number of found objects are put together in such a way that the combined image suggests another form. In Richard Stankiewicz's hands, old bedsprings and coiled springs are transformed into grotesque representations

ASSEMBLAGES | 197

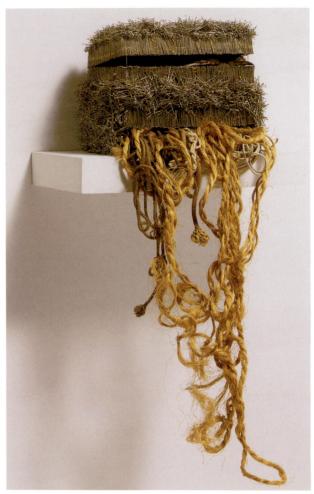

11.5 Roadside shrine, Naples. 1948. Stucco and marble, height 2'6" (0.76 m). 1978 photograph in Rhode Island School of Design Museum. Photo Salvatore Mancini, Providence, Rhode Island.

11.6 Lucas Samaras. *Untitled Box*Number 3. 1963. Pins, wood, rope, and stuffed bird. Overall (approximate): 27 × 10 × 10"

(68.6 × 25.4 × 25.4 cm). Collection of Whitney Museum of American Art, New York. Gift of the Howard and Jean Lipman Foundation, Inc., 66.36a-b.

of the lacy veil and tender curls of *The Bride* (Fig. 11.8). Stankiewicz began making junk sculptures when his attempts to turn his yard into a garden unearthed a quantity of old metal objects. The artist said he found them so "beautiful" in themselves that he "set them aside as objects to look at . . . , and of course it was only a short step of the imagination to combine various of these things together to make compositions from them." Making abstract peoplelike figures from unwanted machine parts inevitably prompts symbolic associations, as though these grotesqueries are apt metaphors for the human inhabitants of industrial society. As Stankiewicz noted, "Visual puns, mechanical analogies and organic resemblances in machinery provide a large and evocative vocabulary for sculpture." It is a vocabulary that may evoke humor or despair, depending on the intention of the artist and the psychology of the viewer.

Although the junk of our civilization often inspires works with a busy variety of lines, forms, colors, and textures, it is possible to create quietly simple art from found objects. An example of this approach is Varujan Boghosian's *Orpheus*

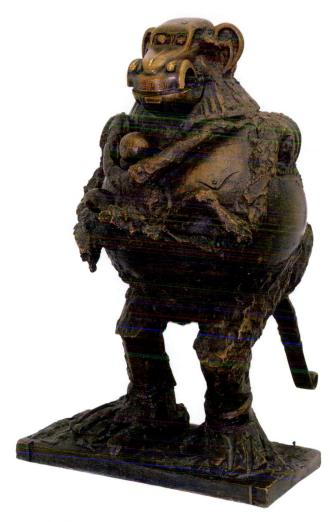

11.7 Pablo Picasso. *Baboon and Young.* 1951. Bronze (cast 1955), after found objects, $21 \times 13^{1}/4 \times 20^{3}/4$ ". Mrs. Simon Guggenheim Fund. (196.1956). The Museum of Modern Art, New York. © Digital Image. © The Museum of Modern Art/licensed by SCALA/Art Resource, New York.

(Fig. 11.9), in which only two found objects—an old doll and a vise mounted on a piece of wood—are used to create a wealth of symbolic or psychological associations. With the title as a clue to the content, we can imagine the legendary Orpheus as a figure from the sunlit world traveling into the darkness of Hades to rescue his wife, Eurydice. The vise holding the doll in place may suggest Orpheus's attempt to avoid turning back to look at Eurydice until she reaches the sunlight. Those who are unfamiliar with the myth may experience other associations: the dreamlike sense of a past remembered; the pathos of a once-loved but discarded child's toy, juxtaposed with and even being held captive by an adult's tool, itself hand-worn. In another sense, the vise becomes more than a vise; it becomes part of the body of the doll, or even a pedestal for it. Striking also is the contrast of the doll's lightness to the darkness of the wood.

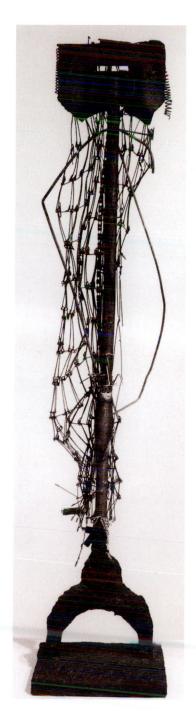

11.8 Richard Stankiewicz. *The Bride*. 1955. Steel, $5'9'' \times 14'' \times 13''$ (175.3 \times 35.6 \times 33 cm). Private collection.

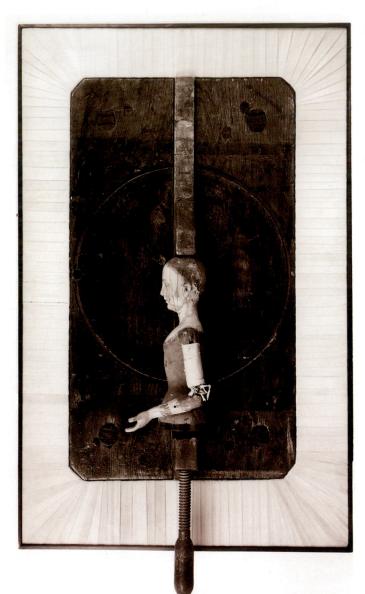

11.9 Varujan Boghosian. *Orpheus.* 1973. Wood and cloth. $41^{1}/_{4} \times 26^{1}/_{4} \times 9$ ". Courtesy Berta Walker Gallery, Provincetown.

11.10 John Chamberlain. *Acme Thunderer.* 1989. Painted, stainless, and chromium-plated steel, $9'4^3/4'' \times 8'8^1/4'' \times 6'1^3/4''$. Photo courtesy The Pace Wildenstein Gallery, New York.

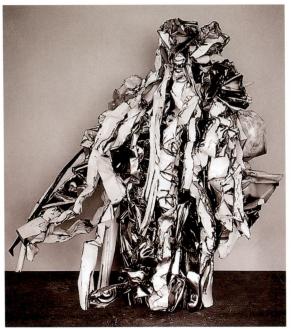

Whereas found objects offer great potential for representational allusions, certain artists present junk as abstract sculptures to be appraised solely on the basis of their design characteristics. John Chamberlain scavenges used car bodies from junkyards and then cuts, paints, twists, mashes, and welds the pieces together into sculptures such as *Acme Thunderer* (Fig. 11.10). Chamberlain walks among rows of color-sorted parts in his studio, waiting for his eye intuitively to match pieces that somehow belong together. He has explained this way of working: "If I find two things that go together for me at the moment, then I've got something started. I don't understand it too much myself. I'm more interested in seeing what the material tells me than in imposing my will on it. You have to know when to stop."

 $^{^{1}}$ John Chamberlain, as interviewed by Ken Johnson for "Of Industry and Intuition," Art in America, April 1991, pp. 132, 134.

The reflective surfaces and lines formed where the bare metal is exposed continually play off one another. In Chamberlain's hands, old cars undergo a metamorphosis into sculptures of strange beauty; nothing suggests the tragedy of a terrible car accident. This metamorphosis is often the aim of the junk sculptor. To make something from scratch is an act of creation; to reclaim things that no one wanted and turn them into art is an act of salvation.

INSTALLATIONS

In the growing genre of installation pieces, many artists are using found objects to present their message. These may be purchased ready-made items rather than discarded artifacts. The aesthetics of their use requires an eye for how something might be used in an entirely different context and what it might do if juxtaposed with something else.

Choice and placement of found objects become important, if subtle, parts of how an installation piece works. Jessica Stockholder playfully put found objects such as a small radio, plastic crates and baskets, dinner service, and table into a semblance of their originally intended usage, set up as a living room of sorts with chairs and artworks contributed by other artists, but she splashed the found objects with bright paint hues, unifying the pseudo-domestic installation as a rather humorous aesthetic experience, entitled *Table Top Sculpture* (Fig. 11.11).

11.11 Jessica Stockholder. *Table Top Sculpture*. 2003. Installation Gorney Gravin and Lee, New York. © Jessica Stockholder, courtesy Mitchell-Innes & Nash, New York.

INSTALLATIONS | 201

Even though found objects may be individually identifiable in an installation piece, the statement they make together may still leave a lot of room for interpretation. In many cases, knowledge of certain cultures or historical events broadens the field of possible interpretations. For the piece shown in Figure 11.12, Braco Dimitrijevic gathered as found objects René Magritte's painting Le Beau Ténébreux, the black hats and coats of Hasidic Jewish men placed atop white pedestals, and apples. There are obvious references to Judaism here, including the apple of the biblical story of Adam and Eve, but what is the relationship of the clothing and apples to Magritte's painting, in which a man's disembodied face appears within a top hat? Magritte once painted an apple so huge that it fills a room. Does it help to be familiar with that painting? Does it help to know that Magritte wore a suit when he painted? What is the symbolic meaning of the coats and hats to traditional Hasidic Jews? The installation, Hopes and Ways to Identity, is surrealistic, yet we get the distinct sense that there is some symbolic meaning in this dream. It lies just beyond the level of consciousness, and we are invited to bring all our associations to the task of figuring out what is going on here.

As we unravel the conceptual reasons why an artist has chosen to juxtapose certain found objects, we discover strong political statements in many contemporary installations. In David Hammons's *Public Enemy* (Fig. 11.13), the viewer is placed outside police barricades and sandbags but within a space lit-

11.12 Braco Dimitrijevic. Triptychos Post Historicus, or Hopes
and Ways to Identity. 1990. Part
1: René Magritte, Le Beau
Ténébreux, 1950. Part 2: Coats
from Mea She'arim, hats gift of
David Redberg, Jerusalem. Part
3: Apples. Gift of the artist in
memory of Jacques Ohayon.
Photo © Israel Museum/
Avi Ganor.

11.13 David Hammons. *Public Enemy.* 1991. Photographs, balloons, sandbags, guns, and other mixed media. Photograph © Scott Frances/Exto.

tered and enlivened with the debris of a great parade. In a cordoned-off area are photos of the four sides of the statue of Theodore Roosevelt triumphant on a horse, while a Native American and an African American walk alongside on foot. The first impression of celebration is gradually replaced with other emotions, as we discover secondarily that there are guns here—some toy, some real—trained on the figures, and that we are on the side of those who have created and armed the barriers.

A final motivation for the use of found objects is sheer exuberance for life in all its forms. Simon Rodia's *Watts Towers* (Fig. 11.14) is a monumental expression of this all-embracing aesthetic. Trained in tile setting but unschooled in art, Rodia spent 33 years creating his marvelous towers from a framework of concrete and wire mesh, covered with a rich mosaic of found objects: glass from broken bottles, shells, mirrors, tiles, shards of dishes. The airy structures rise almost 100 feet into the Los Angeles sky, assertions of the grandeur and dignity

11.14 Simon Rodia. Watts Towers,
Los Angeles. 1921–1954. Concrete and steel with bits of glass,
broken dishes, shells, pieces of
mirrors, and other debris from
the streets. Height of tallest
tower 99'6" (30.17 m). © Michael
Newman/Photo Edit.

of the spirit no matter how oppressive the surroundings. At close hand, as in the foreground of the photograph, the objects' individual identities can be distinguished. But from a distance, they merge into exuberant abstract patterns of color and form. Whether a work is seen as "naive" folk art or the intentional choice of a formally trained artist, the ability to appreciate the design possibilities of whatever is at hand is a compelling motivation for the construction of works from found objects.

ADDITION AND 12 MANIPULATION

HEREAS FOUND OBJECTS are often used as is, other techniques for three-dimensional construction involve changing the form of the original material. The techniques explored in this chapter are based on manipulating forms directly without significantly changing their physical volume and/or putting units together to create a larger whole. The two remaining chapters focus on methods of subtracting excess material to reveal a smaller form or creating desired forms through less direct casting processes. These categories are not mutually exclusive, for many pieces are constructed by a combination of various methods. In addition, the same material may also be handled in a number of different ways. Wood, for instance, may be built up in units for additive sculpture or carved away by subtractive methods.

MANIPULATING MALLEABLE MATERIALS

One very direct method of working three-dimensionally is shaping **malleable** materials by hand or handheld tools. These are media that are pliable enough to be stretched, flattened, bent, curved, or twisted without falling apart. Their ability to be worked in these ways is often referred to as their **plasticity**. In the long run, plasticity is not usually considered desirable, so these media are typically worked in a soft state and then hardened for durability.

To create additive sculptures with malleable materials is to build up forms in space. This may be done directly, as in the classic Mayan urn shown in Figure 12.1, with relatively thin expanses of clay modeled with hands and tools and then fired to hardness. The building up of forms does not always require kiln firing. An artist may begin with an underlying armature of a stiff material such as wood or metal, then cast the piece in metal such as bronze. (Casting techniques are discussed in Chapter 14.) Certain metals will support extensions from the central mass; an example is the lovely twelfth-century Indian bronze

12.1 Urn incensario (incense burner). Ruler seated on deity head with figure seated on monster head, Tabasco, Mexico.
Classic Mayan, AD 250-900.
Unslipped buff earthenware, 16 ½" (40.8 cm). Indianapolis Museum of Art, The Wally and Brenda Zollman Collection of Pre-Columbian Art. K3097.
Photo © Justin Kerr 1985.

12.2 Kaliya Krishna. Chola dynasty, 12th century. Bronze, 2'11'/4". Government Museum and National Art Gallery, Madura, Tamil Nadu, India. © Giraudon/Art Resource, New York.

shown in Figure 12.2. The traditional way of building up forms additively is to envision and model the major underlying forms in space and then elaborate the secondary contours on the surface.

Clay

Clay is a highly plastic material that has been used for three-dimensional construction since ancient times. This medium is pliable enough to be shaped between the hands when wet, yet becomes hard and relatively durable when fired. It can be glazed to a variety of finishes. Clays are found as natural deposits resulting from the disintegration of certain kinds of rock, each differing in characteristics such as plasticity, color, texture, and behavior when fired for hardening purposes. Artists who use clay often mix their own **clay bodies** from various types of clay in order to get just the properties they want. Their contact with the clay is quite intimate and direct, for the traditional method of building or throwing a form on a wheel is a distinctly hands-on experience with the material. As potter Minnie Negoro (shown at her wheel in Fig. 12.3) explained:

You have to like the feel of this very plastic malleable material. It's a sense on your fingertips, moving in and out. When you can control this, when you have the ability to make the clay move just the way you want it to, it's very personal. And since clay is a material that you

12.3 Minnie Negoro throwing on a wheel. Photo Beverly Dickinson. Courtesy Minnie Negoro.

can compound yourself of different kinds of clays to make the textural feel you want, that becomes very important. Before it's even fired, when it's still in the raw state, you can get that kind of feel that you like to use. You can have it just as smooth and silky or grainy and rough as you want, and then apply force to it to create the form you have in mind ¹

Although throwing a pot on a wheel is a very direct method of shaping in the sense that the artist's hands guide the growth of the pot from the bottom up, the skills involved are anything but spontaneous. The procedure of clay compounding, firing, and glazing is highly technical and subject to endless experimentation. To create a classical, symmetrically rounded form takes great control, developed over years of practice. Clay directly and honestly mirrors the movements of the human hand.

Wheel-thrown forms may be cut, reshaped, or otherwise manipulated into nonsymmetrical forms. There are numerous other means of working clay, such as pinch, coil, slab, and direct modeling techniques. These methods may rely heavily on chance and the inspiration of the moment, or they may involve considerable planning and control, depending on the intent of the artist. Peter

¹ Personal communication to coauthor, October 1985.

Voulkos used pottery techniques imaginatively to create a huge body of vigorous ceramic sculptures. In his seven-foot-high (2.13 m) *Gallas Rock* (Fig. 12.4), he pushed clay to a great height by stacking around a central support about 100 slab-formed and wheel-thrown pieces opened "to let the dark out." Although Voulkos worked very quickly and spontaneously, his ability to create such a technical tour de force came from years of experience and experimentation with clay.

Whether they emphasize control or happenstance, artists have often chosen to work in clay because of its immediacy. Sometimes clay is used to capture an idea that will later be translated into some more permanent material. If it does not need to be fired for permanency, clay can be built up as a solid mass, with bits added and molded as needed. Models for new cars—both outer bodies and interiors—are typically developed through a series of clay studies, such as the one shown in Figure 12.5. Auguste Rodin created quick clay studies of his models as they moved through his Paris apartment to capture their natural movements, later to be sculpted more permanently in the slow method of carving marble.

Clay is also used as a permanent medium for modeling figures. Luca della Robbia's *Madonna and Child* (Fig. 5.20) was modeled of terra-cotta back in the fifteenth century, but it survives in good shape today. This lovely piece is not very thick, because it is a relief. But when clay is used to model thick forms,

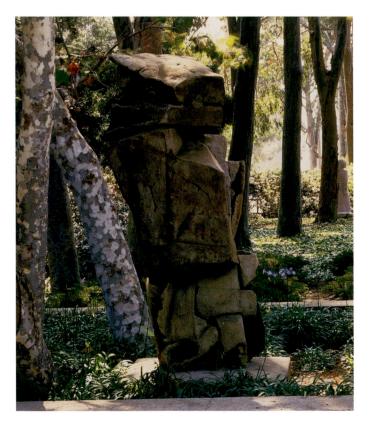

12.4 Peter Voulkos. Gallas Rock. 1960. Terra-cotta, height 84", width 37", depth 26 3/4". Franklin D. Murphy Sculpture Garden, University of California, Los Angeles. Gift of Julianne Kemper, 1973. Courtesy UCLA Wight Art Gallery.

12.5 Preparing a clay model for a bucket seat for General Motors. Photo © Dick Durrance, 1986/Woodfin Camp & Associates, New York.

they must be built hollow or hollowed out with an air hole left to the inner cavity before firing, for a thick piece may burst in the kiln when fired. Clay has little strength under tension. And because of its plasticity, clay succumbs rather readily to the tug of gravity. Projecting forms, such as arms held out from the body, are particularly vulnerable. Large works must be carefully supported by an internal armature to avoid unintentional sagging or breaking. The size of works to be fired is also limited by the relatively small size of most kilns. Large works may be created in sections, hollowed, fired, and then reassembled.

Large ceramic works are not uncommon now that ceramists have begun exploring the far boundaries of what can be done with clay. Tom McMillin used a forklift to compress clay and rammed earth into wooden forms and then coated them with charcoal so that the large sculptures (Fig. 12.6) became their own kiln as they were fired in place.

Firing (baking to remove moisture and harden the clay) and **glazing** (application of a glasslike liquid that fuses with the clay when fired) require extensive knowledge of complex variables. Most pieces are first fired for several hours at relatively low heat to harden the form but keep the clay porous enough to receive a glaze. This **bisque** ware is then glazed and refired at a higher temperature.

Glazes are used decoratively and also serve the function of making ceramic pieces watertight and nonabsorbent. Glazes carry pigments to color the surfaces of a piece; they can be brushed, poured, or sprayed on, or the piece can be dipped into a container of glaze. The minerals used to formulate them and their proportions within the formula can be varied for different effects.

In ancient work with clay, pieces were baked directly in the coals of a fire or in covered pits. The contemporary **kiln** is an insulated furnace for firing

12.6 Tom McMillin, in the process of building rammed earth and clay sculpture to be fired in place with a coat of charcoal. From Susan Peterson, *The Craft and Art of Clay* (Englewood Cliffs, N.J.: Prentice Hall, 1992).

Photo Susan Peterson.

ceramic pieces that is heated by electricity or by a wood, coal, oil, or gas fire in a separate combustion chamber. Control and even distribution of the heat are critical. **Earthenware**, which uses coarse clays such as terra-cotta to create rough-textured, porous pieces, is fired at a relatively low temperature (about 800° C, or 1470° F). **Stoneware**, made from finer clays, is fired at a higher temperature to form a more glasslike body. **Porcelain**, made from the finest clays, is fired at the highest temperature (up to 1613.4° C, or 3000° F).

Wax

Another highly plastic medium is wax. Warmed slightly for softening, sometimes just by being rolled in the hands, it can withstand a great amount of twisting, bending, and reforming without breaking. Additional pieces can easily be attached to a form in the building-up process. The artist presses dabs of wax in place or heats both surfaces with a hot tool to allow them to bond without the misshaping of pressing. Like clay, wax can be smooth- or rough-textured in its final form. Edgar Degas did a series of small wax sculptures, such as for the horse shown in Figure 12.7, in which he did not fully smooth the dabs of wax into the figure's contours. In addition to creating interesting textures, the wax pieces increase the liveliness of the figure by conveying a sense of spontaneity, as though the work came so recently from the artist's hands that we can still see his thumbprints. These wax figures were later cast in bronze—wax

12.7 Edgar Hilaire Germain Degas. *Statuette: Horse Galloping on Right Foot.* c. 1881. Bronze cast of wax model, height 11⁷/8" (30 cm). The Metropolitan Museum of Art, bequest of Mrs. H. O. Havemeyer, 1929. The H. O. Havemeyer Collection.

melts too easily to hold its shape in warm weather—and the cast retains the fresh quality of the way Degas handled the wax.

Plaster and Cement

Plaster and cement can also be built up directly with the hands and simple hand tools, though they need a supporting understructure to hold projections or curving contours. Materials commonly used to build up the armature include wire, rods, screening, hardware cloth, metal lath, wood, and foam. Plaster or cement is usually applied to this base in wet layers and finished wet. Rodin's plaster Young Woman in a Flowered Hat (Fig. 12.8) shows obvious signs of having been gouged with pointed tools when the plaster was wet to create textures such as strands of hair and herringbone weaving on the hat. These materials can also be allowed to dry and then chiseled or filed away. Pigments can be added to the mixture for color, and filler materials such as sand, fine gravel, or marble chips may be added to the final layer to produce desired textural effects. Plaster has little tensile strength and may crack when it is worked dry or may chip afterward. But its low cost and flexibility make it an inexpensive choice for pieces to be used indoors or patterns for projects to be cast or otherwise translated into more durable media. Concrete is somewhat more coarse, but this characteristic is appropriate for certain large, simple outdoor forms.

12.8 Auguste Rodin. Jeune femme au chapeau fleuri (Young Woman in a Flowered Hat). 1865–1870. Plaster, $27 \times 13^{1/2} \times 11^{5/8}$ " (0.69 \times 0.344 \times 0.295 m). Musée Rodin, Paris. Photo Bruno Jarret, Paris.

Malleable Metals

Some metals, though not pliable enough to be shaped by the artist's hands alone, are nonetheless sufficiently malleable to be formed by bending, stretching, twisting, and hammering over a hard flat or shaped surface. As metals are worked, they become harder and therefore less malleable, a condition that can be reversed temporarily by heating, a process called **annealing**. Metals and alloys, or combinations of metals, vary in physical characteristics. In metals, **malleability** is the ability to be shaped readily by hammering; **ductility** is a property permitting the metal to be drawn out into wire or threads. Hardness is measured by the depth of a scratch that can be made on a metal by a weighted diamond point. The table on the next page summarizes variations in these three properties for some common metals.

Metalsmiths and jewelry makers use a variety of tools and techniques to change thin sheets or rods of the relatively soft metals into desired forms and surface textures. Thin wire can be bent into desired shapes; thicker metals may be struck with a variety of tools, each of which leaves its own shape as an impression in the soft metal. In jewelry, **repoussé**—hammering thin sheet metal from the back, using a variety of punches—creates low relief patterns on the front side. These patterns may be further worked from the front with hammer and punches, a process known as **chasing**. The artist in **Figure 12.9** is using the process of **raising**—hammering a flat sheet of metal over a stake, compressing it to create a hollow form. The finished piece can then be left with the texture created by the hammer, or filed and polished to a high finish, as in his *Vase and Bowl* (**Fig. 12.10**).

12.10 Douglas Steakley. *Vase and Bowl.* Vase: silver-plated brass, height $7^{1}/2^{n}$ (19 cm); bowl: copper, raised with oxide finish, height $4^{1}/2^{n}$ (11 cm). © Douglas Steakley.

12.9 Artist Douglas Steakley raising a piece of hollowware, © Douglas Steakley.

PHYSICAL PROPERTIES OF METALS

Hardness	Ductility	Malleability
Lead (softest)	Gold (most ductile)	Gold (most malleable)
Pewter	Silver	Silver
Tin	Platinum	Lead
Aluminum	Iron	Copper
Gold	Nickel	Aluminum
Silver	Copper	Tin
Zinc	Aluminum	Platinum
Copper	Zinc	Zinc
Nickel	Tin	Iron
Platinum	Lead (least ductile)	Nickel (least malleable)
Iron		
Steel (hardest)		

Information based on Jack C. Rich, *The Materials and Methods of Sculpture* (New York: Oxford University Press, 1947), p. 129.

Even iron and steel can be reshaped if heated to a relatively malleable state. Long used to create a limited range of functional pieces, blacksmithing is now used as a fine-art technique as well. L. Brent Kington's *Rocking Horse* (Fig. 12.11) is not only a delightful child's toy but also a beautiful study in flowing line and positive and negative form. The techniques used to shape the steel are ancient—forging (hammering over an anvil or other hard surface), chiseling to define contours, and chasing to provide details on the head. What is new here is the increasing freedom artists and craftspeople feel to push their media and methods into previously unexplored aesthetic territory.

12.11 L. Brent Kington. Rocking Horse. 1972. Steel, forged, chiseled, and chased, length 44" (112 cm). Westwood Art Center, Cincinnati, Ohio. Courtesy the artist.

FIBER ARTS

Some of the most exciting redefinitions of the possibilities of specific construction methods are occurring in the **fiber arts**. This label covers all work created by interweaving single fibers of some material to create a larger whole. Conventionally, techniques such as weaving, knitting, and basket-making were used solely to create functional objects. In recent years, artists have ranged far beyond the traditional uses and methods of working with fibers. For example, rugs and tapestries were traditionally flat-woven to warm and decorate floors and walls. Some fiber artists are now bringing these techniques off the walls and into three-dimensional space. As is true in any undertaking, if creativity is allowed to flow freely, the results will be living, changing, and ever-expanding.

Crocheting, once limited to clothing and decorative items, offers the inventive artist unbounded opportunities for creating three-dimensional forms. One solution to making a crocheted piece occupy three-dimensional space is to coat it with some stiffening agent such as lacquer, as Norma Minkowitz did in creating *The Ghost of Icarus* (Fig. 12.12).

Guo Zhenyu used a combination of fiber-joining techniques and stuffed forms to create large-scale rootlike structures in *The Chinese Roots* installation piece (Fig. 12.13). The resulting knotted, entangled, intertwined textural

12.12 Norma Minkowitz. *The Ghost of Icarus.* 1991. Fiber and paint, $22 \times 22 \times 10^{\prime\prime}$. Courtesy the Bellas Artes Gallery, Santa Fe, New Mexico.

12.13 Guo Zhenyu. *The Chinese Roots*. 1999–2003. 13' high \times 66' wide. Also shown, in foreground, Shi Zhongying, *Scene Netting Scene*, 2003. Photo Richard Vine.

12.14 Joyce J. Scott. Big Mama. 1991. Beads, thread, wire, wood, $27 \times 8 \times 10''$ Photo Kanji Takeno. Courtesy the artist.

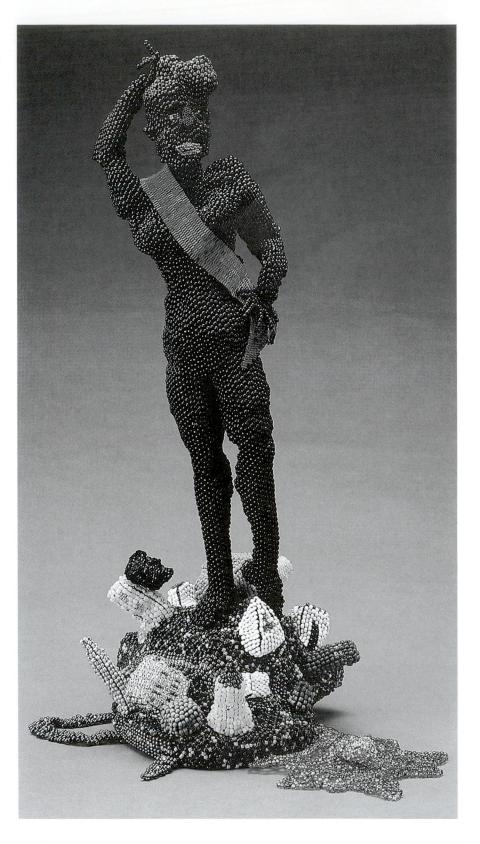

12.15 Hiltrud Schaefer. *Transitoriness and Decay.* 1990–1991. Handmade vegetal paper (various sorts of grass, reed, fern, etc.), bleached, hardened, with stitched-on cane sections, $2.7 \times 5 \times 10$ m. Courtesy Biennale Internationale de Lausanne, CITAM.

12.16 Virginia Gorman. *Ten Walking Jeans*. 1991. Recycled jeans. Photo Debbie Van Blankenship.

effects—a visual evocation of the multiple strands of an ancient cultural heritage—could not have been as effectively achieved in other media.

Beads are usually strung into flat designs, but Joyce Scott threaded them onto thin wire in order to shape them three-dimensionally for her *Big Mama* (Fig. 12.14). Paper is likewise traditionally pressed into flat sheets, but Hiltrud Schaefer fabricated huge sheets of paper by hand and supported them with cane to make a 32-foot-long three-dimensional sculpture suggesting the decay of material objects (Fig. 12.15).

Some fiber arts even negate the classical traditions by which fibers are knitted, knotted, crocheted, pressed, or woven together. In *Ten Walking Jeans* (Fig. 12.16), Virginia Gorman recycled ten pairs of blue jeans by adding a hardening compound. The free-standing openness is a fitting metaphor for the freedom with which artists like Gorman are exploring the design possibilities of fibers.

Contemporary artists are also taking the notion of fiber arts outside the traditional range of fiber media, drawing in materials from other spheres. Anniken Amundsen used fishing line to create an enormous fiberlike installation, *Transition* (Fig. 12.17). The piece creates an unsettling—whether awesome or fearsome—impression of some living and moving thing, be it plant or animal, in the air or under the sea. Almost 20 feet high, such a work entails considerations outside the realm of more traditional fiber arts, such as the need for special installation techniques.

12.17 Anniken Amundsen. *Transition*. 2003. Fishing line, $29^{1/2} \times 9^{1/4}$. Photo Chapman/Forsyth.

12.18 Blowing a glass tube into a vessel.

12.19 Dale Chihuly and assistant (William Morris) prepare to do final shaping of a glass work in its still-hot malleable state. Photo courtesy Chihuly Studio.

GLASS

Glass becomes highly malleable when it is hot, and hard when it is cool. Despite the fragility of their transparent beauty, manufactured glass objects have been made for thousands of years. The glass itself is traditionally made simply of sand, mixed with soda to lower its melting point, and stabilized by an ingredient such as lime. Although the resulting material can be broken, it does not decay, for it is resistant to water, acids, and gases. Substituting lead oxide for the soda produces glass compounds of great brilliance.

Unlike other materials, the silica in sand does not expand much when it is heated and is almost completely elastic. Under heat, it can be cast or modeled into any shape. Glassworkers use a fire—such as the flames of gas jets—that is hot enough to melt glass for working but not so hot that the glass melts beyond control. Often they begin with a tube or rod of glass, rolling it for symmetrical flaring as heat is trained on the area being worked. Blowing into a glass tube causes the heated end to expand (Fig. 12.18). The glass rod or tube can be cut with a glass cutter or by being heated and pulled in both directions.

Glassworking often requires two people, one to handle the rod and one to shape the glass at its end. In Figure 12.19, Dale Chihuly is waiting with a paddle to shape quickly a still-warm glass disk spun out by an assistant. Colors may be added to the glass by dyes or fused onto the exterior as enamels.

Techniques for working and coloring glass were extensively elaborated upon during the twentieth century in the studio glass movement. These advances have made possible such exquisite tours de force as Dale Chihuly's organic sealike forms, such as the piece shown in Figure 12.20.

FABRICATION WITH RIGID MATERIALS

Units of more rigid materials such as wood, metals, plastics, and stone can be assembled into larger wholes. Sometimes these materials are first reshaped to some extent, though their rigidity limits their malleability.

Wood Fabrication

In additive sculpture, woods may be used as lumber milled into standard flat shapes, such as sheets of plywood or two-by-fours. Koichi Ebizuka used milled logs in *Related Effect S-90LA* (Fig. 12.21) but very subtly curved their contours, thus relating them once again to the organic forms of the tree trunks from which they were shaped. Found woods—such as barn boards or weathered driftwood—may be used as the elements have shaped them. Wood can also be steamed to a pliable state and then curved, as in bentwood chairs or the beautifully curving wooden frame of Edward Livingston's *Cradle* (Fig. 12.22). Curving wooden forms can also be created by laminating—gluing thin, flat sheets of wood together—and then sanding them in such a way that their outer surfaces form curving contours, as they do in H. C. Westermann's *Nouveau Rat*

12.20 Dale Chihuly. Green Cobalt Sea Form Set with Red Lip Wraps. 1985. Glass, $4'7'' \times 10'2'' \times 7''$. Photo Dick Busher.

12.21 Koichi Ebizuka. *Related Effect S-90LA.* 1990. Wood and coal. Collection Galerie Tokoro, Tokyo. Photo Tadasu Yamamoto.

12.22 Edward Livingston. *Cradle.*© 1973. Walnut, width 24"
(61 cm), length 43" (109 cm), height 36" (91 cm). Sterling Associates, Palo Alto, California. Photo Edward Livingston, Bly, Oregon.

12.23 H. C. Westermann. *Nouveau Rat Trap.* 1965. Collection Mr. and Mrs. Robert Delford Brown, New York. Photo Nathan Rabin, New York. © Estate of Lester Beall/Licensed by VAGA, New York.

Trap (Fig. 12.23). In this humorous satire on the curvilinear Art Nouveau approach to functional pieces, woods of varying values have been used. These value striations enhance the interest of the design by accentuating the fact that the form has been built up of many sheets of wood rather than trying to make them blend together into a single tone.

Wood is soft enough to be cut readily with tools such as hand and power saws, lathes, and planes. Pieces of wood can then be attached to each other by nailing, gluing, joinery, or bolting. The strength of the joints is critical. In a piece of furniture, the stress of being sat on and pushed around, added to changes in temperature and humidity, may cause joints to separate. Outdoor pieces must bear not only their own weight but also stand up to wind, rain, and perhaps snow loads and the weight of climbing human visitors. The larger the piece, the stronger the joints must be.

If bolts, rivets, screws, or other fasteners are needed, how will they affect the aesthetics of the design? Sometimes fasteners are totally hidden; sometimes they are used as subtle counterpoints or accents to the primary form. Jackie Winsor took a third approach in her *Bound Grid* (Fig. 12.24): The knobby joints created by thick lashing of horizontal and vertical wooden members, and the asymmetrical negative spaces defined between them, become the primary focuses of the piece, rather than the pieces being bound.

Metal Fabrication

With the growing interest in large-scale outdoor sculpture, many artists have turned to metal fabrication. Many metals have great **tensile strength**, a characteristic that allows thin unsupported pieces to span great distances without sagging or breaking. Metal is also highly durable over time; rustproofing methods can be used for those metals that tend to rust. To sculpt with metals, artists have had to learn industrial techniques not traditionally associated with art. To create his machinelike metal sculptures (see *Wind Chant*, for instance, **Fig. 2.18**), John Matt became a skilled machinist and equipped his studio as a

FABRICATION WITH RIGID MATERIALS | 221

12.24 Jackie Winsor. *Bound Grid.* 1971–1972. Wood, twine, $6'3^{1}/2'' \times 6'4'' \times 14^{1}/2''$. Fonds National d'Art Contemporain, Paris. Courtesy of Paula Cooper Gallery and the artist.

12.25 John Scott. Ocean Song. 1990. Work installed at Woldenberg Park, New Orleans, $16 \times 12 \times 12'$. Photo Owen Murphy, courtesy Arthur Roger Gallery, New Orleans.

complete machine shop. To fabricate aluminum strips into works such as *Star Burst* (Fig. 8.17), Linda Howard became a master welder.

Sculptors cut metals using the same techniques as industrial metal fabricators: flame cutting with a torch and mechanical cutting with tools ranging from hacksaws to power handsaws and shearing machines. The basic techniques for attaching one piece of metal to another are welding, adhesives, and fastening devices such as rivets and bolts. **Soldering** and **brazing** are useful for student projects because they use a minimum of heat from a soldering iron or air-acety-lene torch to melt soft solder or brazing rods to fuse joints between relatively thin pieces of metal.

Many works in metal also involve high polishing to create reflective surfaces. The pillars of John Scott's *Ocean Song* (Fig. 12.25) reflect not only the surrounding cityscape but also the wind-driven movements of the circles and rods suspended above them. The result is the visual equivalent of jazz music, referring especially to the "diddlie bow," a single-stringed instrument played with a bow by African slaves in America. For Scott, one of the most compelling aspects of jazz music is "the silence between the notes," so in such works he attempts to evoke that "spatial rhythm, space bridged by movement."²

Plastic Fabrication

Another industrial material whose characteristics are being explored by artists is plastics: synthetic materials that vary considerably in characteristics. The possibilities seem almost limitless, and new plastics are being created continually. Specific plastics may be hard or soft, brittle or flexible, opaque, translucent, or transparent. In *Untitled* (Fig. 12.26), made in the early years of her long art career, Lee Bontecou used the translucency of vacuum-formed plastic to add delicacy to petal shapes, and counted on the thickness of the plastic stem to give an industrial heft to the flower, as if it were a fan with streamers blowing from it. In her view, we are free to form our own associations: "The individual is welcome to see and feel in [these works] what he wishes in terms of himself." This piece—from concept to final shape—is so perfectly in tune with the material it is made from that to change the medium would change the work totally. The sheer organic shapes are striking against the mechanical imagery, and the nature of the plastic allows the light to unite them visually.

Some plastics can be cast in molds. Plastics tend to expand in hot temperatures and to lack the strength of metals. But reinforcing fibers can greatly increase their tensile and impact strength, and individual plastics offer special characteristics not found in other usable materials, such as transparency, corrosion resistance, and light conduction. For example, Larry Bell's *The Iceberg and Its Shadow* (Fig. 8.6) relies on the tintability and optical clarity of clear plastic sheets for its unusual transparency effects.

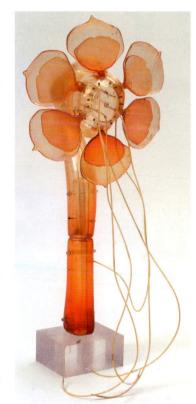

12.26 Lee Bontecou. *Untitled* (flower sculpture). 1968.

Vacuum-formed plastic, 21 × 10 × 9". Copyright © Lee Bontecou/Courtesy Knoedler & Company, New York.

² John Scott, as quoted in Hilary Stunda, "Playing It Straight, Upside-Down, and Backwards: A Conversation with John Scott," *Sculpture*, October 2004, p. 34.

³ Lee Bontecou, quoted in Ann Landi, "Lost and Found," ArtNews, September 2003, p. 115.

Modern plastic technologies allow artists to create almost any form they can imagine. Liquid plastics such as epoxies and polyesters can be poured into nearly any configuration or thickness and still be light in weight. Polycarbonates and acrylics can be shaped into large, thick forms with better optical clarity than glass, with a fraction of the weight of glass. Fiberglass-reinforced polyester resin and fiberglass-reinforced epoxies are so flexible that they can take on any shape or curve; they also are strong enough to be self-supporting and hard enough to take considerable surface abrasion. Foams can span large areas, be formed into huge volumes of any shape, and yet be quite lightweight; some foams are almost indestructible.

Available in many forms such as rods, pastes, tubes, sheets, foams, and films, plastic can be sawed, stamped, sheared, carved, or machine-formed and then assembled by welding, bolting, gluing, riveting, or other mechanical means. For heat-formed shapes, plastic is heated until it is flexible, bent into the desired shape, and held that way until it cools. (Casting, a common way of shaping plastics, is described in Chapter 14.)

Stonemasonry

Although most additive sculpture requires some method of fastening units to each other, artists have in some cases placed units together without bonding them in any way. The hardness and heaviness of stone make it difficult to attach to anything, although stones may be set into mortar to help hold them in place. People living in rocky, stony regions have experimented with additive stone constructions that reach astonishing heights without any bonding agent. Consider the ancient stone construction at Stonehenge (Fig. 5.5). Massive horizontal stone slabs are set across the tops of enormous rough stone pillars. The horizontal lintels are held in place by mortise- and tenon-style joints, and the structure has remained nearly intact for centuries. No one knows how the great stones were moved into position, but once placed, they have shifted little through time.

Equally astonishing is the mortarless stonework of the Incas at Machu Picchu (Fig. 12.27). High atop a mountain rising above the Peruvian jungle, they constructed buildings and terraces of huge stones that were cut, ground, and polished. These stones fit together, like a jigsaw puzzle, with such precision that the structures have defied earthquakes and jungle overgrowth for five centuries. So closely are the stones joined that in places a knife cannot even be slipped between them. Perhaps in celebration of their own skill, the Inca stonemasons countersunk the joints so that the faces of the stones bulge outward slightly, accenting by their lightness the darker values of the joints.

MIXED MEDIA

A final category in additive construction is the use of **mixed media**—the assembling of different materials to form a coherent whole. For this approach to work, the varying materials must hold together both physically and visually.

From an aesthetic point of view, a variety of natural materials can be used together successfully because of their common reference to the natural world.

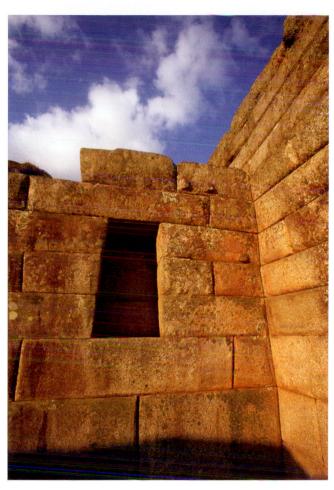

12.27 Detail of Machu Picchu stonework. AD 1460-1470. Machu Picchu, Peru. Photo © Kevin Schafer/Corbis.

Joseph Shuldiner combined handmade paper, pieces of various kinds of wood, and linen thread to create the strangely evocative construction *Eyrie* (Fig. 12.28). Its visual fragility gives it a surreal quality, for although there appears to be a raised platform and a shelter, the thin, bowed branches are unlikely supports for any kind of weight. The artist explained how the viewer is integral to his approach:

Natural biological form is alluring and fascinating to me and defines the basis for my exploration of form. Building on the forms of the natural world, I combine instinctual and imaginative impulses with dream imagery to explore the boundaries where mind and nature meet. I feel my work is most successful when the viewer finds understanding of the piece in being intrigued with the unknowable. The content of the work is for the viewer to contemplate and complete; it only becomes whole with the intellectual and spiritual contribution of the viewer.⁴

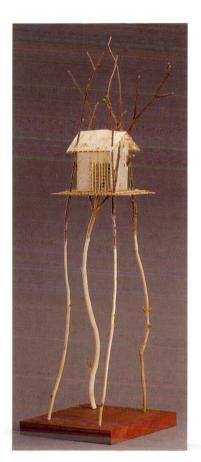

12.28 Joseph Shuldiner. Eyrie. 2004. Washi (Japanese handmade paper), willow, eucalyptus, waxed linen thread, padukwood; constructed, knotted, and mounted, $36 \times 12 \times 12$ ". Photo by Ted Roberts.

⁴ Joseph Shuldiner, quoted in Kevin V. Wällace, "Celebrating Nature, Craft Traditions/Contemporary Expressions," *FiberArts*, November/December 2004, p. 33.

Artists who make jewelry have long recognized the beauty of certain stones, their supposed magical properties, and their accepted use to proclaim wealth and status. They have combined their stones with precious metals, such as gold and silver, exploiting both their reflective qualities and malleability. The challenge is varied: to fasten stone to metal in a way that is sturdy but does not spoil the design or the beauty of the stone, and to make stone and metal work together visually, complementing rather than competing with each other. Georg Jensen's *Dragonfly Brooch* (Fig. 12.29) captures semiprecious stones in bezels (metal collars) and weaves their oval shapes into the design by repeating oval shapes in space. These shapes are defined by silver lines that move, widen, and narrow continually, with the rhythm of natural forms. Against such a setting, the stones act as rich, colored accents, neither overwhelming the design nor being lost in it.

Even the synthetic products of industrialization can be used together so harmoniously that they suggest a single variegated being. Naum Gabo's *Linear Construction* (Fig. 3.19) marries clear plastic sheeting and nylon thread so perfectly that we have difficulty in perceiving them as two different materials. The thread is added to provide visual textures that allow us to "see" the plastic and to elaborate the forms begun in the plastic. But so subtly are the two joined physically and aesthetically that together they create a single **gestalt**, or whole, that is much greater than the sum of the parts. One of its most beautiful features is the central void defined by the apparent absence of either material.

There is no limit to what materials can be combined with one another. Our everyday lives are full of examples. John Matt, whose *Wind Chant* (Fig. 2.18) is assembled from metals and woods, has analyzed the feasibility of additive construction, particularly with mixed media:

12.29 Georg Jensen. Dragonfly Brooch. 1904. Silver and semi-precious stones, $3^{1/2} \times 1^{13/16''}$ (7.8 \times 4.6 cm). Museum of Decorative Art, Copenhagen.

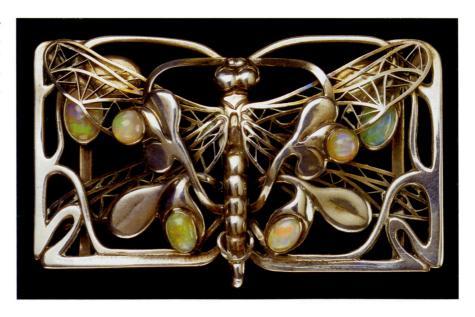

It's so obvious it will hit you between the eyes. Your automobile is built in pieces. Jet planes, your house, your watch—everything is assembled. Why can't it be so with sculpture? Why does it have to be one solid form that you subtract from: In the past, I was doing big asymmetrical blocks. I remember sitting in the studio in Rome, looking out a huge window, and all of a sudden I noticed the telephone poles and wires. The telephone poles were wood, the wires were copper, the insulators were glass, there was rubber around certain things. There was aluminum this, galvanized that, Plexiglas. . . . I was looking through a window, which was made of glass and wood, and the walls were concrete and paint, and so it went, all the way down to me! If you think about it, your shoes are glue, leather, cloth, string—all sorts of stuff. Your teeth probably have silver and plastic and maybe gold in them now. It can be the same with art. No holds are barred if you are confident in yourself about visual things. You can use anything in any combination, and if you're convinced you can do it, it's going to work. If your sense of the aesthetics is strong, what's to hold you back except your ignorance of the technical details? Even then, you just find out how to do it, and then you do.5

⁵ John Matt, personal communication with coauthors, September 1986.

13 Subtraction

three-dimensional forms is **subtraction**. In this process, the artist begins with material larger than the desired finished piece and carves away any excess. An explicit example of this method is Sabu Oguro's *Katzenfamilie* (Fig. 13.1), in which areas have been cut out of the overall shape. These shapes interplay with one another and can be taken apart from the larger form. Each form cut from the main shape becomes a cat, thus accenting the rhythm of the whole with an interplay of contrasting sizes. Because the total piece is a standing puzzle, all of the cats fit precisely into one another.

We usually think of subtraction in terms of carving away extraneous material from the outside of a form. Atsuo Okamoto revealed this process by reassembling the major blocks of stone removed from a white granite boulder. The inner material is presented as if it were a work in progress next to its matrix, which now resembles an empty womb (Fig. 13.2).

Subtraction can also refer to the shaping of the interior of a form. A monumental example is the *chaitya*, or Buddhist assembly hall, carved as a cave from the living rock in Karli, India (Fig. 13.3). Modeled on wood architecture, it is lined with huge fluted columns bearing figures riding elephants. Above them a vaulted ceiling soars 45 feet (13.72 m) upward within the hollowed-out cliff.

By extension, subtraction may also occur when the forces of nature wear away materials. Fire, wind, and water all have their ways of altering and eroding matter and are sometimes engaged aesthetically by artists.

QUALITIES OF THE MATERIALS

Materials most often used subtractively are wood and stone. Wood has perennial appeal because of its warm organic feel, texture, and grain patterns. As it ages and is repeatedly handled, it develops a pleasing soft patina. The softest woods include white pine, redwood, spruce, and cedar. Medium-hard woods

13.1 Sabu Oguro, designer. *Katzenfamilie* from *Tierpuzzles.* Manufactured by Naef Spiele AG, CH-4800 Zofingen, Switzerland. Copyright Naef Spiele AG.

13.2 Atsuo Okamoto. *Stones Dimension/Resolution for Materials.* 1987. White granite, $8\times23\times7.5$ m. Gallery Yamaguchi, Tokyo.

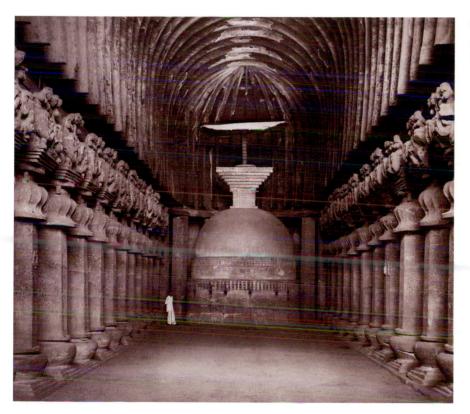

13.3 Interior of carved *Chaitya* cave, Karli, India. c. AD 100. © ephotocorp.com.

include birch, butternut, and fruitwoods such as apple, cherry, and pear. The fruitwoods sometimes grow rounded knobs called **burls** with beautiful grain patterns that may be emphasized by the artist. Hardwoods such as maple, walnut, oak, hickory, and teak have attractive fine grain and are very durable. Softness is not directly equated to ease of working, for the soft woods may mash or splinter when chiseled unless the tools are kept extremely sharp. The artist may have more control when working with harder, more cohesive woods.

Like woods, stones used for subtractive sculpture range from relatively soft to extremely hard. At the soft end of the spectrum are rocks such as sandstone, soapstone, and alabaster, which can even be carved with a knife when wet. Marble is harder and has long been prized for its beauty. Granite is extremely hard but also extremely durable.

Working these resistant materials is often a slow and painstaking process. Wood may split along the grain as it is being carved; it may check (develop cracks) as it dries if it has not been fully dried before being worked; knots and other faults in the wood must be dealt with somehow. Sculptors may encounter unexpected fissures running through the interior of pieces of stone and must either work with or around them or else abandon the work. Some stones are also quite expensive; sculptors do not tackle them lightly. In ancient China, an artist might spend his entire life carving a single jade bowl such as the work shown in Figure 13.4.

The initial stages of roughing out a design can in some cases be facilitated by power tools, such as chainsaws for wood or electric drills or pneumatic

13.4 Carved Bowl on Pedestal (Yu-Yung cup). China, 18th century (Ch'ien-lung mark and period). White jade, height 5 3/8". The Asian Art Museum of San Francisco, The Avery Brundage Collection (B60 J144).

hammers for stone. But for the most part, subtraction is a lengthy process of careful removal of excess material by the use of points, chisels, or gouges struck with a mallet or hammer. For a highly polished surface, various abrasives are used for final finishing after the initial roughing-out and intermediate carving.

Although the artist who works subtractively in resistant media is not directly hand-shaping the material, as in modeling clay, the artist's hands are nevertheless closely linked with the material through the tools used. For sculptor Barbara Hepworth, her two hands have very different functions, as the right wields the hammer against a point held to the stone by the left hand:

My left hand is my thinking hand. The right is only a motor hand. This holds the hammer. The left hand, the thinking hand, must be relaxed, sensitive. The rhythms of thought pass through the fingers and grip of this hand into the stone. It is also a listening hand. It listens for basic weaknesses of flaws in the stone; for the possibility or imminence of fractures. ¹

For quicker, less expensive subtractive work, plaster or cement can be cast into blocks and then carved. Even plastic in the form of acrylic, epoxy, or polyester blocks can be carved by sawing, drilling, and filing rather than the chipping and gouging techniques used with wood and stone.

REVEALING THE FORM

It is often said that a sculptor is one who sees a form in a block of material and simply carves away everything that covers the form. In some cases, sculptors do get their ideas from the existing form. More characteristically, however, they choose a piece of material that will allow them to develop a form they have imagined. To release the image in the stone or wood means working the piece to its best advantage.

Carved wood sculptures may often retain a strongly vertical linear thrust, having been subtracted from a cylindrical tree trunk. In the ancient sculpture *Sheikh el Beled* (Fig. 13.5), there is a strong sense of the trunk, which was carved into only slightly to release the torso, legs, and head. Note that the arms and spear were carved out of separate pieces of wood and then attached at the shoulders. If they, too, had been carved with the body, the sculptor would have required a very thick piece of wood; a great deal of excess would have been carved away in order to reveal the form. It is possible to carve projecting forms in the full round out of a solid block, but it does take time. Projecting limbs are also highly susceptible to being broken during or after creation of a piece. The great effort and skill needed to release the linear forms of the lyre player

13.5 Sheikh el Beled, from his tomb at Saqqara, Egypt, Dynasty V, ca. 2450-2350 BC. Wood, approximately 3'7" high (109 cm). Egyptian Museum, Cairo. © Jurgen Liepe, Berlin.

¹ Barbara Hepworth, *Barbara Hepworth: A Pictorial Autobiography* (Wiltshire, U.K.: Moonraker Press, 1978), p. 79.

13.6 Seated Man with Harp from Keros (Cyclades), Greece, ca. 2700-2500 BC. Classical Cycladic statuette. Marble, height approximately 9". © The Art Archive/National Archaeological Museum, Athens/Dagli Orti.

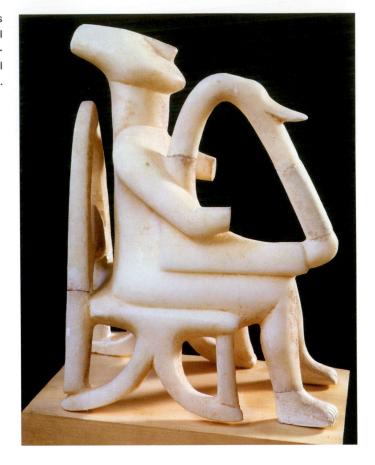

13.7 Henry Moore. *Internal and External Forms*. 1953-1954. Elmwood, 8'7" × 3' × 8'13" (circumference). Albright-Knox Art Gallery, Buffalo, New York.

(Fig. 13.6) from a small block of marble also rendered the piece vulnerable to breakage afterward, as evidenced by the many places it has been glued back together or where pieces are missing altogether.

Most earlier sculptures from Western civilizations are **monolithic**. That is, they retain the closed form of the original single stone or wood, with arms and legs of figurative works perhaps carved away from the body to a certain extent. In the twentieth century, sculptors like Henry Moore introduced **open forms** in which carving into the original material penetrated so deeply as to open voids in its center. In Moore's *Internal and External Forms* (Fig. 13.7), the center of a trunk has been penetrated only to reveal another trunklike form. In both internal and external forms, the vertical thrust of the original trunk is still apparent, if hollowed out.

Some contemporary sculpture abandons the original form of the material or materials entirely. Fumio Yoshimura's *Child's Bicycle* (Fig. 13.8) is carved entirely of wood. This tour de force is so masterfully carved into likenesses of objects not made of wood—metal chains, rubber tires, flexible gear cables—that the wood totally loses its identity as tree trunk and instead becomes whatever Yoshimura declares it to be.

13.8 Fumio Yoshimura. *Child's Bicycle* from *Three Bicycles in a Rack.* 1987. Wood. 77 × 53 × 29¹/₂". The Albuquerque Museum, Gift of Sherry and Rick Levin. Photo David Nufer.

When approaching a piece of wood or stone, the artist must have a very clear sense of how the form fits into it. The process of chipping away just enough but not too much to reveal that form has been likened to playing three-dimensional chess: The artist plans many moves in advance, even though the form may change as it is developed. Usually a rough guide to where everything will lie is sketched in chalk on the surface of the material. Some artists then work into all sides of a piece at once, continually shaping areas in relationship to one another.

An alternative approach is to work one side at a time. This is more difficult than continually working around the piece. Unless the form is flexible or one knows precisely where it lies, the sculptor can carve himself or herself into an impasse, with not enough material left to develop certain contours. Michelangelo apparently had some such trouble with his *Saint Matthew* (Fig. 13.9), for he abandoned it after carving partway toward the back from the

13.9 Michelangelo. Saint Matthew. 1506. Marble, height 8'11" (2.72 m). Museo Nazionale, Florence. © Arte & Immagini srl/Corbis.

front. The figure appears imprisoned within the marble, unable to open fully. Is there enough marble left to carve the foot on the right side of the photograph, for example? The sculptor can make certain compromises or changes as a piece develops, but beyond a certain point areas simply may not work well in relationship to one another and the piece may seem spatially starved.

A third possibility is for the artist to make a small model of the form in some malleable material like clay. The model can then be translated into a more permanent material such as stone by master stonecutters taking points from the model to determine how deeply to carve each section.

No matter which approach is used, artists are advised to think of the inside rather than the outside of the form they are modeling. Rodin explained this principle, which he learned from his teacher:

Never consider a surface except as the extremity of a volume, as the point, more or less large, which it directs toward you. . . . Instead of imagining the different parts of a body as surfaces more or less flat, I represented them as projectures of interior volumes. I forced myself to express in each swelling of the torso or of the limbs the efflorescence of a muscle or of a bone which lay deep beneath the skin. And so the truth of my figures, instead of being merely superficial, seems to blossom from within to the outside, like life itself.²

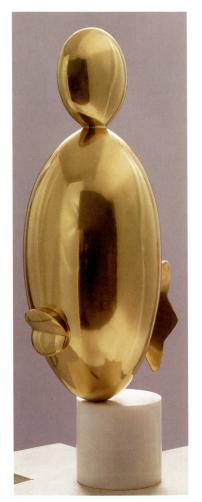

TEXTURES AND VALUES

Although the surface is not the chief consideration in developing the form through subtraction, the final appearance of the surface does affect how a piece works. Constantin Brancusi purposely left and accentuated the marks from the chisel he used in sculpting the marble base of *Blond Negress, II* (Fig. 13.10). He used the coarse and rippling texture of these marks to emphasize by contrast the polished smoothness of the bronze upper portion.

In highly representational works, chisel marks are not designed to be seen as such. Rather, they are blended into the appearance of the visual texture of the object being represented. It is impossible to tell that Fumio Yoshimura's

13.10 Constantin Brancusi. *Blond Negress, II.* 1933. Bronze, on four-part pedestal of marble, limestone, and two wood sections (carved by the artist): head, $15\,^3/4''$ high; four-part pedestal of marble, $3\,^5/8''$ high $\times\,3\,^3/4''$ diameter; limestone, $9^7/8\,\times\,14\,^5/8\,\times\,14\,^1/8''$; two wood sections, $7\,^3/8\,\times\,14\,^3/8\,\times\,14\,^1/4''$ and $35\,^1/2\,\times\,11\,\times\,11''$ overall $71\,^1/4\,\times\,14\,^1/4\,\times\,14\,^1/2''$. The Philip L. Goodwin Collection (097.1958.a-e vw2). The Museum of Modern Art, New York. Digital image © The Museum of Modern Art/licensed by SCALA/Art Resource, New York.

² Auguste Rodin, *Art*, trans. from the French of Paul Csell by Mrs. Romilly Fedden (Boston: Small, Maynard and Co., 1912), pp. 74–76.

Child's Bicycle has been created by a carving process, for the artist's tools have left no tracks. Instead, we are presented with many nonwood textures, from the patterns of rubber tires to the soft drape of the flag, each convincingly disguising both the characteristics of wood and the artist's hand at work.

Sometimes wood or stone is highly polished to bring a pleasing smoothness and glossiness to its surface, as in the beautifully carved marble elephants in the twelfth-century *Hastishala* at the Delwara Jain Temples in Mount Abu, India (Figure 13.11). In pieces that are handled repeatedly over time, such as the slate *Birdstone* in Figure 13.12, the smooth quality is heightened by the patina of wear. Many touchstones from primitive cultures were clearly designed to be fondled—to be appreciated by hand as well as eye. In our culture, people collect old wooden tools out of appreciation for the hands that used them as well as the hands that carved them.

13.11 Hastishala (Elephant Cell). AD 1147-1149. Delwara Jain Temples, Mount Abu, India.

235

13.12 Birdstone. Hopewell. Slate, length 6 1/2" (17 cm). National Museum of the American Indian, Smithsonian Institution (#22/278).

13.13 Hitching Post of the Sun.

AD 1460-1470. Altar for observation and worship of the sun.

Machu Picchu, Peru. Carved from the live rock. © Archivo Iconografico, S.A./Corbis.

Surfaces are also used to develop values. Any areas that are deeply undercut will tend to create dark shadows where light cannot penetrate. The Incas referred to Machu Picchu's most sacred altar as the *Hitching Post of the Sun* (Fig. 13.13). This stone structure, dedicated to worship and observation of the sun, owes much of its drama to the severe contrasts between light and dark created by the chiseling of sharply angled forms from the living rock of the mountain. Value shifts in the unworked rock below are much more gradual, demonstrating in one picture the creative potential of the subtractive process in enhancing the impact of the artist's chosen material.

CASTING 14

HE FINAL THREE-DIMENSIONAL construction method discussed here is casting. It is an ancient process, sufficiently perfected thousands of years ago to allow production of pieces as aesthetically and technologically advanced as the ceremonial vessel shown in Figure 14.1, created during the Shang dynasty in China. In general, casting involves creation of a mold—an outer shell into which another material is poured in a fluid state. When this material hardens, the mold is removed leaving its imprint in the more permanent material of the inner form—the cast.

14.1 Spouted ritual wine vessel (Guang), Shang Dynasty, early Anyang period (ca. 1300–1050 вс), 13th century вс, China.
Bronze: W. 13" (33 cm). The Metropolitan Museum of Art. Rogers Fund, 1943 (43.25.4).

14.2 Frank Gallo. *The Faint.* Cast in handmade paper, 32" (81 cm) high \times 48" (1.22 m) wide. Edition of 150. Reproduced by permission of the artist and special permission of *Playboy* magazine. © 1978 by Playboy.

Casting is an indirect process, with most shaping work done on the mold or the **pattern** from which the mold is made, rather than on the finished piece. It therefore allows artistic use of a number of desirable materials that cannot easily be worked directly into complex forms. The traditional material used for casts is bronze, poured into molds in a hot liquid state. Bronze is prized for its durability and rich color, seeming translucency, and softness of its surface patina, a glow that gets richer with time. Other metals, such as steel, aluminum, and iron, can also be cast, as can wax, clay, plaster, and concrete. Many plastics are also readily cast for both artistic and industrial purposes. Even handmade paper, which is a liquid slurry before it dries, can be used to make casts, as in Frank Gallo's *The Faint* (Fig. 14.2).

SOLID CASTS

Casting can be approached in many different ways. Perhaps the simplest is the direct relief mold method—preparation of a negative mold into which the desired material is simply poured and then removed when hard. This produces a relief with one finished side. The negative mold can be made of a great variety of materials, including sand, clay, dirt, plaster, wood, cardboard, and foam, with some kind of border added to contain the poured casting material. In Figure 14.3, a negative mold is being created with sheets of polystyrene foam. The design was then cut into blocks and surrounded with wood sides; cast

14.3 Albert S. Vrana. Negative mold being prepared from carved sheets of polystyrene foam. Courtesy of the artist.

stone—a refined concrete—was poured into these shallow molds. In the result, used as a facade for a building (Fig. 14.4), anything that was concave in the mold became convex in the finished cast, and vice versa. The cast picks up the surface qualities of the mold—in this case, a smooth surface—as well as the textures of the materials used in the cast. Cast stone, for instance, can be compounded from cement, sand, and rock aggregates of varying size.

For a form to be cast in the full round, there are several general options. One is to cast the form as a solid, suitable for lightweight, inexpensive materials or small objects. A full-size pattern is first created out of some malleable material. This might be wax or clay; for the sculpture entitled *Mutant*, Elbert Weinberg

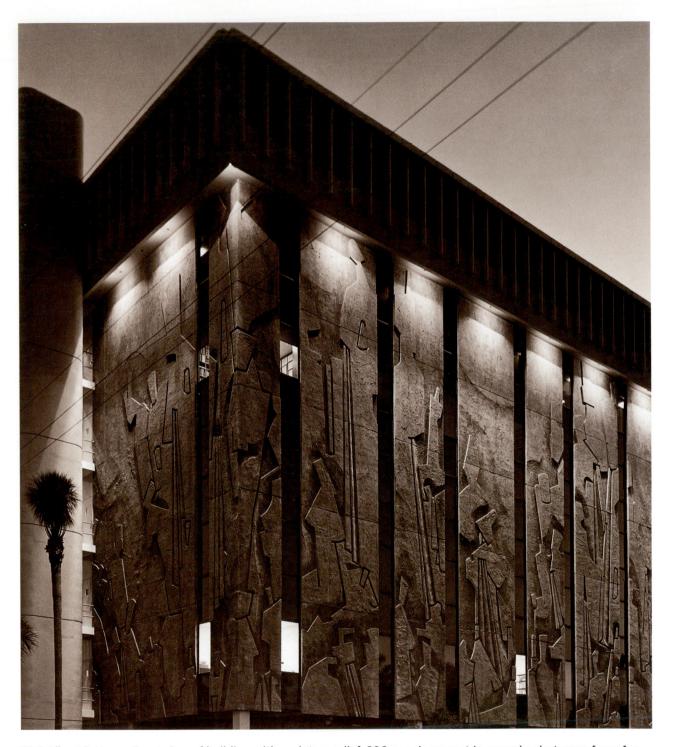

14.4 Albert S. Vrana. Front view of building with sculpture relief. 200 panels precast in carved polystyrene foam for exterior of Professional Arts Building, Miami. 1967. Panels of Chattahoochee stone and sand aggregate in Lehigh Early Strength Cement over 23,000 square feet. Individual panels are 6'' (15.2 cm) thick and vary from $9 \times 12'$ (2.7 \times 3.6 m) to $17 \times 12'$ (5.18 \times 3.6 m). Courtesy of the artist.

14.5 Elbert Weinberg. Plaster model for epoxy cast of *Mutant*. 1973. Height 33" (84 cm), length 31" (79 cm), width 27" (69 cm). Collection of the Elbert Weinberg Trust.

14.6 Plaster piece mold.

first created a pattern out of plaster, shown in Figure 14.5. Negative molds were then made from this positive pattern.

For a **rigid plaster piece mold**, the surface of the pattern is divided into separate areas by thin metal **shims**, or fences, as shown in **Figure 14.6**. Each fenced area is coated with plaster to make a partial mold that can be pulled away from that part of the form without breaking. The inner pattern is then removed, and the partial molds are reassembled to create a full hollow mold into which the casting material is poured. This process is not suitable for bronze or for casts with intricate details or numerous undercuts.

The cast shown of Auguste Rodin's *Severed Head of Saint John the Baptist* (Fig. 14.7) has not been worked to remove lines where the pieces of the mold came together. We can see exactly how the piece was thought out so that the pieces of the mold could be pulled away from the cast.

Plaster piece molds with ball-and-socket joints for precise assembly are often used for **slipcasting** of ceramic objects or sculptural modules. In this process, clay in liquid suspension (slip) is poured into the plaster molds. Because the plaster is porous, it absorbs water from the slip, allowing it to harden. Excess slip that does not harden is poured off. When the cast slip is hard as leather, the molds are removed for drying and firing of the piece.

14.7 Auguste Rodin. Severed Head of Saint John the Baptist. 1916. Untinted plaster with traces of piece mold, $10^{3}/8 \times 8^{1}/8 \times 6^{3}/16$ ". The Fine Arts Museum of San Francisco. Gift of Adolph B. Spreckels, Jr. (1933,12.6).

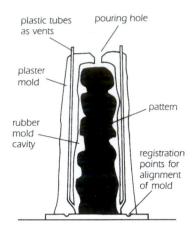

14.8 Flexible mold.

For a **flexible mold**, more suitable for multiple reproductions or more complex forms, the positive pattern is coated with liquid rubber or silicone, which picks up all the surface characteristics. A shell of plaster is then applied on top of the rubber for stiffness. The resulting mold (shown diagrammatically in **Figure 14.8** and in a foundry setting in **Figure 14.9**) is then cut in half and removed from the original pattern. The empty halves (plaster outside, rubber inside) may then be reassembled and the material desired for the finished piece poured in to fill the assembled mold. When the molten material hardens, the two halves of the mold are pulled away, revealing a positive form that exactly duplicates the form of the original pattern. The cast of *Mutant*, made of lightweight plastic resin, looks exactly like the pattern in **Figure 14.5**, except that the material is different.

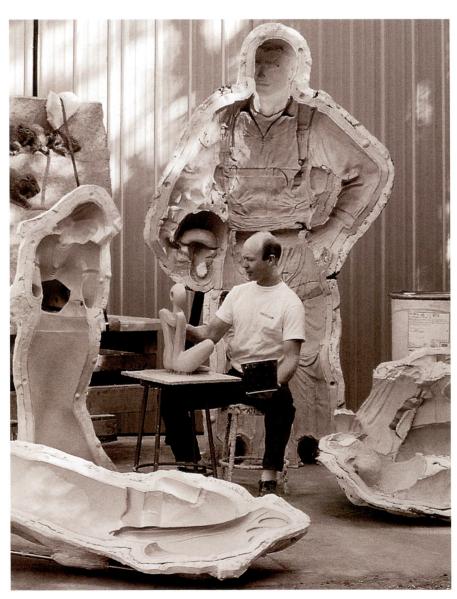

14.9 Shidoni Foundry, Dow
Corning® HSII RTV Clay Catalyst
being applied for rubber molding systems, with the two halves
of one mold in the foreground.
Photo courtesy of Shidoni
Foundry.

14.10 Duane Hanson. Flea Market Lady. 1991. Polyester resin figure and various media. © Timothy A. Clary/AFP/Getty Images. Art © Estate of Duane Hanson/Licensed by VAGA, New York. Image 52778873.

Sculptors sometimes go directly to the real item for their patterns. Duane Hanson's realistic sculptures such as *Flea Market Lady* (Fig. 14.10) were patterned on real people. For this process, Hanson coated people with cutaway molds of silicon rubber and then filled these molds with a melted plastic—polyvinyl acetate. This material, colored with oil paint to match human skin tones, becomes astonishingly lifelike when painted and clothed in human likeness and surrounded by familiar objects such as bags and paperback books.

Erwin Hauer pushed the solid cast to an extreme by using extremely heavy materials cast into solid modules and assembling them to form a large interlacing vertical wall, Design 3 (Fig. 14.11). The artist later described the work as "two separate continua that exist within each other without ever touching and, like two voices, maintain their distance but interact and complement each other in the creation of a greater entity." First he made "mother molds" and in them cast hollow front and back shells of a mixture of dolomite limestone and white Portland structural cement, chosen for the whiteness of their color and the ability to sand the final surface later to hide the joints between modules. Then he assembled the hollow cast shells, inserted steel rebar for reinforcement, and filled them with grayer structural cement for additional strength. Some of the hollow front and back shells and assembled outer shells ready for filling are shown in Figure 14.12. Once these modules were filled with cement, the solid casts were so heavy that it took six men to carry them. Hauer was interested in creating "a structure of minimal mass and of maximum interaction with light," but the construction of the piece turned out to be a Herculean effort, as even the artist acknowledged:

SOLID CASTS | 243

14.11 Erwin Hauer. Woman Standing in Front of Design 3. 1952. Cast stone, installation in Liesing, Vienna, Austria. Photo courtesy of author.

14.12 On-site production of modules for *Design 3* in Liesing, Vienna, Austria. 1952. P. 31 in Erwin Haver Continua, Princeton Architectural Press.

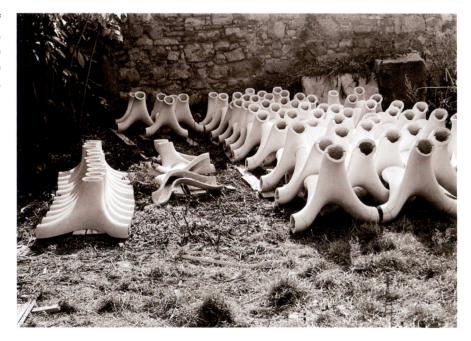

The structure, as it relates to physical gravity and construction, was a secondary consideration in the design process, and it turned out to be a considerable tour de force. Engineers called it structurally undetermined and would not touch it. They did not say it could not be done, only that there were no procedures on the books to calculate its physical requirements. If the wall had been produced in hollow, welded metal there would not have been much of a problem, but the tons of cast stone it took to build it and that had to be supported made it a concern, Good old intuition had to fill in, and every step in the construction had to be my own judgment call. The final assessment has to be that I traded in the highest light effect for the lowest amount of structural efficiency. With the help of some strong backs, I carried out the construction of the wall personally. As a consequence, this is the only extant installation of this design. ¹

HOLLOW CASTS

If a piece is large or the material to be used for the cast is very heavy, as is the case with metals such as bronze, the **lost-wax process** is often used to create a hollow cast. In the **direct lost-wax method**, the original pattern is built of some nonmelting material such as clay or plaster with its final surface modeled in a layer of wax of the same thickness as the ultimate metal cast. A negative mold is constructed over this wax surface, with vents here and there to allow air to escape during the later casting process. Provisions are made for breaking the mold in half and reassembling it after the cast has set. The piece is then heated to the point that the wax melts, leaving a cavity that duplicates the contours of the pattern. What was wax becomes metal as the material for the final piece is poured into this cavity and allowed to harden. Once it is hard, the negative molds are pulled away from each side, the hollow walls of the cast are separated, the inner core of the original pattern is removed, and the pieces of the cast are reassembled, leaving a hollow core.

The more complex **indirect lost-wax method**, illustrated in **Figure 14.13**, involves first creating a negative plaster or gelatine mold of the positive pattern. The pattern is then removed and wax is applied to the inner surface of the negative mold. Wax rods to form vents are added, and a core of some material such as ground brick and plaster mixed with water is poured or tamped into the wax shell. Metal pins are added to hold the layers together. Layers of fire-resistant material are also built up around the outside of the wax shell. The finished mold is then baked to melt the wax, and molten metal is poured into all the cavities once occupied by the wax.

Yet another process uses **sand molds**, frames of sand mixed with a binder to create negative molds. Sand is often porous enough that complex venting is not needed to allow gases to escape when molten material is poured into the mold.

¹ Erwin Hauer on *Design 3*, in booklet "Erwin Hauer Continua" (New York: Princeton Architectural Press, n.d.), n.p.

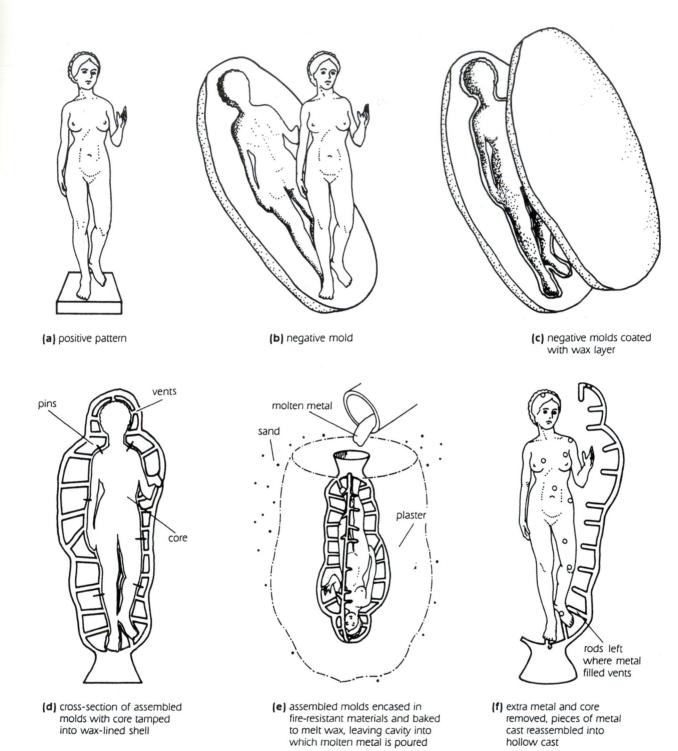

14.13 Stages of lost-wax casting. (a) positive pattern (b) negative mold (c) negative molds coated with wax layer (d) cross-section of assembled molds with core tamped into wax-lined shell (e) assembled molds encased in fire-resistant materials and baked to melt wax, leaving cavity into which molten metal is poured (f) extra metal and core removed, pieces of metal cast reassembled into hollow cast.

The sand mixture is packed in halves or sections around a positive pattern to receive its imprint. The molds are then taken apart, the pattern is removed, a core is added if the piece is to be hollow, the sand molds are reassembled, and the molten casting material is poured in. Like all mold materials, the sand must be sufficiently fine-textured to recreate fine details and strong enough to hold its shape when the heavy metal or other casting material is poured in. Although sand molds can be used to make many duplicates of a piece, they tend to lose fine details; lost-wax processes yield a single cast, since the original wax modeling is lost in the process, but they register finer detail than sand molds.

No matter what process is used, large and/or complex pieces must often be cast in sections with ends designed to be rejoined after casting. *The Great Image of Buddha* at Kamakura, Japan (Fig. 14.14), is 53 feet (16.16 m) tall, so huge that it could be cast only by breaking the form down into pieces. Some of the lines along which they were reassembled can be seen in the photograph as horizontal marks across the chest, arms, and folded legs.

FOUNDRIES AND EDITIONS

Because of the exacting technology, skill, and time required for casting and the great cost of some casting equipment, many artists now send their work to foundries to be cast. At every stage of the process, certain qualities of the original model may be lost, so provision is often made for retouching molds as well

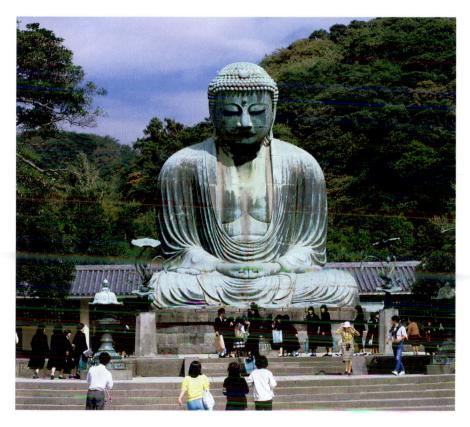

14.14 The Great Image of Buddha, Kamakura, Japan. 1252. Bronze, height 53' (16.17 m). © Royalty-free/Corbis.

as the finished piece. In **Figure 14.15**, workers at the Johnson Atelier are chasing a cast sculpture by Andrea Grassi to bring out the grooves in its surface. Some artists choose to turn over all such details to the foundry; others rework both molds and finished pieces.

With some casting processes, it is possible to create small editions of a piece by saving the molds and repeating the procedures several times to create several more or less identical copies of a work. Each is an original work of art, and by casting an edition, the artist is able to lower the per-unit cost of casting by spreading certain fixed costs across many units. Industrial casting processes are designed to allow a great number of copies to be cast from the same mold. Certain casting procedures do not allow deep undercuts, which would prevent detaching the mold from the cast without breaking the mold; industrial designers must sometimes work within the limitations of this consideration, beveling all angles with ease of separation from the mold in mind.

14.15 Apprentices Betsy Brown and Jill Rednor chasing piece by Andrea Grassi at the Johnson Atelier, Mercerville, New Jersey. Photo © Don Hamerman, New York. Courtesy of Johnson Atelier Foundry.

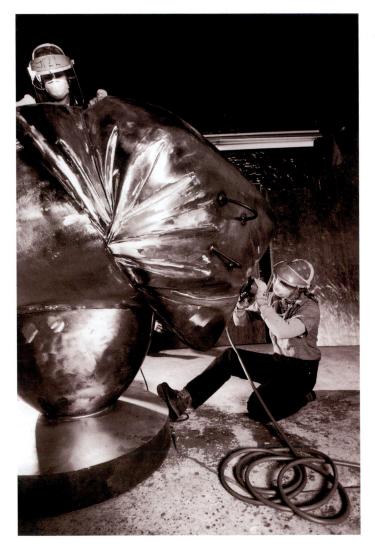

THE OUTSIDES AND INSIDES OF CASTS

Casts can be used to create a great range of surface textures, for they duplicate the surface of whatever is used for the mold or the pattern, depending on the process used. A sand casting will have the granular texture of the sand mold. Pieces cast from a pattern made of a malleable material such as wax will retain the freshness and immediacy of the modeling without the impermanence of the original material. Picasso's *She-Goat* (Fig. 14.16) is a permanent copy of an assemblage of ceramic flower pots, metal elements, a palm leaf, and a wicker basket, with plaster added to create all the textures of "goathood," from the scraggly fur of an unkempt animal to the coarse undulations of the horns to the smoothness of the udder. The casting process allows considerable surface detail to be elaborated, as in the Shang ceremonial vessel (Fig. 14.1). Textures can also be developed on the surface after casting, as in Andrea Grassi's piece shown in Figure 14.15, which is polished to a smooth, reflective sheen.

Traditional hollow bronze casts also reflect the unique quality of hollowness, of being merely the outer covering bulging out around an inner void. As metal is poured, it thrusts outward into every cavity of the mold. This outward thrust may give casts a curious vitality, as if instead of being merely empty, the casts are bursting with inner life.

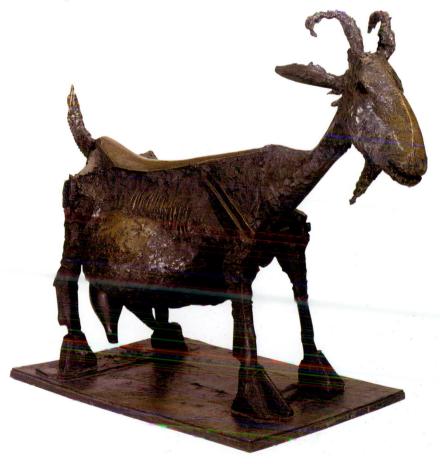

14.16 Pablo Picasso. *She-Goat*. Vallauris, 1950. Bronze (cast 1952), after an assemblage of palm leaf, ceramic flowerpots, wicker basket, metal elements, and plaster, $46.3/8 \times 56.3/8 \times 28.1/8''$; including base, weight 349 lbs. Mrs. Simon Guggenheim Fund. (611.1959). The Museum of Modern Art, New York. © Digital Image. © The Museum of Modern Art/licensed by SCALA/Art Resource, New York.

STUDIO PROJECTS

CHAPTER 1

1.1 From Three-Dimensionality to Two-Dimensionality

Using the medium of photography, transpose a three-dimensional experience of an actual object or sculpture into a two-dimensional visual experience. How can you photograph the piece to best indicate its three-dimensionality? Its size? What features of the original object are enhanced or lost in the photograph? In a class situation, each student could take one photograph of the same object on campus and then the class could compare the results.

1.2 From Two-Dimensionality to Three-Dimensionality

First draw a simple nonrepresentational design on an 8 1 /₂ × 11" piece of paper. Then translate the drawing into a three-dimensional piece of sculpture of any material(s) you choose, such as wood, cardboard, fabric, or wire. How can this be done? What aesthetic differences can be seen in the two versions of the design? What factors do you have to deal with in the three-dimensional piece that were not at issue in the two-dimensional drawing?

1.3 Modular Low Relief

Use two pieces of foam core (plastic-coated foam sold in 1/4-inch-thick sheets at art supply stores) to create a low-relief work. Use one for backing; cut the other into a series of identical or similar flat shapes and attach them to the backing to build up a low-relief design. These modules (the series of similar pieces) can be joined to each other and to the backing in any way you choose—glue, cut grooves, pins, even some form of tying. What visual effects develop as the flat shapes begin to move outward into three-dimensional space?

1.4 The Wrapped Object

Choose an everyday functional object and wrap it with some other material, such as string or lace, so that no portion of the object remains uncovered. Then do the same thing with an object from nature, perhaps wrapping it with a different material. How can you accomplish this in a way that will draw viewers into looking at the solution? Could the object and the wrapping be antitheses of each other, such as a hammer wrapped with lace? Is there a sense of mystery about what the wrapping conceals? What about evoking a sense of humor or intellectual curiosity? Can the underlying shape be easily recognized within a wrapping that creates a visual pun? You might work with contrasts, such as hard and soft, or with a close relationship between the object and the wrapping.

1.5 Walk-Through Work

Given or choosing a specific location, create an installation piece that controls how people move through the space. You can use any material(s) you choose, such as cardboard or fabric or sand. Part of the problem is figuring out how to set up the piece and how to take it down. Your control of people's movement through the space can be physical or psychological. This project could be done by individuals or by groups of three to five students working together.

CHAPTER 2

2.1 Good and Bad Design

Bring in a functional piece that you consider well designed and a functional piece that in your opinion is poorly designed. If you can't bring in the pieces themselves, photographs will do. Consider both aesthetic appeal and functionality, or lack thereof, and describe for the class the characteristics that enhance or detract from the aesthetics and functionality of the pieces you have selected.

2.2 Form and Function

Using any materials, make a chair. It must support weight without falling over or falling apart and must also be aesthetically interesting.

2.3 Working with the Setting

Using whatever materials and as many forms as you choose, create a site-specific piece that controls all space within an existing indoor or outdoor environment. That is, all the space within certain obvious boundaries should appear to "belong to" the work.

This problem can be solved in any size, from a large-scale designed environment to a small-scale model within a scaled-down indication of an environment, and by individuals or small groups. An alternative would be for several students to use pieces created as earlier projects and explore ways to combine and present them so they work well together and in relationship to a specific settling.

2.4 Defying Gravity

Using any materials you choose, create a piece that appears to defy gravity and, by so doing, draws the force of gravity to the viewer's attention. For instance, the piece might fly or appear to be about to fall. If it flies, it should not look so much like a standard kite that the viewer takes its ability to fly for granted. If it is earthbound and seemingly about to fall, whatever keeps it from falling should not be apparent to the viewer, to preserve the illusion of defying gravity.

2.5 Working on a Large Scale

The point of this project is to create the largest three-dimensional piece you can using no more than \$10 for materials. At the instructor's discretion, a time factor might even be specified; that is, the piece might have to be sturdy enough to stand up on its own for a certain number of hours—perhaps 6 to 8 hours. The student who turns in the largest work that holds up for the duration "wins"—perhaps a prize might be offered. This project may get you thinking about the economics of materials and size as well as the artistic challenge of creating a large piece.

CHAPTER 3

Projects for this chapter are based on varying arrangements of identical or similar forms, from cubes or slabs of wood or clay to scissors, cups, or paper bags. To aid exploration of the effects of each principle of design, the same forms could be used and simply disassembled and rearranged, if bonding techniques used allow their reuse; if not, you could start with many identical forms and use some of them for each project. The decision whether to require that all projects be done with the same forms rests with the instructor. If you are required to use the same forms, you might want to review all projects assigned for this chapter before deciding what forms to use.

3.1 Repetition

Assemble four or more identical or similar forms, either found objects or forms made from some easily worked material such as wood or clay. Use them together to create a piece that is more than the sum of its parts. The viewer should be aware that the same unit is being repeated, but the real excitement should be the overall form.

3.2 Variety

Again using four or more identical or similar forms, assemble them in such a way that they give an impression of variety. For instance, they might be piled together in varying amounts or placed in varying directions, but yet maintain a clear overall cohesiveness.

3.3 Visual Rhythm

Using four or more identical or similar forms, set up a visual rhythm that gives the viewer a distinctive way to "read" the work. A certain rhythm may well appear in the solutions to the first two problems, but here the emphasis is placed on a rhythmic effect. Note that apparent movement varying through space and time—in and out, up and down, flowing and pausing—can be used to create the impression of rhythm.

3.4 Visual Balance

Using four or more identical or similar forms, assemble them in two ways: (1) a symmetrically balanced structure; (2) an asymmetrically balanced structure.

3.5 Emphasis

Using four or more identical or similar forms, assemble them in a way that emphasizes some aspect of their nature or some area of the sculpture. The object is to give the viewer a visual tool for organizing the whole. If necessary, the forms can be altered to emphasize some characteristic, or an auxiliary part—such as a base—may be added.

CHAPTER 4

4.1 From Flat Material to Volume

Experiment with paper folding to develop an understanding of **planar construction**—creation of flat-sided forms. First use an $8^{1}/2 \times 11$ " sheet of paper, creasing or scoring it along one or more lines and then folding it along the creased lines to raise the flat surface into a series of planes angling away from or back toward each other in three-dimensional space. Do as many as you like, choosing the one that is most effective as a low relief or free-standing sculpture. A minimum of tape can be used to fasten edges together if necessary. Then do the same thing with the additional option of cutting the original sheet to see what forms can evolve. The forms need not be symmetrical, and the fold lines can be either straight or curving.

4.2 Curvilinear Form

Using any media, accent the strong horizontality or verticality of a piece by using curvilinear form. That is, use curving contours to draw the viewer's eye along the longest dimension of a very horizontal or very vertical piece.

4.3 Exterior and Interior Forms

Using any method and material you choose, create a piece that reveals both external and internal forms and uses their interplay as the major focus of the work.

4.4 Metamorphosis

Using Plasticine (a nonhardening modeling material), transform one representational form into another in five stages. First create the first and last representational forms in a realistic manner; then create an abstraction of each in which its form approaches the other. Finally, construct the middle stage using the two abstracted forms as reference, so that it becomes an abstraction of abstractions.

4.5 Fill-a-Bag

Fill a bag of any sort with some loose material—such as sand, sugar, water, or stones—in such a way that the bag controls the form of the loose material. The bag need not be tightly bound—floppiness is a possibility, provided that it is under control.

CHAPTER 5

5.1 Negative Forms in Space

Assemble six to eight blocks of wood in such a way that they delineate and draw attention to one or more forms in unfilled space. The pieces of wood should be similar but need not be identical; you can paint them if you choose.

5.2 Activated Surrounding Space

Using materials of your own choosing, create a piece that seems to extend beyond its own physical limits, activating a larger area of the space around it. Refer to the text for ideas about how this subtle effect might be achieved.

5.3 Confined Space

Using any materials, including found objects, create a confined space and then develop forms within it. By thus isolating these forms, you will draw special attention to them.

5.4 Scale Change

Using any materials, create a situation in which the viewer must realize that something has been presented in an unaccustomed scale, much larger or smaller than its usual reality.

5.5 Illusionary Space

Using any materials, create a piece that gives the illusion of behaving differently in space than it actually does. For example, by the way you cut or paint a form, you could make a shallow piece appear to occupy very deep space or make square contours appear rounded.

CHAPTER 6

6.1 Wire Sculpture

Use wire to create a line or lines in space that describe a human or animal form. The wire can vary in size and can be painted black to be seen more readily.

Bend the wire into curves that encompass fully three-dimensional forms in unfilled space, as if you are creating a three-dimensional drawing.

6.2 Directional Line

Using any material, create a work that uses line to lead the eye in a specific direction. The larger the piece, the more the eye will follow it.

6.3 Line and Form

Use wire to create a linear three-dimensional sculpture, fully rounded in space rather than frontal; present it in relationship to a wooden base, perhaps with U-nails used unobtrusively to join the two. The mass of the base should work with the airy linear structure to create a unified, well-balanced whole. Using standard bases available in most art departments, experiment with various sizes and shapes of bases to determine what works best. If the linear sculpture extends horizontally beyond the edges of the base, how well do they relate to each other?

CHAPTER 7

7.1 Texture Switch

Using two already existing objects, create a new surface texture on each that will contradict the previous sense of pleasantness or unpleasantness. For example, the smoothness of a bar of soap might be covered with crushed glass; the roughness of a cinder block might be covered with terrycloth.

7.2 Three Textures Together

Using worked and/or found textures, create a piece having three different textures that work well together. They might be unified by contrast rather than by similarity.

7.3 Visual Textures

Using an existing object or a solution to a previous problem, manipulate its surface to alter its visual texture and affect the way viewers would respond to it. The new optical effects could be created by painting or drawing on the surface, or you could devise some other way of optically changing the visual texture of the piece.

7.4 Soft Sculpture

Manipulate soft material(s) by processes such as sewing, wrapping, stuffing, and tying to create a soft sculpture large enough to work well by itself as a floor piece. What are the possibilities and limitations of each process?

7.5 Contradicting a Form

Using applied or real texture, try to contradict an existing form. For instance, take a solid block of wood and paint holes in it. In project 7.1, you will switch textures. In this project, try to obliterate the form.

CHAPTER 8

8.1 Natural versus Artificial Lighting

Show how the appearance of any of your previous projects could be altered by artificial lighting and natural lighting. Note the changes that occur as the placement of the light source changes, as in the movement of the sun through the day or intentional shifts in studio lighting to heighten the impact of the piece. If your piece has both straight edges and curved contours, note the different ways that they are affected by light.

8.2 Shadows

Create an outdoor sculpture in which shadows are part of the excitement of the piece. Utilize shadows on the form and shadows cast by it.

8.3 Light as a Medium

Using materials of your own choosing, create a piece in which light is used as a "three-dimensional" medium. Some examples might be a series of mirrors reflecting a flashlight beam, a fishtank full of smoke with a light shining in one end, or a light shining through colored water.

CHAPTER 9

9.1 Natural Colors

Find three to five objects with different local colors, such as wood, stone, brick, or fabric. Combine them in such a way that they are harmonious not only in form but also in color.

9.2 Applied Color

Create or find three identical simple geometric forms, or use projects you have already completed. Apply color to each piece in a different way, comparing the effects: (1) Paint the piece in a solid color; (2) paint each surface a different color; (3) break up the surfaces by painting them in geometric patterns or splattering paint on them.

9.3 Psychological Effects of Color

Find an everyday object and paint it in such a way that viewers will respond to it in a different way. You could simply change its solid color to another solid color, as in painting a yellow banana purple. Or you could paint its surface with nonobjective designs such as stripes or representational images. How can you use color to alter the psychological effect of the object?

9.4 Removal of Color

Increase sensitivity to the effects of color by removing color from a familiar environment. Create an installation using objects from our everyday world, painting the objects in values of gray to replace local colors. The values need not be the same as the original color values.

9.5 Color Combinations

Using nine simple wooden forms, create three 3-piece sculptures that are identical except for color. Paint each sculpture in a different kind of color combination, choosing from monochromatic, analogous, complementary, split-complementary, triad, or tetrad color schemes. What effects does each create? Which seems to work best for the piece? For comparative purposes, it is helpful to paint each 3-piece sculpture identically, except for the colors chosen. If you further limit the variables to combinations that involve one particular hue, you will be better able to judge the effects of different combinations.

CHAPTER 10

10.1 Growth or Decay

Using any media, including found objects, create a piece that is not permanent and that draws attention to processes of growth or decay. Influences such as wind, rain, fire, color, or heat can be used to alter the physical appearance of the piece through time.

10.2 Kinetic Sculpture

Make a three-dimensional object that moves in a controlled space, in controlled time. Solutions could include wind-up toys or fan-moved works.

10.3 Controlling the Viewer's Movements

Using inexpensive materials, create an installation piece or even an earthwork that controls the movements of viewers, forcing them to become participants in the work. What happens psychologically when a viewer is led through physically awkward spaces? Through welcoming spaces?

10.4 Changes by the Viewer

Design a piece that changes with each viewer's participation in it. Some possibilities include games, processes, or forms to be manipulated. Consider the possibility of motion or movable parts as a primary focus of the piece.

CHAPTER 11

11.1 Ready-Made

Find an object that already suggests a human or animal form, or that will if slightly altered. Present it as a sculpture.

11.2 Assemblage

Put together three or more found objects in such a way that they present a coherent whole. In a successful solution, the new whole will be perceived before its components are.

CHAPTER 12

12.1 Clay or Wax Sculpture

Using clay, Plasticine, or wax, model a simple sculptural form whose surface reflects the tools used to shape it.

12.2 Addition with Malleable Materials

Use at least three different malleable materials together—paper, plaster, cement, papier-mâché, fibers, soft metals, clay, wax, or any similar easily shaped material—to create a three-dimensional piece. How do you use these materials? How can you attach them to each other? What do they do together?

12.3 Fabrication with Rigid Materials

Use three or more materials that are rigid in their final form to create a threedimensional piece. What effects are typical? Do you choose to contradict these effects? How can you attach the materials to one another?

12.4 Skin and Structure

Use balsa wood and light coverings such as rice paper, sheet fabric, or plastic to create a piece in which the "skin" and the structure that supports it are equally important. References to kites, flight vehicles, or oriental design may develop.

12.5 Wood, Burlap, and Plaster Construction

Build a sculpture using wood, burlap, and plaster of paris. One common solution is to use the wood as an armature and build up plaster forms on it. In such a piece, the burlap can be used both to bind the wood joints and to serve as a base for the plaster.

12.6 Joinery

Using any materials, create an additive sculpture in which the way the parts are held together is a significant aspect of the design. No screws, nails, or glue can be used.

CHAPTER 13

13.1 Wood Carving

Carve a simple form in soft wood in such a way that one area flows into another in a continuous series of changes. Concentrate on exploring the subtractive process of creating form by removing excess material. Excess could be carved away with a pocket knife, hammer and wood chisels, file, drill, saw, or sandpaper.

13.2 Plaster Carving

Fill a half-gallon milk carton with plaster of paris mixed according to the package directions. After the plaster dries, pull away the carton and carve the mass into a three-dimensional form using tools such as a knife, file, drill, and/or sand-paper. The piece may be monolithic or open, pierced by a void. Either way, its form must draw the viewer into moving all the way around it to see all sides.

13.3 "Stone" Carving

For an introduction to the experience of stone carving, cast a block of cement or cast stone in a box or carton. Sketch a simple form onto its surface and then work into the material with hammer and stone chisels, always being aware of where the form is within the block.

CHAPTER 14

14.1 Paper Casting

Manipulate a piece of paper and then use it as a mold into which plaster of paris is poured. After the plaster has hardened, cut away any undesired edges of the cast with a saw. The result can be put together with other students' work to make a modular wall piece.

14.2 Plaster Casting in Clay

Build a simple wooden frame with a plywood floor, not too large (anywhere from $12" \times 12"$ [30.48 \times 30.48 cm] to $18" \times 22"$ [45.72 \times 55.88 cm]), to hold clay and liquid plaster. Place a layer of nonhardening clay or Plasticine on the floor of the frame. Shape the clay by pushing, pounding, squeezing, and drawing it into a desired "terrain" whose concave areas will be convex in the finished piece, and vice versa. Concentrate on the process of working in reverse. Any tools or materials may be used to create desired textural effects. Then prepare plaster of paris according to the package directions and pour or scoop it quickly into the clay mold, smoothing the upper surface of the plaster, which will become the back of the piece. When the plaster dries, lift the plaster and clay out of the frame and peel away the clay, exposing the surface of the plaster as a low relief that is the reverse of the contours of the clay bed.

An alternative is to use wet sand rather than clay to create the mold. Sand will not hold fine details as well as the clay but is good for rough work.

14.3 Cast Hands

Mix a quantity of plaster of paris, remove any jewelry, and grease your hands well with petroleum jelly. Make a "bowl" of your cupped and joined hands. Have a classmate fill the "bowl" with plaster. Hold it in your hands until it sets. Experiment with different ways of holding your hands to create interesting effects. Once the plaster is dry, cut off the rough edges with a saw. Can the hands of the whole class be combined as an effective modular construction?

GLOSSARY

Words used that are defined elsewhere in this glossary are *italicized*.

- **abstract** Referring to art that simplifies, emphasizes, or distorts qualities of a real-life image rather than art that tries to represent its surface details accurately. In some cases, the intent is to present the essence of an object rather than its outer form.
- activated space The area controlled by a three-dimensional piece, including not only its form but also a subtly energized but physically unfilled area in or around the work.
- additive color mixing Mixtures of light to create colors, called "additive" since each colored light adds its energy to the mixture, raising its value slightly.
- additive sculpture Three-dimensional work made by putting pieces of material(s) together to build up a form.
- analogous colors *Hues* lying next to each other on a *color wheel*, sometimes used together in color schemes.
- annealing The process of heating and cooling of metal while shaping it by techniques such as hammering, to return it to *a malleable* state.
- applied arts See applied design.
- **applied color** Color added to a material, concealing or changing its original color.
- **applied design** Use of the principles and elements of design to create functional pieces.

- **armature** A simple inner skeleton that provides support for *modeling* with more pliable materials, such as clay or wax.
- **artificial lighting** Use of light from humanmade sources such as incandescent or fluorescent bulbs to illuminate an area or a work of art.
- **assemblage** A work made from objects or pieces of objects originally intended for other purposes.
- asymmetrical balance Placement of nonidentical forms to either side of a balancing point in such a way that the two sides seem to be of the same visual weight.
- atmospheric perspective The optical illusion that areas closer to the viewer are sharper in detail, color *intensity*, and *value contrast* than areas farther away, sometimes used intentionally by artists to create illusions of spatial depth.
- **balancing point** A fulcrum at the base of a work, upon which the whole piece rests.
- bas-relief See low relief.
- **bezel** A metal collar designed to hold a stone in a piece of jewelry.
- **bisque** An initial stage of ceramic ware, *fired* at low heat for partial hardening while remaining porous enough for applying glaze.
- **box set** In set design, the illusion of a room with one wall cut away so that the audience can see in.
- **brazing** *Soldering* at high temperature with an alloy of copper and zinc.
- burl A rounded knotty growth on a tree.

- **cast** A form made by any of various techniques of creating a mold into which a material is poured in liquid form, allowed to harden, and removed from the mold.
- **ceramics** Decorative or functional pieces made from clay and *fired* for permanence; also, the art of making ceramic pieces.
- **chasing** Engraving of the surface of a piece, often to help define contours or details.
- chroma See saturation.
- **clay body** A mixture of clays compounded for specific characteristics.
- **color wheel** A two-dimensional circular model of relationships among *hues*.
- complementary colors *Hues* that are opposite each other on a *color wheel*. When mixed, they gray or neutralize each other; when juxtaposed, they intensify each other.
- **conceptual art** Works or events in which idea is more important than outer form.
- **confined space** A spatial field with clearly defined enclosing boundaries.
- **content** The subject matter of a work of art, plus its emotional, intellectual, symbolic, spiritual, and/or narrative implications, as opposed to its physical form.
- contrast Juxtaposition of dissimilar areas.
- **controlled time** Referring to the movement of works of art through a predetermined sequence of events.
- cool colors Hues in the green and blue range.
- crafts Disciplines in which functional pieces are made by hand or as if by hand, with the individuality associated with handmade objects. In a broader sense, crafts are occupations requiring manual skill and aesthetic sensitivity to create objects that may or may not be functional.
- **delineated space** An unfilled area described by filled areas of a three-dimensional work.
- direct lost-wax method Use of wax to create a cavity between a positive *pattern* and a negative *mold;* when the wax is heated, it melts and is drained off, and molten metal is poured into the cavity.

- **direct relief mold** A simple casting method by which material is poured into a *mold* and removed when hard, creating a *relief* that is flat on one side.
- **directional line** A line that seems to guide the viewer's eye along a particular visual path.
- **dominance** Emphasis placed on a particular area or characteristic of a work, with other areas or aspects given subordinate or supporting roles.
- **ductility** The ability to be stretched or extended without breaking.
- **dynamic form** A three-dimensional work that conveys an illusion of movement and change.
- **earthenware** Ceramics made from the coarsest clays, usually fired at the lowest temperatures.
- **earthworks** Large-scale sculptures in which the surface of the earth is the medium.
- **economy** Deletion of nonessential details to reveal the essence of a form.
- **edge** A boundary where two planes or areas treated differently meet.
- elements of design Those qualities of a design that can be seen and worked with independently of the figurative content. They include *line, form, value, space, texture,* color, and time.
- **emphasis** Stress placed on a single area of a work or a unifying visual theme.
- **encaustic** A method of painting with pigment-bearing hot wax.
- **ergonomics** The study of how people relate physically to their environment, of particular interest to designers seeking to increase job efficiency and decrease workers' fatigue.
- exterior form The surface shape of a work of art.eye line The illusionary line between a figure's eyes and something at which it appears to be looking.
- **fabrication** Assembling of rigid materials into units by techniques such as welding, bolting, or *lamination*.
- **fiber art** Work created by manipulation of strands of varying materials by any of a variety of methods.
- figurative Representing human or animal forms.

fine art Nonfunctional art, such as painting and sculpture.

firing The baking of ceramic pieces to make the clay's form permanent.

flexible mold A casting process by which a positive *pattern* is coated with liquid rubber or silicone to pick up the surface details and then plastered to make a *mold* that is cut in half; the two halves are cast and reassembled.

focal point The area in a work to which the eye is most compellingly drawn.

folk art Works that are created by people without aesthetic training but that may be appreciated for their vigor, humor, and highly personal style.

forced perspective Exaggeration of the illusionary convergence of parallel lines toward the horizon, used in set design to make a shallow space appear deeper.

forging Shaping of metal by hammering it over a hard surface, often after first heating the metal to a *malleable* state.

form The volume and shape of a three-dimensional work, perhaps including unfilled areas that are integral to the work as a whole.

found object An object not originally created as art but used in or appreciated as a work of art.

free time Referring to art that moves and changes somewhat unpredictably through time.

frontal Seen or made to be seen only from the front, as opposed to pieces that encourage viewing in the *full round*.

full round Works designed to be appreciated from all sides, in fully three-dimensional space.

functional arts See applied design.

gestalt In a successful work of art, a whole that has properties that transcend the sum of its parts.

glaze In *ceramics*, a colored or transparent liquid applied to pieces made of clay; when *fired*, it bonds to the clay and forms a hard, glassy coating.

Golden Section (Golden Mean) According to ancient Greek aesthetics, an ideal proportional relationship between parts, whereby the smaller is to the greater as the greater is to the whole. This ratio is approximately 5:8, or 1:1.618.

gray scale The representation of gradations of value as a series of equal steps from black to white

half-round Three-dimensional works in which only 180 degrees of a full circle is presented as being of aesthetic interest.

high relief Three-dimensional *form* raised considerably off a flat background.

highlight A brightly lit area that appears as a luminous spot on a work.

horizontal axis An imaginary central line between upper and lower parts of a piece.

hue The characteristic of color identified by color names, such as red and blue. It corresponds to a particular wavelength within the spectrum of visible light.

idealized In representational art, the portrayal of objects as approaching some imagined rather than actual appearance of perfection.

implied form See negative form.

implied line A line in a work that is subtly perceived by the viewer but that has no physical form; the overall flow of one line into another in a work, with continuation from one to the next suggested by their common direction and/or juxtaposition.

indirect lost-wax method A casting process similar to the *direct lost-wax method*, but instead of the positive form, the negative *mold* lined with wax is filled with a nonmelting core of crushed material.

industrial design Design of the mass-produced products of our everyday environment, from sinks and furniture to computers.

inner form See interior form.

installation pieces Designed environments installed in museums or gallerles, sometimes temporarily.

intensity See saturation.

intent The central idea or problem with which the artist is working.

interior form The shape of the inside of a hollow work of art; an inner form that appears to be emerging from or contained within the outer form.

intermediate hues Albert Munsell's term for secondary colors.

junk sculpture Three-dimensional works of art created from the castoff products of our society.

kiln An oven, furnace, or other enclosure used for the *firing* of *ceramics*.

kinetic art Works designed to move and perhaps change through time.

laminate To create a larger unit by gluing together thin sheets of a material or materials.

layout The arrangement of a site or design, often conceived as a two-dimensional diagram as seen from above.

line An area whose length is considerably greater than its width, or in which two planes are abutted.

linear Of or relating to a line or lines.

linear perspective The optical illusion that parallel lines converge toward a distant vanishing point.

local color The natural color of an object.

lost-wax method Any of several *casting* processes by which a layer of wax is melted away from surrounding positive and negative *molds* to create a space into which the material for the cast can be poured.

low relief Three-dimensional form that is barely raised from a flat background.

malleable Capable of being shaped, pliable.

maquette A small-scale model of a work, usually developed to aid the planning process.

mass See form.

minimal art Extremely simplified art, using very few forms and colors, and avoiding narrative and representation of anything other than itself.

mixed media Combinations of different materials to create a visually and physically coherent whole.

mobiles Hanging sculptures that turn when moved by air currents.

modeling Shaping pieces from a pliable material such as clay by using the hands and hand tools.

moiré An illusory wavelike pattern.

mold A hollow form created for casting materials that flow into the form when in a liquid state and

then duplicate the form in reverse when hardened.

monochromatic A color scheme using closely related colors derived from a single *hue* but perhaps varying in *value* and *saturation*.

monolithic A piece having a relatively closed form that reflects the single stone or block of wood from which it was carved.

monumental works Very large, imposing works of art that may or may not serve memorial purposes.

narrative art Pieces that tell a visual story.

natural lighting The use of existing outdoor lighting rather than artificial lights to illuminate a piece.

negative form A shaped space that has no physical existence but is enclosed or defined by *positive forms*; a void.

negative line An unfilled area with a linear quality.negative mold A receptacle for *casting* that is the reverse of the finished form. See *mold*.

negative space A physically unfilled area in a three-dimensional work; in subtractive sculpture, a previously filled area that was cut away to reveal the *form*.

neutrals Colors of very low *saturation*, approaching grays.

nonobjective art Works that have no apparent relationship to objects from our three-dimensional world; nonrepresentational art.

nonrepresentational art See nonobjective art.

open form A mass penetrated by negative spaces.
optical color mixture Colors mixed visually, as when hues are closely juxtaposed in space or when transparent layers of different colors are overlaid.

outline The line described by the outer boundary of a *form*.

participatory sculpture Three-dimensional art designed to engage the viewer physically.

patina The sheen produced on a surface by aging or handling; the thin layer of coloration, usually green or brown, that appears on a bronze surface as it oxidizes or weathers.

pattern A full-size model of a desired form, to which casting materials are applied to create a *mold*.

- **performance piece** A live experience conducted or set up by the artist.
- **pigment** A powder that is the coloring ingredient for paint or other color media.
- **planar construction** Three-dimensional work using flat-sided forms.
- plastic Capable of being shaped; polymerized organic compounds that can be shaped in many different ways,
- plasticity Malleability.
- **point of view** The distance and angle from which something is seen.
- polychromed (polychromatic) Multicolored.
- **porcelain** Usually white ceramic pieces made of very fine clay and fired at the highest temperatures.
- **positive form** A solid area that physically occupies space in a three-dimensional work of art.
- **positive space** A physically filled area in a three-dimensional work.
- primary colors In color theory, those basic *hues* from which all other hues can be mixed. Different color theories suggest different primaries. In traditional color theory about pigment mixtures, the primary colors are red, yellow, and blue.
- **primary contour(s)** The shape of the outermost extremity of a three-dimensional work.
- **principal hues** Albert Munsell's term for *primary colors*.
- **principles of design** Basic aesthetic considerations that guide organization of a work of art.
- **proportion** A sense of appropriateness in the size relationships of different parts of a work.
- **raising** In metalworking, the hammering of a flat sheet of metal over a stake, thus compressing and curving it into a hollow form. In *ceramics*, one of the stages of the throwing process.
- **read** To scan or perceive a work of art in a particular way or with a particular understanding.
- **ready-made** A functional manufactured object that is displayed as a work of art for its unintentional aesthetic qualities.
- **realism** Visual accuracy in artistic representation of known objects.
- reflected light The light waves that bounce back to our eye from a surface rather than being

- absorbed into it. These reflected waves determine what we call the "color" of the object.
- **refracted light** The bands of color seen when white light is passed through a prism.
- **relief** Three-dimensional form raised from a flat surface.
- **repetition** Use of similar design features again and again.
- **repoussé** In metalwork, the technique of hammering a thin metal sheet from the back side to shape and raise areas on the surface.
- **representational art** Artworks intended to present likenesses of known objects.
- **rhythm** Unification of parts of a work through measured repetition of visual accents.
- **rigid plaster piece mold** A casting method by which the outside of a full-size positive *pattern* is divided into pieces; each piece is cast separately and then the pieces are reassembled as a hollow *cast*.
- **sand mold** A casting *mold* made of sand and a binder.
- **saturation** A measure of the relative purity and brightness or grayness of a color; also called "chroma" or "intensity."
- **scale** The size of an object in relationship to other objects and to its surroundings.
- **secondary colors** In color theory, the *hues* created by mixing two *primary colors* together.
- **secondary contours** The forms developed within the outer boundaries of a work.
- shade A dark value of a hue.
- **shadow study** An analysis of where *natural lighting* will create shadows at different times of day and different seasons at a particular location.
- **shim** In casting, a thin piece of material used to separate parts of a *rigid plaster piece mold*.
- simultaneous contrast The principle that the juxtaposition of two colors exaggerates their differences and reduces their similarities.
- **site-specific** Referring to works expressly designed for and installed in a particular location.
- **slipcasting** Creating cast forms by pouring slip (clay in liquid suspension) into *molds* of plaster that pulls much of the water out of the slip, allowing it to dry and harden.

soldering Joining metals with a heated fusible alloy.

space The three-dimensional field with which the artist works, including both filled and unfilled areas.

spatial presence The size and impact of the field in which a three-dimensional work is experienced. This field may not stop at the physical boundaries of the work.

static form A three-dimensional work that appears stationary.

stoneware *Ceramic* pieces made of medium-fine clays and fired at medium temperature ranges.

stylized Altering the visual characteristics of an object to fit a desired way of design or cultural aesthetic.

subtraction Creation of a work of art by carving away the excess from a larger piece of material.

subtractive color mixing Mixing of *pigments*, producing a slightly darker *value* since each pigment subtracts its energy from the light reflected by the mixture.

superrealism Extremely accurate representation of actual three-dimensional objects.

symmetrical balance The placing of identical forms to either side of the central axis of a work to stabilize it visually.

temporal Relating to existence in and perhaps change through time.

tensile strength The resistance of a material to a force tending to tear it apart.

tertiary colors In color theory, the *hues* created when a *primary* and a *secondary color* are mixed.

texture The tactile surface characteristics of a work of art that are either felt or perceived visually.

thermoformed In plastics, a shape created by bending the material when hot.

thermoplastic Capable of being remelted and reformed, a characteristic of some plastics, metals, and glass.

thermosetting Not capable of being remelted after initial shaping and setting, a characteristic of certain plastics, rubbers, and clay.

three-dimensional Having height, width, and-depth.

tint A very light value of a hue.

transition Gradual introduction of Variety.

trompe l'oeil "Fool the eye" optical illusion.

two-dimensional Having height and width, but not depth.

undercutting Creation of an overhanging surface by carving material beneath away.

unity Organization of parts so that all contribute to a coherent whole. The term is sometimes listed as one of the organizing principles of design, but in this book it is used to connote the combined result of all principles of design (repetition, variety, rhythm, balance, emphasis, economy, and proportion).

value Degree of lightness or darkness.

value contrast Juxtaposition of light and dark areas.

variety A principle of design in which parts are seemingly different but nonetheless have something in common.

vertical axis An imaginary line through the center of a piece between the right and left sides.

vertical balance Distribution of *visual weights* in a piece in such a way that top and bottom seem to be in equilibrium.

video art Use of television techniques for purely aesthetic purposes.

virtual reality Computer-animated simulated experience in which the viewer seems to interact with a scene as if inside it.

visible spectrum The humanly perceptible bands of colored light created when white light passes through a prism.

visual balance The appearance that parts of a work offset each other in such a way that it will not fall over.

visual economy. See economy.

visual texture The apparent rather than actual tactile quality of a surface.

visual weight The apparent lightness or heaviness of a work or a portion of a work.

void See negative form.

volume See form.

warm colors Red, orange, and yellow hues.

INDEX

Abbey Church, in Ottobeuren, Germany, 162 Abraham Lincoln (French), 39-40, 41.143-144 Abramovic, Marina, 29-31 abstraction, 21, 92 Acetabularia (Zelanski), 28-29 Acme Thunderer (Chamberlain), 200 activated space, 96-100 Adams, Peter Michael, 157 additive construction, 205, 226-227 additive method, of mixing color, 154 Adolescence (Hajdu), 117, 118, 122 African wood sculpture, 196 Ajanaku, Lawrence, 171-172 Ambasz, Emilio, 58-59, 60 Amundsen, Anniken, 217 analogous color schemes, 168, 171 - 172Anamorphosis Architects, 104, 106 annealing, 213 Another Place (Stone), 80, 81 Aoyama College, 60-61 applied art, 52 applied color, 160-165 applied design, 32 Arad, Ron, 146, 147 Arango House (Lautner), 90 architectural systems, 35 armatures, 205 Art Tower Mito (Isozaki), 186 The Artichoke Lamp (Henningsen), 139-140

artificial lighting, 143–146

Ascension (Hendee), 150, 151
assemblages, 196–201
asymmetrical balance, 72
atmospheric perspective, 110, 167
"Atollo" lamp (Magistretti), 73
audlence, 57–61
Aztec art, 26, 27

Baboon and Young (Picasso), 198, 199 The Back I, II, III, IV (Matisse), 21, 22 balance, 71-74 balancing point, 72 Barber, Joseph, 12 Barcelona Chair (Mies van der Rohe), 190 Baskin, Leonard, 145 bas-relief, 11-12 Bauhaus/Blocks, 54-55 Le Beau Ténébreux (Magritte), 202 Bell, Larry, 140, 141, 223 Bernini, Gianlorenzo, 27, 44, 58, 92 bezels, 226 Big Easy (Arad), 146, 147 Big Mama (Scott), 216 Bill, Max, 70 Bird in Space (Brancusi), 8-9, 148 Birdstone, 235, 236 Bison, 11 bisque ware, 209 Blenheim Palace Park, 105 Blond Negress II (Brancusi), 234

Blood #8 (Lipski), 32

blue, 165, 166, 167-168 Blue Sky (Strider), 167 Blue Small Forms (Takaezu), 167 Boccioni, Umberto, 4-5, 177 body art, 133 Boghosian, Varujan, 198, 200 Bontecou, Lee, 223 Booker, Chakaia, 130 Borgatta, Isabel Case, 131-132 Borofsky, Jonathan, 120-121 Boston's Post Office Square, 40, 42, 142 Bottle Rack (Duchamp), 196 Bound Grid (Winsor), 221, 222 Bound Slave (Michelangelo), 82-83 Bourgeois, Louise, 95-96 Brancusi, Constantin, 8-9, 92, 93, 148, 234 The Brass Family (Calder), 114, 115 brazing, 223 The Bride (Stankiewicz), 198, 199 bronze, 238, 241 Bronze Bell (Takaezu), 62 Brotonne Bridge, 55, 56 Brussels Construction (Rivera), 180 Burj Al Arab, 2-3 burls, 230 Bust of a Nubian (Cordier), 135, 158

Calatrava, Santiago, 50–51 Calder, Alexander, 114, 115, 182, 183 Camels (Graves), 16 Carpeaux, Jean-Baptiste, 118, 119

Carved Bowl on Pedestal, 230	for contrast creation, 110	De Maria, Walter, 9, 10
Casa de Retiro Espiritual (Ambasz),	cool vs. warm, 166	de Rivera, José, 180
58-59, 60	definitions, 154-157	DeAndrea, John, 91
Casa Milá apartment house, 123	effects of, 165-169	Degas, Edgar, 211-212
casts and casting	importance of, 153	della Robbia, Luca, 110, 208-209
definition of, 237	intensity of, 155	Denes, Agnes, 132
editions, 248	and light, 157	Depression Bread Line (Segal),
foundries, 247-248	natural, 157-160	170-171
hollow casts, 245-247	primary, 154	Der Setzungandere Seite (Jetelova),
process of, 237-238	secondary, 154-155	127
solid casts, 238-245	value, 137-141	Design 3 (Hauer), 243-245
and texture, 249	color schemes, 168-174	di Suvero, Mark, 73, 177
cave paintings, 11	color wheel, 154, 155, 169,	diagonal lines, 124
Cellini, Benvenuto, 54	172, 173	Die (Smith), 81
cement, 212, 231	Coming through the Rye (Remington),	Dimitrijevic, Braco, 202
ceramic pot (Coper), 77	69, 70	direct lost-wax method, 245
ceramics, 53, 206–211	complementary colors, 155, 156,	direct relief mold method, 238
Chamberlain, John, 199-201	173	directional lines, 120-121
Chartres Cathedral, 23, 24, 26	computer technology, 5, 7,	"Dislocations" (Piper), 188
chasing, 213	50–51	display, 107–108
Chicago, Judy, 124, 125	computers, design of, 54	Dolbin, Steven, 26, 28
Chicago Millennium Park, 189	conceptual art, 9	dominance, 74
Chihuly, Dale, 18, 218, 219	concrete, 212	Donovan, Tara, 118, 119
Child's Bicycle (Yoshimura),	confined space, 100–103	door handle (Horta), 90
232–233, 235	Construction in Wood (Ferren),	Doré, Gustave, 8
The Chinese Roots (Zhenyu), 215	172–173	Dotoh (Adams), 157
Chinese works	Constructivist movement,	
ceremonial vessel, Shang dynasty,	92–93	double-complementary colors, 173
237		Dragon (Snelson), 38, 39, 43
	content, 25–27	Dragonfly Brooch (Jensen), 226
jade bowl (18th century), 230 porcelain, Ming Dynasty, 158	contour, 84, 86	drawings, 48
	contrasts, 68–69, 131–132,	Dubuffet, Jean, 117, 118
Christo, 37, 38, 48, 53, 184	139–141	Duchamp, Marcel, 196
chroma, 155	controlled time, 181–185	ductility, 213
Church of the Sagrada Familia	cool colors, 166	Dunne, Michael, 173
(Gaudi), 75, 76	Coombes, Polly, gravestone of, 12	Dwelling (Simonds), 7, 23
Ciona (Pilobolus Dance Theater),	Coper, Hans, 75, 77	dynamic form, 90
114, 115	Cordier, Charles Henry Joseph, 135,	
clay, 206–211	158	earthenware, 211
clay bodies, 206	Cornell, Joseph, 100–101	earthworks, 116, 186
Cleopatra's Wedge (Pepper), 72	cost, of producing pieces, 57	East Coast Sea Cairn (Goldsworthy),
Cliff Palace (Grant Heilman	Cradle (Livingston), 219, 220	142, 143
Photography), 8	crafts, 52–53	Easter Island statutes, 69
Clothespin (Oldenburg), 24	crocheting, 215	Ebizuka, Koichi, 219, 220
Cloud Gate (Kapoor), 189	Crown Fountain (Plensa), 189	economy, visual, 75–76
Coatlicue, 27	Cubi XII (Smith), 94-95	The Ecstasy of Saint Theresa
color	Cubo Virtual (Soto), 114	(Bernini), 27, 44, 92
applied, 160-165	curiosity, 19–20	edges, 117
and balance, 71	curving lines, 122-123	Edison's Direct Current Was Failed to
combinations of, 169-174	David (Michelangelo), 90-91, 92,	the Alternating Current
complementary, 155, 156, 173	109, 190	(Zhenzhong), 25-26

editions, 248 nonobjective, 92-93 Gorky's Pillow (di Suvero), 177 Gorman, Virginia, 217 The Egg Package, 83 positive vs. negative, 86-89 elements of design, 53, 63-64 representational, 91-92 Grant Heilman Photography, 8 Elizabeth Whiting & Associates, 173 static vs. dynamic, 89-90 Grassi, Andrea, 248 Ellenzweig Associates, 42 stylization, 21, 92 Graves, Nancy, 16 emotional responses, to color, subtraction method, 231-234 gravestone carvings, 12 165-166 Forms in Space (Storrs), 74 gravity, 34-38 emphasis, 74-75 found objects gray scale, 138-139 Enamel Garden (Dubuffet), 117, 118 assemblages, 196-198 A Great Hall (Hockney), 111 encaustic method, 160 definition of, 194 Great Image of Buddha, 247 Ephemera Bundle (Hicks), 128-129 individual, 194-196 Great Mosque, 39, 40 installation pieces, 29, 100, Great Pyramids at Giza, 89 Ergon chair, 44 201-204 Green Cobalt Sea Form Set with Red ergonomics, 44 Esherick, Wharton, 16 junk sculpture, 198-201 Lip Wraps (Chihuly), 219 foundries, 247-248 Gudea Worshiping, 89, 92, 190 Eva Hesse's Studio (Hesse), 66-67 Guggenheim Museum (Bibao, Ex nihilo (Hart), 51-52 Fountain Sculpture (Fitzgerald), exterior form, 82-84 186-187 Spain), 40, 41 eye lines, 96 fountains, 57-58, 72, 186-187 Guggenheim Museum (New York), 6, Fox Games (Skoglund), 163 64,65 Eyrie (Shuldiner), 225 free time, 185-189 Habitat (Safdie), 64, 66 fabrication, 48 French, Daniel Chester, 39-40, Hajdu, Etienne, 117, 118, 122 The Faint (Gallo), 238 41, 143 Fallingwater (Wright), 140, 142 frontal works, 13-15 Halvorson Company, 40, 42 Ferren, John, 172-173 full round, definition of, 15 Hammons, David, 202-203 fiber arts, 114, 134, 215-217 function, form, vs., 52-57 Hanson, Duane, 243 figurative form, 91-92 functional art, 52, 53 Hart, Frederick, 51-52 fine art. 52 Futurists, 177 Harvey, Bessie, 174 firing, 209 Hastishala, 235 Gabo, Naum. 74, 75, 95, 226 Hauer, Erwin, 88, 107-108, First Gate Ritual Series (Singer), 71 Gallas Rock (Voulkos), 208 243-245 First Personage (Nevelson), 126 Hawaiian Image, 127 Fischer, Johann Michael, 162 Gallo, Frank, 238 Fite, Harvey, 178, 179 Galston, Beth, 190-191 Heizer, Michael, 122 Hendee, Stephen, 150, 151 Fitzgerald, James, 186-187 Gardener's secateurs, 112, 122 Henningsen, Poul, 139 Five Angels for the Millennium gardens, 79, 104, 105, 110, 159-160 (Viola), 165 Gartenskulptur (Roth), 178 Henry VIII, 84 Hepworth, Barbara, 86-87, 139, Flea Market Lady (Hanson), 243 Gateless Gate (Lewis), 33 flexible molds, 242 140-141, 231 Gateway Arch, 116 Hercules Crushing Antaeus focal point, 74 Gaudi, Antoni, 75, 76, 123 folk art, 182 Gehry, Frank, 40, 41 (Pollaiuolo), 36 Herman Miller, 44 For Paul (Von Rydingsvard), 15 gestalt, 226 forced perspective, 110 The Ghost of Icarus (Minkowitz), 215 Hesse, Eva, 66-67 Ford Foundation Building, 102 Giacometti, Alberto, 116, 141 Hicks, Sheila, 128-129 forging, 214 glass, 218-219 high relief, 12-13 form glazing, 209 highlights, 138, 156 abstraction, 21, 92 Goddess Vidyadevi, 12-13 Hill, Christine, 185 contours, 84, 86 Goldberger, Paul, 106-107 Hitching Post of the Sun, 236 definition of, 80 Golden Section, 78 Hockney, David, 110, 111 Hoener, Arthur, 52, 53, 65, 74 exterior vs. interior, 82-84 Goldsworthy, Andy, 9, 10, 68-69, vs. function, 52-57 142, 143 Holley, Lonnie, 18-19

Good, Jesse, 181, 182

lines within, 117-118

hollow casts, 245-247

Holt, Nancy, 121 (Heizer), 122 landscape design, 159-160 Holzer, Jenny, 6 Isozaki, Arata, 60, 180-181, 186 Laocoön, 86 Homage to New York (Tinguely), 182, Lautner, John, 90 It's So Hard to be Green (Booker), 130 lavouts, 48 Hoover, Nan, 190, 191 Le Beau Ténébreux (Magritte), 202 Hopes and Ways to Identify Jaguar Woman (Borgatta), 131–132 Le Corbusier, 87, 149 (Dimitrijevic), 202 James, Clayton, 80, 81 LeMessurier Consultants, 42 Horace E. Dodge and Son Memorial Japanese garden shears, 112, 122 Levens Hall, 159-160 Fountain (Noguchi), 57-58,59 Japanese gardens, 79, 104, 105, 110 Levine, Marilyn, 21, 44, 135 horizontal axis, 73 Japanese works Lewis, John, 171, 172 horizontal lines, 123 Great Image of Buddha (at Lewis, Maria, 33 Horse, 23 Kamakura), 247 LeWitt, Sol. 88-89 Horse Dance Stick (Fox), 93 Horse (5th-6th century), 23 light Horta, Victor, 90 "package," 83 artificial, 143-146 The House with the Ocean View jazz music, 223 and color, 157 (Abramovic), 29-31 Jeanne-Claude, 37, 38, 48, 53, 184 as medium, 149-152 How High the Moon (Kuramata), 84 Jefferson National Expansion Memornatural, 142 Howard, Linda, 48, 49, 148-149, ial (Saarinen), 116 reflected, 146-149 223 Jensen, Georg, 226 stage lighting, 150-152 hues, 154, 156 Jetelova, Magdalena, 127 value of, 137-141 human body, 78, 91, 92, 114-116 jewelry, 13-14, 28-29, 213, 226 light sculptures, 149-152 Hupka, Robert, 145-146 Joan (DeAndrea), 91 The Lightning Field (De Maria), 9, 10 The Iceberg and Its Shadow (Bell), Johnson Atelier, 248 Lightwall (Galston), 190-191 140, 141, 223 Judd, Donald, 64, 65 Lightweb (Kraft), 149 junk sculpture, 198-201 Lincoln Center for the Performing idealized form, 91-92 Arts, 144-145 illusions, 109-111 Kahn, Louis, 29 Lincoln Center Reclining Figure implied lines, 118-121 Kapoor, Anish, 189 (Moore), 146-148 Inca stonework, at Machu Picchu, Karina, Elena, 82 Lincoln Memorial, 39-40 224, 225 Katzenfamilie (Oguro), 228, 229 Linear Construction (Gabo), 74. Indian works Kienholz, Edward, 14-15 75, 95, 226 bronze (14th century), 205-206 Kienholz, Nancy Reddin, 14-15 linear perspective, 5, 110 Buddhist assembly hall, kilns, 209 linear works, 112-116 228, 229 kinetic art, 180-185 lines at Delwara Jain Temples, 235 kinetic sculpture performance, 184 definition of, 112 temple art, 12-13 Kington, L. Brent, 214 within forms, 117-118 indirect lost-wax method, 245 Knight Rise (Turrell), 150, 151 implied vs. directional, 118-121 industrial design, 53 Kraft, Craig, 149 linear works, 112-116 Infante, Francisco, 148 Kuang, 237 qualities of, 121-125 Inner Rhythms (Minkowitz), 134 Kuramata, Shiro, 53, 54, 84 Lipchitz, Jacques, 72, 73, 74 installation pieces, 29, 100, Kuspit, Donald, 168-169 Lipski, Donald, 32 201-204. See also specific work Livingston, Edward, 219, 220 intensity, of color, 155 La Cama (Osorio), 62-63 local color, 157 intent, of work, 62 La Vigne (Doré), 8 Loewy, Raymond, 54 interior form, 82-84 Labyrinth (Morris), 17 lost-wax process, 245, 246 Internal and External Forms (Moore), Lachaise, Gaston, 138, 142 low-relief, 11-12 232 Lambert, Ron, 113-114 in-the-round, definition of, 15 laminating process, 219 Machu Picchu, 224, 225, 236 Inversion of Volumes (Hauer), 88 Land Rollers (von Rydingsvard), Madonna and Child (della Robbia).

130-131

110, 208-209

Isolated Mass/Circumflex

models, 51-52, 208 Notre Dame du Haut (Le Corbusier), Madonna and Child (Moore), 87, 149 96, 97 Moebius Extension (Paque), 120 Nouveau Rat Trap (Westermann), The Magic Flute stage set moiré patterns, 148 molds, 237, 238, 241, 242, 245, 219, 221 (Hockney), 110, 111 247, 248 Magistretti, Vico, 73 Object (Oppenheim), 32 Magritte, René, 202 Monoangulated Surface (Bill), 70 monochromatic color scheme, 168, Ocean Song (Scott), 222, 223 Mali, Great Mosque at Dyenné, 169-170 Odate, Toshio, 124-125 39, 40 Odeum Karaoke Club (Totah), 163, malleability, 213 monolithic sculptures, 232 Monumental Head (Giacometti), 141 164 malleable materials, 205-214 Moore, Henry, 42-43, 96, 97, Odogu (Ajanaku), 171-172 Man Walking to the Sky (Borofsky), 120-121 146, 232 Oedipus Rex (Sophocles), 152 The Morphic Excess of the Oguro, Sabu, 228, 229 maquettes, 51-52 Natural/Landscape in Excess Okamoto, Atsuo, 228, 229 Marabar (Zimmerman), 45, 46 Marisol, 129-130 O'Keeffe, Georgia, 129-130 (Anamorphosis), 104, 106 Oldenburg, Claes, 24, 38, 39, 46-47, mass, 80 Morris, Robert, 17, 75-76, 77 movement, illusion of, 175-177 materials, 44-48, 205-214, 228, Movement from Either Direction opals, 158 230-231 (Hoover), 190, 191 open form, 232 Matisse, Henri, 21, 22 Mozart's Birthday (di Suvero), 73 Oppenheim, Meret, 32 Matt, John, 47, 48, 49, 52, 96, 221, Muller, Jean, 55, 56 Oppressed Man (Baskin), 145 226-227 optical color mixtures, 154 Munsell, Albert, 155-156 Matton, Charles, 108 Opus 40 (Fite), 178, 179 Murray, Don, 150-151 Max II Cups and Saucers (Vignelli Orpheus (Boghosian), 198-199, 200 Mutant (Weinberg), 239, 241 Associates), 57 Osorio, Pepon, 62-63 Mayan urn, 205, 206 N Lines Vertical (Rickey), 96-97, ostrich eggshell drinking vessel, 195 Mayer, Erika, 19-20 outdoor art, 38-39 120, 180 McMillin, Tom, 209, 210 outlines, 117 Naples, roadside shrine in, 197 Meadmore, Clement, 98, 99 Nathan Phillips Square, 102 Merz, Frank, 152 National Cathedral, Ex nihilo Paik, Nam June, 31 Merz-Relief (Schwitters), 13 Panton, Verner, 37, 38 tympanum, 51-52 metals National Geographic Society buildpaper casting, 238 casting of, 238 Paque, Joan Michael, 120 ing, Marabar sculpture, 45 fabrication of, 221-223 "Paragraphs on Conceptual Art" natural color, 157-160 manipulation of, 205-206, (LeWitt), 88-89 natural light, 142 213-214 The Parking Garage (Segal), 158, 159 natural objects, 195-196 properties of, 47, 214 Parsons Brinkerhoff Quade & natural texture, 127-129 Michelangelo, 82-83, 90-91, 92, Douglas, Inc., 42 109, 145, 190, 233 Nazca lines, 23, 25 Parthenon, 78 Needle (Bourgeois), 95-96 Mies van der Rohe, Ludwig, 190 participatory sculpture, 98 negative form, 86-89 Millennium Park, Chicago, 189 negative lines, 114 patterns, 238 miniatures, 108, 187-188 negative molds, 238 People Holding Bound Ducks (Kienminimal art, 75-76 holz and Kienholz), 14-15 Minkowitz, Norma, 134, 215 negative space, 94 Negoro, Minnie, 206-207 Peplos Kore. 160-161 Mirror Displacement (Cayuga Salt neutrals, 155 Pepper, Beverly, 72 Mine Project) (Smithson), Nevelson, Louise, 14, 126 Perec Library #3 (Matton), 108 128, 129 performance art, 184-185 No Wake Glut (Rauschenberg), 67-68 Mitchell, Bruce, 45-46 performance pieces, 29, 31 mixed media, 224-227 Noguchi, Isamu, 57-58, 59 nonobjective form, 92-93 perspective, 110 Miyawaki, Aiko, 150 Perspectives 8 (Holley), 18-19 mobiles, 182 nonrepresentational form, 92-93

Peru, Nazca lines in, 23, 25 Queen's Head, 195-196 Salicylic (Lambert), 113-114 Pevsner, Antoine, 93 Saltcellar of Francis I (Cellini), 54 photographs Rainbow Pickett (Chicago), 124,125 Samaras, Lucas, 197, 198 space in, 97 raising, 213 San Francisco Museum of Modern of three-dimensional art, Rauschenberg, Robert, 67-68 Arts, 53 limitations, 3-11 reading, of lines, 122 sand molds, 245, 247 Picasso, Pablo, 198, 199, 249 "ready-made" art, 196 saturation, 155, 156 Pierced Form (Hepworth), 86-87 Rectangles (Howard), 48, 49 scale, 7-8, 22-25, 108-109 Pietá (Michelangelo), 145 reflection, 146-149, 154 Scaur Water (Goldsworthy), 9, 10 pigments, 154 refraction, 154 Schaefer, Hiltrud, 217 Pilobolus Dance Theater, 114, 115 Related Effect S-90LA (Ebizuka), 219, Schwitters, Kurt, 13 Piper, Adrian, 188 Scott, John, 222, 223 plaster, 212, 231 Relic of Memory (Dolbin), 26, 28 Scott, Joyce J., 216 plastic, 223-224, 231, 238 relief, 11-13, 100 Seated Man with Harp, 232 plasticity, 205 Remington, Frederic, 69, 70 secondary colors, 154-155 Plensa, Jaume, 189 repetition, 64-65 secondary contour, 84, 86 point of view, 4-5 repoussé, 213 Segal, George, 158, 159, 170, 171 political intent, of work, 25, 62-63 representational art, 20-21, 108 Serra, Richard, 44-45 Pollaiuolo, Antonio, 36 representational form, 91-92 setting, 38-43 polychromed pieces, 161 The Revolving Cabinet (Kuramata), 54 Severed Head of Saint John the Pomodoro, Arnaldo, 82 rhythm, 69-71 Baptist (Rodin), 241 porcelain, 158, 211 Rickey, George, 96-97, 180 shade, 154 Portrait of Georgia O'Keeffe with rigid plaster piece molds, 241 shadow studies, 142 Antelope (Marisol), 129-130 Rigoulot, the Strong Man (Calder), Shaker furnishings, 55, 56 positive form, 86-89 182, 183 Sheep Piece (Moore), 43 positive space, 94 ritual displays, 196 She-Goat (Picasso), 249 pottery, 206-211 Rivera, José de, 180 Sheikh el Beled, 231 Pride of New England (Odate), Robbia, Luca della, 110, 208-209 Shidoni Foundry, 242 124-125 Roche, Kevin, 102 shims, 241 primary colors, 154 rock outcroppings, 153 shrines, 197 primary contour, 84, 86 Rockefeller, David, 123, 124 Shuldiner, Joseph, 225 principles of design, 53, 63-64 Rocking Horse (Kington), 214 Silver Liqueur Decanter (Sørensen), Professional Arts Building, Miami Rodia, Simon, 203-204 53 (Vrana), 239, 240 Rodin, Auguste, 175-176, 208, 212, Simonds, Charles, 7, 22, 23, Progression from Two Corners 234, 241 187-188 (LeWitt), 88-89 Rogers, John, 20 simultaneous contrast, 156 Project California Condor (Hauer), Rose Engine Lathe, 136 Singer, Michael, 71 107-108 Roth, Deiter, 178 site-specific works, 48, 50 Prometheus Strangling the Vulture Rothschild, Eva, 106 size, 43-44 (Lipchitz), 72, 73, 74 Rydingsvard, Ursula von, 15, sketches, 48 proportion, 76-79 130 - 131Skoglund, Sandy, 163 Proposed Colossal Monument: Scissors Ryoan-Ji rock garden, 78, 79 Sky Cathedral- Moon Garden (Nevelin Motion (Oldenburg), 50 son), 14 Public Enemy (Hammons), 202-203 Saarinen, Eero, 103, 104, 116 Sky Trumpet (Karina), 82 public spaces, 102, 106-107 Safdie, Moshe, 64, 66 Sledhoff-Buscher, Alma, 54-55 Puckey, Thom, 37 Saint John the Baptist Preaching slipcasting, 241 Puerto Rican art, 62-63 (Rodin), 175-176 Smith, David, 94-95, 136 pyramids, at Giza, 89 Saint Matthew (Michelangelo), Smith, Tony, 81, 101-102 Queen Califia's Magical Circle (Sainte 233-234 Smithson, Robert, 116-117, Phalle), 163, 164 Sainte Phalle, Niki de, 163, 164 128, 129

Smoke (Smith), 101-102 Steakley, Douglas, 213 texture and casting, 249 smoothness, 132-133 steel, 44-45 Snelson, Kenneth, 38, 39, 43 Steinkamp, Jennifer, 165, 166 definition of, 126 "Snow Show," 104 Stella, Frank, 134 natural, 127-129 Soft Toilet (Oldenburg), 38, 39 stereognosis, 140 subtraction method, 234-235 visual, 126, 134-136 soldering, 223 Sticks Stacked Around Two Rocks worked, 129-134 solid casts, 238-245 (Goldsworthy), 68-69 Sørensen, Oskar, 53 Stockholder, Jessica, 201 Thonet, Gebrüder, 112-113 Soto, Jesús, 114 stone, 230, 239. See also Thorn Puller, 118, 119 Soto, Merian, 62 subtraction three-dimensional art sound, 59 Stone, Sylvia, 80, 81 definition of, 2 Stonehenge, 98, 224 degrees of, 11-17 space photographs of, limitations, activation of surrounding, stonemasonry, 224 96-100 stoneware, 211 Tiffany, Louis Comfort, 158 confined, 100-103 Storrs, John, 74 definition of, 94 street theater, 189 time controlled, 181-185 delineated forms in, 94-96 Strider, Marjorie, 167 illusions, 109-111 Study: Falling Man (Trova), 133 free, 185-189 scale, 7-8, 22-25, 108-109 Stumpf, William, 44 viewing of, 177-180 spatial relationships, 103-108 stylization, 21, 92 timelessness, 190-191 Spatial Construction in the 3rd and subtraction Tinguely, Jean, 182, 184 4th (Pevsner), 93 definition of, 228 tint, 154 spatial illusions, 109-111 form, 231-234 titles, 33 spatial presence, 96 materials, 228, 230-231 Tokyo, Japan, challenge to architexture, 234-235 tects, 59-60 spatial relationships, 103-108 Sphere with Perforations (Pomodoro), Torqued Ellipses (Serra), 44-45 value, 236 subtractive method, of mixing color, Totah, Larry, 163, 164 Spiral Jetty (Smithson), 116-117 Trajan's Column, 86, 178-180 Suhrawardi Hospital, in Dhaka, 29 transition, 69 The Splash (Puckey), 37 Suite de la Longitude (Cornell), Transition (Amundsen), 217 split-complementary colors, 173 100-101 Transitoriness and Decay (Schaefer), Spoonbridge and Cherry (Oldenburg and van Bruggen), suits of armor, 84, 85 Transplanted (Donovan), 118, 119 Sun Tunnels (Holt), 121 Spot's Suitcase (Levine), 21, 44 superrealism, 91 triad color schemes, 173-174 St. Louis Arch, 116 Suvero, Mark di, 73, 177 Tribal Spirits (Harvey), 174 Stacking Side Chair (Panton), symmetrical balance, 72 Triton Fountain (Bernini), 57, 58 37.38 trompe l'oeil, 44, 135 Trova, Ernest, 133 stage design, 110 Table Top Sculpture (Stockholder), stage lighting, 150-152 201 Truisms, Inflammatory Essays, The stairway, by Esherick, 16 tactile appeal, 18 Living Series, The Survival Standing Figure No. 2 (Hoener), Takaezu, Toshiko, 62, 167 Series, Under a Rock, Laments 53.74 Taliesin (Wright), 158, 159 (Holzer), 6 Standing Woman (Lachaise), 138, Tall Figure (Giacometti), 116 Turrell, James, 150, 151 139, 142 Team Disney Building (Isozaki), 181 TWA Flight Center (Saarinen), Stankiewicz, Richard, 198, 199 Technology (Paik), 31 103, 104 Ten Walking Jeans (Gorman), 217 Two Segments and Sphere (Hep-Star Burst (Howard), 148-149, 223 Star Chamber (Mitchell), 45-46 tensile strength, 221 worth), 139 static form, 89 tertiary colors, 155 two-dimensional art, 5 Statuette: Horse Galloping on Right Teshigahara, Hiroshi, 29, 30 Two-Toned Golf Bag (Levine), 135 tetrad color schemes, 174 Foot (Degas), 211-212

Ugolino and His Sons (Carpeaux), 118, 119 unexpected elements, 32 Unique Forms of Continuity in Space (Boccioni), 4-5, 177 unity, 63 University of North Carolina, Department of Computer Science building, 98, 99 Untitled (Bontecou), 223 Untitled Box Number 3 (Samaras), 197, 198 Untitled (Judd), 64, 65 Untitled (Morris), 77 Upstart (Meadmore), 98, 99 Urn (Lewis), 171, 172

Valley Curtain (Christo and Jeanne-Claude), 37, 38, 48, 53, 184
value, 5, 137–141, 155–156, 236
van Bruggen, Coosje, 109
variety, 66–69
Vase and Bowl (Steakley), 213
vertical axis, 72
vertical balance, 73–74
vertical lines, 123
video art, 31–32, 163
video computer disc (VCD)
technology, 5
Vignelli, Massimo and Lella, 57
Viola, Bill, 163, 165

Utsurohi (Miyawaki), 150

Virgin and Child, 161–162
virtual realities, 7
visible spectrum, 154
visual appeal, 18–19
visual balance, 72–74
visual economy, 75–76
visual texture, 126, 134–136
voids, 86–89
"The Volksboutique Home Office
(Hill), 185
von Rydingsvard, Ursula, 15,
130–131
Voulkos, Peter, 207–208
Vrana, Albert S., 239, 240

walk-through works, 16–17
warm colors, 166
Watanabe, Makoto Sei, 60–61
water, 186–187
Water Organ, 72
Waterdancer (Mayer), 19–20
Watts Towers (Rodia), 203–204
wax, 211–212, 245
Weinberg, Elbert, 239, 241
Weinstein, Saskia, 170
Westermann, H. C., 219, 221
whirligigs, 182, 183
White Seal ("Miracle") (Brancusi), 92, 93
Wind Chant (Matt), 47, 48, 49,

96, 226

Winsor, Jackie, 221, 222

Woman of Willendorf, 21
wood, 47, 219–221. See also subtraction
worked texture, 129–134
World Trade Center PATH
terminal, 50–51
"Wounded to the Rear," One More
Shot (Rogers), 20
Wright, Frank Lloyd, 65, 140, 142,
158, 159
written statements, 32–33

XI Books III Apples (Smith), 136 X-Room (Steinkamp), 165, 166 Yellow (Good), 181, 182

Yoshimura, Fumio, 232–233, 234–235 Young Woman in a Flowered Hat (Rodin), 212

Zagourski, Casimi d'Ostoja, 133 Zelanski, Ruth, 18, 28–29 Zhenyu, Guo, 215 Zhenzhong, Yang, 25–26 Zimmerman, Elyn, 45, 46 Zimming (Stella), 134

PHOTOGRAPHIC CREDITS

Credit lines not appearing in photo captions are listed below.

Part Openings Part 1: Photo courtesy of Jumeirah. Part 2: Peter Maus/Esto, courtesy ACME, Los Angeles and Green-grassi, London. Part 3: Courtesy of the artist. Photo: Chapman/Forsyth. Part 4: Photo courtesy Chihuly Studio.

Chapter 1 1.4a and 1.4b: Photo David Heald © The Solomon R. Guggenheim Foundation, New York © 2006 Jenny Holzer/Artists Rights Society (ARS), New York. 1.5: © 2006 Charles Simonds/Artists Rights Society (ARS), New York. 1.8: Digital Image © The Museum of Modern Art/Licensed by SCALA/Art Resource, NY © 2006 Artists Rights Society (ARS), New York/ADAGP, Paris. 1.9: © CNAC/MNAM/Dist. Réunion des Musées Nationaux/Art Resource, NY © 2006 Artists Rights Society (ARS), New York/ADAGP, Paris. 1.14: Kuldeep Singh, Rajhans Colour Lab, Mount Abu. 1.15: © Lempertz, Cologne, Germany. © 2006 Artists Rights Society (ARS), New York/VG Bild-Kunst, Bonn. 1.16: Photograph by Ellen Page Wilson/Courtesy of the Pace Wildenstein Gallery © 2006 Estate of Louise Nevelson/Artists Rights Society (ARS), New York. 1.21: Institute of Contemporary Art, Philadelphia. @ 2006, Artists Rights Society (ARS), New York. 1.22: Courtesy of the artist. Photo: Dick Busher, 1,28a-d; © CNAC/MNAM/Dist. Réunion des Musées Nationaux/Art Resource, NY @ 2006 Succession H. Matisse, Paris/Artists Rights Society (ARS), New York. 1.30: © 2006 Charles Simonds/Artists Rights Society (ARS), New York. 1.31: © Claes Oldenburg and Coosje Van Bruggen. 1.37: Courtesy of the artist. 1.38: Courtesy Ruth Zelanski. 1.41: Courtesy: Sean Kelly Gallery, New York (ARS), New York/VG Bild-Kunst, Bonn. 1.44: Digital Image © The Museum of Modern Art/Licensed by SCALA/Art Resource, NY © 2006 Artists Rights Society (ARS), New

York/DACS, London. 1.45: "Maria Lewis. " 2006 Artists Rights Society (ARS), New York.

Chapter 2 2.3: Photo: Thom Puckey © 2006 Artists Rights
Society (ARS), New York. 2.5: Digital Image © The Museum
of Modern Art/Licensed by SCALA/Art Resource, NY.
2.6: © Claes Oldenburg and Coosje Van Bruggen.
2.15: © FMGB Guggenheim Bilbao Museoa, 2006. Photo
Erika Barahona Ede/copyright ARS, NY and DACS, London, 2006, Guggenheim, Bilbao, © 2006 Richard
Serra/Artists Rights Society (ARS), New York. 2.22: Photo
courtesy of the artist. © 2006 Artists Rights Society (ARS),
New York. 2.25: Courtesy of the artist. 2.27: Luminaire ©
Cappellini. 2.34: © Dave G. Houser/Corbis. © 2006 Artists
Rights Society (ARS). 2.36: Courtesy of the artist.

Chapter 3 3.3: Guggenheim Museum New York. © The Solomon R. Guggenheim Foundation, New York. © 2006 Frank Lloyd Wright Foundation, Scottsdale, AZ/Artists Rights Society (ARS), NY. 3.8: © Andy Goldsworthy, Courtesy Galerie Lelong, New York. 3.11: © The Detroit Institute of Arts. Gift of W. Hawkins Ferry. © Artists Rights Society (ARS), NY. 3.17: Digital Image © The Museum of Modern Art/Licensed by SCALA/Art Resource, NY. 3.22: Digital Image © The Museum of Modern Art/Licensed by SCALA/Art Resource, NY © 2006, Artists Rights Society (ARG), New York.

Chapter 4 4.1: Courtesy Paula Cooper Gallery, New York.
© 2006, Artists Rights Society (ARS), New York. 4.2: Photo by Mary Randlett, University of Washington Libraries, Special Collections, UW25811z. 4.4: Courtesy of the artist. 4.14: Courtesy of the artist. 4.15: Photo Hollis Taggart Galleries. © 2006 Artists Rights Society (ARS), New York.

- 4.19: Photographer; Alan Weintraub/Arcaid. © John Lautner Foundation. 4.23: Solomon R. Guggenheim Museum, New York, © The Solomon R. Guggenheim Foundation, New York. (56.1450). © 2006 Artists Rights Society (ARS), New York/ADAGP, Paris. 4.24: © CNAC/MNAM/Dist. Réunion des Musées Nationaux/Art Resource, NY © 2006 Artists Rights Society (ARS), New York/ADAGP, Paris.
- Chapter 5 5.9: Courtesy Paula Cooper Gallery, New York.

 © 2006 Estate of Tony Smith/Artists Rights Society (ARS),
 New York. 5.18: © Charles Matton, courtesy of Forum
 Gallery, New York. © 2006 Artists Rights Society (ARS), New
 York/ADAGP, Paris. 5.19: © Claes Oldenburg and Coosje Van
 Bruggen.
- Chapter 6 6.3: Courtesy of the artist. 6.4: Photo Luis Becerra. Courtesy of the artist. 6.5: Whitney Museum of American Art. Gift of the artist, 69.255. © 2006 Estate of Alexander Calder/Artists Rights Society (ARS). 6.7: Hirshhorn Museum and Sculpture Garden, Smithsonian Institution. Gift of Joseph H. Hirshhorn, 1966 (66.2031). © 2006 Artists Rights Society (ARS), New York/ADAGP, Paris. 6.10: © Nicolas Sapieha/Art Resource, NY. © 2006 ADAGP, Paris/ARS, NY. 6.11: Hirshhorn Museum and Sculpture Garden, Smithsonian Institution. Gift of Joseph H. Hirshhorn, 1966 (66.2314). © 2006 Artists Rights Society (ARS), New York/ADAGP, Paris. 6.15: Courtesy of the artist. 6.18: Dia Center for the Arts, New York. Courtesy of the artist. 6.21: Photo: Donald Woodman. © 2006 Artists Rights Society (ARS), New York. 6.22: Courtesy of the artist.
- Chapter 7 7.1: Brooklyn Museum. Gift of Mr. and Mrs. Nathan Berliawsky, 57.23A-B. © 2006 Estate of Louise Nevelson/Artists Rights Society (ARS), New York. 7.9: Courtesy of the artist. 7.13: Photo by Bob Hanson. Courtesy of the artist. 7.14: © 2006 Frank Stella/Artists Rights Society (ARS), New York.
- Chapter 8 8.5: Courtesy Chicago Historical Society. © 2006
 Frank Lloyd Wright Foundation, Scottsdale, AZ/Artists
 Rights Society (ARS), NY. 8.7: Hirshhorn Museum and
 Sculpture Garden, Smithsonian Institution. Gift of Joseph H.
 Hirshhorn, 1966 (66.2042). © 2006 Artists Rights Society
 (ARS), New York/ADAGP, Paris. 8.17: Courtesy of the artist.
 8.18: Courtesy of the artist. 8.20: Courtesy of the artist,
 Photo: Mark Gooch.

- Chapter 9 9.5: Photo Dan Bailey. Courtesy of the artist. 9.8: © Layne Kennedy/Corbis © 2006 Frank Lloyd Wright Foundation, Scottsdale, AZ/Artists Rights Society (ARS), NY. 9.15: Photo by Shubroto Chattopadhyay. © 2006 Artists Rights Society (ARS), New York/ADAGP, Paris. 9.19: Courtesy of the artist. 9.23: Courtesy of the artist.
- Chapter 10 10.8: Courtesy of the artist. 10.10: Collection of Whitney Museum of American Art. © 2006 Estate of Alexander Calder/Artists Rights Society (ARS), New York. 10.11: Photo by David Gahr. © 2004 David Gahr. © 2004 Artists Rights Society (ARS), New York/ADAGP, Paris. 10.12: Ronald Feldman in NYC. © 2006 Artists Rights Society (ARS), New York. 10.14: Photo by John Schoettler, Seattle, Washington. Courtesy of Unico Properties. 10.15: Courtesy of the artist.
- Chapter 11 11.7: Digital Image: © The Museum of Modern Art/Licensed by SCALA/Art Resource, NY © 2006 Estate of Pablo Picasso/Artists Rights Society (ARS), New York.

 11.8: Courtesy of the artist. 11.10: Photo courtesy: The Pace Wildenstein Gallery, New York. © 2006 Artists Rights Society (ARS), New York.
- Chapter 12 12.4: Courtesy of UCLA Hammer Museum. 12.12: Courtesy of the artist. 12.17: Courtesy of the artist. Photo: Chapman/Forsyth. 12.20: Courtesy Chihuly Studio, photo by Dick Busher. 12.21: Courtesy of the artist. Photo: Tadasu Yamamoto. 12.28: Courtesy of the artist, photo by Ted Roberts.
- Chapter 13 13.7: Albright-Knox Art Gallery, Buffalo, New York. Charles Clifton James, James G. Forsyth, Charles W. Goodyear, Edmund Hayes, and Sherman S. Jewett Funds, 1955. 13.10: Digital Image © The Museum of Modern Art/Licensed by SCALA/Art Resource, NY. © 2006 Artists Rights Society (ARS), New York/ADAGP, Paris.
- Chapter 14 14.11 and 14.12: Photo by Erwin Hauer. 14.16:
 Digital Image: © The Museum of Modern Art/Licensed by
 SCALA/Art Resource, NY. © 2006 Estate of Pablo
 Picasso/Artists Rights Society (ARS), New York.